In Crime's Archive

This book investigates what happens to criminal evidence after the conclusion of legal proceedings. During the criminal trial, evidentiary material is tightly regulated; it is formally regarded as part of the court record, and subject to the rules of evidence and criminal procedure. However, these rules and procedures cannot govern or control this material after proceedings have ended. In its 'afterlife', criminal evidence continues to proliferate in cultural contexts. It might be photographic or video evidence, private diaries and correspondence, weapons, physical objects or forensic data, and it arouses the interest of journalists, scholars, curators, writers or artists. Building on a growing cultural interest in criminal archival materials, this book shows how in its afterlife, criminal evidence gives rise to new uses and interpretations, new concepts and questions, many of which are creative and transformative of crime and evidence, and some of which are transgressive, dangerous or insensitive. It takes the judicial principle of open justice – the assumption that justice must be seen to be done – and investigates instances in which we might see too much, too little or from a distorted angle. It centres upon a series of case studies, including those of Lindy Chamberlain and, more recently, Oscar Pistorius, in which criminal evidence has re-appeared outside of the criminal process. Traversing museums, libraries, galleries and other repositories, and drawing on extensive interviews with cultural practitioners and legal professionals, this book probes the legal, ethical, affective and aesthetic implications of the cultural afterlife of evidence.

Katherine Biber is Professor of Law at the University of Technology, Sydney.

A GlassHouse Book

In Crime's Archive
The Cultural Afterlife of Evidence

Katherine Biber

Routledge
Taylor & Francis Group
a GlassHouse Book

First published 2019
by Routledge
2 Park Square, Milton Park, Abingdon, Oxon OX14 4RN

and by Routledge
711 Third Avenue, New York, NY 10017

A GlassHouse Book

Routledge is an imprint of the Taylor & Francis Group, an informa business

British Library Cataloguing-in-Publication Data
A catalogue record for this book is available from the British Library

Library of Congress Cataloging-in-Publication Data
Names: Biber, Katherine, 1972- author.
Title: In crime's archive : the cultural afterlife of evidence / Katherine
 Biber.
Description: Abingdon, Oxon ; New York, NY : Routledge, 2018. |
 Includes index.
Identifiers: LCCN 2018006804 | ISBN 9781138927117 (hardback)
Subjects: LCSH: Criminal investigation. | Evidence, Criminal.
Classification: LCC HV8073 .B523 2018 | DDC 363.25—dc23
LC record available at https://lccn.loc.gov/2018006804

ISBN: 978-1-138-92711-7 (hbk)
ISBN: 978-1-315-68227-3 (ebk)

Typeset in ITC Galliard Std
by Swales & Willis Ltd, Exeter, Devon, UK

Printed and bound in Great Britain by
TJ International Ltd, Padstow, Cornwall

For Daniel and Julian

who ask so many questions.

'Through this great gallery of murder, therefore, together let us wander hand in hand, in delighted admiration, while I endeavour to point your attention to the objects of profitable criticism.'

Thomas de Quincey, 'Of Murder
Considered as One of the Fine Arts', 1827.

Contents

Acknowledgements

This idea has been brewing for many years, and I owe many long-standing debts to those who have supported, encouraged and distracted me as I tried to concoct it into a book.

For scholars of evidence, the idea that criminal evidence leads an afterlife is a frankly weird thing to investigate. Where evidence goes when the law's work is finished is something that nobody had thought to investigate before, but about which everyone suddenly had an anecdote to share. In my early attempts to articulate this project, I was grateful to colleagues and peers who urged me to persist with it, and agreed that mine were questions worth asking. For making this project viable, I am grateful to the Australian Research Council for providing generous funding that gave me the time and the ability to travel to undertake this work. I also appreciate the Institute for Advanced Legal Studies at the School of Advanced Study, and the Birkbeck School of Law, both at the University of London, for hosting me as this research unfolded. I thank many audiences who listened to me attempt to articulate these ideas and, at a crucial moment, I was honoured to deliver the John V. Barry Memorial Lecture in Criminology at the University of Melbourne, which marked a turning point.

My first personal thanks go to Colin Perrin, my editor, who from the outset felt that this was a book worth writing. His curiosity and his patience struck exactly the right balance.

Scholarly and personal friends made contributions to this work, some of which were highly practical and some more fun or collegiate, and all of them important to me. These number more than I can recount here, but I particularly thank Michelle Arrow, Judith Bannister, Alison Bell, Jose Bellido, Tilly Boleyn, Avi Brisman, Michelle Brown, Nerida Campbell, Eamonn Carrabine, Derek Dalton, Annette Dasey, Peter Doyle, Katie Dyer, David Ellison, Laila Ellmoos, Bradley Fraser, Chris Gaul, Ann Genovese, Harriet Grahame, Helen Groth, Piyel Haldar, Claire Hooker, Tammy Horsley, Jill Hunter, Fleur Johns, Daniel Joyce, Joan Kee, Sarah Keenan, Travis Linnemann, Michael Lorenzini, Arlie Loughnan, Natalya Lusty, Desmond Manderson, Dave McDonald, Shaun McVeigh, Stephen Mason, Denise Meyerson, Les Moran, Linda Mulcahy, Carl Power, Julia Quilter, Nicky Rafter, Kate Rossmanith, Peter Rush, Renata Salecl, Mehera San Roque, Brent Salter, Luc Sante, Martha Sear, Tom Sear, Vicki Sentas, Tim Slade, Brett Todd,

Dave Trudinger, Oliver Watts, Shane White, Holly Williams and – with particular affection and gratitude – Alison Young.

My investigations were enriched by the extraordinary people who agreed to speak to me, formally and informally, about their professional and creative work using criminal evidence. I thank Nora Atkinson, Annette Day, Peter Doyle, Jason File, Sophie Jensen, Fiona McGregor, Pam (P.M.) Newton, Lachlan Philpott, Kylie Scroope, Deborah Staines, Sarah Streatfeild, Jane Taupin, Alana Valentine and Finbarr Whooley. My most heartfelt thanks go to Lindy Chamberlain-Creighton, whose courage and tenacity motivated me to continue this work, and taught me the importance of paying attention to all the details. To Lindy and to Rick Creighton I am grateful, and humbled by their time and generosity.

This work would not have been possible without the support of research assistants who, over the years, injected energy and rigour. I thank Jeannine Baker, Dean Biron, Eloise Chandler, Althea Gibson, Starla Hargita, Divya Murthy and – at the final hurdle – Matthew Sidebotham, who judiciously deleted much of it, thereby improving it.

I have the great luck to be surrounded by generous and wonderful colleagues at the University of Technology Sydney, a vibrant intellectual community. In the Faculty of Law, I have been rescued countless times by Jenni Millbank and Isabel Karpin who, over many years and across every form of communication technology, provided wry observations and strategic advice. For camaraderie, support, expertise and enthusiasm, I am also grateful to Isabella Alexander, Thalia Anthony, Laurie Berg, Mal Booth, Tracey Booth, David Carter, Anna Clark, Chris Croese, Penny Crofts, Shaunnagh Dorsett, Beth Goldblatt, Chris Goth, Nicole Graham, Emily Hammond, Lesley Hitchens, Paul Holt, Alicja Jagielska-Burduk, Trish Luker, Jill McKeough, Lisa Merry, Karen O'Connell, Michael Rawling, Gabrielle Simm, Alecia Simmonds, Anita Stuhmcke, Cory Thomas, Lesley Townsley, Honni van Rijswijk, Anthea Vogl, Ana Vrdoljak and Jane Wangmann.

And finally, and most importantly, I thank my family. Every day I am reminded by them of how to see the world from a different perspective, and of all the little tasks, lists and labours that keep our lives rolling forwards. To my parents, Alex Biber and Marika Biber, I am so grateful for every opportunity you thought to offer me, and for encouraging me to follow a path none of us had ever taken before. I thank my brother, Andrew Biber, for taking the populist view of things, and for doing it so laconically and provocatively. From my astonishing children, Daniel and Julian, who couldn't care less about my work, I have learned new languages, philosophies and ways of seeing. I acknowledge Maciek, our beloved mongrel, who oversees our lives with barely concealed indifference. And to Paul McCartan, my husband and best friend, my first reader and most honest critic, whose curiosity and intellect exhaust and inspire me, I am amazed and relieved that he continues to find daily ways to offer me strength, comfort, solidarity and laughter.

Permissions

Cover image: Yves Marchand and Romain Meffre, Offices, Highland Park Police Station, 2007. From their series *The Ruins of Detroit* (2005–10). Reproduced with permission. I thank Yves Marchand for his assistance and cooperation.

Images in Chapter 1: Figures 1.1, 1.2, 1.3, 1.4, 1.5, 1.6 and 1.7 are held in the NSW Police Forensic Photography Archive, Justice and Police Museum, Sydney Living Museums. Reproduced with permission. I thank Nerida Campbell, Holly Schulte and Susan Sedgwick for their support in accessing these images.

Images in Chapter 2: Figure 2.1 was obtained from the Mayor's Office for Policing and Crime [London, United Kingdom] and is reproduced with permission. I thank Mario Black, Paul Bickley and Jackie Keily for assistance with this image. Figure 2.2 is an image of Frances Glessner Lee, from the *Saturday Evening Post*, 10 December 1949; it was provided by Glessner House Museum, Chicago, IL, and is reproduced here with permission. I thank William Tyre for his assistance. Figures 2.3, 2.4, 2.5, 2.6, 2.7 and 2.8 are photographs of the Nutshell Studies of Unexplained Death, by Frances Glessner Lee, from the collection of the Harvard Medical School, Harvard University, Cambridge, MA, courtesy of the Office of the Chief Medical Examiner, Baltimore, MD. The photographs were taken by Katherine Biber at the Renwick Gallery of the Smithsonian Museum, 2017. I thank Nora Atkinson, Amy Doyel, Elana Hain, Bruce Goldfarb and Dominic W. Hall for their support and permission in reproducing these images.

Image in Chapter 3: Figure 3.1 is a photograph of Jill Meagher's handbag from the police brief of evidence, released to media agencies following a decision of the Melbourne Magistrates' Court. [Victoria Police v Adrian Bayley, 12 March 2013]. It is reproduced here with permission from Victoria Police. I am grateful to Senior Sergeant Clint Wilson for his assistance.

Images in Chapter 5: Figure 5.1 is a photograph of maggots from the bodies of Ruxton's victims, obtained from NHM Images and copyright of The Trustees of the Natural History Museum, London. It is reproduced with permission and I thank Emily Frost for her assistance. Figure 5.2 is by Angela Strassheim, titled Evidence #11, 2009, 48" × 60", archival pigment print. Figure 5.3 is by Angela Strassheim, titled Evidence #8, 2009, 48" × 60", archival pigment print. These images are courtesy of Angela Strassheim and reproduced with permission. I thank Angela Strassheim for her assistance and advice. Figure 5.4 is Teresa

Margolles, *32 años (Suelo donde cayó el cuerpo asesinado del artista Luis Miguel Suro)* [32 Years (Floor where the murdered body of the artist Luis Miguel Suro fell)], 2006. 105 ceramic tiles, metal frame. 200 × 200 × 1 cm (78 ¾" × 78 ¾" × 3/8".). Courtesy the artist and Galerie Peter Kilchmann, Zurich. Figures 5.5 and 5.6 were provided by the Mayor's Office for Policing and Crime [London, United Kingdom] and are reproduced with permission. I thank Mario Black, Paul Bickley and Jackie Keily for assistance with these images.

Images in Chapter 6: Figure 6.1 is a metal panel from the area under the dashboard of the Chamberlains' car, now held in the National Museum of Australia; photo by Dragi Markovic, National Museum of Australia; reproduced with permission. Figure 6.2 portrays evidence tags now held in the National Museum of Australia; photo by National Museum of Australia; reproduced with permission. Figure 6.3 shows archive boxes containing papers of Lindy Chamberlain-Creighton in the National Library of Australia, Papers of Lindy Chamberlain, 1944–2010, MS 9180. National Library of Australia, reproduced with permission.

Images in Chapter 7: Figure 7.1 is Šejla Kamerić, *Ab uno disce omnes,* multimedia installation and ongoing web project. Installation view at Wellcome Collection, 2015; courtesy Galerie Tanja Wagner, Berlin. Figure 7.2 is Jason File, *The End* (2015), from The Hole Truth series. Copyright Jason File; courtesy Jason File and Zabludowicz Collection, London. Figure 7.3 is Jason File, *The Earth and the Stars (II)* (2015). Installation view, Stroom, The Hague, Netherlands. Copyright and courtesy Jason File. Figure 7.4 is Jason File, *The Earth and the Stars (III)* (2015). Installation view, Stroom, The Hague, Netherlands. Copyright and courtesy Jason File. I thank Jason File for his assistance and advice.

Images in Conclusion: Figures 8.1, 8.2 and 8.3 are from a project of the People's Paper Co-op (PPC) a program of the Village of Arts and Humanities in Philadelphia. Titled *Without My Record I Am Free to Be . . .* (2014–16), these photographs were taken by Katherine Biber at the exhibition Philadelphia Assembled, exhibited in the Philadelphia Museum of Art, Perelman Building, 2017, and are reproduced with permission. I thank the People's Paper Co-op, particularly Mark Strandquist and Courtney Bowles, for assistance.

Several of the ideas and themes for this book appeared in earlier forms and differently expressed, in other publications by the author, and appear here in compliance with the terms of those publication agreements. Those publications are: Katherine Biber (2018), 'The art of bureaucracy', in D. Manderson, ed. *Law and the Visual,* Toronto: University of Toronto Press; Katherine Biber (2017), 'Law, evidence and representation', in M. Brown and E. Carrabine, eds, *Routledge International Handbook of Visual Criminology,* London and New York: Routledge; Katherine Biber (2017), 'The archival turn in law: The papers of Lindy Chamberlain in the National Library of Australia', *Sydney Law Review* 39(3), 277–301; Katherine Biber (2017), 'Evidence in the museum: Curating a miscarriage of justice', *Theoretical Criminology* DOI: 10.1177/1362480617707950 [first published 11 May 2017]; Katherine Biber (2016), 'Peeping: Open justice and law's voyeurs', in C. Sharp and M. Leiboff, eds, *Cultural Legal Studies,*

Abingdon UK: Routledge; Katherine Biber (2015), 'The rules of evidence', in B. Andrew and K. Dyer, eds, *Evidence*, Ultimo NSW: Museum of Applied Arts and Sciences Media; Katherine Biber (2015), 'Open secrets, open justice', in G. Martin, R. Scott Bray and M. Kumar, eds, *Secrecy, Law and Society*, Abingdon UK: Routledge; Katherine Biber (2014), 'Inside Jill Meagher's handbag: Looking at open justice', *The Alternative Law Journal* 39(2), 73–77; Katherine Biber (2013), 'In crime's archive: The cultural afterlife of criminal evidence', *The British Journal of Criminology* 53(5), 1033–49; Katherine Biber (2011), 'Evidence from the archive: Implementing the Court Information Act in NSW', *Sydney Law Review* 33(3), 575–98; Katherine Biber (2009), 'Bad Holocaust art', *Law Text Culture* 13, 227–59; Katherine Biber (2006), 'Photographs and labels: Against a criminology of innocence', *Law Text Culture* 10, 18–40.

Introduction
Afterlife, evidence, archive

At the end of the criminal trial, where does the evidence go? During the trial, strict rules govern the access to and the use and interpretation of evidence, but after the conclusion of proceedings these rules no longer apply. This book explores the eclectic, often surprising, places in which evidence reappears after the criminal trial. Sustained by the interest of artists, writers, scholars, collectors and curators, as well as its lingering legacy in the lives of legal professionals and parties to the legal dispute, criminal evidence often leads what this book describes as a *cultural afterlife*.

A national museum preserves evidence used to secure the conviction of a woman for the murder of her baby; the same evidence later exonerated her. A gun that killed an unarmed teenager, sparking the Black Lives Matter movement, is listed for sale on an online marketplace. Maggots removed from a murder victim, used to establish the time of death, are displayed in an exhibition. In researching this book, so many people shared with me stories about the strange cultural afterlives of evidence. To take one example: after a drug importation trial, which saw the defendants sentenced to lengthy terms in prison, the judge asked who was going to take the taxidermied big cat. My informant couldn't remember whether it was a lion, tiger or leopard, but the trafficked drugs had been concealed within its body, and the big cat was adduced into evidence. One of the defence barristers offered to take the animal, after which it served as a conversation piece in his chambers. In its afterlife, this dead animal served as a memorial of the trial in which it had established proof of guilt. Of course, before it was criminal evidence it was a trophy for those who had hunted and killed it and, before that, had lived its own life as a wild apex predator; the evidentiary life of an object marks just one episode of its existence. The 'cultural afterlife' reflects the fact that evidentiary objects often live before the trial, and sometimes continue to live afterwards. While some objects and documents are brought into existence solely for an evidentiary use, and some are destroyed at the end of their evidentiary life, this book explores those that haunt crime's afterlife.

It is difficult to identify the moment when it first occurred to me, as a scholar and teacher of the laws of evidence, to explore the cultural afterlife of evidence. Perhaps it was in 2008, when a friend returned from New York and mentioned William E. Jones's work *Tearoom* (1962/2007) at the Whitney Biennial. She

described the work, made from 56 minutes of silent covert surveillance footage taken by police officers in a men's public lavatory in 1962 in Mansfield, Ohio – footage used to secure at least 31 convictions for sodomy. As an artwork, it was sub-titled 'A document presented by William E. Jones', and was essentially evidentiary footage screened in an art gallery. I contacted Jones, explained my scholarly curiosity about his work, and he generously sent me a copy of the film. I sat down to watch it but soon began to regret what I had seen. The film is not erotic, not intrinsically interesting and is often incredibly sad. The furtive nature of the sex acts, the looming sense of fear and danger, the absence of any evident pleasure, scene after scene in which the subjects wait – often in vain – for something to happen; all made me feel that I was compounding the humiliation of these men, seeing something that was not intended for me. Although the evidence against them was lawfully obtained, watching the footage now seemed somehow wrong. Notwithstanding that these men's conduct was public and criminal, this film captured secrets. Watching it outside and after the law seemed like a breach of some boundary. Jones, in his own writing about his artwork, and his supporters in the queer and arts press, justified the screening of the footage for its ability to teach us about 'the closet', and the policing of gay sexualities, and what sex looked like before mass pornography (Jones 2008).[1] Still, I felt uneasy about *Tearoom* and in some ways it launched the project that resulted in this book.

Afterlife

The notion of an 'afterlife' has interested philosophers and theologians for millennia. It might be expressed as life-after-death, or as life-after-life. While some view death as the end of existence, others would disagree. Death, for these believers, marks the emancipation of the soul; some would say that the possibility of an afterlife ought to influence one's conduct during life, on the chance that life after death may include a hell. The 'afterlife' of cultural artefacts can be examined according to similar principles. Time and materiality remain significant but, whereas in the human afterlife it is the material body that has died, where cultural objects are concerned, their material form is what remains after they are removed from their original context. The afterlife is a zone of either immortality or waste; it is where we keep things which are not dead to us. No longer useful for their intended purpose, surviving phenomena acquire new capacities for finding and making meaning. The afterlife provides an important new vantage point from which to survey the life that preceded it, so that the survival or haunting becomes a part of that thing's narrative. In the afterlife, we can perceive the transformations wrought by law upon one of law's artefacts.

The concept of the 'afterlife' or 'survival' of cultural objects can largely be attributed to the cultural critic Walter Benjamin (1892–1940), who wrote that any analysis of the life and afterlife of a cultural artefact demanded 'unmetaphorical objectivity' (Benjamin 2007, 71). Benjamin, whose writing often had a theological strand, was attentive to the transformations that an object underwent during its life and afterlife. Benjamin's final work, *The Arcades Project*, was

his unfinished attempt to understand the afterlife of cultural artefacts (Benjamin 1999). This could include works of interpretation or translation, reproduction and revival, each of which in some way transformed the original object and, in so doing, somehow abetted its survival. A similar outlook is at play in the works of art historian Aby Warburg (1866–1929), whose own unfinished project was *Mnemosyne*, 'memory', described as an 'atlas of pictures', documenting the survival, transformation, migration, rescue and revival of cultural objects from antiquity, resituated into a later cultural moment (Sauerländer 1988). For Warburg, survival was not a triumph, but rather a kind of haunting: a phantom that has survived its own death (Didi-Huberman 2002). Warburg's work has been sustained by contemporary interlocutor Georges Didi-Huberman. Didi-Huberman wrote that the *surviving* object, 'having lost its original use value and meaning, nonetheless comes back, like a ghost, at a particular historical moment: a moment of "crisis", a moment when it demonstrates its latency, its tenacity, its vivacity' (Didi-Huberman 2005, xii).

In the cultural sphere, evidence might reappear in contexts that are intentional, public and often creative, and that are not tethered to the constraints of the law. In its afterlife evidence acquires new and often competing attributes: its physicality, its fragility, its history, its probative value, its symbolic power and its emotional heft. It invokes the concepts of archive and memory, transparency and secrecy, sensitivity and dignity (Biber 2011 and 2013). The afterlife of evidence doesn't occur in any imaginable space; evidence is not neatly gathered into a box and placed on a shelf. Of course, some evidence *is* preserved in that manner, but that literal archive co-exists with the graveyard, the garbage bin, the garage and the museum as zones in which evidence might be dispersed, preserved or forgotten. In such 'heterotopias' – places in the world but somehow separate from it – things accumulate but are, themselves, 'outside of time and inaccessible to its ravages' (Foucault 1986, 26).

Evidence

Evidence is law's epistemology; it establishes what the law knows, or what can be known through law's methods. By the production of evidence, and its subsequent use and interpretation, facts are found, disputes settled and law enforced. 'Evidence' refers to both an object and a process; it is a noun and a verb. It may be testimony, documentary or material; it can be circumstantial, provisional, rebuttable, presumptively true, reliable, unreliable, or it might demand that inferences be drawn from it. It can be voluminous and complex, requiring specialised knowledge to understand. It may be public knowledge, or something recovered by forensic examination. It can be visible to the naked eye or detectable only with instruments. It can be digital, ephemeral, a trace left upon one's memory. Because lawyers love rules, there are lots of laws of evidence, and so evidence must be approached with formality, seriousness and deliberation. Evidence – in law – must never be self-evident and, where it is, there are rules about that too.

Legal story-telling, persuasive advocacy, building cases upon incomplete facts, these are the foundations for the laws of evidence. The laws of evidence enable us to tell stories within agreed rules. The criminal trial is essentially two stories at war with each other (*'I didn't do it'; 'Yes, you did'*). The laws of evidence provide the guidelines for telling these contested narratives. And the artefacts of evidence – exhibits, documents, witnesses – provide the props and the protagonists.

Evidence can be given or taken. It can be tendered, admitted and withdrawn. Evidence can be tampered with, concealed or destroyed. That which is not in evidence cannot be deliberated upon, but exists nonetheless. New evidence comes to light. Innovations in evidence present ongoing challenges for investigators, litigants, legislators and courts. The rules of evidence are under perpetual scrutiny and in a constant state of review and reform. For artists and curators, all these qualities of evidence are at once necessary and superfluous. Creative work made from evidence relies, for its impact, upon these evidentiary origins. But creative work is not bound by the rules of evidence and, if nothing else, provides an unsettling perspective from which the lawyer might see evidence afresh, its rules broken, and needing to be picked up and put back together again, or simply left in pieces and unrepaired.

Archive

This book imagines the evidentiary afterlife as constituting *crime's archive* – a vast warehouse, too large to apprehend, in which crime's evidence is gathered, arranged, preserved and, usually, ignored. The concept of the 'archive' encompasses both traditional record-keeping practices and more contemporary methods of file-sharing and open access. Engagements with the archive today understand that it can be a repository, a subject, a method – even an aspiration.[2] For some contemporary practitioners, the archive can also be a feeling or a disposition. This reflects what anthropologist Ann Laura Stoler has termed 'the archival turn' in the humanities and social sciences (Stoler 2002), echoed in concepts of 'the archival impulse' (Foster 2004), 'archival logics' (Burton 2005) and 'archive fever' (Derrida 1996). Crime's archive has been imagined and preserved in many ways; this book explores just a sample. It engages with contemporary archival practitioners about their responsibility for, and relationship with, criminal records. Contemporary official archives, including the notional repository of criminal evidence, now function within a wider cultural sensibility that recognises that the archive is a constantly revised, unstable resource (Biber and Luker 2017). This sensibility tolerates archival projects that might be creative, critical, revisionist, interventionist, speculative, non-serious or counter-archival. Archival materials enjoy a concurrent status as 'anthropological artefact' and 'social instrument' (Enwezor 2008, 13). That these materials may now include digital files, emails, Tweets, photographs, moving images, ephemera, objects, the internet and events demands what archivist Brien Brothman called a 'poetics' of archiving (cited in Ridener 2008, at 119). This responds to the difficulty – indeed, the futility – of trying to distinguish between information, administration and cultural production.

For creative practitioners throughout the twentieth century, the archive has been the site of repeated confrontations with history, historicity, order, linearity, time and bureaucracy. Artists including Christian Boltanski, Joseph Beuys and Gerhard Richter used archival fragments in attempts to memorialise the past (see Buchloh 1999). This archival fascination continued into the twenty-first century, where manipulation, citation and documentation have become widely practised artistic techniques. Archival materials formed the basis for transgressively imagined pasts, as in the work of artists such as Tom Sachs, Alan Schechner, Piotr Uklański, Rudolf Herz and Boaz Arad, who played with unexpected juxtapositions, alternate endings or aesthetic aspects of the Nazi Holocaust (Biber 2009; see also Chapter 7). Other artists worked with the stark disjuncture between the notoriety of certain crimes and the banality of the criminal evidence they produced. This might include Richard Barnes's repeatedly photographing Ted Kaczynski's Montana cabin after it was taken into evidence (Richard Barnes, *Unabomber*, 1998), or Christian Patterson's photobook of redneck sentimentality memorialising the 1957–58 murder spree of Charles Starkweather and Caril Ann Fugate (Patterson 2011). Jamie Wagg enhanced photographs taken from security cameras showing two-year-old James Bulger being led away to his death by two ten-year-olds, Jon Venables and Robert Thompson (*'History Painting'*, *Shopping Mall, 15:42:32, 12/02/93*, 1993–94; *'History Painting'*, *Railway Line*, 1993–94), which were heavily criticised by Bulger's family and the exhibition's sponsors (Cusick 1994; McGrath 2004). Numerous artists have used the crime scene as a site of creative engagement, re-photographing locations in which homicides occurred in order to produce new claims upon forensic aesthetics; this is evident in the work of, for instance, Taryn Simon, Teresa Margolles, Angela Strassheim, Deborah Luster, Stephen Chalmers and Krista Wortendyke. Within the museum, the criminal archive itself has become an object of display, with curators and artists including Ross Gibson, Kate Richards, Peter Doyle, Nerida Campbell and Michael Lorenzini all finding ways to present police photographic archives in crime's afterlife.

The archive can be understood in the context of its relationship with the state; as Jacques Derrida noted in *Archive Fever*, 'There is no political power without control of the archive, if not of memory' (Derrida 1996, 4, footnote 1). However, an archive need not be an official institution; it can be any intentional accumulation of materials with a view to their future retrieval. The archival turn interrogates the institution of the archive itself, its claims to authority, and its political, cultural, legal and emotional effects. In the context of recent scholarly concerns that any accumulation of materials might be understood as an 'archive' (Burton 2005, 11), and warnings 'not to void [the term "archive"] of any specific meaning' (Spieker 2011), the archival turn invites us to think anew about the purposes, uses and effects of accumulated papers and things.

It also demands that we see documents *as* things – and that we see the object in relationship to its own past, but are also able to provide it with a future never imagined by its creator. As Derrida wrote on the archive, 'if we want to know what [it] will have meant, we will only know in times to come' (Derrida 1996, 36).

For historians, the concept of 'historicism' demands that documents be interpreted in the context of the practices that produced them, which the legal historian Christopher Tomlins has reminded us is complex and contingent (Tomlins 2012, 33). In *The Archaeology of Knowledge*, Michel Foucault recognised that the work of historians had shifted away from the location and interpretation of documents and towards 'defin[ing] within the documentary material itself unities, totalities, series, relations' (Foucault 2002, 7). Every archival scholar has experienced, if rarely, disbelief or astonishment at having retrieved a document that shouldn't be there, but nevertheless *is*, that document's survival eventually eclipses its informational value. This is partly what Michel Foucault meant when he wrote that history 'transforms *documents* into *monuments*' (Foucault 2002, 8, emphasis in original).

Historians have embraced the archival turn, with document-based research now conducted with awareness of the physical environment of 'the archive', and the architectural, personal, emotional and tactile effects of archival labour. Evident in Timothy Garton Ash's memoir *The File* (1997), and most commonly associated with Carolyn Steedman's book *Dust* (2001), a considerable outpouring of scholarly historical work represents this new material engagement with the archive.[3]

The archival turn has also been advanced further through the work of anthropologists, whose ethnographic and descriptive methods have been adopted by some legal scholars. Anthropologist Ann Laura Stoler, in *Along the Archival Grain* (2009), recognised that records do more than prove what happened; in them we might also find 'the visionary and expectant', 'scrupulously planned utopias' that, for the legal scholar, represent a close analogy with law's vocation (Stoler 2009, 21). Stoler demands that we pay attention to the form, placement and organisation of records, so that the archive is not so much a source as an 'epistemological experiment'. Through her work we come to understand records as embedded within a 'culture of documentation' (Stoler 2009, 87, 88); gaining a clearer understanding of that culture provides legal scholars with important tools for interpreting these records. Anthropologist and legal scholar Annelise Riles also urged scholars to examine documents as 'ethnographic artefacts', with ethnographic methods of analysis and description potentially exposing distinctive epistemological, ethical and aesthetic attributes. Working with documents ethnographically, Riles explained, helps us understand them as distinct from the bureaucracy that created, mandated or preserved them (Riles 2006, 10). For anthropologist Bruno Latour, law's materials make law 'visible', enabling it to be 'located and traced' (Latour 2010, 70). Latour describes his immersion in one of France's superior courts, and provides a compelling account of the folders, shelves, pigeonholes, meetings and file work that mark the law's progress from dispute to judgment. The slow and purposeful accumulation of papers, the construction and consultation of files, their movements around the building, and their gradual inching towards a decision, in Latour's study, represents a paradigmatic instance of the material study of law. As explained by legal scholar Alain Pottage, 'materiality' refers not to the things themselves, but rather to 'the kind

of agency that is afforded by, elicited from, or ascribed to them' (Pottage 2012, 168). Material agency draws our attention to 'density, conformation, disposition, and operability' of our tools, and the 'gestures, perspectival axes, and textual traces' they generate from those who act with or upon them (Pottage 2012, 168). In Pottage's critique of Latour, he argues that material thinking has tended 'to give substance to the assumption that there is such a thing as "law"' (Pottage 2012, 178). In effect, some scholars have used materiality to help them 'find' law in novel places, a project Pottage challenges.[4] Pottage suggests we work in the opposite direction, 'ask[ing] whether a reflection on materiality might not actually lead to the dissolution of law as a social instance' (Pottage 2012, 180).

For legal scholars, a major contribution to thinking materially about records and documents comes from Cornelia Vismann, who argued that it is through documentation and record-keeping that law is actually produced. By paying close attention to the making of documents, their movements and their management, their amendments, annexures and cancellations, Vismann largely inaugurated material thinking within legal discourse. She wrote, 'Legal studies lack any reflection on their tools . . . Files remain below the perception threshold of the law' (Vismann 2008, 11). She found traces of law in documents otherwise 'analytically invisible', 'mundane' (Brenneis 2006, 42) – the registers, indexes, forms, lists and templates generated by bureaucracies that are not consciously engaged in acts of self-description or self-documentation. Vismann's book was, in Tomlins's view, 'an object lesson in how to write of law fetishized as things . . . [and] of things fetishized as law' (Tomlins 2016).

Law's work is evident in the volume of papers it leaves in its wake, in its afterlife, and a material engagement with documents also enables us to glean law's aspirations and failures, its false starts and its valiant attempts. By understanding papers, files and folders as legal instruments, probative of the incremental accretion of ideas, decisions and strategies, we assume a new perspective on how law is made, enforced and preserved. And we are left with a trove of material which, in law's afterlife, provides us with clues, souvenirs and memorials to law's work.

Structure of the book

Each of the chapters in this book focuses on the cultural afterlife of evidence within a different institutional context. Most of these institutions are formal public ones – museums, archives, tribunals, the news media. Many have called upon creative practitioners, particularly artists and curators, to give thought to how evidentiary materials might be sustained in the afterlife of crime. Sometimes, commercial considerations arise in crime's afterlife; where they do, this book explores how crime is commodified and transacted in the marketplace.

In researching this book, I encountered so many instances of the cultural afterlife of criminal evidence, and it would not be possible to do justice to them all. I have chosen instead to conduct a series of case studies, each of which illuminates distinctive practices, concepts or concerns. Throughout, I have drawn upon interviews, fieldwork, observation and other encounters to enrich my understanding.

Forensic photographs are probably the first form of criminal evidence to have led an afterlife. The publication of *Evidence* by Luc Sante might be claimed as the moment that criminal evidence was welcomed as a mainstream cultural artefact (Sante 1992). This book, in which he presented violent and strange crime scene photographs taken by the New York Police Department between 1914 and 1918, launched many other cultural projects that sought to imitate, expand or transform Sante's pioneering work. Police photographs play a significant role in contemporary representations of crime, and historical forensic photographs are now popular and uncontroversial materials for curators, publishers and other cultural practitioners. Chapter 1 examines one of the world's most important and distinctive collections of historical police photographs, the Forensic Photography Archive, created by the New South Wales Police between 1910 and 1964. The Archive is a 'closed' collection because of its physical fragility and the sensitivities and potential dangers associated with public records relating to criminal matters. Despite being closed, public attention has been drawn to the scale and significance of the collection through selected interpretive projects, including successful exhibitions and publications. Scholars, historians and creative writers have relied upon the Archive; fashion designers have been inspired by it; and theatrical projects have been staged in response to selected images from the collection. This chapter draws upon the experiences and hesitations of cultural practitioners in aestheticising crime and trauma, and their concerns about pursuing creative projects made from historical and evidentiary records.

In one extraordinary instance, forensic and creative responses to crime combine in a collection of miniature dollhouses, known as the Nutshell Studies of Unexplained Death. Made in the 1940s and 1950s by Frances Glessner Lee, the nutshells were based upon real criminal cases and evidence, and are examined in Chapter 2. Emphatically insisting that her project was a scientific one, attempting to improve police investigative methods at crime scenes, Lee's nutshells have nevertheless acquired a unique cultural charge, and have been the subject of creative work in the fields of film, television, poetry and curation. Primarily kept outside public view at the Office of the Chief Medical Examiner in Baltimore, the nutshells were displayed publicly for the first and only time in 2017 at the Smithsonian Museum, and this chapter explores Lee's unique legacy for the cultural afterlife of criminal evidence.

Given the public fascination with crime, the news media dominate the way we understand and consume crime. More than ever, criminal evidence is a commodity for news organisations, and Chapter 3 explores the afterlife of evidence in the news media. Examining the dynamic processes of crime reportage, this chapter interrogates the relationship between the courts, the police and the media to understand how criminal evidence is released to, and broadcast by, media agencies. Increasingly, decision-making about access to evidence is made in the shadow of the courts: by registrars, court clerks and court information officers. Photographic images, private diaries, CCTV footage, exhibits, video recordings of police interviews, and the substantial and eclectic contents of police briefs – these evidentiary materials are now being used to drive traffic onto media sites

online, and are also being screened on primetime television. This chapter investigates whether contemporary media practices take advantage of open justice mechanisms, without serving the objectives of open justice.

Situated within the contemporary context of news media practices, where commerce and voyeurism converge around crime, Chapter 4 is a case study of the broadcast murder trial of Oscar Pistorius. Accused of the murder of his girlfriend Reeva Steenkamp in South Africa, his trial in 2014 was broadcast live after media agencies applied to the court for comprehensive access to the courtroom. The decision to broadcast all the evidence globally, in real time, was ostensibly an experiment in open justice. The principles of transparency and accountability were given unique significance in post-apartheid South Africa, and were daily balanced by the court against accusations of sensationalism, voyeurism and the constitutional protections available to the accused. In this chapter, the book acknowledges that the 'afterlife' of criminal evidence in the digital age can occur literally moments after the evidence is adduced in court. This chapter, which explores many episodes during the trial, also seeks to understand what is at stake when the cultural afterlife of evidence occurs with extreme speed.

An important institution in the cultural afterlife of evidence is the museum, and Chapter 5 examines how the techniques of curation and display are engaged. Focusing on two major exhibitions staged in London in 2015 – at the Wellcome Collection and at the Museum of London – this chapter reveals the challenges that arise for curators, and the difficulties of negotiating the legal, ethical and creative problems posed by criminal evidence. In one important respect, these challenges are met by a closer engagement with cultural practitioners, particularly artists, and this chapter explores how artists use criminal evidence, and how museums work with artists to help them think through the aesthetic, historical and political opportunities that arise from exhibiting criminal artefacts. Where artists and curators use criminal evidence, we can see how this material moves beyond probative value, and how it might provoke us to be affected, aroused, curious, nostalgic, or to feel pleasure in circumstances that were once traumatic or transgressive.

Further testing the potential of the museum and the archive, the book next examines the case of Lindy Chamberlain (Chapter 6), victim of probably the best-known miscarriage of justice in Australia. The Chamberlain case – and Lindy herself, wrongly convicted of the murder of her baby daughter Azaria – divided public opinion and continues to linger in the public imagination. The evidence in that case has dispersed in unusual ways, and much of it was returned to, or generated by, Lindy Chamberlain. This chapter of the book, which draws upon interviews with Lindy Chamberlain-Creighton (as she is now), archivists, curators, conservators and creative practitioners, explores the strange afterlife of the evidence in this case. It investigates how the evidence continues to have probative value after law's work has concluded. It asks whether different ethical precepts are engaged by the manner in which the evidentiary artefacts entered the cultural field: much of this is Lindy's personal archive, and her continuing role shapes its afterlife.

In the final chapter, this book recognises that while most criminal evidence is adduced in ordinary courtrooms, in which ordinary crimes are prosecuted, over the course of the twentieth century the international criminal tribunal has emerged as an important site of criminal prosecution. Responding to the unique challenges posed by war crimes, genocide and crimes against humanity, these tribunals have developed new evidentiary processes, and have received distinctive forms of evidence. Chapter 7 explores two such tribunals – the International Military Tribunal at Nuremberg, which between 1945 and 1946 prosecuted leading Nazis, and the International Criminal Tribunal for the former Yugoslavia, established in 1993 to prosecute crimes and violations of international humanitarian law arising from conflicts in the Balkan region. Both tribunals generated evidence, testimony, papers, archives and these materials have since led cultural and creative afterlives. This chapter seeks to understand the difficulty of making creative work that responds to international crimes, and which is made from criminal evidence.

In its Conclusion the book tests one technique for managing the sensitivities and dangers arising from the afterlife of evidence: destruction. The legal process itself offers multiple methods by which law's materials are destroyed in order to fulfil law's functions. These might include spoliation, cancellation, redaction and more benign-sounding arts, such as version-control and document-management. In its afterlife, the destruction of evidence sometimes achieves more dramatic and performative effects, and these give rise to new opportunities for cultural practitioners. In the end, this book concludes, the laws of evidence activate the imaginative work made from evidentiary materials. This book invites us to use the afterlife of evidence as a vantage point from which to study the laws of evidence, and their capacity to give us tools for telling and re-telling stories about the crimes and transgressions we seek to comprehend.

Notes

1 See also Biber and Dalton (2009); Feaster (2008); Lange (2008); Weist (2008); Lee (2008); Knight (2008); Armstrong (2008); Camper (2008); Chang (2008); Sicinski, (2007); Kee (2016).
2 See, for a sample of the extensive scholarship, Ridener (2008); Burton (2005); Merewether (2006); Spieker (2008).
3 See e.g. Enwezor (2008); Hull (2012); Gupta (2012); Farge (2013); Weld (2014); Gitelman (2014); Sands (2016).
4 Pottage (2012, 179–80). Pottage promotes systems theory and actor-network theory as better alternatives.

References

Armstrong, Skot (2008), 'Bunker vision: William Jones', *Artillery* (January), 45.
Benjamin, Walter (1999), *The Arcades Project*, trans. Howard Eiland and Kevin McLaughlin, Cambridge MA: The Belknap Press.
Benjamin, Walter (2007), *Illuminations*, London: Jonathan Cape.
Biber, Katherine (2009), 'Bad Holocaust art', *Law Text Culture* 13, 227–59.

Biber, Katherine (2011), 'Evidence from the archive: Implementing the *Court Information Act* in NSW', *Sydney Law Review* 33(3), 575–98.

Biber, Katherine (2013), 'In crime's archive: The cultural afterlife of criminal evidence', *British Journal of Criminology* 53(6), 1033–49.

Biber, Katherine and Derek Dalton (2009), 'Making art from evidence: Secret sex and police surveillance in the Tearoom', *Crime Media Culture* 5, 243.

Biber, Katherine and Trish Luker (2017), 'Introduction: Evidence and the archive: Ethics, aesthetics and emotion', in Katherine Biber and Trish Luker, eds, *Evidence and the Archive: Ethics, Aesthetics and Emotion*, London: Routledge, 1–14.

Brenneis, Don (2006), 'Reforming promise', in Annelise Riles, ed., *Documents: Artifacts of Modern Knowledge*, Ann Arbor MI: The University of Michigan Press.

Buchloh, Benjamin (1999) 'Gerhard Richter's "Atlas": The anomic archive', *October* 88, 117–45.

Burton, Antoinette (2005), 'Introduction: Archive fever, archive stories', in Antoinette Burton, ed., *Archive Stories: Facts, Fictions and the Writing of History*, Durham NC: Duke University Press.

Camper, Fred (2008), 'Critic's choice: Tearoom', *Chicago Reader* (15 May), 78.

Chang, Chris (2008), 'In Flagrante Delicto: William E Jones collaborates with the police in Tearoom', *Film Comment* 44(4), 17.

Cusick, J. (1994), 'BT disowns James Bulger pictures: Parents of murdered child "appalled and upset" by images at a London art exhibition sponsored by telecoms company', *The Independent*, 26 May.

Derrida, Jacques (1996), *Archive Fever: A Freudian Impression*, trans. Eric Prenowitz, Chicago IL: University of Chicago Press.

Didi-Huberman, Georges (2002), 'The surviving image: Aby Warburg and Tylorian anthropology', *Oxford Art Journal* 25(1), 59–70.

Didi-Huberman, Georges (2005), *Confronting Images: Questioning the Ends of a Certain History of Art*, University Park PA: Pennsylvania State University Press.

Enwezor, Okwui (2008), *Archive Fever: Uses of the Document in Contemporary Art*, exhibition, 18 January–4 May 2008, International Center of Photography, New York.

Farge, Arlette (2013), *The Allure of the Archives*, New Haven CT: Yale University Press.

Feaster, Felicia (2008), 'William E. Jones: The secret history', *Creative Loafing* (20 February), accessible at http://clatl.com/atlanta/william-e-jones-the-secret-history/Content?oid=1272210

Foster, Hal (2004), 'An archival impulse', *October* 110, 3–22.

Foucault, Michel (1986), 'Of other spaces', trans. Jay Miskowiec, *Diacritics* 16(1), 22–27.

Foucault, Michel (2002), *The Archaeology of Knowledge*, trans. A.M. Sheridan Smith, New York NY: Routledge.

Garton-Ash, Timothy (1997), *The File: A Personal History*, New York NY: Vintage Books.

Gitelman, Lisa (2014), *Paper Knowledge: Toward a Media History of Documents*, Durham NC: Duke University Press.

Gupta, Akhil (2012), *Red Tape: Bureaucracy, Structural Violence and Poverty in India*, Durham NC: Duke University Press.

Hull, Matthew S. (2012), *Government of Paper: The Materiality of Bureaucracy in Urban Pakistan*, Berkeley CA: University of California Press.

Jones, William E. (2008), *Tearoom*, Geneva: 2nd Cannons Publications.

Kee, Joan (2016), 'Towards law as an artistic medium: William E. Jones's Tearoom', *Law Culture and the Humanities* 12(3), 693–715.

Knight, Richard (2008), 'Queercentric: William E. Jones' "Found Document" is mesmerising', *Windy City Times* (14 May 2008), 17.

Lange, Christy (2008), 'Editors Blog: In the Tearoom . . . Not really what I expected', *Frieze Magazine* 10/2008.

Latour, Bruno (2010), *The Making of Law: An Ethnography of the Conseil d'Etat*, trans. Marina Brilman and Alain Pottage, Cambridge UK: Polity Press.

Lee, Ryan (2008), 'Jailbait: Tearoom exposes hidden, persecuted gay oasis in 1962', *Southern Voice* (15 February), 23.

McGrath, J.E. (2004), *Loving Big Brother: Performance, Privacy and Surveillance Space*, London: Routledge.

Merewether, Charles, ed. (2006), *The Archive*, Cambridge MA: Whitechapel Gallery London & MIT Press.

Patterson, Christian (2011), *Redheaded Peckerwood*, photobook, MACK.

Pottage, Alain (2012), 'The materiality of what?', *Journal of Law and Society* 39(1), 167.

Ridener, John (2008), *From Polders to Postmodernism: A Concise History of Archival Theory*, Duluth MN: Litwin Books.

Riles, Annelise, ed. (2006), *Documents: Artifacts of Modern Knowledge*, Ann Arbor MI: The University of Michigan Press.

Sands, Philippe (2016), *East West Street: On the Origins of Genocide and Crimes against Humanity*, London: Weidenfeld & Nicolson.

Sante, Luc (1992), *Evidence*, New York NY: Farrar, Straus and Giroux.

Sauerländer, Willibald (1988), 'Rescuing the past' (review of E.H. Gombrich, *Aby Warburg: An Intellectual Biography*), *The New York Review of Books*, 3 March 1988, accessible at www.nybooks.com/articles/1988/03/03/rescuing-the-past/

Sicinski, Michael (2007), 'Tearoom (William E Jones)', review, *Academic Hack* (April), accessible at http://academichack.net/reviewsApril2007.htm

Spieker, Sven (2008), *The Big Archive: Art from Bureaucracy*, Cambridge MA: MIT Press.

Spieker, Sven (2011), 'Un-knowing, getting lost, linking points in space: The new archival practice', paper presented at *Artists & Archives: A Pacific Standard Time Symposium*, Getty Research Institute (12 November). Proceedings accessible at www.youtube.com/watch?v=NVKTtyr6dBk [Part 1 of 3 at around 1.02.00–1.05.12.]

Steedman, Carolyn (2002), *Dust: The Archive and Cultural History*, New Brunswick NJ: Rutgers University Press.

Stoler, Ann Laura (2002), 'Colonial archives and the arts of governance', *Archival Science* 2(1), 87–109.

Stoler, Ann Laura (2009), *Along the Archival Grain: Epistemic Anxieties and Colonial Common Sense*, Cambridge MA: Princeton University Press.

Tomlins, Christopher (2012), 'After critical legal history: Scope, scale, structure', *Annual Review of Law and Social Science* 8, 31–68.

Tomlins, Christopher (2016), 'Historicism and materiality in legal theory', in Maksimilian Del Mar and Michael Lobban, eds, *Law in Theory and History: New Essays on a Neglected Dialogue*, Oxford: Hart Publishing.

Vismann, Cornelia (2008), *Files: Law and Media Technology*, trans. G. Winthrop-Young, Stanford CA: Stanford University Press.

Weist, Nicholas (2008) 'From gulag to gallery: How William E. Jones made high art from a '60s sex sting", *Out* (May), 9.

Weld, Kirsten (2014), *Paper Cadavers: The Archives of Dictatorship in Guatemala*, Durham NC: Duke University Press.

1 The afterlife of police photographs

The Forensic Photography Archive is a collection of 130,000 negatives made by or for the New South Wales Police Force in Sydney, Australia, between 1910 and 1964. The photographs in the Archive are violent, humiliating, distinctive, disturbing, banal, beautiful, surprising and often inexplicable. Most of them are on fragile glass plates or flexible negatives. The Forensic Photography Archive ('FPA', or 'the Archive') is stored at Sydney's Justice and Police Museum, in an old colonial courthouse beside the harbour quays. Its custodian is Sydney Living Museums (SLM), a state heritage agency that oversees a group of museums and historic houses in and around Sydney. This chapter seeks to understand *what remains* of these images in their afterlife, after the forensic processes have concluded. It examines the effects of using police photography in the cultural sphere, exposing the aesthetic and affective attributes of evidentiary photographs and the personal lives captured within them.

The Archive is thought to be more significant, intact and distinctive than the forensic photography collections held by the New York City Municipal Archives, the British National Archives and the Los Angeles Police Department, which, together with the Archives de la Préfecture de Police de Paris, are all heavily used and internationally celebrated collections (Lorenzini 2013; Sante 1992 and 2003; Bond 2009; Bratton, Ellroy and Wride 2004; Parry 2000). The Archive has been a source of inspiration for historians, novelists, fashion designers, playwrights and others, and this chapter investigates some of these uses. The photographs in the Archive include domestic interiors, suburban landscapes, strange portraits of 1920s criminals, close-ups of evidence and stolen goods, forced doorways and windows, images of fingerprints and forged signatures, blown safes, evidence of break-ins and escapes, corpses and skeletons, car accidents, industrial accidents, homicides, suicides and quite a few photographs that are just baffling or surreal, such as the photograph of the police detective wearing a show-girl's skirt over his suit, or the image of an overturned empty baby carriage.

The contemporary narrative of the Archive begins with an extraordinary account of its survival against the odds. The Archive – before it was rescued by the Justice and Police Museum from a flooded warehouse in 1989 – had been moved from one premises to another, enduring vermin, mould, dust and the

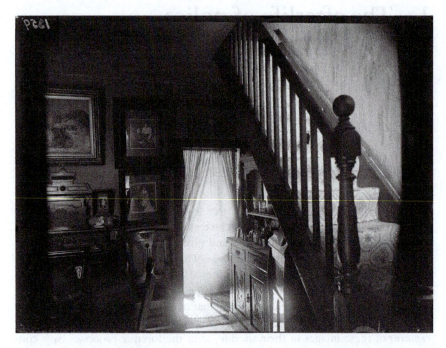

Figure 1.1 NSW Police Forensic Photography Archive, Justice and Police Museum, Sydney Living Museums. Reproduced with permission.

ravages of time. In 2006, Sydney Living Museums (then known as the Historic Houses Trust) formally acquired responsibility for managing and conserving the Archive. The photographic plates had become separated from the documents and files that once might have explained them, and these papers have since been lost or destroyed. A small portion of the images can today be understood because they were made as part of investigations that achieved notoriety, or at least media reportage, or were used in identifiable criminal or coronial proceedings from which records have survived. The majority, however, cannot be comprehended in any traditional sense, and resist the techniques of research and analysis in their ordinary meaning.

Much of the Archive is a 'closed' collection. While its physical fragility poses access issues, this status relates to the sensitivities associated with its contents. Strictly speaking, the FPA is a state record and the NSW State Archive and Records agency has established directions for accessing state records. Public access to the collection is closed for a period of 70 years (counting from the date a record was created) for reasons of 'sensitive personal information' and 'safety and security' (State Archives and Records NSW n.d., Access Direction 1349). In disseminating information about the Archive and its contents, SLM has undertaken various endeavours, conservative and experimental, to test how the material might 'live' after its evidentiary uses have lapsed.

All the images in the Archive began their lives during a police investigation. That is, all were made with an evidentiary purpose, to record and prove facts about crimes during the criminal investigation and trial. Many are, in this sense, evidence. Having said that, it is unlikely most of these images were actually used in criminal prosecutions. Changes in criminal procedure following advances in camera technologies ensured that photographers were sent to crime scenes to make images, and that people in police custody were photographed prior to their release. Nevertheless, the evidentiary *uses* of these photographs are difficult now to ascertain. They are, nevertheless, *evidentiary* images, and they dwell in the Archive in some kind of afterlife. This chapter investigates the nature and quality of that afterlife.

Law has sought to prove facts from photographs since the first photographs were taken.[1] By deploying these images in legal fact-finding processes, they become *forensic* photographs. Identity, recognition, act, omission, intention, corroboration, motive, credibility, tendency: each of these legal concepts – and others – might be proven with photographs. Law takes literally Susan Sontag's epigram that 'photographs furnish evidence' (Sontag 1971, 5). Ignoring over a century of scholarship on photography, the law looks at photographs as if they were natural or neutral, as if there were nothing impeding law's capacity to see what 'is' in a photograph.

In law's taxonomy, there are three primary forms of evidence: real evidence, documents and witnesses. The photograph might be a document when tendered to prove a fact arising from its contents, or it might be real evidence when its own physicality is somehow in issue. And yet the history of photography's jurisprudence also reveals that the photograph is always also tethered to a witness, a person whose testimony authenticates or narrates the image. While the law was swift to absorb photography into its fact-finding regime, the evidentiary form of the photograph has remained elusive and unstable.

Since the middle of the nineteenth century, photographs have been given evidentiary uses in policing and prosecution. Jennifer Mnookin's legal history of photography identified the frequent use of photography in United States courts in the late nineteenth century. In 1889, a Massachusetts lawyer argued that '[t]he photograph is something more than a copy; it is a *fac simile*, and it is a perfect record of facts, not subject to prejudice, bias, or defective memory' (Mnookin 1998, 18). But the early role of photographs in litigation was limited when 'judges declared that this form of evidence could be used only for illustrative purposes, rather than as independent proof' (Mnookin 1998, 13). This limitation was an early acknowledgement that the photograph could not speak for itself; it demanded that a witness testify to what the image purported to represent. From this constraint developed the common law doctrine that photographs are 'demonstrable evidence', as propounded by John Henry Wigmore in his enduring modern compendium of Anglo-American law of evidence, *A Treatise on the System of Evidence in Trials at Common Law*. Wigmore encouraged law's embrace of new technologies for their capacity to give us new ways of discovering facts or resolving disputes. However, he also wrote of the 'danger

and fallacy' that visual materials could be assumed to speak for themselves. They did not; images demanded a human being, a witness, a testimonial sponsor, to stand behind them, to verify them, or testify to their contents and meaning. An image untethered from a witness was, he said, 'mere waste paper – a testimonial nonentity' (Wigmore 1904, at §790, §793).

In his *Treatise*, Wigmore created a compendium of ways in which photographs had been adduced into evidence before 1904, not all of which were criminal, and not all of which were admitted by the courts at the time. These included photographs of the corpse of a homicide victim, the scene of a railroad injury, a sidewalk, a highway, arson, flood, personal features (such as the wearing of whiskers), bastardy and the likeness of the alleged father, an alleged insane person, a lumber-pile, a pump, the plaintiff as injured and suffering, the position of the plaintiff when run over, injured limbs, flooded land and photographs of a plaintiff's grandfather admitted on an issue of negro ancestry.

Wigmore noted that sometimes photographs would be insufficient, and sometimes they could misrepresent. Importantly, he recognised that sometimes photographs could be *too much*. That is, some images could be so powerful as to be dangerous. By this he meant that some representations could be 'calculated *unduly to excite sympathy* for one party and *unfair prejudice* against another' (Wigmore 1904, at §792; emphasis in original). In an evidentiary sense, this arises where the probative value of the image is exaggerated by an emotional, rather than a rational, response. This arises particularly where images depict gruesome, appalling or humiliating injuries to a victim, and the fact-finder's sympathy prevents them from drawing a rational connection between these injuries and the alleged acts of the accused. That the images show the victim suffered dreadfully does not prove that the defendant caused the suffering. Nevertheless, the defendant is the only person whom the jury might hold responsible and so, where these images are adduced into evidence, their use might be unfairly prejudicial. Susan Bandes and others have noted that not all emotional responses to evidence are necessarily prejudicial – or not unfairly so – but that emotion always complicates our interaction with evidence (Bandes and Salerno 2014, 1005). The persuasive power of images is necessarily related to their emotional impact but this, too, is complicated (Bandes and Salerno 2014, 1007). Colour or black-and-white; silent or with sound; moving or still; real or simulated; live or mediated: there are no processes for sorting the relative probative and persuasive impacts of these different visual formats. There is an extensive jurisprudence of what makes an image 'gruesome', but there is no real way of knowing whether the gruesome image really is more probative than prejudicial, or whether it is possible – or even desirable – to distinguish its emotional from its evidentiary force. There is probably a visual spectrum that separates the 'vivid' from the 'harmful', but it is difficult to distinguish points along that spectrum, and always possible to find images that conflate or collapse it entirely.

The entanglement of the evidentiary with the emotional probably explains the sensational break-out of forensic police photographs, cut loose from the archive and set free in the cultural sphere. That we can now buy coffee-table books of

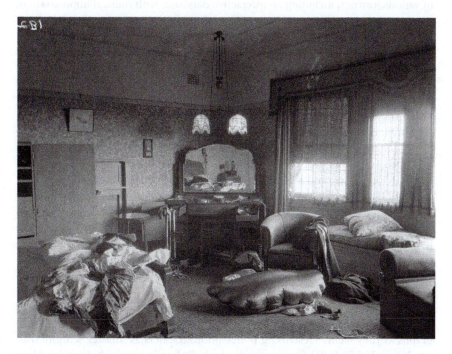

Figure 1.2 NSW Police Forensic Photography Archive, Justice and Police Museum, Sydney Living Museums. Reproduced with permission.

crime scenes and mug shots seems unremarkable, but we can also buy fridge magnets, clothing, tea towels, bottles of wine, skateboards and other consumer goods enhanced with forensic photographs.

The first time the police photographs from the Forensic Photography Archive were publicly exhibited was in 1999 in Sydney, in the exhibition *Crime Scene*, curated by the media artists Ross Gibson and Kate Richards; this included around 100 photographs from the Archive. Gibson had been alerted to the existence of the photographs by the curator, Peter Emmett. He spent several months allowing the archive to 'speak to him', noting its 'concussive stillness' that was also 'soulful and reverberant', before approaching Richards to join a multi-disciplinary collaboration that would later be called *Life After Wartime* (Richards 2006, 447). Although Gibson and Richards began with the intention of finding out the 'stories' behind the photographs, and conducted interviews with retired detectives and police photographers to discover those stories, they gradually came to prefer thinking of the photographs as 'open texts', which would 'prompt speculation' and, later, the creation of fictional characters who would inhabit the imagined stories (Richards 2006, 452; Gibson 2008). They re-presented the FPA images

in various formats, including an interactive database, with musical improvisation, as immersive cinematic environment or as algorithmic story-engine.

The title *Life After Wartime* was prompted by Gibson and Richards's gradual realisation that they were mostly drawn to photographs taken in the period 1945–60, albeit international and civil conflicts continued to rage during this period. *Life After Wartime* is marked by images of crimes that, for Gibson and Richards, seem to correspond to the changing world in which they occurred: drug use, autoeroticism, murder, sexual assault, car accidents, bestiality, suicide, train derailment and robbery. The project comprised, as well as the Crime Scene exhibition, an accompanying database containing images, research texts described as 'prosaic and poetic' (Richards 2006, 448), a soundscape, oral histories with detectives, and a portal to contemporary forensic websites. They made a CD-ROM, described as a 'story engine', in which the user, described as 'the player', could make choices that would navigate them through different pathways into which images and texts would flow. Commencing in 2002, a series of five live musical events were staged in which FPA images were shown during a performance by improvisational jazz trio The Necks, in what Richards described as a 'synaesthetic relationship' (Richards 2006, 455).

Richards and Gibson were interested in images that documented how crime scene investigators approached a crime scene, starting at the periphery and moving gradually to the centre, gathering physical evidence and making photographs as they went. Describing police photographers as 'master semioticians' (Richards 2006, 450), they noticed a technical style in which photographers minimised the appearance of shadows and expanded the depth of field, presumably to increase the amount of 'information' captured in a frame. While Richards noted that these techniques sometimes had the effect of producing images that were 'theatrical' and 'cinematic', 'creating a speculative representation of their first intuitive response to the crime scene' (Richards 2006, 450–51), these methods reflected police operational guidelines at the time. Although it is true, as every criminal defence practitioner repeats daily, that the police brief of evidence is an accumulation of *allegations*, not facts, the making of crime scene photographs is a highly regulated fact-gathering procedure, designed explicitly to quash the temptation of investigators towards the speculative or intuitive. Nevertheless, as many of the creative responses to the Archive's images suggest, the mystique of the police detective with a good nose or eye or gut instinct for crime is pervasive.

In conducting oral history interviews with photographers and detectives, Gibson and Richards came to realise that many of these photographers were ex-servicemen who had held technical roles in the armed forces. These included radar operators, gunsight adjusters, cartographers and air traffic controllers, and their experience and training led them towards the more 'technical' and 'scientific' branches of policing where camera technologies were finding emerging applications. That these photographs would have a post-forensic afterlife in a museum would come as a surprise to these photographers. One, who worked in Scientific Investigation Bureau from 1952–57, was the subject of a 2010 exhibition, *Walter*

Tuchin: Police Photographer.[2] When interviewed about the exhibition, curator Caleb Williams said of Tuchin:

> Yes, he dropped in a couple of weeks ago and was both overwhelmed and delighted. He had no idea that when he created these images half a century ago – for a short term functional purpose of documenting crimes and accidents – that they would wind up in the gallery of a public museum.
>
> (Sydney Living Museums 2010)

Another curator, Holly Schulte, writing about Tuchin, noticed:

> Tuchin's gentle, warm and light-hearted manner often seems at odds with the difficult nature of the work he completed in the service of the community. I am still challenged to reconcile Tuchin the genial, elderly man, and the Tuchin, whose name appears on the small brown envelopes.
>
> (Sydney Living Museums 2010)

Today, critics have attempted to appreciate old police photographs aesthetically and affectively, through an entirely non-evidentiary lens, but there is also resistance to going down this path. Art theorist Thierry de Duve argued against the aestheticisation of the Tuol Sleng prisoner photographs taken by the Khmer Rouge. He described photography as a 'vast gray zone' between art and non-art, and was highly sceptical of the motivations of those who exhibited these images in cultural institutions (de Duve 2008, 6). Nonetheless, procedural, information-gathering, fact-recording processes now prompt speculation and imagination impermissible during the evidentiary process. In one of its experiments with disseminating the Archive, Sydney Living Museums launched a blog titled *From the Loft*, gathering ongoing ideas about the Archive. Its first entry, written by then-curator Caleb Williams, included a forensic photograph from a death investigation around 1942 in Sydney's now-prestigious suburb of Mosman. Taken from a middle distance down a pathway beside an apartment building, it shows the dead man having fallen backwards down stairs. His arms outstretched, striped pyjamas echoing the brick pattern, the photo was taken at night and the man is cast in bright light. For Williams, this was a 'backwards dive out of life', capturing the 'illusion of motion'. He saw the photograph as 'surreal and sombre' and the fact that it was the only surviving image from this crime scene was 'baffling'. Williams speculated that the distance between the photographer and the subject captured the affective response of the police officers sent to the scene, whose first encounter with this victim was exactly replicated in this image; he wrote that it conveyed their surprise and emotion, and somehow invoked both surrealist cinema and film noir, and also the night photography of Brandt, Weegee and Brassai (Williams 2008; see also Williams 2009, 172). Of course, none of this is true, but in the afterlife, it all becomes possible. Today, SLM is more cautious about this image: this man remains unidentified, as does the cause of his death, and without these facts this photograph is always potentially harmful.

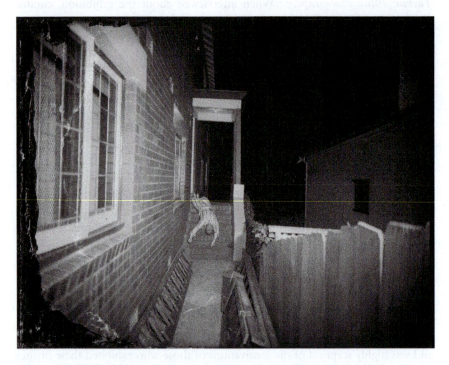

Figure 1.3 NSW Police Forensic Photography Archive, Justice and Police Museum, Sydney Living Museums. Reproduced with permission.

That police photography has an afterlife at all is largely due to the work of the writer Luc Sante, inaugurated by his acclaimed and much-cited book *Evidence*. The book was the result of Sante's research in the New York City Municipal Archives, where a fragment of the Police Department's photo collection had been salvaged; an apocryphal story has the bulk of the archive dumped in the East River. Sante's *Evidence* consists of 55 crime scene photographs, most depicting murder victims. Men lie sprawled in pools of blood; a woman has fallen across a kitchen table; many of the victims have been killed in bed. We see the bodies of people who were murdered on staircases, in hallways, in the street. There is a dead dog. Three children lie together in bed, covered with a quilt, dead. What kind of 'evidence' is this?

Sante wrote:

> As evidence, [these photographs] are mere affectless records, concerned with details, as they themselves become details in the wider scope of police philosophy, which is far less concerned with the value of life than with the value of order. These are bookkeeping entries, with no transfiguring mission, and so serve death up raw and unmediated.

(Sante 1992, 60)

It is a view of evidence that strikes the law practitioner and legal scholar as somehow askew. Sante says that evidence is 'raw and unmediated', which every lawyer knows is not true. Evidentiary images are fully cooked and carefully framed to lead us towards the view of the facts they were designed to prove. Yet Sante's approach to 'evidence' is nevertheless forceful and demands consideration. While he was not the first to re-present crime images in an artistic context, his *Evidence* was the influential harbinger of now well-established curatorial and publishing genres, and Sante's influence on the Forensic Photography Archive and its afterlife has been acknowledged.

Sante has spoken about his first encounter with the NYPD photographs: 'I fell into the images by accident' (Sante and Doyle 2016). He had been in the New York City Municipal Archive looking for photographs of early-twentieth-century slums while researching his earlier book, *Low Life* (Sante 1991). Already familiar with photographs taken of New York city building facades for tax surveys, and also with the work of social documentary photographers including Jacob Riis, Lewis Hine and Jessie Tarbox Beals, Sante described the day that the Archive director 'wheeled out a cart laden with ring binders' (Sante and Doyle 2016). His first encounter with the police photographs represents an important moment of transition. Today, most of us who approach these images – or images in this genre – outside the context of a police investigation do so with a sense of familiarity, but this affinity is in large part formed by Sante's work. Describing this moment Sante later said, the images 'shocked me, haunted me, showed up in my dreams, and would not leave me alone' (Sante 2013a, paragraph 24).

Sante has continued to articulate both the intellectual and the sensory experiences of encountering forensic photographs in the afterlife. His influence on the FPA and its curators is both direct and diffuse, as Sante's presence looms over all subsequent efforts to appreciate evidentiary images in the cultural sphere. Williams wrote of the 'pioneering effort and influence' of Sante in shifting crime archives into cultural discourse (Williams 2005, 20). Initially, Sante explained, he was interested in 'piecing together a life from these photographs'. They represented the 'shards of unknowable stories' (Sante 2013a, paragraph 58), and he wanted to give meaning to these surviving fragments. Most of the photographs that gripped Sante were images of dead people and these, he felt, were 'spooky because they are life interrupted'; these are the dead 'suspended for all time' (Sante and Doyle 2016), surrounded by their possessions like Egyptian kings, only violently awry, and without any formal protocols for honouring these dead.

There is a temptation to regard these afterlife perspectives on criminal photographs as 'the elevation of crime into art' (Hebdige 1979, 2). Depictions of crime have long been powerfully represented in the artistic canon, with Goya, Géricault, Daumier and Sickert identified as key practitioners. Art journalist Laura Cumming pointed to Jacques-Louis David's painting *The Death of Marat* (1793), which she described as 'the ultimate crime scene painting', for its capacity to capture the forensic details of the murder, its clues and its emotional impact (Cumming 2015). Some, however, identify a relevant difference between artistic representations of crime and aestheticised retrievals of criminal evidence. Although the aestheticisation of criminal photography is resisted by

many curators, endless contemporary creative works push us further towards a convergence of these concepts: crime/style; death/beauty; violent/sublime. For the curator Peter Doyle, to strip the crime from these images and appreciate them for their artistry is 'really corrupt and sickening'. For Doyle, these are found objects, salvage, floating free from their institutional shackles. That they can be accessed in their afterlife offers vast opportunities for creative practitioners, but these also pose risks. As he warns, 'it's pretty easy to do shitty stuff with this', work that is 'pretentious and just dumb'.

Within the archive itself, when examining police photographs we confront the possibility that administrative records, with the passage of time, accrue visual attributes that are tempting to call a 'style'. They might look old, analogue, handmade, textured. They look *archival*. Once these archives are untethered from the crimes they were taken to investigate, from the people who committed these crimes, their victims and their detectives; once we acquire visual familiarity with their techniques, and acquire new ways of reading or examining them; once these images accumulate in large numbers; once they are disseminated culturally across both high and low media; *then* can we appreciate their aesthetic transcendence?

Sante noticed that police photographs seem to have a consistent 'style', but then hesitated about calling it a style. He asked, rhetorically, 'wasn't it frivolous to even consider such a thing as style when looking at photographs of victims of violent crimes?' Drilling deeper, he discovered that what he meant by 'style' was in fact an array of concurrent features that included 'happenstance, laziness, hierarchy, bureaucracy, inconsistency and spatial and technical limitations'. He decided that 'style' was not the word, not only because of the 'apparent moral hazard' of aestheticising trauma, but because the visual achievement of these photographs is unconscious. For Sante, the visual qualities of the forensic photograph are closer to a 'fingerprint, a 'profile' or modus operandi (Sante 2013a, paragraphs 25–33).

Central to Sante's work is the irresistible temptation to look at something not intended for our eyes, and the consequences of looking regardless. Lawyers understand this. The risk of visual seduction is something the law has evidentiary rules to guard against. Within the legal process, evidentiary images are carefully presented to prevent the dangers that arise when photographs are said to be, in legal scholar Michael Pardo's words, 'highly persuasive but epistemically weak' (Pardo 2011, 138). This is what Wigmore meant when he said, in 1904, that photographic evidence might be too much: too gruesome, too visceral, too dark. Where the law thinks that the photograph is too much, the evidence is excluded. But for the cultural practitioner, the curator, the critic, the museum visitor, too much is often the desired quantity. In its cultural afterlife, evidence appears in abundance; voluminous and uncontrollable, it can generate a disorienting perspective, a spark that triggers a memory, a psychic leak, a recovered dream.

Sante has spoken about his habit of browsing online auction sites looking for pre-1950 photographs. On one occasion, seeing tiny thumbnail image reproductions on his screen, he realised he was looking at photographs made by New

York City police. Sante contacted the seller and learned that she was the now-elderly daughter of a long-dead Brooklyn detective. Sante's persistent inquiries about the provenance of the photographs went unanswered; Sante described the seller as 'alternately vague, kittenish and obdurate' (Sante 2013a, paragraph 51). Eventually, he bought around one hundred photographs from the 1930s from her, learning in the process that she also had much more gruesome images in her illicit possession, for which she was holding out for more money and had a more specialised collector in mind. For Sante, these photographs represent a marked departure from the images in *Evidence*. They were 'pure abstraction', and reminded him of conceptual art. Whereas the earlier photographs seemed carefully constructed, these images seemed unplanned, made for a specific purpose that was no longer apparent and, significantly, 'not meant for an artist' (Sante and Doyle 2016). These photographs lacked all the 'style' apparent in the earlier photographs; they were 'brutal without mystery', 'sordid' and 'intensely private'. Whereas homicide victims in the *Evidence* photographs seemed to be in a 'state of grace', these victims were 'simply dead' (Sante 2013a, paragraph 54).

These images capture something increasingly apparent in the afterlife of evidence. Today, we can rarely know what these artefacts meant or proved. It is simply the fact that they were once evidentiary that gives them vibrancy now. Sante's ongoing writing project, which he calls 'The Empty Room', is about the experience of looking for something in these images. His writing captures both the evidentiary *something*-ness of them, but also their abstraction, their *who-knows-what*-ness:

> And you couldn't call the photos cinematic, a popular adjective for crime-scene photos. They might as well be going out of their way to be anticinematic, showing you the backsides and armpits of everything, and tilting up to the ceiling and down to the floor like drunks or people with stiff necks. These are photographs of agitation. They are all about the places you look when you're desperate. You're looking for where to climb into the house, where to hide the evidence, where to start the accelerant, where to find the party you want to shake down, where to look for items dropped by the suspects in their flight, where the perpetrators found a point of access, where you left that piece of paper you were carrying around that had the directions on it, where you last saw your wallet, where you were standing when you suddenly felt dizzy, the last sight you remember before everything went black.
>
> (Sante 2013b, 76)

Today, the person the Australian public most closely associates with the Forensic Photography Archive is Peter Doyle. A musician, crime novelist and scholar, Doyle is also the curator of major exhibitions drawn from the Archive that triggered their spectacular break-out into the public domain. His exhibition *City of Shadows* (2005–06, now on permanent display at the Justice and

Police Museum) and the book of the same title associated with it (Doyle and Williams 2005) are the most high-profile instances of the Archive's dissemination. His 2009 book *Crooks Like Us* is also drawn from the Archive's images. In 2013–14 the Museum of Sydney exhibited *Suburban Noir*, curated by Doyle, which exhibited FPA images from the 1950s and 1960s alongside contemporary artworks inspired by these images. A long-time friend and confederate of Sante, Doyle has accepted the challenges of aestheticisation, ethics and sensitivity that the Archive presents.

In undertaking the research that resulted in *City of Shadows*, Doyle all but took up residence in the loft of the museum, spending years living with over four tonnes of filthy and uncatalogued glass plates and negatives. The images in the archive were unidentified and undocumented. Those from the post-war period, around 1945–64, are in envelopes on which is written a date, sometimes a case number and occasionally what Doyle refers to as 'a few cryptic words' (Doyle 2013, 2). Doyle initially thought he might re-unite the images with their stories: why were they taken? What crimes did they seek to solve?

But while undertaking that project, he also began to speculate about what else these criminal images might mean: what can we learn about the world from which they came? The 'shadows' of the exhibition's title prompt an important meditation about secrecy and transparency and the unstable zone between them. How does a photograph constitute evidence of a crime? There are times when the documentation is insufficient, the proof is missing and we simply cannot know what we are looking at in an image. There are times when we probably *could* find out but, for different reasons, Doyle has exercised some judgment about not-telling or not-showing. And there are also times when Doyle tells us what has happened, but the explanation seems inadequate. These confounding curiosities are a hallmark of Doyle's work, and are the most commented-upon feature by those who admire it.

Doyle's initial brief with SLM was, as he explained it to me,

> simply to look and try and work out what was there, eventually to produce an exhibition and a book. So I'd go in each day, sit down in the dark attic, open a box of negs, survey them one by one on a lightbox.

On a typical day, he might find a scene of a motorbike accident, a signature on a cheque, fingerprint samples, a shallow grave, or perhaps just a hole in the ground. There were countless bedrooms, kitchens, second-hand car parts, stolen goods, documents, cheque butts. And 'occasionally a corpse – not that many'. The rarity of dead bodies is important to note, given that these are the images dominating the dissemination of the Archive in its afterlife. Particularly in the later material, from the 1950s and 1960s, death scenes are rare. As captured in Doyle's *Suburban Noir*, crime in suburbia is characterised by roads and road accidents.

Within the *City of Shadows* exhibition spaces, and again in *Suburban Noir*, Doyle assembled a cache of images that appeared in a slide show accompanied by his own voice-over narrative. His narrative conveyed both his painstaking

research and his sense of wonder at what he had found. It invited specula-
tion but also clearly delineated a boundary, showing us how to look for clues
and how to read a police photograph. His narratives teach us about notorious
but hitherto-forgotten incidents, the surprising criminal histories of now-quiet
suburbs, the evolving history of police photography and the emerging police
attention to crimes including abortion, suicide, sex work and drug-related
offending. Sometimes he reported a scholarly dead-end, itself evidence of
something. For instance, he said of one photograph: 'Bedroom in a respectable
house. No idea what happened here'.

One of Doyle's aims is to compare the nature of photography and the nature
of crime. Doyle is reminding us to look at the photographs not only as evidence
of human malice or misfortune, but also as haunting memories of times, places
and people. The context in which he found these pictures – the police archive –
already tells us that these pictures are a form of criminal evidence. But Doyle is
showing us another way of looking at them: these pictures represent the minutiae
of the way people lived: housekeeping practices, products on shelves, private hab-
its. Once the facts in issue have been lost in time, these photographs can become
evidence of something else, and Doyle has exercised judgment about when to
solve a mystery and when to keep it a secret.

Whereas these photographs began with a procedural purpose, as technical
images, we can now see them as having historical, cultural and aesthetic value.
They contain beauty, violence, shame, strangeness. People don't look like this
anymore. People don't dress like this anymore. People don't live in homes like
this; they don't live these lives anymore. And for most of the people who *did*
live these lives, their lives mostly passed unphotographed and unrecorded, unless
their lives collided with a crime serious enough to summon a police photog-
rapher. When they did, these astonishing photographs were taken, recording
alongside the crime all the otherwise-lost little facts of these lives. These are part
of the value of this collection.

However, the value of the collection is complicated by its sensitivities. These
are images of people, of what people did and what was done to them. These are
people who were loved, people who suffered, people who did bad things, or peo-
ple who did nothing at all. Should we protect their privacy and their dignity? Do
they require any legal protection? These images contain evidence of crimes, about
some of which the law limits information: suicides, sexual crimes, crimes against
children, crimes perpetrated by children. Does the sensitive nature of the collec-
tion invoke these laws? Some of these images relate to conduct that is no longer
criminalised, or that is policed differently: homosexuality, political dissidence, sex
work, abortion and again suicide. Do these images deserve some special consid-
eration arising from these historical shifts or transformations?

All images are made to be looked at, but these images were not made to
be looked at in a museum, nor by us. Can we show them? *How* can we show
them? Doyle has for some time been working with the concept of 'showable'
images. Maybe all these images are showable; it is just a matter of finding the
right way. That way might involve providing context, information, data: what is

in the image, why was it made, what happened next? Showing the image might also involve aesthetic judgments: black-and-white or colour? The whole frame or a cropped section? Big or small? Up on the wall or on a digital screen?

Digitisation raises its own challenges. A digital image is much less physically fragile than a glass plate negative, but it is vulnerable in other ways, to manipulation and distortion, to sharing and copying, to dissemination beyond control. In large part, digitisation facilitates transparency and openness, both important principles in our current socio-political discourse. What the state knows, what the state possesses, is something that citizens, in our contemporary moment, feel entitled to see and to scrutinise. The Archive is a public asset; people are interested in looking at it. Digitisation provides a way to show it to them, and to share it with them. But it gives rise to other, perhaps unforeseen, risks.

––––––––––

Just as Sante came to appreciate this quality in some NYPD photographs, Doyle had begun to notice some of the abstract and ineffable qualities of the Archive. He has referred to the 'cryptic importance' of the photographs, a term capturing the fact that they are evidentiary (important) but cryptically so. Doyle acknowledges, 'people at the time were moved by something. There are quite strong emotions off-camera'. We cannot now know what these signified; Doyle concedes, 'maybe it was something that was total bullshit. Or maybe it *was* something going down'. He has come to terms with the not-knowing because, he reasons, 'it's nice not to catch every fish in the lake'.

Importantly, the abstract qualities of forensic photographs arise from their capturing of what was there. Not composed, arranged nor tidied, Doyle describes them as 'all ground, no figure', 'images of negative spaces' and 'residues of sudden movement'. Looking at one series of images, Doyle offered, 'I'm sort of loving the absence of a subject . . . Photos of just an empty street, or through an open window, and what the hell is inside the window? You can't really tell'. For police photographers, fulfilling their professional procedural duties, capturing everything they could, ensured that the Archive is, in Doyle's words, 'so near to being like a huge collective unconscious, the collective Id of the city' (Doyle 2014).

Doyle had begun to understand that police photographs were unlike other photographs. He noted that 'We're so trained for our eye to be guided', but that, with crime scene photographs, 'there's a pleasurable confusion as to what we're supposed to be looking at' (Biber, Doyle and Rossmanith 2013, 809). True, he learned how to locate the image within the genre of police investigation: a homicide photo looked different from a break-in, a prowler, a confidence trick or a cache of stolen goods. But he also recognised that every police photograph recorded a catastrophe that had already occurred, some criminal allegation that had summoned the police photographer, captured the image and opened an investigation file. Invoking Roland Barthes, Doyle concluded

about the photographs in the Archive: 'They're nearly all punctum, that's what I'm saying. They're *nearly all punctum.*' Barthes's punctum is a wound, prick, sting or cut that the photograph inflicts upon its viewer (Barthes 1981, 27). The punctum is uninvited and accidental; we didn't see it coming and we didn't seek it out. Nevertheless, despite our distance or detachment from the events photographed, it seizes us in some intimate manner.

Police photographs accumulate facts, fictions, patterns and accidents. As these photographs accumulate in police files, law is gradually accrued. Jacques Derrida observed this when he wrote that law is produced in the archive (Derrida 1996, 7–8). Michel Foucault observed something similar in the production of knowledge, admitting that we would be able to perceive it only in retrospect: 'History is that which transforms *documents* into *monuments*' (Foucault 2002, 8; emphasis in original). In the New York City Municipal Archive and the Forensic Photography Archive, this is made manifest. Because these photographs are found in the police archive, they are *already* monuments, *already* law. This, then, becomes their least interesting attribute, and we rely on Sante, Doyle, and others, to help us understand *what else* they contain and what else we can learn from them.

Doyle, who has spent more than a decade researching the crimes, the biographies, the subcultures and the worlds captured in the Archive, eventually came to the view that 'they're sort of inexhaustible in many ways'. He began to see the entire Archive as one single body of work, 'with its own repetitions and its riffs and its own internal archetypes, motifs'. Doyle challenged himself to put the legal categories to one side, and create new categories, new patterns, which enabled him to see the Archive afresh. Grouping images in new ways, and giving each group a name, was productive.

Within one category – 'Men in suits looking at stuff' – he produced a surprisingly large series of images of detectives visiting crime scenes, grimly conscientious as they went about their job. The formality of their duty contrasted with the blackly comic title of their category, but also located them – in cheap, tailored suits or police-issue coveralls – firmly in the past. This group of images represents the processes of criminal detection as slow, methodical and formulaic. But Doyle reminds us that police were first-responders to social change, as the Archive documents the ephemeral presence of radical politics, rock music, drug culture, women's liberation and non-hetero sexualities. While he noted that police – emerging from the conservative working classes – were often on the losing side of cultural change, nevertheless they looked, they took notice of these emerging social forces and captured them within the Archive. Fortuitously, there are also several photographs in which a mirror or window reflects the police photographer himself, described by Caleb Williams as 'fugitive portraits' and 'accidental presences' (Williams 2009, 175), providing a rare glimpse of this policing task. Nevertheless, while contemporary curators and creative practitioners seem eager to identify 'haunting and surreal' attributes in these forensic photographs, proper police work disavows these qualities (Justice and Police Museum 2010).

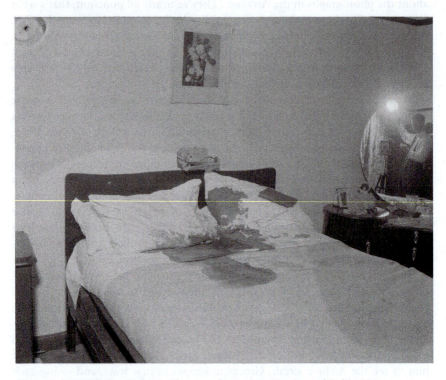

Figure 1.4 NSW Police Forensic Photography Archive, Justice and Police Museum,
 Sydney Living Museums. Reproduced with permission.

Despite their affective and cultural charge, the probative value of forensic
photographs is typically low, while they create a very high danger of unfair
prejudice. This is one of the central balancing exercises in deciding the admis-
sibility of evidence. It demands that the probative value of an item of evidence
be calculated: how strongly does this evidence support or undermine a disputed
fact? Then, the court must calculate the risk that the evidence will result in
unfair prejudice to the accused, meaning that the evidence might be interpreted
in a manner that is unfair, misleading or confusing. Although there is com-
plex jurisprudence about this process, essentially it requires these two potential
forces – probative value and prejudicial effect – to be measured against each
other. In contemporary criminal proceedings, practitioners acknowledge that
there are really only a few things that can be proven from images. Photographs
can set a scene, and they can capture events or details that are ephemeral. There
is considerable debate about whether photographs can prove identity, whether
they can prove the causes of wounds or injuries, or whether they obviate the
need to examine the three-dimensional objects or locations they are tendered to

replace. Contemporary crime professionals concede that photographs are nevertheless highly persuasive and emotive; there is a strong visual impulse in our culture that, as every court observer has noticed, causes everybody to become suddenly more alert whenever images appear in the courtroom.

Considerable jurisprudential thought is given to the effects upon jurors of viewing high-impact images, some of which are known in criminal prosecutions as 'gruesome photographs'. Legal practitioners are conscious that, while jurors are not commonly asked to view many gruesome photographs, when they are required to, it is often more difficult and traumatic than they anticipated. Prospective jurors may be warned about the nature of the visual evidence that will be tendered at a trial, and while some will seek to be discharged at that point, many will underestimate the impact of the evidence until it has been adduced, after which it might trigger a reaction for which they were unprepared.

Criminal lawyers concede that only a very small proportion of the photographs in the police brief of evidence are ever tendered at a criminal trial, and some have come to appreciate the impact *on legal professionals* of looking at police photographs. Some of them describe gradual processes of desensitisation, and some of them deploy strategies of self-protection, in which they might flick quickly through images, hold them at arm's length with eyes averted or store them in an envelope. Others describe a belated realisation of the magnitude of what they have seen, and their own unpreparedness for it. Many have come to understand that these are materials that most laypeople would never encounter. These include images of people who have suffered extraordinary injuries during their death, bodies that bear no resemblance to living people: decapitation, people who have fallen from great heights, people who have been killed by machinery in dreadful workplace accidents.

One lawyer told me that once seen, these images can never be forgotten. One described an instinct to protect others from having to see images of this kind. Another said that images, particularly photographs of perpetrators, had an important humanising effect. Yet another told me that his client, convicted of a notorious massacre, wrote to him from prison asking for the photographs from the brief, to keep as trophies. While our moral tendency might be to distinguish violent offenders from ordinary people, photographs play an important role in representing the wide range of everyday people who commit crimes. Juliet Darling, a film-maker, artist and writer, spoke about her decision to look at the crime scene photographs taken of her partner, Nick Waterlow, an art curator who, alongside his daughter, was killed by his mentally ill son. She had taken advice from a homicide detective, her doctor and her friends, all of whom cautioned her against looking at them. When she finally decided that she did want to see them, she said that a counsellor at the coroner's court carefully described the images to her, and contextualised them within the events leading up to Waterlow's death, before she was given them to look at. For Darling, who had until that moment been wracked with the sense that she could have done something to avert the deaths, seeing the photographs 'dissolved my fantasies'; it was 'a transcendent experience' that left her with 'a sense of peace – the deep peace of love' (Darling 2017, 116).

A former detective who worked during the 1980s and 1990s recalled how police photography, along with other forms of visceral, corporeal confrontation, was used to inaugurate new recruits into policing culture. She described being taken to view an autopsy at the morgue – 'looking at my feet, the sound of saws' – and later to see a trophy board of photos – 'a deliberate wall of horrors' – at the Sydney Police Centre. Both experiences shocked and unnerved her, but were clearly intended to demonstrate the kind of desensitisation that was, at that time – the early 1980s – demanded of police. The photographs were, she recalled, a 'test'; they were 'extreme things', 'all in colour', associated with a 'false bravado'.

A recurring theme in reflecting upon the Archive is the distinction between black-and-white images, which dominate the Archive, and colour photography, which is used in contemporary policing practice. A former police photographer, John Snowden, who worked in the Scientific Investigation Bureau from 1947 to 1984, reflected on the 'ghastly detail' that became visible once police photography was undertaken in colour.

> A colour photograph, you have got flesh in a flesh colour, you've got blood in its dark maroon colour, or if it comes from the lung, a brilliant almost pink colour. It is certainly different. The same with bruises on a face or bruises on a body. Or bite marks, different altogether. We have had, or I have had, objection by the defence counsel to the submission of a colour photo in court because it enflames the jury, your honour. We don't want this sort of thing.
>
> (ABC Radio 2010)

An important consideration for Sydney Living Museums in managing the Archive relates to contents or topics that are governed by external agencies. One example of this is suicide. Peter Doyle discussed this when narrating his own process of selecting and exhibiting a photograph taken at a suicide scene. He showed an image, first apologising for its explicit content: 'I'm sorry, there are a few like this coming up. Just to show it to you, I framed it small on the screen. That seems to do something, framing it small. It's a suicide.' Before he began to narrate the story behind the image, he pointed out: 'We used to not show suicides at all. The Press Council had a ruling that suicides weren't reported, that's recently changed. There's a new kind of openness in Australia about suicide. And this is one [photograph] I want to use.'

Dissemination of public information and reportage about suicide is controlled by the Australian Press Council, which modified its standards about suicide coverage in 2014. Whereas the previous standard recommended against reporting suicide, except in very limited circumstances, the new standard recognises that reporting and comment can have 'substantial public benefit'. These benefits can include improved public understanding of the causes and warning signs of suicide,

a potential deterrent effect, the provision of comfort to relatives or friends affected by suicide, or the promotion of actions to prevent suicide (Australian Press Council 2014, Specific Standard #1). The new standard recommends that the phrase 'committed suicide' not be used, because of its association with the commission of a crime; instead it suggests the terms 'died by suicide' or 'took his life' (Australian Press Council 2014, Explanatory Note #5). Reporting suicide, and the identity of the person who has died, requires either clear and informed consent or clear public interest, both detailed within the Standard (at Specific Standards #3 and #4). The Standard makes an important distinction between 'substantial and widespread significance' and 'something in which many people may be interested'; only the former provides justification for reporting suicide. There are constraints on reporting the method or location of suicide, and reports 'should not sensationalise, glamorise or trivialise suicides', nor should they 'stigmatise' suicides (Australian Press Council 2014, Explanatory Note #6).

In 2010, the Justice and Police Museum exhibited an image from an attempted suicide taken by the police photographer Walter Tuchin, in a solo exhibition of his works from the Archive. There is no visible body in the image. Curator Holly Schulte, who interviewed Tuchin for research about the photographers represented in the FPA, wrote:

> The photo is taken from the edge of a cliff, at The Gap in Vaucluse: a giddy, aerial perspective reveals the power of the waves crashing on the jagged rocks below. Tuchin told me he lay down on his belly, while a detective held onto his heels, to take this image. All the while his upper body snaked over the cliff edge to achieve the best angle for the shot.
>
> (Sydney Living Museums 2010)

Doyle showed an image from another suicide and, as he did so conceded, 'this is actually totally into the pit now, into the abyss, as bad as it gets'. He told the story behind the photograph of a suburban, middle-class man in the early 1960s, an accountant, 'quiet, respectable', who had killed his family and then himself. He showed a photograph of a seven-year-old boy's bedroom. There was no body and no visible sign of violence in the photograph. The impact of the image emerged as Doyle pointed out the room's features, noting that it was 'almost worse . . . [than the] more explicit' photographs. What interested him in the image is that it was rich in 'ancillary detail . . . there's a lot of culture, there's a lot of moment, there's a lot of circumstance', and that that detail gives us a way of accessing and understanding the life that was lived in that bedroom, the life that was taken when the boy was killed by his father. He identified personally with this boy and his bedroom furnishings – 'I had a desk like that in 1964'. He pointed to the boy's school bag under the bed, the name of the local Catholic school he attended, his slippers neatly paired; he felt himself being pulled 'just so intimately into the scene' in a way that made him want to exhibit the photograph. But there were competing factors: the dangers that arose with living memory, the disclosure of information about the traumatic method and circumstances of the

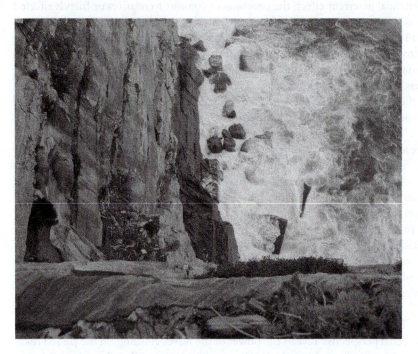

Figure 1.5 NSW Police Forensic Photography Archive, Justice and Police Museum,
 Sydney Living Museums. Reproduced with permission.

death, and the sensitivities arising from images from suicides. Attention was also
needed to how the size or orientation of the image could soften or exacerbate the
viewing experience.

———————

In testing how to make forensic photographs showable in the afterlife, Doyle
has established clear boundaries about the nature of images that he would never
show. These include photographs in which a dead person's eyes are open:

> Oh yeah, many, many, many. I'll tell you something that I wouldn't show:
> dead children, dead babies, photos of sexual violence on corpses, and there's
> a few. There's not that many, but there's a few. They're the ones that turn
> up in detectives' private collections, by the way.

The reference to private collections retained by detectives relates to a raw and
unresolved conundrum faced by Doyle, who is now custodian of his uncle's private
archive (Doyle 2016). Brian Doyle was a distinguished senior Sydney detective,
said to be incorruptible, honest and tenacious, who received awards for bravery
and who arrested several high-profile criminals in the 1950s and 1960s including

David Scammony (the 'Kingsgrove Slasher') and Stephen Bradley, the kidnapper and murderer of the eight-year-old Graeme Thorne (see Brown 2002). As Peter Doyle explained, 'He kept his greatest hits, like a lot of coppers do, you know?' Those records are now colloquially referred to as The Brian Doyle Archive, and are generating new creative and socio-historical projects for his nephew. Brian Doyle was said to be typical of detectives of his era, keeping personal copies of files, photographs and other materials, usually in a garage or shed, in an attempt to preserve materials that were at risk of dispersal or destruction.

Doyle has noticed that much of what turns up in retired detectives' archives has a freakish or bizarre quality; these are trophies or souvenirs, and he reasons, 'Because that's just what detectives do. It's not even necessarily particularly individually perverse. It's sort of occupationally perverse.' Doyle suspects that his uncle was implicitly aware of how his private collection might appear, should an unsuspecting stranger stumble upon it. Towards the end of his life, in the spidery handwriting of an elderly man, he had written a retrospective label that he hoped might justify his strange archive: 'Crime photos used for teaching' (Doyle 2013, 9). Collections such as these later pose problems for state records agencies or museums who, after the death of a detective, might be offered such a collection. These materials are illicit, improperly retained, sensitive public records. That they have become untethered from the formal archive, and can likely never be reunited with it, presents Doyle with a creative challenge for deploying this material in its afterlife.

The Archive has inspired creative and literary work extending far beyond museum exhibitions to the genres of drama, fiction, creative non-fiction, visual art and architectural history.[3] Even the world of fashion has drawn on this unique photographic resource. In 2011, a number of the mugshots from the Archive were purchased by fashion designer Ralph Lauren, and displayed in some of his flagship menswear stores internationally. Nor was he the first fashion-world heavyweight to notice the visual allure of these images; a few years earlier, Karl Lagerfeld, from the House of Chanel, was given the *City of Shadows* book, which was said to have inspired some of his design. One of Ralph Lauren's brands, Double RL, makes men's workwear – casual, rugged clothing in neutral colours. His Fall/ Winter collection in 2011 was based on *City of Shadows* and the catalogue was an extraordinary aesthetic citation of Doyle's exhibition. Models wearing Lauren's clothing were styled to look exactly like the people in the mug shots, and were superimposed onto the real backgrounds from those earlier photographs. The real names of the original suspects remained etched into the fashion catalogue. That these were once real evidentiary images seems necessary to the aesthetic charge of these photographs. These photographs transform criminal suspects into fashion models, a hitherto unforeseen afterlife, presumably chasing the provocation needed to garner attention in a crowded apparel marketplace.

In an effort to re-assert its authority over an Archive that had begun to run wild, in late 2017 SLM launched a major exhibition at the Museum of Sydney.

Titled *Underworld: Mugshots from the Roaring Twenties*, curated by Nerida Campbell, it presents over 130 police arrest photographs taken between 1920 and 1930 which were referred to by police as the 'Specials'. At least 2,500 photographs belong to the Specials category and a book accompanying the exhibition includes 220 of these images (Campbell 2017). While the explanation for their name – the Specials – has been lost, their enduring popularity arises from their extraordinary aesthetic qualities. These are police portraits that look like no others; they follow no scientific nor technical standards, subjects have been invited to sit or stand in their own chosen pose; sometimes they are photographed in pairs or groups, but usually alone. Mostly taken outside the holding cells at Sydney's busy Central Police Station, they promise a rare insight into the moment of police photography, because they show their subjects scowling, smirking, sometimes smiling. Some seem to be almost in tears, while some look indignant, and others are clearly bearing fresh injuries. One of the subjects, Thomas Bede, charged in 1928 with 'suborning a witness', obstinately poses with his eyes shut. The photographer has etched into the glass plate the words: 'This Man Refused to Open His Eyes'.

In one respect, *Underworld* responds to the seemingly insatiable public demand to see forensic photographs from the collection, and in this regard the exhibition is generous and thoughtfully staged. In another respect, SLM, having commenced major projects to stabilise, digitise and catalogue the Archive, was determined to retrieve its position as the custodian of the FPA and, importantly,

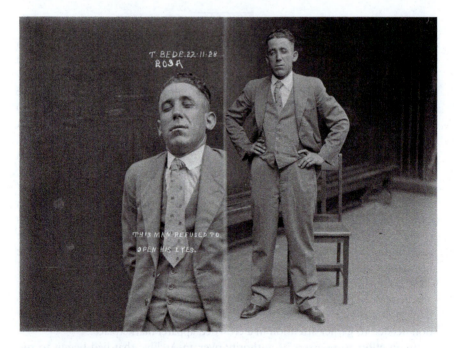

Figure 1.6 NSW Police Forensic Photography Archive, Justice and Police Museum, Sydney Living Museums. Reproduced with permission.

its own role in interpreting the collection. Campbell, *Underworld's* curator, is an SLM staff curator and a social historian, and has long and deep knowledge of the FPA. The core objective of the exhibition was to link the people in the photographs to the circumstances that led to their arrests: who were these people and why were they photographed? What can we learn about this historical time from these images and from these criminal allegations?

For Campbell, these photographs are 'social documents', and can bring us towards a better understanding of the society from which they emerged (2017, 37). In the exhibition's labels and wall texts, and in the book, the context is carefully established after World War I. Returned servicemen and post-war migration are evident in the Specials, as are the influences of other social transformations. Youth culture and Hollywood-inspired fashions are visible in police portraits made in response to crimes occurring in that historical moment: drug crimes, and particularly the use of cocaine, brought dealers and sex workers before the police camera. A crackdown on opium was met with an increased appearance of Chinese subjects in the Specials. The popularisation of motor vehicles produced joyriders and dangerous drivers. In its presentation of 1920s gangsters, *Underworld* shows all levels of this criminal hierarchy, from bosses to petty crims, and shows the incursion of international criminal syndicates, largely from southern Italy. Another group, presented as 'plotters', are non-violent offenders, con artists, involved in schemes, blackmail, fraud and honeytraps. The growing

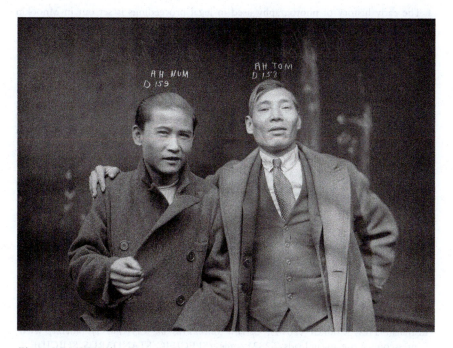

Figure 1.7 NSW Police Forensic Photography Archive, Justice and Police Museum, Sydney Living Museums. Reproduced with permission.

popularity of cut-throat razors amongst the violent criminals – the 'bruisers' – is evident in the scars and injuries worn by some of the portrait subjects; the ravaging effects of drug abuse are starkly apparent in the faces of others.

Underworld presents us with images of the people accused of crimes, but it hasn't forgotten crime's victims. While some of the portraits present people who appear desperate and forlorn, the captions – and further information in the book – point to the harm that many of them did. Campbell reminds us of their beaten wives, the pensioners whose life savings they stole, or the dreadful injuries they caused with their violence or misconduct (2017, 47).

In the final section of the exhibition – titled 'Afterlife' – *Underworld* invites visitors to reflect on the experience of viewing police photographs outside of the investigative and evidentiary process. Short videos present speakers from a range of critical contexts (war, contemporary photography, law, music, fashion, curation) responding to the cultural afterlife of this unique archive.[4] In this manner, SLM has begun to retrieve some of these images from the strange and sometimes undesirable places into which they had been taken. In establishing its leading role in guiding the public understanding of this collection, SLM also demands of us some self-reflection about the consequences – both the opportunities and the harms – of viewing criminal evidence in its afterlife.

Notes

1 The early history of photography used in legal proceedings is set out in Mnookin (1998, 18). She cites an 1852 publication in the United States which seeks to draw attention to an extant practice in France where 'the lawyers are using daguerreotypes as a means of convincing the judge and jury more eloquent than their words': at 8, footnote 21.
2 https://sydneylivingmuseums.com.au/exhibitions/walter-tuchin-police-photographer
3 See e.g. Lachlan Philpott's play *The Trouble with Harry* (2015); Fiona McGregor's novel-in-progress about Iris Webber (interviewed by the author, 25 June 2014); Mark Tedeschi's non-fiction works *Eugenia: A True Story of Adversity, Tragedy, Crime and Courage* (2012) and *Kidnapped: The Crime That Shocked the Nation* (2016); *Suburban Noir*, exhibition at Museum of Sydney, 30 November 2013–6 April 2014 (https://sydneylivingmuseums.com.au/exhibitions/suburban-noir); and for architecture, Preston (2013, 761–73).
4 These include Peter Stanley (military historian), Luke Stambouliah (photographer and artist), Katherine Biber (professor of law), Russell Morris (musician), Kirstie Clements (journalist and former Editor in Chief, *Vogue Australia*) and Peter Doyle (writer, author, curator of *City of Shadows* and *Suburban Noir*).

References

ABC Radio (2000), 'John Snowden', *Verbatim*, written and presented by Jeannine Baker, 29 April, accessible at www.abc.net.au/radionational/programs/verbatim/john-snowden/3466574

Australian Press Council (2014), *Specific Standards on Coverage of Suicide*, www.presscouncil.org.au/uploads/52321/ufiles/SPECIFIC_STANDARDS_SUICIDE_-_July_2014.pdf

Bandes, Susan A. and Jessica M. Salerno (2014), 'Emotion, proof and prejudice: The cognitive science of gruesome photos and victim impact statements', *Arizona State Law Journal* 46, 1003–56.

Barthes, Roland (1981), *Camera Lucida: Reflections on Photography*, New York, NY: Hill and Wang.

Biber, Katherine, Peter Doyle and Kate Rossmanith (2013), 'Perving at crime scenes: Authenticity, ethics, aesthetics: A conversation', *Griffith Law Review* 22(3), 804–24.

Bond, Henry (2009), *Lacan at the Scene*, Cambridge MA: MIT Press.

Bratton, William J., James Ellroy and Tim Wride (2004), *Scene of the Crime: Photographs from the LAPD Archive*, New York NY: Harry N. Abrams.

Brown, Malcolm (2002), 'Nemesis of crims and corruption' [Brian Kevin Doyle, obituary], *The Sydney Morning Herald*, 9 August, accessible at www.smh.com.au/articles/2002/08/08/1028157988202.html

Campbell, Nerida (2017), *Underworld: Mugshots from the Roaring Twenties*, Sydney NSW: Sydney Living Museums.

Cumming, Laura (2015), 'Forensics: The anatomy of crime; Cornelia Parker; Cai Guo-Qiang – review', *The Guardian*, 22 February, accessible at www.theguardian.com/artanddesign/2015/feb/22/forensics-the-anatomy-of-a-crime-cornelia-parker-review-wellcome-collection-whitworth-manchester

Darling, Juliet (2017), 'On viewing crime photographs: The sleep of reason', in K. Biber and T. Luker, eds, *Evidence and the Archive: Ethics, Aesthetics and Emotion*, London: Routledge, 115–18.

de Duve, Thierry (2008), 'Art in the face of radical evil', *October* 125, 3–23.

Derrida, Jacques (1996), *Archive Fever: A Freudian Impression*, trans. Eric Prenowitz, Chicago IL: University of Chicago Press.

Doyle, Peter (2009), *Crooks Like Us*, Sydney NSW: Historic Houses Trust of NSW.

Doyle, Peter (2013), 'The kibitzing archive', *Text* 18, 1–13.

Doyle, Peter (2014), 'Dark arts', Museum of Sydney, Curator Talk for *Suburban Noir*, 16 March.

Doyle, Peter (2016), 'Stranger in the house', *Sydney Review of Books*, 14 November, accessible at https://sydneyreviewofbooks.com/stranger-in-the-house/

Doyle, Peter and Caleb Williams (2005), *City of Shadows: Sydney Police Photographs 1912–1948*, Sydney NSW; Historic Houses Trust of NSW.

Foucault, Michel (2002), *The Archaeology of Knowledge*, trans. A.M. Sheridan Smith, London: Routledge.

Gibson, Ross (2008), *The Summer Exercises*, Crawley WA: University of Western Australia Press.

Hebdige, Dick (1979), *Subculture: The Meaning of Style*, London: Routledge.

Justice and Police Museum (2010), 'Walter Tuchin – Police Photographer', Justice & Police Museum exhibition, 8 May 2010–13 February 2011, details at https://sydneylivingmuseums.com.au/exhibitions/walter-tuchin-police-photographer

Lorenzini, Michael (2013), *Crime in the Archives: The Ethics of Looking*, M. Lib. Sci. thesis, CUNY.

Mnookin, Jennifer (1998), 'The image of truth: Photographic evidence and the power of analogy', *Yale Journal of Law & the Humanities* 10(1), 1–74.

Pardo, Michael S. (2011), 'Upsides of the American trial's "Anticonfluential" nature: Notes on Richard K. Sherwin, Wallace, David Foster and James O. Incandenza', in A. Sarat, ed., *Imagining Legality: Where Law Meets Popular Culture*, Tuscaloosa AL: The University of Alabama Press, 133–51.

Parry, Eugenia (2000), *Crime Album Stories: Paris 1886–1902*, Zurich: Scalo Verlag Ac.

Philpott, Lachlan (2015), *The Trouble with Harry*, London: Oberon Books.

Preston, Jennifer (2013), 'Opening the archive: The New South Wales Forensic Photography Archive as evidence of architectural history', in Alexandra Brown and Andrew Leach, eds, *Proceedings of the Society of Architectural Historians, Australia and New Zealand* 2, 761–73.

Richards, Kate (2006), 'Report: *Life After Wartime*: A suite of multimedia artworks', *Canadian Journal of Communication* 31, 447–58.

Sante, Luc (1991), *Low Life*, New York NY: Farrar Straus and Giroux.

Sante, Luc (1992), *Evidence*, New York NY: Farrar, Straus and Giroux.

Sante, Luc (2013a), 'Further evidence', *The Point* [online publication], accessible at http://thepointmag.com/2013/criticism/evidence

Sante, Luc (2013b), 'Further evidence', *Contrapasso* [Noir Issue], December, 71–77.

Sante, Luc and Peter Doyle (2016), 'Forensics in art and literature', program session with Peter Doyle, facilitated by Kate Rossmanith, Sydney Writers' Festival, Sydney, 19 May.

Sontag, Susan (1971), *On Photography*, London: Penguin.

State Archives and Records NSW (n.d.), 'Access Direction 1349', *Access Directions by Public Offices: Sydney Living Museums – The Historic Houses Trust*, www.records.nsw.gov.au/archives/collections-and-research/register-of-access-directions/public-offices-s

Sydney Living Museums (2010), 'Tuchin in the archive gallery', *From the Loft . . . of the Justice & Police Museum*, posted 5 July, accessible at http://blogs.sydneyliving museums.com.au/justice/index.php/page/22/

Tedeschi, Mark (2012), *Eugenia: A True Story of Adversity, Tragedy, Crime and Courage*, Australia: Simon and Schuster.

Tedeschi, Mark (2016), *Kidnapped: The Crime That Shocked the Nation*, Australia: Simon and Schuster.

Wigmore, J.H. (1904), *A Treatise on the System of Evidence in Trials at Common Law*, Boston MA: Little, Brown and Co.

Williams, Caleb (2005), 'The forensic eye: Photography's dark mirror', in Peter Doyle and Caleb Williams, *City of Shadows: Sydney Police Photographs 1912–1948*, Sydney NSW: Historic Houses Trust of NSW.

Williams, Caleb (2008), 'Murder scene, Mosman c1942. Photographer unknown', *From the Loft . . . of the Justice & Police Museum*, posted 4 March, accessible at http://blogs. sydneylivingmuseums.com.au/justice/index.php/page/34/

Williams, Caleb (2009), 'A future undreamed: The forensic photo beyond the darkroom, case-file and courtroom: Memory, mediation, museology', *Law Text Culture* 13, 165–77.

2 The Nutshell Studies of Unexplained Death

Crime scenes as doll's houses

The Nutshell Studies of Unexplained Death is a collection of at least 20 miniature doll's houses made by Frances Glessner Lee beginning in 1944, to assist police detectives to learn techniques of criminal investigation. Based on real cases, and funded by her own substantial inherited wealth, Lee's nutshells are still used in police training courses and are on permanent loan to the Medical Examiner's Office in Baltimore, Maryland (Montgomery 2017). Lee coined the term 'nutshells' because they captured the motto 'Convict the guilty, clear the innocent, and find the truth in a nutshell'; she never referred to them as doll's houses (Schuessler 2004). Preferring to name them 'miniatures', she described herself as having 'worked sporadically' on making them, eventually displaying them in a purpose-built and temperature-controlled room in Harvard University's Department of Legal Medicine (Lee 1951, 18). Described as 'opulent structures' and 'ghoulish scenes' (Flanagan 2009, 34), the nutshells are tiny and fully furnished buildings, primarily domestic interiors, that depict an unexplained or suspicious death. Little doll corpses are lavishly fashioned and displayed in their unassuming homes; no expense has been spared in recreating the humble rooms in which white working-class people strived and died. Every feature is a clue, nothing is accidental, and the nutshells are intended to reward slow and methodical observation. Described by the poet Simon Armitage as 'serious pieces of kit', the nutshells also convey Lee's 'lavish love' for her project (*In a Nutshell* 2014).

The nutshells have been accumulating a strange cultural charge over the past decade. Long obscured in a dusty Baltimore corridor, they are now cited with increasing regularity in mainstream cultural contexts, belying the hip insider cachet they have hitherto enjoyed. In late 2017, they were publicly exhibited together for the first time, in a major exhibition at the Renwick Gallery of the Smithsonian American Art Museum. It includes the 18 nutshells held in the Medical Examiner's Office, and an incomplete nutshell (long thought to be lost) that Lee was believed to have been crafting at the time of her death, loaned by the Bethlehem Heritage Society in New Hampshire (Jensen 2015). A twentieth nutshell is thought to have been destroyed (Monahan 2017).

In the long history of doll's houses, their earliest contexts – associated with the afterlife, having been found in Egyptian pyramids – were later displaced by domestic European showcases for the work of artisans, with hand-crafted models

made for the homes of the wealthy. It was only during the Industrial Revolution that mass-produced doll's houses were constructed, and not until the twentieth century that they were regarded, across the class spectrum, as children's toys. For Walter Benjamin, industrialisation generated the 'sociocritical significance' of the doll descended from the doll's progeny, the automaton (Benjamin 1999, 64). With the mass production of doll's houses developed cultural norms and practices that formed contemporary understandings of the doll's house. Whether and how to play with it, who it is made by and for, its possibilities and limits – all these are culturally prescribed. There are established obligations upon both the maker and the user of a doll's house, and clear rules for apprehending and resolving the discrepancies that arise from the reduction of scale. Frances Glessner Lee's nutshells demand attention to all the established cultural assumptions formed around dolls and doll's houses, for their conflation of domesticity, crime, criminal science and the professionalisation of policing. In his Arcades Project, Benjamin presented a fragment of dialogue from the dramatist Paul Lindau's 1896 play *Der Abend* ('The Doll' or 'The Automaton'): 'You have no idea how repulsive these automatons and dolls can become, and how one breathes at last on encountering a full-blooded being in this society' (Benjamin 1999, 694). It is a remark that has an uncanny resonance with Lee's doll's houses, and, in particular, their impact upon their students and viewers. The lure that draws us towards them is a strangely unpleasant compulsion, and being released from them comes as a relief.

Lee's nutshells are neither humorous nor ironic, neither playful nor childish. They are not assembled with any regard for thrift or frugality. Everything is custom made and expensive, and her doll's houses are deadpan and deadly serious. In a letter to her son, written while constructing a model, she wrote, 'Some of the details are quite amusing and I have my own private fun about them' (cited in Botz 2004, 36). While Lee's pleasure and satisfaction in making the nutshells is plainly evident, any amusement remains strictly private. They are not funny, and they do not invite joy. At most, they give rise to a wry reaction in the contemporary viewer, for their kitsch contribution to now well-worn cultural practices of making art from misery.

The nutshells were not the first attempt to shrink crime scenes into doll-like proportions. In 1924, on the southeast coast of England, Patrick Mahon murdered his pregnant lover, Emily Kaye, in gruesome circumstances and later claimed she died by accident. The case was notable for many reasons. One of these was the intervention of the pathologist, Sir Bernard Spilsbury, who was appalled at the manner in which the police investigation was undertaken. Another was the admission of crime scene photographs into evidence at Mahon's trial. And significantly, a police constable, Edward Shelah from Brixton, made a model reconstruction of the bungalow in which Kaye died. A replica made to scale, with tiny furniture, wallpaper and upholstered seats, the newspapers of the time praised Shelah for having 'faithfully reproduced' these articles, and making 'one of the most interesting exhibits ever displayed' (in Keily and Hoffbrand 2015, 76). While the model itself has since been lost, the furniture remains in the collection of the London Metropolitan Police (the Mahon murder trial was a feature of the

Figure 2.1 Photograph of miniature model of caul cauldron made by PC Edward Shelah
and used in prosecution of Patrick Mahon. © Mayor's Office for Policing and
Crime. Reproduced with permission.

exhibition The Crime Museum Uncovered, discussed in Chapter 5). Surviving
also is the miniature coal cauldron, standing two centimetres in height, which in
Mahon's account caused Kaye's death when she fell. Although Shelah's motiva-
tions for making the small-scale bungalow are now unknown, his work represents
an important precedent for Lee's project.

Lee's nutshells are satisfying for their attention to detail, the skill with which
they have been made, and their extraordinary weirdness. Lee knitted these crime
victim's socks on pins; she hand-painted the wallpaper; she wanted miniature
rocking chairs to rock with the same natural frequency as the life-sized ones in

real crime scenes. Each dead doll wore handmade clothing and undergarments. Lee stocked their tiny larders and peeled miniature potatoes which she placed in their little kitchen sinks. Beneath a sink, the floorboards might be water stained. She ensured there were mineral deposits visible in an old bathtub. These are superb doll's houses, furnished, appointed, decorated, but with the dolls either hanged or drowned or stabbed or bitten or poisoned or shot dead. They include accidental and natural deaths, and also deaths that 'because of inexpert or careless investigation, remain undetermined'. In her own words, 'No effort has been spared to make every detail perfect and complete'. The tiny door-keys lock tiny doors, the latches work on cabinets; Lee carved clothes pegs out of match sticks (Bruce Goldfarb, in *In a Nutshell* 2014). While conceding that the nutshells do not portray individual crime scenes, she wrote that 'everything demonstrated has actually happened'. As well as documenting the death, she was also concerned to capture 'the social and financial status of those involved' (Lee 1951, 676–77). As Bruce Goldfarb, executive assistant to the Maryland Chief Medical Examiner and Lee's impending biographer, observed, 'I'm pretty sure [Lee] never used a bathroom like this in her life' (*In a Nutshell* 2014; see also Dickinson 2017).

Frances Glessner Lee (1878–1962), born in Chicago and known as 'Fanny', was an heiress to the International Harvester fortune. She was thought to be 'a big fan of Sherlock Holmes', and perhaps also M.R. James's 1923 short story, 'The Haunted Doll's House' (*In a Nutshell* 2014). Raised in a grim and austere mansion designed by the architect H. H. Richardson, her childhood home is now the Glessner House Museum. Her father, John Jacob Glessner, who commissioned the building, later wrote a memoir about its design, construction and furnishings (Botz 2004). In a spooky pre-emption of his daughter's legacy, his book claimed: 'The Anglo-Saxon portion of mankind is a home-making, home-loving race' (cited in Botz 2004, 20). The Glessner House furnishings were described as creating a 'refined, cultured and moral environment' for the family, reflecting conservative and traditional values. Lee's mother, Frances Macbeth Glessner, kept a journal in which she recorded affectless lists of her daily activities, callers, invitations and meals; one reader noted of the entries: 'they read like police reports' (Botz 2004, 20–21).

Lee's family had denied her permission to study, and she instead formed an influential friendship with her brother's Harvard University classmate, George Burgess Magrath, a medical student who would become the medical examiner for southern Boston. She married and later divorced Blewett Lee, described as 'a milquetoast law professor' (Kahn 2004). Together they had three children, but, during and after their marriage, Lee remained financially dependent upon her father. Lee's fascination with policing and her commitment to the use of medical science in criminal investigation was encouraged by Magrath, who later provided her with an introduction to Dr Alan Gregg, chairman of the medical science section of The Rockefeller Foundation's General Education Board. The Rockefeller Foundation had already committed to advancing and professionalising forensic medicine and, using funds and advice provided by Lee, was instrumental in the establishment of the Department of Legal Medicine at Harvard University, the

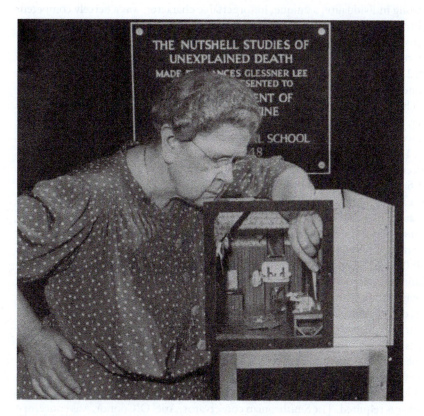

Figure 2.2 Frances Glessner Lee, from the *Saturday Evening Post*, 10 December 1949. Glessner House Museum, Chicago, IL. Reproduced with permission.

first of its kind. Following the death in 1936 of her father, who disapproved of her interests, Lee made a substantial endowment to the department to guarantee its survival and establish the first chair of legal medicine in America, and her role in the department continued with what forensic pathologist Jeffrey Jentzen described as her 'constant and unsolicited intervention', 'persistent pestering', 'police bias' and 'constant meddling'.[1] In particular, Lee was emphatic about the provision of ongoing training and instruction to police officers, and her intention in the construction of the nutshells was to supplement the training of police.

Lee, 'a queenly looking woman with the high-white coiffure and the tiny gold-rimmed eyeglasses', has been described as the 'mother' of modern forensic science (Bruce Goldfarb, in *In a Nutshell* 2014), the 'patron saint' of criminal investigation (Jerry Dziecichowicz, in *Of Dolls and Murder* 2012) and a 'passionate crusader for justice and a tireless lobbyist for reform' (George Oswald writing in *The Coronet* in 1949, cited in Ramsland 2008, 16). In an obituary, her friend Erle Stanley Gardner, author of the Perry Mason series, wrote: 'Captain Lee had

a strong individuality, a unique, unforgettable character, was a fiercely competent fighter, and a practical idealist' (Ramsland 2008, 20). There has been speculation that she was the inspiration for Jessica Fletcher, the amateur detective character played by Angela Lansbury in the television series *Murder, She Wrote* (Stamp 2012). Despite these acclamations, at the age of 73 Lee reflected, 'This has been a lonely and rather terrifying life I have lived' (Botz 2004, 22).

The nutshells were initially presented to the Department of Legal Medicine and later, following the closure of the department and with the permission of her family, were moved to Baltimore after her death. However, it was during her lifetime that Lee withdrew her ongoing support for the department at Harvard, after a disagreement about the ongoing mission and direction of the department. Without her financial contributions the department lost its focus on legal medicine, eventually expanding into other fields (health insurance, psychiatry and medical ethics). Because she lived such a long life, dying at the age of 83 in 1962, her expected bequest did not eventuate, as she was obliged to draw upon the principal of her inheritance to support herself in her final years (Jentzen 2009, 51). In 1992, a $50,000 donation from the Maryland Medical-Legal Foundation was raised to restore and conserve the nutshells. The journalist Eve Kahn wryly noticed the resemblance of the conservation report to a crime log; for example, 'The blood on the [doll's] body was discoloured and faded' (Kahn 2004).

In large part, the decision by the Medical Examiner's Office to exhibit the nutshells in the Smithsonian's Renwick Gallery was motivated by the need for them to be more expensively restored. As their spokesman, Bruce Goldfarb, conceded, 'They [the Smithsonian] came at just the right time' (Wenger 2017; see also Solly 2017). In preparation for the exhibition at the Smithsonian, further conservation work was required. The Smithsonian conservator, Ariel O'Connor, was concerned to restore the nutshells to the way they looked when Lee designed them. Three pools of blood had cracked with age. As the journalist Allison Meier explained, 'Much like a crime scene investigator, [O'Connor] is determining what materials Lee utilized, how these are deteriorating, and how to safely transport them' (Meier 2017). In this way, she aimed to circumvent the misinterpretations that might arise when red blood later appeared as purple blotches, erroneously suggesting decomposition or asphyxiation. Also, acting like a detective, O'Connor used ultraviolet lights and x-rays to examine the crime scenes, and examined photographs from the 1950s and 1960s to determine whether items had been moved or were missing; in preparing for the exhibition she discovered a knife – supposed to be placed on a table – underneath a sofa (Meier 2017).

There have been suggestions that, despite their commitment to accuracy in representing criminal evidence, the nutshells also hold 'autobiographical clues' about Lee. For example, the painting hanging over a fireplace in one of the models depicted Lee's own house, known as 'The Rocks', her family's 1,000-acre summer estate in New Hampshire (Schuessler 2004, 16). Some of them had wallpaper that matched the patterns in her own home (Ramsland 2008, 18). Artist Corinne May Botz suggested that the fact that most of Lee's nutshells portray female victims is also an autobiographical allusion, reflecting

Lee's failure to overcome the constrictive class and gender norms of her family, who prevented her from studying or entering a profession (Botz 2004, 22). As forensic psychologist Katherine Ramsland explains, all of Lee's victims in the nutshells were Caucasian and many lived in 'deprived circumstances' (Ramsland 2008, 18). For Goldfarb, the close detail in which she represented the lives of people far removed from her own reflected her 'empathy' (*In a Nutshell* 2014). In a different tone, *The New York Times* described Lee as having 'spent years looping nooses and painting blood smears on vignettes of working-class misery' (Kahn 2004). There has been speculation that Lee was drawing attention to domestic violence; the architect Jennifer Doublet wrote,

> For me there is perhaps nothing more satisfying in the Nutshells than the subversive pleasure of seeing the world of male detecting [sic] blown wide apart by the macabre depiction of domestic violence in the precious, controlled, female space of a doll's house.
>
> (Cited in Kahn 2004)

Lee's intention in creating the nutshells was to assign them for close study by trainees and students. In her own words, 'these models are not 'whodunits' – they cannot be solved merely by looking at them. They are intended to be an

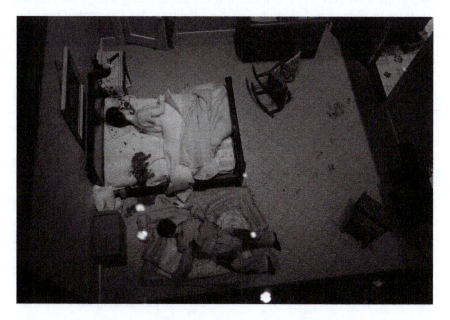

Figure 2.3 Nutshell Studies of Unexplained Death, Three-Room Dwelling, detail. Exhibition view, Renwick Gallery, Smithsonian Museum. Photograph: Katherine Biber. Collection of the Harvard Medical School, Harvard University, Cambridge, MA, courtesy of the Office of the Chief Medical Examiner, Baltimore, MD.

exercise in observing, interpreting, evaluating and reporting – there is no 'solution' to be determined' (Lee 1951, 677). Notwithstanding this claim, there are answers – or solutions – to the questions provoked by the models, and the custodian of these is, at present, Jerry Dziecichowicz who works in the Office of the Chief Medical Examiner in Maryland. Introducing himself, Dziecichowicz said: 'I am the nutshell man. I am the one with the secrets. I know the solutions to all the nutshells' (*Of Dolls and Murder* 2012). Yet Botz has said that the solutions are 'only mildly interesting', eclipsed by the fanaticism and ambiguity at the heart of Lee's endeavour (Botz 2004). Ariel O'Connor agrees: 'There are solutions, but they're not solutions that you need to know' (Meier 2017).

According to her carpenter, Ralph Mosher, Lee was interested only in 'enigmatic cases', baffling ones that somehow piqued her interest. They could not be solved by close examination, but impressed upon the investigator the need to communicate with medical and forensic examiners and other law enforcement officers, demanding a methodical approach to crime investigation (Botz 2004, 27). For Lee, one of the 'essentials' in studying the nutshells is that they be approached 'with an *open mind*' (Lee 1951, 677; emphasis in original). For her, legal medicine was 'an unremitting quest for the facts', 'a constant and continuous search for truth in the interests of science and justice, to expose the guilty, to clear the innocent. It is a dedication of its own peculiar wisdom and experience to the service of mankind' (Lee 1951, 678). During Lee's twice-yearly seminars at Harvard, participants were invited to study an assigned nutshell for a prescribed period of time, noting important evidence and developing an account of the death. In written instructions Lee told participants to use a grid pattern in examining the scene. Her curriculum notes suggested, 'The inspector may best examine them by imagining himself a trifle less than six inches tall' (Kahn 2004). They were to look at the entire scene and attend to all clues, some of which were subtle, and some of which might contradict an initial account of the death. She provided very brief descriptions of each scenario: for example, 'April 12, 1944: Mrs Fred Barnes, housewife, dead' (Ramsland 2008, 18). She also provided short statements given by witnesses. The nutshell 'Dark Bathroom', in which Maggie Wilson is found dead, is accompanied by a witness statement from Lizzie Miller:

> I roomed in the same house as Maggie, but we only spoke when we met in the hall. I think she was subject to fits (seizures). A couple of male friends came to see her fairly regularly. Tonight, the men were in her room and there seemed to be a good deal of drinking going on. Sometime after they left, I heard the water still running in the bathroom, so I opened the door and found Maggie dead in the tub with water pouring down on her face.
>
> (Reproduced in Botz 2004, 83)

In Katherine Ramsland's account of the seminars, each concluded with a lavish reception at the Ritz Carlton served on Lee's exquisite fine china used exclusively for these occasions, a luxury unfamiliar to most of the attendees (Ramsland 2008, 18). Caviar, foie gras and filet mignon were served, and Lee

was said to have spent hours working on the seating plans and floral arrangements (Kahn 2004). Guests were given gifts when they left the dinners: a miniature nutshell containing a miniature set of cufflinks (Zhang 2017). Art critic Richard B. Woodward notes drily, 'What ill-paid policemen gained from invitations to these events, except the chance to play a parlor game and dine well at the Ritz, is not recorded. Probably Lee was as humored as much as she was respected' (Botz 2004, 11).

―――――――

The murder mystery is a conservative genre. The detective examines the evidence in order to identify the transgressor, enforce the law and restore order. However, the murder mystery has always relied on modern innovations; usually these have invoked concepts from medicine, psychology and psychoanalysis. As Woodward has written, the investigator operates in what Baudelaire called 'a forest of signs', and the demand that they remain constantly alert can give rise to the danger that they become hypersensitised or paranoid. Framed thus, Woodward asserts that Lee was 'not crazy' but that her nutshells are 'touched with madness' (Botz 2004, 10). The film maker John Waters recalled, 'When I saw these miniature crime scenes I felt breathless over the devotion that went into their creation. Even the most depraved Barbie Doll collector couldn't top this' (Kahn 2004). The poet Simon Armitage observed, 'They are not the work of an ordinary mind' (Armitage 2015b).

Lee's first miniature, created when she was 35 years old, was a replica of the Chicago Symphony Orchestra, made as a birthday gift for her mother. It represented 90 musicians and their respective instruments, fully dressed and each with the correct musical score. It occupied her for two months, and instigated another project, two years in duration, also representing musicians (Ramsland 2008, 16). A quartet that was said to bear an uncanny resemblance to its models, their miniature instruments could produce sounds; they sat before musical scores composed for them by the conductor of the Chicago Symphony, who had jestingly written music that was impossible to play (Botz 2004, 24). This kind of painstaking creativity was not an uncommon hobby for a woman of her period and class; her Chicago contemporary, Narcissa Niblack Thorne, usually known as Mrs James Ward Thorne, also oversaw the making of a series of celebrated miniature period rooms, which are now held at the Art Institute of Chicago (Miller 2005, 201).

Working in miniature reflects a commitment to detail, and demands concentration and intensity. Lee herself wrote, 'At first, [detectives] are impressed mainly by the miniature quality – the doll house effect – but almost immediately they enter into the reality of the matter and completely lose sight of the make-believe' (cited in Dickinson 2017). For Patricia Storace, 'changing scale' is one of the enduring dramas of childhood, and children's literature and toys enact this drama repeatedly, whether miniaturizing or magnifying, this play with proportions can be 'comic, ridiculous, and terrifying' (Storace 2016, 19). In contracting a world into a doll's house, they might charm, delight or instruct.

But that world is reanimated in full-size – in Storace's view it regains its true dimensions – through the biography of its maker. What motivated the miniaturist to shrink a world thus? Is there always some autobiographical explanation? Writing about Lee's dioramas, Storace identified these interiors as 'false shelters, places carefully furnished to conceal ongoing crimes, lies, suffering, and fury' (Storace 2016, 20). Mary Flanagan has drawn the connection between Lee's nutshells and Henrik Ibsen's 1879 play *A Doll's House*, another representation of female repression and 'the trap of domesticity' (Flanagan 2009, 35). In a similar vein, Laura J. Miller argued that Lee's dioramas subvert the moral didactic aspirations of the traditional doll's house – programmed to instruct young girls into the norms of domesticity. Instead, she wrote, they convey 'the dark side of domesticity': 'a domestic scene gone disturbingly wrong', 'dystopia in a doll's house' (Miller 2005, 202, 204). They represent what several writers have assumed to be the twin conflicts that motivated Lee: confinement and escape.

Another crucial effect of the miniature is its ambiguity about point of view; as Storace noted, we are 'unable to be fully inside or outside' (Storace 2016, 19). Similarly, Miller wrote that they are both 'impenetrable' and 'intimate' (Miller 2005, 204). In their fragility, they remind us of danger and risk, but they are also 'quotidian', 'matter-of-fact'. By demanding attention to the small, Storace wrote, Lee was reminding the detective of his own vulnerability, putting him 'on the same scale as the victim', alert to the nuances of domesticity (Storace 2016, 20–21). However, point of view also has a moral facet, and Miller noticed that Lee's victims, most of whom were women, were not from her own world. The nutshells represent 'tawdry middle-class domesticity' as well as the boarding houses and rented rooms of 'society's disenfranchised' (Miller 2005, 203–4). For their custodian, Bruce Goldfarb, Lee 'had such an eye, or an empathy, for this way of life' (*In a Nutshell* 2014). Miller wrote that Lee's victims were women who had been 'led astray' by 'alcohol, men, misfortune, or their own desire', although this is not true of all the scenarios portrayed in the nutshells. While Miller asserted that there was likely an act of moral judgment underpinning these representations, she was also open to the possibility that, following Judith Butler's writing on gender, they might also be 'drag' or 'burlesque' performances of female domesticity (Miller 2005, 204, 208). Unexpectedly, these might also be burlesque representations of crime and criminal investigation. Their high-camp attributes have been acclaimed by the film maker John Waters, who celebrated their weirdness. Waters narrated the 2012 documentary film *Of Dolls and Murder* and his voice conveys hyperbolic inflections that seem appropriate to the unforeseen camp melodrama that may now be the nutshells' legacy. For example, one scene in the film shows two male detectives examining a nutshell during a training exercise: they point flashlights into its corners, speak in hushed voices, make professional observations, but remain good-humoured and archly self-aware about the arcane policing rite-of-passage they are undertaking.

For Storace, Lee's nutshells 'evoke the incomparable silence of houses whose objects have suddenly and unexpectedly outlived the inhabitants who arranged

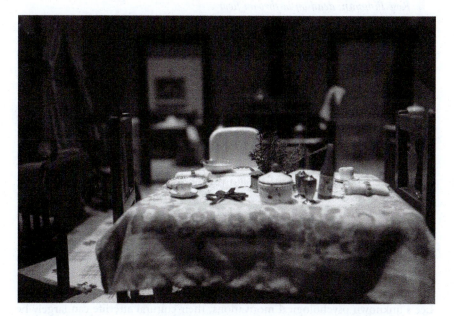

Figure 2.4 Nutshell Studies of Unexplained Death, Three-Room Dwelling, detail. Exhibition view, Renwick Gallery, Smithsonian Museum. Photograph: Katherine Biber. Collection of the Harvard Medical School, Harvard University, Cambridge, MA, courtesy of the Office of the Chief Medical Examiner, Baltimore, MD.

them' (Storace 2016, 21). True, they evoke silence, but Lee demanded that their viewers re-animate them by paying attention to their whispers. Several writers noticed that, by portraying scenes of domestic violence, Lee demanded that viewers, and particularly police detectives, pay attention to what would otherwise be a hidden crime. Botz insisted that Lee was 'certainly not a feminist', but nor was her fascination with women victims of crime 'voyeuristic' (Botz 2004, 38). Others have observed that Lee demonstrated an anxiety about the status and role of women in society, and that she took full advantage of her status as a traditional woman of the upper class (her enormous inheritance, freedom from paid work, an abundance of household staff, the freedom to divorce her husband) while also resenting the constraints this traditional role imposed upon her, remaining under the control of her father until his death. Most of Lee's victims were women who had died violently in their homes. As Corinne Botz summarised:

> *Robin Barnes: dead on kitchen floor*
> *Kate Judson: shot in bed*
> *Linda Mae Judson: shot in crib*
> *Marie Jones: stabbed in bedroom closet*
> *Jessie Comptom: hanged in attic*

Rose Fishman: dead on bathroom floor
Dorothy Dennison: dead on parsonage parlor floor
Unknown woman: dead in bathtub
Maggie Wilson: dead in bathtub
Ruby Davis: dead on living-room stairs
Annie Morrison: dead on ground below second-story porch
Wilby Jenks: dead in bed.

(Botz 2004, 38)

Botz asked, rhetorically, what Lee gained by making the miniature corpses herself (Botz 2004, 39). Certainly she had the means and the connections necessary to have them professionally made, and yet she spent countless hours labouring painstakingly over these dolls herself, which she made with such devotion and then mutilated in a strange dyad of composition and decomposition. Botz's unanswered query captured the awkward tension between the respectful restraint with which the nutshells are today admired, and the spectral haunting sense that Lee was an obsessive and strange tyrant whose memory has been favourably preserved because of her wealth and influence.

Although ostensibly made for a pedagogical purpose, notwithstanding Lee's unknown psychological motivations, their cultural afterlife can largely be attributed to the artist Corinne May Botz. Botz studied and photographed the nutshells for over seven years, and her beautiful images and careful notes have been published in a lavish book, *The Nutshell Studies of Unexplained Death*. In a clear effort to situate Botz within the genre of highbrow practitioners working aesthetically with criminal artefacts, her book contains an endorsement from writer Luc Sante, whose work made celebrated artistic use of crime scene photography from the New York City Municipal Archives (see Chapter 1). Fittingly, it appears in tiny text on the spine of her book, where he wrote: 'it never previously seemed possible to use the words "forensic" and "cute" in the same sentence' (Botz 2004, printed on the spine on the dust jacket). (It seems unlikely that Sante had forgotten about the lyrics to Elvis Costello's 1977 single *Watching the Detectives*: 'She is watching the detectives/Ooh, he's so cute'.) Over the last decade, a gradual percolation of the nutshells into mainstream cultural artefacts has been evident, as they experienced a kind of 'break out' from their context as police instruction tools into a cultural domain in which they have acquired new significance. In 2007, the makers of the TV series *The Wire*, set in Baltimore, released short prequel episodes to the series. The episode titled 'When Bunk Met McNulty', set in 2000, documents the first meeting of the series' two lead homicide detectives, and represents an early instance of the cultural citation of the nutshells. One of the detectives, Bunk Moreland, quizzes his new partner: 'Any other training? Forensics? In-service DI seminar? Frances Glessner Lee?' McNulty shakes his head.

The nutshells were later the basis for a character in the TV crime drama *CSI: Crime Scene Investigation*, known as 'The Miniature Serial Killer', who was the subject of the show's seventh season (*CSI: Crime Scene Investigation* 2006).

They were the subject of the 2012 documentary film *Of Dolls and Murder*, and in 2014 they were the basis for a Radio 4 documentary, *In a Nutshell*, made by the poet Simon Armitage, who has also written poems about them. In early 2017, the BBC TV adaptation of G.K. Chesterton's short story character Father Brown featured a scenario based upon the nutshells. A Catholic priest and amateur detective, Father Brown uses spiritual and personal observations to solve crimes, making him a counterpoint to the more scientific Sherlock Holmes. The episode 'The Smallest of Things' sees guests at a reception at a grand country estate pronounce the dioramas as either 'bloodbaths' or 'beautiful', and the plot turns upon the realisation that, by immersing herself in creating these dioramas, their maker can repress her own childhood of loss, tragedy and personal torments (*Father Brown* 2017).

For Richard B. Woodward, in his introduction to Botz's book on the nutshells, 'Lee seems to have anticipated a school of postmodern photography by creating environments where grim realism and childish whimsy collide' (Botz 2004, 11). Doll's house noir, outsider handicrafts and a metacritical play with scale; all of these are evident in Lee's extravagant folly. As Simon Armitage told their custodian Bruce Goldfarb at the Chief Medical Examiner's Office in Baltimore,

> some friends of mine at home, crime writers, are very jealous that I'm getting an opportunity to do this [see the nutshells]. Because for them, they talk about it as if it's the Holy Grail or the Ark of the Covenant or something.
>
> (*In a Nutshell* 2014)

For their Smithsonian curator, Nora Atkinson, the nutshells have attained a 'cult following' (Judkis 2017; see also Downtown Baltimore 2017). Certainly at the Renwick Gallery, with its exhibition space cast into darkness, enthusiastic visitors clustered around each nutshell, eagerly deploying the provided torches. Strangers engaged in collaborative investigations, pointing out 'clues', reminding each other of the information provided in the textual statements, sharing tips they had overheard and drawing inferences about what these tiny characters would or could have been thinking at the time of their death. Occasionally, one would pause to marvel at the 'fun' they were having, or note what a 'weird' activity this was.

At the Medical Examiner's Office in Baltimore, the nutshells are described as lining a darkened corridor, fronted in clear plastic, and with a motion sensor triggering their tiny lamps whenever somebody walks past. They share a hallway with displayed copies of technical publications bearing titles such as 'Suicide Using a Compound Bow and Arrow' and 'Pathogenesis of Vertebral Artery Occlusion' (Kahn 2004). Contemporary viewers and commentators are adamant that the nutshells always were, and remain, a very serious enterprise, although much of their contemporary cultural presence relies upon the ironies implicit in the juxtaposition of crime and craft. The Maryland Chief Medical Examiner said in 2004, 'I've never seen anybody make jokes, because of the degree of intricacy

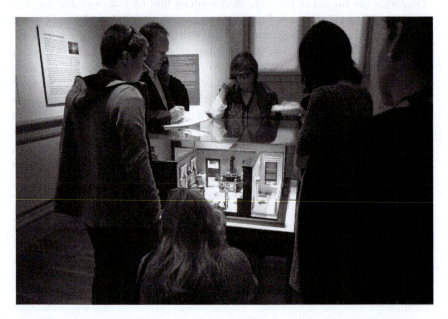

Figure 2.5 Murder Is Her Hobby: Frances Glessner Lee and the Nutshell Studies of
Unexplained Death, Exhibition staged at Renwick Gallery, Smithsonian
Museum, 20 October 2017–28 January 2018. Photograph: Katherine Biber.

and detail' (Kahn 2004). Nevertheless, their context takes advantage of crime's
popular cultural productions; not far from the nutshells is another room called
'Scarpetta House', donated by the crime fiction writer Patricia Cornwell and
named after her detective heroine, Kay Scarpetta. Inside Scarpetta House, inves-
tigators stage death scenes that are used for training detectives; reflecting their
adaptability to fluctuating scale, detectives refer to it as the 'life-sized nutshell'
(Armitage 2015a).

Frances Glessner Lee's nutshells represent composites of real crime scenes. In
researching their contents, Lee drew upon police reports, newspaper accounts
and interviews with witnesses; she paid visits to the morgue and went on ride-
alongs with police officers to crime scenes. She gave their characters old-timey
pseudonyms: Homer Cregg, Wilby Jenks, Sergeant Moriarty, and gave each
diorama a name, 'a creepy name': Burned Cabin, Unpapered Bedroom, Dark
Bathroom (Kahn 2004). They demand close inspection and present their
examiner with ambiguities. For instance, an apparent suicide might be chal-
lenged by a freshly baked cake and a pile of freshly laundered clothing. The
underside of a tiny wooden ironing board has a pencil inscription that reads
'50 cents', prompting the artist Botz to ask, 'What's that about?' (cited in
Kahn 2004). Because nothing is inadvertent, everything becomes significant.
This, too, is a part of their ambiguity, because not everything that is intentional
is significantly so.

The second storey of Lee's four-level country house was transformed into a workshop known as Nutshell Laboratories. The nutshells were created with the assistance of Ralph Mosher, whom Lee employed as a full-time carpenter to build them. Following his death, she employed his son, Alton Mosher, to continue the project. They built about three nutshells per year, each said to cost roughly the same, and to take roughly as long to build, as a real house would have at that time (Botz 2004, 32–33). They were built on a scale of one inch to one foot, and include a log cabin, a woodman's shack, a barn, a two-storey porch, a three-room dwelling, a garage and a parsonage. They built stairwells and yards that would be barely visible to a viewer. Using dental instruments and jewellers' tools, scenes were perfectly constructed and then obscured from vision – for example, a complete tavern bar room, named 'Saloon and Jail', was built and then concealed behind a wall where it cannot be seen; the viewer has access only to the outside of the building where the body of the victim appears near the tavern's exterior door. Details visible in the distance, outside windows, were also constructed in three dimensions. A nutshell named 'Burnt Cabin' was based on a 1943 case in which a young man claimed to have escaped from a night-time fire in which his uncle died while they were sleeping. A crucial clue in this scenario was the fact that the young man was fully dressed when rescued. To create this model, having painstakingly researched and built the cabin, Lee used a blowtorch to burn it down again (Ramsland 2008, 18). 'Burnt Cabin' is

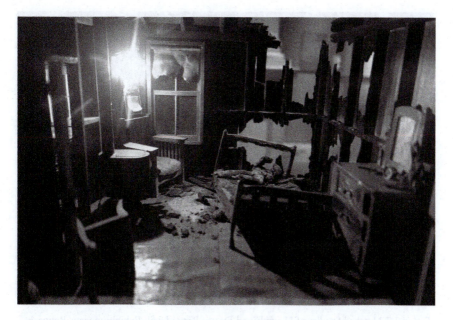

Figure 2.6 Nutshell Studies of Unexplained Death, Burned Cabin, detail. Exhibition view, Renwick Gallery, Smithsonian Museum. Photograph: Katherine Biber. Collection of the Harvard Medical School, Harvard University, Cambridge, MA, courtesy of the Office of the Chief Medical Examiner, Baltimore, MD.

now the most fragile of the nutshells, presenting new challenges for conservators. The skeleton that is barely visible in the charred bed is now unstable, and the plastics on the windows are brittle and warped. The electric lights are being restored to reflect instructions in Lee's handwritten notes that they should be blue or green. Preparing for the Smithsonian exhibition, the curator O'Connor said, 'This will be the first time that you'll actually see them again as night scenes' (Meier 2017).

Their Baltimore conservator, Sian B. Jones, acknowledged that Lee was 'neurotic about detail' (Goldfarb n.d.). Lee herself made and clothed the dolls, these miniature corpses, the victims of these unexplained deaths. She stuffed their cloth bodies with BB gun pellets, she painted their faces, stitched or knitted their clothes. Carefully selecting fabric from samples, in at least one instance she made herself a garment from her chosen cloth and wore it for months until it had accrued exactly the correct amount of wear and tear to suit its intended corpse. She rolled miniature cigarettes, three millimetres long, let them burn and then extinguished them in tiny ashtrays. That their brand was Lucky Strike was supposed to be a clue. She created miniature books and magazines, some with facsimile covers, and their headlines and sub-headings were legible. She made tiny prescription bottles with hand-printed labels. As Katherine Ramsland wrote, 'Once each doll was ready, Lee would decide just how it should "die" and proceed to stick a knife in one, drown another, or hang one up with a noose' (Ramsland 2008, 18). She

Figure 2.7 Nutshell Studies of Unexplained Death, Barn, detail. Exhibition view, Renwick Gallery, Smithsonian Museum. Photograph: Katherine Biber. Collection of the Harvard Medical School, Harvard University, Cambridge, MA, courtesy of the Office of the Chief Medical Examiner, Baltimore, MD.

would then paint them in a manner that accurately captured, for instance, their death by carbon monoxide poisoning, or their decomposition.

Like all doll's houses, the nutshells play upon the ambiguity of scale. Botz's photographs take advantage of this. She has focused her lens on tiny features of the doll's houses and then enlarged them. By magnifying them, she has somehow rendered them more terrifying and suspenseful, creating an atmosphere of danger that invites our careful attention. The enlargements also have the effect of disclosing their kitsch, camp qualities, which makes them rather sad. In Botz's photographs we can see every stitch and fibre, every speck and strand. She frames a tiny pair of slippers on a bathroom mat, a hat dropped on the ground, the flying fish painted onto wallpaper. As the journalist Douglas Maxwell wrote, 'We find ourselves in front of Botz's images making imaginary evidentiary findings, solving, trying and closing cold cases' (Maxwell 2006). Botz explained that she sensed Lee's presence while photographing the nutshells, saying: 'I thought of myself as an investigator looking at her life from this cold but enthralling case' (*In a Nutshell* 2014). Botz intuited that the nutshells were the product of Lee's 'unused intellect' (Botz 2004, 22). For Botz, the nutshells drew together 'gender, home, fear, space, sexuality' (Schuessler 2004). In Botz's description, these houses are 'so safe and controlled'; they are 'under siege, yet there are neat and tidy solutions' (Kahn 2004). Yet Botz has also said that, within Lee's home, she was feared: 'As a person she was difficult – sometimes impossible. A lot of her help were scared to death of her' (*In a Nutshell* 2014). Botz, who spent over seven years researching and photographing the nutshells, admitted, 'It's time to move on. It wouldn't be sort of healthy for me to stay with this any longer' (Kahn 2004).

The nutshells, and particularly Botz's photographs of them, have reminded some viewers that legal photography is primarily 'a photography of interiors' (Lussier 2013, 29). By rendering crime scenes as doll's houses, Lee made manifest the interiority and domesticity of these crimes, which, for Alexis Lussier, invoked the categories of 'privacy' or 'intimacy' as evidentiary categories. For Lussier, a scholar of literary studies, Botz's photographs dramatise the crime scenes by deploying 'framing effects, amplifying colours, or upsetting our sense of proportion'. Whereas these close-ups have the effect of magnifying and tightly focusing the subject of the image, the blurring that occurs at the margins becomes somehow dreamlike or spectral: 'something whose form isn't completely apprehended'. For Lussier, Botz's photographs of the nutshells, by disaggregating and isolating the components of these dioramas, shifted them into 'the register of ambiguity', as if unravelling the careful narratives that Lee had painstakingly stitched together (Lussier 2013, 32).

The artist and game designer Mary Flanagan invoked Lee's Nutshell Studies in her work on games and play (Flanagan 2009; see also Morrissey 2014). The social role of games, and their transformative and subversive potential, was at the centre of her study of 'critical play', and she explained how Lee's doll's houses represented a wider adult engagement with doll culture. For Flanagan, Lee's project enacted three styles of critical play: Lee 'reskinned' the doll's house as a

crime scene; she 'unplayed' the conventions of both police work and appropriate child's play through the medium of the doll's house; and she 'rewrote' her own role and that of doll play into her social context (Flanagan 2009, 34–35). These acts of inversion, subversion and boundary-pushing are all central to Flanagan's thesis on critical play, and she located them within Lee's project. These acts are also apparent in many of the afterlife reincarnations of criminal evidence. 'Critical play' seems to capture the intentions of many cultural practitioners who engage with criminal evidence outside of the law. It is a term that embraces both the pleasure and the transgression that we experience in many of our afterlife confrontations with evidence.

While these entanglements and dislocations certainly give rise to ambiguities and incongruities, Lee's nutshells have, for most of their viewers, prompted a reflection upon scale. Taking evidence from one place and moving it elsewhere achieves an effect; mixing evidence with something else achieves another effect. Changing its size demands specific inquiry. The art historians Joan Kee and Emanuele Lugli wrote that scale has the effect of 'displacing the viewer', challenging notions of proportion, priority, relationality and centrality. They explained that measurement is an act of power, and shifting size distributes power in a manner that doesn't necessarily fit to scale; that is, it doesn't shift in proportion (Kee and Lugli 2015, 252, 259, 263). The scale, or grid, conveys the appearance of objectivity but masks the operation of power and authority that lies beneath it. Lee recommended that detectives use a grid system in their examination of the nutshells, as this would force them to notice everything. The smallness of things within each model also commanded attention, because the compression and shrinkage affected not only a thing's appearance, but also its function, perception and potential. Its size was in no way an indicator of its significance.

Playing with scale can invite technical and professional responses, but also social and affective ones. Kee and Lugli drew attention to an important but under-theorised distinction between scale and size, with terms like 'miniature' and 'monumental' having the effect of conflating textual and visual experiences that ought to remain distinct. There is also the important consideration of whether scale amounts to substitution, and what is gained and lost by a shift in scale. Kee and Lugli made the important link between scale and function – given the labour and expense invested into the nutshells, how do they function? (Kee and Lugli 2015, 254–56). And are they actually used in that manner? For example, the nutshell 'Three-Room Dwelling' contains a small-scale rocking chair that was made to rock exactly as does its full-size model, but nobody will ever sit in it, and it will never be expected to oscillate. Kee and Lugli also pointed to the discrepancy between the duration of making and of viewing experience (Kee and Lugli 2015, 256). While it is clear almost nobody will spend as long with a nutshell as was spent by its makers crafting it, even a cursory glance confirms that they are laboriously handmade, and that their production was time-consuming. To a great extent, they took so long to make *because* they are small, and so a portion of our viewing time demands our reflection upon *how* they were made, as well as why.

Playing with scale alters the materiality of the object, as working in miniature changes the physical properties of the materials and construction methods required (Kee and Lugli 2015, 256). Margaret Graves's work on miniaturisation referred to the 'shared sense of artistic licence between maker and user'; this licence permits both parties to overlook the omissions necessitated by the reduction in scale, and to resolve whether the miniature world is a reproduction of the full-sized one, or an attempt at mimesis, or whether it shares form or function, or has some other kinship relationship with it (Kee and Lugli 2015, 257). An important feature of the licence is that the parties share an understanding of its role and power within their relationship. Lee's nutshells do, in some ways, breach the licence; in other ways, however, they are necessarily constrained by it. Not all the effects of miniaturisation are, or need to be, visible. Importantly, miniaturisation invites communication and knowledge that would be impossible or difficult to obtain at full-size, and this is a vital effect of its licence.

In 2014, the poet Simon Armitage made a BBC Radio 4 program, *In a Nutshell*, documenting his journey to Baltimore to view Lee's models and speak to their custodians. Armitage was elected Oxford Professor of Poetry in 2015, having devoted himself to full-time poetry since 1994 after leaving his employment as a probation officer in Greater Manchester. Following his father into a career in which he provided support and supervision for criminal offenders, it is not surprising that criminal themes arise in his poetic work. Earlier, Armitage had written a series of poetic monologues for radio, 'Black Roses: The Killing of Sophie Lancaster', based on a real-life murder in Lancashire, and which was later adapted into a television film. Talking to a poetry journalist about that project, he reflected closely on questions of 'permission', 'responsibility' and 'blessing', in that case from the victim's mother, before he felt he could make the work that he then did (Broad 2015). In creating a poetic voice through which a crime victim would speak, Armitage reflected, 'I hope there's a sense of Sophie not being here, a voice from the other side, if you like'. Here was a murder victim revived in the afterlife in a poem. Hers was an afterlife mediated by her surviving mother, who Armitage had charged with the duty of guarding her poetic voice. Armitage explained, 'There was a moment where I had to give those poems back to Sylvia [Sophie's mother] and say "Is this ok? Is this what Sophie would have sounded like or said?"' He didn't explain whether he did this for veracity or in fulfilment of some ethical compunction.

In a subsequent afterlife engagement with criminal evidence, Armitage wrote three poems about the nutshells and, although they remain unpublished, he has read them live on stage and on his BBC 4 Radio program (Armitage 2015a; *In a Nutshell* 2014). His nutshell poems respond to the models 'Three-Roomed Dwelling', 'Barn' and 'Dark Bathroom', and he has described them as 'the easiest poems I'd ever acquired. All I did was describe what was there, then threw in a few half-rhymes at the end of lines' (Armitage 2015b). This is an accurate account, as the poems do primarily catalogue the objects he sees within the nutshells, with his observations precisely capturing these shabby tableaux caught in the moment that they went awry. It is evident that Armitage had studied the scenarios, as his poems

contain clues and theories as to what befell these doll corpses, tightening his focus onto small details before stepping back and observing one everyday feature that captures the sorrow evoked by these domestic calamities.

Armitage explained that when he first saw the nutshells, for their details, their stories, their frames and their miniature size, he said 'They were what I thought of as poems' (Armitage 2015a). This observation offers new insights into the cultural afterlife of evidence: *Can* evidence be poetry? Poems, for Armitage, are already miniatures – 'little scenes, little sketches of life', 'they don't tell us everything, they hold quite a lot back' – and the nutshells share these qualities (*In a Nutshell* 2014). So, too, does criminal evidence. The fragmentary nature of evidence, the range of small pieces that must be assembled into a perceptible whole, the gaps and dark places, all these attributes point to the fact that – in the grand tragedy of justice – evidence is a jumbled assortment of miniatures. The nutshells were, for Armitage, 'little theatres in which mini-psychodramas are played out', complete with stories, characters and punchlines (Armitage 2015b). For Armitage, the nutshells were both playful and macabre, and combined weirdness and voyeurism. When he spoke about the nutshells at a crowded event in London in 2015, Armitage made a remark that somehow captured a great deal about the unease associated with the afterlife of criminal evidence. While visiting the nutshells in the Baltimore Medical Examiner's Office, he accepted an

Figure 2.8 Nutshell Studies of Unexplained Death, Sitting Room and Woodshed, detail. Exhibition view, Renwick Gallery, Smithsonian Museum. Photograph: Katherine Biber. Collection of the Harvard Medical School, Harvard University, Cambridge, MA, courtesy of the Office of the Chief Medical Examiner, Baltimore, MD.

invitation to watch an autopsy. Of this experience, Armitage reflected: 'I didn't feel queasy. I felt *uninvited*' (Armitage 2015a).

Frances Glessner Lee was one of law's reluctant lifelong outsiders, working tirelessly to inveigle herself into the law. Towards the end of her long life, after her eyesight failed and her doctors instructed her to cease working, she had a police radio installed in her home so that she might listen to live police reports (Ramsland 2008, 20). It is a curious gesture, confusingly uncertain as to whether it finally transformed her into one of law's insiders, or whether she ended her life as one of law's tolerated voyeurs. Criminal proceedings occur in public. It is this publicity that, articulated through the principles and jurisprudence of open justice, provides the qualities of accountability and transparency that are said to give us confidence in the criminal justice system. While these values are mostly sound and uncontroversial, there is a distinct contextual shift that occurs when one of law's outsiders begins playing with law's materials, and more so when they do so *uninvited*. Within the bounds of the legal process, the rules of evidence give some assurance that the access, use and interpretation of evidence will be relevant, cautious and fair. Yet beyond the law's reach, these rules have no power. Evidentiary materials, however, remain vibrant and charged. They continue to attract and fascinate, and outlive the law. This book pursues the questions arising from what happens – what changes – when evidence is cut loose and runs wild. That Armitage hesitated – that he felt uninvited – strikes a chord, and gives further motivation for this project. Are law's outsiders subject to different constraints, or ought they to be? Unlike law's insiders, law's outsiders are not desensitised to crime, and so their responses to it can be rich and instructive.

Note

1 Jentzen (2009, 40, 49). This book provides much of the background context to the slow development of legal medicine in America. Obstructed by the American Medical Association, which saw coroners as unprofessional and intrusive, Lee's support for the emerging discipline showed her advancing a political and advocacy role as well as supporting scientific research and advancing the training of professionals.

References

Armitage, Simon (2015a), reading at 'The poetry of dolls and murder', a Wellcome Collection film screening, 16 April; details at https://wellcomecollection.org/events/poetry-dolls-and-murder

Armitage, Simon (2015b), 'Putting poetry in its place', *Arete* 46, accessed online at www.aretemagazine.co.uk/46-springsummer-2015/putting-poetry-in-its-place/

Benjamin, Walter (1999), *The Arcades Project*, trans. Howard Eiland and Kevin McLaughlin, Cambridge MA: The Belknap Press.

Botz, Corrine May (2004), *The Nutshell Studies of Unexplained Death*, New York NY: The Monacelli Press.

Broad, Leah (2015), 'The Unaccompanied: An interview with Simon Armitage', *The Oxford Culture Review*, 18 June, accessible at https://theoxfordculturereview.com/2015/06/18/the-unaccompanied-an-interview-with-simon-armitage/

Costello, Elvis (1977), 'Watching the Detectives', UK: Stiff Records, US: Columbia Records.

CSI: Crime Scene Investigation (2006), television broadcast, Season 7, CBS. Written by Sarah Goldfinger and Naren Shankar; directed by Kenneth Fink.

Dickinson, Elizabeth Evitts (2017), 'The woman who invented forensics training with doll houses', *The New Yorker*, 5 November, accessible at www.newyorker.com/culture/culture-desk/the-woman-who-invented-forensics-training-with-doll-houses

Downtown Baltimore (2017), 'Elizabeth Evitts Dickinson, The Nutshell Studies of Unexplained Death', podcast 3 November, *Hey Baltimore*, accessible at http://eedickinson.com/portfolio-items/podcast-the-nutshell-studies-of-unexplained-death/

Father Brown (2017), television broadcast, Season 5, Episode 7, 'The smallest of things', BBC One; written by Tahsin Guner; directed by Bob Tomson.

Flanagan, Mary (2009), *Critical Play: Radical Game Design*, Cambridge MA: MIT Press.

Goldfarb, Bruce (n.d.), 'The Nutshell Studies of Unexplained Death', blog post, accessible at http://brucegoldfarb.com/the-nutshell-studies-of-unexplained-death

In a Nutshell (2014), radio broadcast, 10 November, BBC 4; written and presented by Simon Armitage, accessible at www.bbc.co.uk/programmes/b04mgxt4

Jensen, Chris (2015), 'Tiny murder scenes are the legacy of N.H. woman known as "The Mother of CSI"', *NHPR.org*, 11 July, accessible at http://nhpr.org/post/tiny-murder-scenes-are-legacy-nh-woman-known-mother-csi#stream/0

Jentzen, Jeffrey M. (2009), *Death Investigation in America: Coroners, Medical Examiners, and the Pursuit of Medical Certainty*, Cambridge MA: Harvard University Press.

Judkis, Maura (2017), 'At a new Renwick show, dollhouses become scenes out of "CSI", modeling real-life murders', *The Washington Post*, 26 October, accessible at www.washingtonpost.com/goingoutguide/museums/at-the-renwick-its-homicide-sweet-homicide-as-exquisite-dollhouses-become-detective-tools/2017/10/25/b471d60c-b350-11e7-a908-a3470754bbb9_story.html?utm_term=.fb3a2e0beed8

Kahn, Eve (2004), 'Murder downsized', *The New York Times* [Home & Garden], 7 October, accessible at www.nytimes.com/2004/10/07/garden/murder-downsized.html

Kee, Joan and Emanuele Lugli (2015), 'Scale and size: An introduction', *Art History* 38(2), 250–66.

Keily, Jackie and Julia Hoffbrand (2015), *The Crime Museum Uncovered: Inside Scotland Yard's Special Collection*, London: I.B. Tauris & Museum of London.

Lee, Frances Glessner (1951), 'Legal medicine at Harvard University', *Journal of Criminal Law, Criminology and Police Science* 42, 674–78.

Lussier, Alexis (2013), 'Malaise dans la demeure' ['A residue of uneasiness'], *Ciel Variable* 93 (Special issue: Forensique [Forensics]), 29–34.

Maxwell, Douglas F. (2006), 'Oh you beautiful doll', *NY Arts Magazine*, 1 July, accessible at www.nyartsmagazine.com/oh-you-beautiful-doll-douglas-f-maxwell/

Meier, Allison (2017), 'The Smithsonian conserves blood pools and charred Skeletons from 1940s crime dioramas', *Hyperallergic*, 5 October, accessible at https://hyperallergic.com/396833/nutshell-studies-of-death-smithsonian-frances-glessner-lee/

Miller, Laura J. (2005), 'Denatured domesticity: An account of femininity and physiognomy in the interiors of Frances Glessner Lee', in Hilde Heynen and Gülsüm Baydar, eds, *Negotiating Domesticity: Spatial Productions of Gender in Modern Architecture*, London: Routledge, 196–212.

Monahan, Jenny (2017), 'Rocks Estate relic headed to Smithsonian for exhibit', *Littleton Courier*, 19 April, accessible at www.newhampshirelakesandmountains.com/Articles-Littleton-Courier-c-2017-04-19-163283.113119-Rocks-Estate-relic-headed-to-Smithsonian-for-exhibit.html

Montgomery, David (2017), 'These miniature murder scenes have shown detectives how to study homicides for 70 years', *The Washington Post*, 14 September, accessible at www.washingtonpost.com/lifestyle/magazine/these-miniature-murder-scenes-have-shown-detectives-how-to-study-homicides-for-70-years/2017/09/13/6037b9c4-812a-11e7-902a-2a9f2d808496_story.html?tid=a_inl&utm_term=.515e99107dc8

Morrissey, Judd (2014), 'Operations in mixed reality', *International Journal of Performance Arts and Digital Media* 10(2), 205–15.

Of Dolls and Murder (2012), documentary motion picture, I See Dead Dolls LLC; produced by John Kurtis Dehn and Susan Marks; written and directed by Susan Marks.

Ramsland, Katherine (2008), 'The truth in a nutshell', *Forensic Examiner* 17(2), 16–20.

Schuessler, Jennifer (2004), 'Murder in the dollhouse: How an heiress's meticulous crime-scene miniatures helped bring better medical science into detective work', *Boston Globe*, 24 October, E2.

Solly, Meilan (2017), 'Home is where the corpse is – at least in these dollhouse crime scenes', *Smithsonian Magazine*, 16 October, accessible at www.smithsonianmag.com/smithsonian-institution/home-where-corpse-frances-glessner-lees-miniature-dollhouse-crime-scenes-180965204/

Stamp, Jimmy (2012), 'The pink bathroom: Virtual and physical reconstructions of a crime scene', *Life Without Buildings*, posted 5 March, accessible at http://lifewithoutbuildings.net/2012/03/virtual-crime-scene.html

Storace, Patricia (2016), 'The shock of the little', *The New York Review of Books*, 14 July, accessible at www.nybooks.com/articles/2016/07/14/dollhouse-shock-of-the-little/

Wenger, Yvonee (2017), 'Dollhouse death scenes are being refurbished for Smithsonian exhibit', *The Washington Post*, 26 August, accessible at www.washingtonpost.com/local/dollhouse-death-scenes-are-being-refurbished-for-smithsonian-exhibit/2017/08/26/d7d6cec4-89be-11e7-961d-2f373b3977ee_story.html?utm_term=.ed3c967ec833

The Wire (2007), internet broadcast, HBO on Demand December 2007, prequel episode: 'McNulty's first day on the job', HBO; produced by David Simon. See www.buddytv.com/articles/the-wire/hbo-releases-three-prequel-vid-14452.aspx. See also 'When Bunk met McNulty – 2000', accessible at www.youtube.com/watch?v=38U15ytW24o

Zhang, Sarah (2017), 'How a Gilded Age heiress became the "Mother of Forensic Science"', *The Atlantic*, 14 October, accessible at www.theatlantic.com/science/archive/2017/10/nutshells-frances-glessner-lee/542757/

3 The afterlife of criminal evidence in the news media

In June 2008, in the outer suburbs of Brisbane, twin toddlers starved to death as a result of parental neglect. During their parents' trial, evidentiary photographs of the crime scene were published by news agencies (Baskin 2013). Taken by police investigators, they depicted a squalid home infested with insects and strewn with unwashed and mouldy laundry.

Should we share the most wretched moments in the lives of strangers? Can we poke through their personal effects, however vicariously? If these people had secrets, does their encounter with criminal proceedings deprive them of the right to keep those secrets? These are moral rather than legal questions, but contemporary practices of open justice force us to ask them – and sometimes, given the speed of digital media, they are graphically answered before we have had opportunity to reflect: *Should I look at this? Should I have seen that?*

The above example, and countless others like it, represents a new genre of visibility. Whereas once open justice meant members of the public or the media made the effort to attend court, media agencies have begun demanding access to exhibits and other evidentiary materials without the expectation of attending, or even reporting, proceedings (see e.g. Australian Law Reform Commission 2015). Responding to media pressure, courts have appointed 'media liaison officers' or 'court information officers', who serve as a conduit between the courtroom and the press. Often – and more so in a contracting commercial media environment – these are themselves former media professionals, their understanding of open justice characterised by a presumption of disclosure. Gone is the expectation that journalists will take the trouble to research the evidence before the court, and situate it within the context of the criminal charges, or the prosecution case. Gone, also, is the distinction between pre-trial proceedings and the trial itself; exhibits might appear in the media before a defendant has had the opportunity to examine the evidence against them, and before they have entered a plea. Evidence might be released to the media that could be inadmissible, privileged, confidential, private, humiliating, sensitive, irrelevant or unfair. And while media agencies couch their demands for these evidentiary materials in terms of open justice, in truth these are no more than valuable commodities, driving traffic to their websites.

The principles of open justice demand that law's work be conducted in public. Open justice is 'one of the most pervasive axioms of the administration of justice' (Spigelman 2006) and 'the best means of winning . . . public confidence and respect' for the law (*Rinehart v Welker* at [32]). It takes seriously Jeremy Bentham's aphorism that 'publicity is the very soul of justice' (cited by Shaw LJ in *Scott v Scott* at 477). To be accountable, the law must be transparent; law must be seen to be done. Admittedly, eighteenth-century proponents of transparency, such as Kant, Rousseau and Bentham, imagined open government and open justice very differently from the contemporary 'transparency movement' – groups such as Transparency International, OpenSecrets.org or Wikileaks. As the actions in recent years of Chelsea Manning, Edward Snowden and Julian Assange have shown, transparency may also be deployed more radically, in the exposure of official data by those who hope it may transform or destroy the authority of state institutions.

In Australia, as an Anglophone common law jurisdiction, open justice is understood as a collection of principles and rules drawn from common law and statutory sources, as well as an emerging constitutional jurisprudence. As legal scholar Emma Cunliffe writes, 'Australian case law has not yet coalesced around a coherent theory of the substance of open justice principles' (Cunliffe 2012, 405). Most of the Australian discourse of open justice, and that internationally, is conducted by media lawyers – since what occurs in the courts generates profitable fodder for media organisations.

The New South Wales Court of Appeal has said that 'the administration of justice must take place in open court' (*Fairfax v Police Tribunal of NSW*, per McHugh JA at 476)[1] and especially so in criminal proceedings (*R v Tait* at 487; *Raybos v Jones* at 58; see also Judicial Commission of NSW 2017). Unsurprisingly, most media attention is directed towards criminal cases, and consequently there is not a significant body of jurisprudence relating to open justice in civil cases. In contrast to its position on criminal matters, the Court of Appeal has held that, in civil cases, media applications for access require open justice to be balanced against the interests of the parties, and weighed against 'prematurity, in the sense that the evidence had not been tested', the danger of 'trial by media', the need to weigh legitimate public interests against 'the urges of prurience', 'surprise or ambush', commercial confidences, and the potential abuse of fair reporting privileges arising from defamation laws (*ASIC v Rich*, per Austin J; see also Judicial Commission of NSW 2013, *Defamation Act 2005* (NSW) s27).

In an open justice regime, to bring disputes before the law is to surrender to publicity that which might not otherwise have been disclosed. Law already has the capacity to protect some information on the grounds that it may be private, sensitive, privileged, confidential or secret. One aim of this chapter is to propose a 'jurisprudence of sensitivity' as a response to the dangers of over-disclosure, in an attempt to keep some criminal secrets, sometimes, hidden from view. Public spaces, including courtrooms, are frequently the scene of acts and disclosures that might

be personal, humiliating, intimate or secret, or simply not intended for an audience that includes strangers, or a broad public. A jurisprudence of sensitivity enables the law to assume responsibility for these secrets. Criminal lawyers recognise that criminal conduct is usually characterised by its clandestine nature. These hidden acts, once they form the basis for criminal charges, are resolved in public, in the courtroom; they become open secrets. However, criminal lawyers also recognise that, in revealing criminal secrets, additional harm might be done – to defendants and others – and a jurisprudence of sensitivity aims to address this.

Digital technologies have driven a kind of new visibility, the ability to see secrets on an ever-larger and more immediate level, and this new visibility demands a sensitive response. Given the nature and quantity of this imagery, we must now ask ourselves: *Should I see this?* A jurisprudence of sensitivity can provide a conceptual framework for thinking through difficult questions where hurt, harm, indignity or danger might result from the unfettered operation of open justice. Sensitivity might provide robust justifications for why, in some circumstances, criminal facts and criminal evidence ought *not* to be released to the public. The category 'sensitive' already exists in law to capture a range of reasons information might not, in certain contexts, be released. These can include privacy, personal information, health records, protected confidences, trade secrets, disclosures against the public interest or matters of national security. 'Sensitive information' is distinct from 'personal information'. For example, under the Australian Privacy Principles, 'sensitive information' is personal information that is *also* information or an opinion about an individual's racial or ethnic origin; political opinions; membership of a political association; religious beliefs or affiliations; philosophical beliefs; membership of a professional or trade association; membership of a trade union; sexual orientation of practices; criminal record; or health information; genetic information; or biometric information or biometric templates.[2]

There are other examples of legal instruments defining 'sensitive' in order to manage or protect information (see e.g. Australian Government 2011), as well as many that use the term 'sensitive' without defining it (for example, the *Health Records and Information Privacy Act 2002* (NSW), Guideline 4.4(d)), and while none captures the kinds of harm that criminal disclosures might effect, they offer a promising starting point. None recognises 'sensitivity' in any way that demands a sensory response. Listing what is 'sensitive' is an intellectual undertaking, whereas recognising what is 'sensitive' demands *feeling something*. A jurisprudence of sensitivity must recognise sensibilities, emotions and harm. It must acknowledge the special susceptibility of some individuals, especially those whose context or experience makes them vulnerable. It recognises that certain materials require delicacy or tact. A jurisprudence of sensitivity would help us respond to criminal evidence, and the context in which it is collected, displayed and received, in a manner that combines openness *and* secrecy, exposure *and* sanctuary, disclosure *and* tact.

Law has developed a range of terms and principles that might guard intimate facts or personal secrets against disclosure, and these principles emerge from the recognition that sometimes disclosure is harmful, and that sometimes knowledge is distributed according to a hierarchy of interests, where one party's interest

in disclosure is measured against another's interest in non-disclosure. But often there is another competing legal principle that is satisfied through the disclosure: the disclosure might be evidentiary, it might be lawful, it might be in the public interest, or it might promote the objects of open justice.

Literary critic D.A. Miller invoked the term 'open secret' to capture the tension between knowledge and discretion (in Kosofsky Sedgwick 1993, 45–46). The open secret seems to encapsulate some of the attributes of 'sensitivity', in trying to articulate a space for guarding or respecting secrets within a regime of transparency and accountability. Anthropologist Michael Taussig used the term 'public secret' to describe the double power of the secret: first, that it *is* a secret and will not be disclosed, and second, that its existence is *publicly* acknowledged *as* a secret (Taussig 1999). In many respects, the practice of open justice in the digital age represents precisely this phenomenon: the criminal case file is a public zone of secrecy. The concurrence of these contradictory concepts – public, secret – compounds our viewing pleasure; we have seen something that was not supposed to be seen, that was not intended for our eyes.

Legal scholar Mark Fenster remarks that secrecy harbours this paradox: if secrecy represents the boundary between those who are permitted to know and those who are not, then the secret must be communicated by those inside the boundary in order for the secret to be identified, and also for the boundary to be perceived (Fenster 2014).[3] For Jacques Derrida, secrecy is not something that is concealed by a single individual, but a shared cultural, religious and – significantly – now a technological phenomenon. Democracy, for Derrida, is damaging to notions of privacy and secrecy; he held that, 'if a right to the secret is not maintained, we are in a totalitarian space' (Derrida 2001; see also Masco 2010). In his book *A Taste for the Secret*, Derrida argued that transparency – 'the demand that everything be paraded in the public square and that there be no internal forum' – exposes the 'totalitarianisation of democracy' (Derrida 2001, 59).

This fear of a 'totalitarian public' can be taken too far; as Jeremy Gilbert wrote, 'no-one has a taste for the secret like Monsanto or Microsoft, so perhaps it isn't a taste we should be too relaxed about cultivating' (Gilbert 2007, 36). Instead, Gilbert noted that postmodern political discourse has been transformed by secrets; we have lost our traditional and open public sphere, and with it a robust sense of what is 'private' or separate from it. Instead, 'we now find ourselves inhabiting a culture constituted by moments of (often sensational) disclosure', with these disclosures often 'discursively constitut[ed] *as secrets*' (Gilbert 2007, 37 & 24).[4] For Gilbert, we are faced with a new challenge: not only do we now need to recognise these 'gestures of disclosure' as an inherent feature of modern public life; we also need to find ways of distinguishing 'mere telling of secrets' from 'real acts of . . . publicity'. We need to retain '*respect* for the secret' without becoming '*addicted* to it' (Gilbert 2007, 38 & 40; see also Derrida 1987/1996).

In administering open justice, managing disclosures is now a matter of policy. Policing agencies and the courts have media policies that drive telegenic materials out of the brief of evidence and into the public arena. The change has occurred relatively recently. A lawyer explained to me,

many years ago now, judges would hardly ever allow the media to have access to the exhibits, including the photographs. They'd basically say, 'You go and ask the police', and the police would say, 'You go and ask the prosecutor', and the prosecutor would say, 'You go and ask the judge', and the judge would say, 'Well I'm not going to make anything available'.

Now, the law has performed a complete volte-face; such materials are routinely delivered to the media, and only very limited circumstances justify a suppression or non-publication order. Even in 'closed' proceedings, where the evidence relates to sexual offences, children, terrorism, national security or protected witnesses, the guidelines for judges start from the presumption that the media ought to be present, although they do not permit the release of exhibits without proper scrutiny (see e.g. Judicial Commission of NSW 2017, at [1-349]–[1-359]).

Increasingly, evidence is released to the media before the matter is even before the courts. Police agencies have recognised the role of the media in bringing attention to their work, including during live investigations, and have begun to frame a 'positive and proactive' approach to dealing with the media (NSW Police Force 2016). The New South Wales Police Force, for example, has a Police Media Unit that is staffed 24 hours a day, seven days a week, serving both police and media professionals. As well as facilitating a productive relationship between these sectors, the unit also produces and distributes polished media packages, in which exhibits, crime-scene footage, interviews with bystanders and police statements are prepared for the various media platforms: television, print, radio and online, including police digital media platforms on Facebook, Twitter and YouTube (Lee and McGovern 2013). The Police Media Policy distinguishes the various stages of a police matter, and the different types of information that can be released at each stage – for example, during an investigation but before an arrest has been made, or after proceedings have commenced but before they have concluded. Certain kinds of information cannot be released, or can be released only with proper authorisation. The policy describes the release of images and video recordings as a 'powerful investigative tool' (NSW Police Force 2016, 20).

Once criminal proceedings have commenced, the assumption is that material – including exhibits – produced or preserved by police becomes the subject of judicial policy or decision-making. Again, a marked cultural shift has occurred, with the police record of interview with the accused, recorded on digital video, a commonplace feature in criminal case media reporting. All exhibits are now routinely made available to the media unless the parties and the court have agreed – together – to a non-publication order. Media agencies can appeal these decisions to a superior court; when they do, it provides a rare opportunity to scrutinise the jurisprudence of this new form of open justice. Typically, however, there is no opportunity to review the decision-making in this area because it is primarily undertaken by court media units. During a long trial, for example, material that was tendered in open court will be given to the court's media liaison officer on a daily basis. Once checked by the parties, it can be released to the media. Typically, the only justifications for withholding evidence from the

media are that the material is gruesome, or would encourage the commission of a crime, or reveal details of police operations. Advocates and judges have explained that they really only apply instinctive responses to these arguments, and rarely consider jurisprudential or other principled grounds.

Most of the material sought by media outlets purports to narrate the crime through persuasive visual means. Whether video footage of an arrest or a police interview, or evidentiary images from a criminal investigation, these materials are captured in legal scholar Jessica Silbey's term *'evidence verité'*; for Silbey this is evidence that purports to prove 'what happened' in a manner that tends to 'overwhelm' other evidence, and which seems to be 'immune to critical analysis' (Silbey 2010, 1257). Silbey demonstrates the constructedness of all *evidence verité*, and the skilfulness with which its techniques of staging, deployment and interpretation hide in plain sight. The power of *evidence verité* is associated with the visual medium, and its capacity for 'moving an audience to render judgment they can believe in' (Silbey 2010, 1290). Photographs and video imagery provide more than 'mere evidence of some fact'; they are also reliant upon the iconic status of photographic images in our culture, and the 'iconisation' of photography in law. The 'iconicity' of a photograph occurs not at the moment of its taking, but in the recurrent processes of capture, use, display and distribution (Silbey 2010, 1260–61). It is not that a single distributed image will acquire evidentiary force or persuasive power, but rather that photography *itself* has accrued status as a truth-making technology – and we participate unreflexively in this process, despite the long and well-known history of photographs that have caused us to misunderstand – or inadequately apprehend – what really happened (see e.g. Sontag 1971; Berger 1980; Barthes 1981; Tagg 1988; Biber 2007).

The widespread circulation of evidentiary imagery has the dual effect of satisfaction and surprise. In one respect, seeing the evidence for ourselves satisfies our expectation that our image-making regime has fulfilled its commitment to visibility. In another, the novelty of each representation – whether for its unusual attributes, or its unexpected banality – inspires our curiosity. Watching real police interviews with murderers, on television or online – often on the same day they were screened in a courtroom – is an unsettling experience. These are not criminal masterminds or telegenic sociopaths, and these detectives are not engaged in untangling a complex mystery. These are sad and ugly films in which ordinary people tell wretched lies or offer inexplicable denials about dreadful criminal acts. That these videos are staged performances is both noted and overlooked. The attributes of *evidence verité* allow us to ignore the fact that these are carefully-crafted productions, and to focus instead on their unexpected qualities, the little departures from mundanity that prompt us to believe that these images are 'real'.

In April 2012, Allison Baden-Clay was reported missing by her husband, Gerard Baden-Clay, in Brisbane. Eleven days later, her body was found under a bridge

on the banks of the Kholo Creek. The case captured the attention of the public, with exhaustive media coverage of the investigation and subsequent criminal proceedings against 'GBC'. The Baden-Clays were a seemingly solid middle-class suburban family who, upon closer examination, were experiencing crushing stresses. Gerard was having an extra-marital affair with a former colleague and had promised her he would end his marriage. He was in also serious financial difficulty, and his most valuable asset was his wife's life insurance. Allison, who had become aware of her husband's affair, was seeking counselling to help her manage her feelings and responses. She kept a diary, which one journalist described as a 'book of goals' (Calligeros 2014a).

In June 2012, Gerard Baden-Clay was charged with Allison's murder and, following a jury trial in 2014, was found guilty. He was given a life sentence. Following an appeal, his murder conviction was downgraded to manslaughter, but the murder conviction was reinstated upon appeal to the High Court of Australia.[5]

Significantly for an examination of the 'afterlife' of criminal evidence, materials that would eventually become key exhibits at the trial had already been given a vivid media life following Baden-Clay's bail applications, and again following his committal to stand trial.[6] A significant number of photographs, as well as pages from Allison's diary, were published in the media before the trial had commenced. In the digital age, and with a 24-hour media cycle, the afterlife of evidence proceeds with alacrity; it is only moments after the material acquires its status as 'evidence' that it enters the public sphere. The evidentiary process need not have concluded before this afterlife begins.

Parts of Allison Baden-Clay's diary were released to the media by the Supreme Court of Queensland following Gerard's second failed bail application. During the bail hearing, portions of Allison's diary were read to the court (Kyriacou 2014). These revealed questions she had prepared, upon her counsellor's advice, to put to Gerard about his affair, and recounted her feelings about their relationship, and her broader regrets about her life and marriage. These personal notations were advanced, by the Crown, as evidence supporting the pressure on Gerard Baden-Clay's defence counsel, Peter Davis, read other portions of the diary to the court, in advancing the theory that Allison's death was a suicide (Baskin 2012).

Brisbane's tabloid newspaper, *The Courier-Mail*, which covered the trial exhaustively and with a prurient fascination with the Baden-Clays' marriage, reproduced photocopied pages from the diary. In the hands of reporter Kate Kyriacou, the diary became 'the last lonely words of a woman trying desperately to hold onto a broken marriage', a 'heartbreaking diary', and Allison's 'haunting words' were subjected to public scrutiny, in which her doubts, anguish and humiliation were reproduced for a media audience (Kyriacou 2012). This media representation, like many others, was not concerned with contextualising the diary as an exhibit, nor with evidentiary interpretations. Instead, it was presented as a rare insight into the private disclosures and thoughts of a stranger whose death had rendered her secrets matters of public interest.

Media audiences needed to wait longer – but not much longer – to see the photographs police had taken of Gerard Baden-Clay following the discovery of Allison's body. These showed his face badly scratched by what could have been her fingernails, but which he said were shaving cuts. Unlike some jurisdictions, where practitioners report little scrutiny is given to media requests for exhibits, the Magistrates Court did give close attention to the media's demand for the photographic evidence (*Police v Gerard Baden-Clay*).

Six media organisations had applied for access to photographic exhibits tendered at the committal proceedings, as well as additional photographic and video evidence (including materials that turned out not to exist). In effect, they were making a broad ambit claim for anything of a visual nature that could find an audience across the press, television and online media spectrum. Counsel for Baden-Clay opposed the application and the Crown Prosecutor declined to be heard. The parties canvassed the requirements of open justice, which the magistrate regarded as principle and not a right (*Police v Gerard Baden-Clay*, per Butler SC at [19]). He held that a positive right to access court documents could only be created by statute and, in this instance, none was identified. Having said that, any decision to exclude the public from the courtroom, or the media from reporting on proceedings – including the publication of exhibits – needed to be limited to circumstances where it would promote the proper administration of justice (*Police v Gerard Baden-Clay*, per Butler SC at [20]–[22]).[7] For Judge Butler SC, presiding, there needed to be a balance between the public interest in scrutinising the proceedings and the defendant's right to a fair trial. To that end, of the more than 200 exhibits to which the media sought access, only those that had been the subject of oral examination, including cross-examination, were made available to the media, on the grounds that to publish any of the remaining photographs 'would be likely to give a distorted view of the case' (*Police v Gerard Baden-Clay*, per Butler SC at [36] and [41]).

It was more than a year before Baden-Clay's murder trial commenced that these materials – Allison's diary and the photographs – formally acquired their evidentiary status as proof of the charges against Gerard. Journalists were live tweeting during the trial, and reported that Crown prosecutor Todd Fuller QC had shown 'graphic' crime scene images of Allison's body underneath the Kholo Creek Bridge, and additional 'confronting' images (SBS News 2014). Journalists reported that several of Allison's family and friends left the public gallery when these images were shown. The *Brisbane Times* website included these photographs, credited as court exhibits – among them crime scene images and photographs of Gerard's facial cuts, the interior of the Baden-Clay home and Gerard's car interior. The boot of the car had been sprayed with luminol, a chemical used by forensic examiners to highlight the presence of blood. This showed a glowing area in the boot of the car, and this was shown to the court, and released to the media.

Allison's journal was introduced by the Crown prosecutor in his opening address (Calligeros 2014b). The jury was shown images of the journal, and it was referred to throughout the Crown's case. On Day 10 of the trial, pages

from the journal were presented to the court to accompany the testimony of the detective who had arrested Baden-Clay. The prosecutor displayed the pages of the journal using an overhead projector while the detective read aloud from it (Kyriacou 2014).

The evidentiary use of the diary – and its wider publication – fits into a long history of courts engaging in strange violations of a confidence. In consigning her secret fears and insecurities to a journal, Allison Baden-Clay had not intended for them to find a mass readership in the tabloid press. The same violation was suffered by Kathleen Folbigg in 2003; accused of the murder of all four of her children, Folbigg's private diary was similarly subjected to public evidentiary wrangling (*The Sydney Morning Herald* 2003; see Cunliffe 2011). Lacking narrative form and deprived of the context or purpose for which they were written, these personal records have questionable evidentiary value. Meanwhile, their publication perpetrates an intrusion into this secret sphere, and this alone renders these diaries fascinating to their public readers. Knowing that we are reading something intended to be a secret, and knowing that these diaries might provide an insight into the private life of a tragic figure, these documents are transgressively compelling.

———————

On 22 September 2012, Jill Meagher was raped and murdered in a Melbourne laneway as she walked home. In the days following her disappearance, during the police investigation and the discovery of her grave, 30,000 mourners marched in Melbourne, demanding respect and safety for women in public places. On 5 April 2013, Adrian Bayley pleaded guilty to Meagher's murder and three sexual assault offences against her. He is now serving a life sentence in prison.

Between those two dates, on 12 March 2013, Bayley's committal proceedings commenced in the Melbourne Magistrates' Court. Before the proceedings formally began, a group of media agencies made an application seeking access to a wide range of documents, including photographs, contained in the police brief of evidence.

In announcing that there was a media application before the court, Deputy Chief Magistrate Felicity Broughton acknowledged that the principles of open justice would guide her decision, but she also articulated a sensitivity to some of the visual evidence:

> So I raise [the media application] now as an issue that will need to be considered. In the appropriate and dignified manner in which these proceedings need to take place, be very mindful of having some fruitful discussions as to how [the media application] might be managed in accordance with the principles of open justice, but having regard to what I already anticipate are some extremely distressing and sensitive materials which certainly, on the face of it, without having made any final decision in relation to that, certainly give me some concern (*Victoria Police v Adrian Bayley*).[8]

As the proceedings unfolded, she interrupted the media lawyer to correct him about the degree of sensitivity involved.

Mr Cashen: I understand that there has also been an indication from Your Honour that there is some sensitive material—

Her Honour: *Extremely* sensitive material.

Mr Cashen: I should say from the outset my client certainly doesn't seek any of that sensitive material. We are obviously in the invidious position of not knowing what's in the brief [of evidence]. It is often the case that there is some material that's sensitive—

Her Honour: . . . *Very* sensitive and *very* distressing.

In discussions with the parties, Her Honour identified two primary concerns that arose from the images. One issue arose from the fact that Meagher was sexually assaulted, as there are legal protections for sexual assault victims to prevent undue distress and embarrassment. Broughton DCM gave consideration to whether Meagher was entitled to these protections even after her death. Later in the proceedings, Broughton DCM raised the issue that gave rise to the greatest sensitivities, the scene of the grave. This referred to images of Meagher's partially naked body buried in a shallow grave. Her Honour recognised the sensory concept of sensitivity, although she did not attempt to provide any legal framework for her feelings. It was clear that she *felt* there was something wrong with showing these images, and that everyone in the courtroom felt it too. This could be an illustrative moment showing how a jurisprudence of sensitivity might start, but more is needed to ensure that while everyone in the courtroom may be *feeling something*, the wheels of justice are actually turning.

In the Melbourne courtroom, the term 'sensitive' operated flexibly. Sometimes it referred to the dignity of Jill Meagher; at other times it was used when protecting her family from distress. At times, it appeared to protect the sensibilities of strangers – casual consumers of the news media. And, on at least one occasion, it referred to the accused, Adrian Bayley, and the concern that the release of this material could cause unfair prejudice to him at a future trial, given that the media application was made and resolved before he had been committed to stand trial.

Significant, and worthy of further study, is the issue of sensitive jurisprudence as a form of labour; it demands effort, time and care in a courtroom that is already busy and under pressure. In Bayley's committal, the labour of sensitivity was apparent, although the court lacked a language for valuing it as a jurisprudential technique. Counsel for the media agencies acknowledged the effort that would be required to sort the distressing/sensitive/excluded materials from those that could be released. Broughton DCM replied: 'Well, we all agree that the principles of open justice are paramount. So I don't think we need to go any further in terms of the effort that needs to be made' (*Victoria Police v Adrian Bayley*). Here, the court was making clear that open justice, moderated with sensitivity, was worth the effort. Meanwhile, Bayley's counsel, Helen Spowart, wanted to go through the hand-up brief and the tendered witness statements to ensure any inadmissible

or controversial material was not released to the media. Her Honour had asked for 'considered submissions' and Spowart, who had not had advance notice of the media application, offered to have written submissions to the court at 9.30 the following morning. Her Honour responded that she wanted to release some materials that day; while the defence counsel wanted to work carefully, the court wanted to work quickly. Her Honour offered the parties a short adjournment to allow them to identify the materials that would not be released, and to provide some legal justification for the non-disclosure. When they returned, the order was made.

The next morning, as a result of the media application, visitors to the *Herald Sun*, *The Age* and the Australian Broadcasting Commission (ABC) websites could take a look inside Jill Meagher's handbag. While Broughton DCM was naturally concerned about more intrusive disclosures, it is not clear how opening Meagher's handbag was an act of open justice (see Biber 2014). Looking inside a woman's handbag is a recognised transgression of a boundary (see e.g. Hagerty 2002, 10); that her violent rape and murder might erase the boundary and result in a right to rummage through her bag seems to pervert the objects of open justice. Significantly, media reproductions of the handbag photographs did not include reports of earlier allegations that the handbag had been moved, tampered with or 'staged' for the photographer (e.g. *The Australian* 2012; Dowsley and Flower 2012). If open justice is advanced on the grounds of fair and accurate reporting, the public release of these photographs did not fulfil that aspiration.

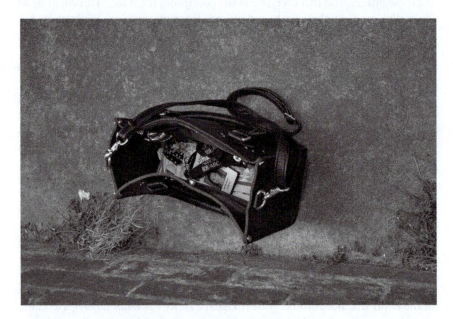

Figure 3.1 Photograph of Jill Meagher's handbag from police brief of evidence, released to media agencies following a decision of the Melbourne Magistrates' Court. Reproduced with permission from Victoria Police.

For Kate Rossmanith, an academic and non-fiction writer about court processes, the publication of images in this genre represents an 'immediate democratisation' of courtroom events, and she cites other writers in the genre – including Dominick Dunne, Janet Malcolm and Helen Garner – whose work relies upon this kind of access (Biber, Doyle and Rossmanith 2013, 807). For these writers, the courtroom is a source, and their work aims to overcome what a former Chief Justice of NSW termed the 'practical obscurity' of legal proceedings (Biber, Doyle and Rossmanith 2013, 809). Rossmanith noted that the online publication of evidentiary exhibits introduces an entirely new category of 'layperson' who is transparency's beneficiary. This person – the online media consumer – has expended no effort to approach the court, or to comprehend the law. They are simply voyeurs; taking the term from Garner, she says they are 'perving' (Garner 2004).

Perving or not, viewers of these materials are looking for something to help them apprehend their world and the dreadful things some people do to others. A slideshow of images from the investigation appeared on multiple online media sites, showing a series of evidence photographs taken inside Bayley's home and car: his tidy bedroom with the bed made, a pile of clothing on the bed beside parts of a mobile phone, his bedside table with several coins and keys, buckets in his laundry, a laundry basket with a damaged SIM-card in it, a pile of materials on the floor of his living room. True crime narratives, including those that appear in media discourse, rely upon continuities and ruptures. Looking at the photographs from the Jill Meagher investigation, Peter Doyle, the curator of police photography, described them as 'remarkably congruent with the genre of crime scene photography, going back half a century or more in Australia' (Biber, Doyle and Rossmanith 2013, 807). For Doyle, the importance of these images is not only that they are of crime scenes, but that they appear in a sequence. A sequence of police photographs, even if it does not reflect an accurate chronology of events, is a quest for narrative, making stories from criminal fragments. Authenticity, for Doyle, is what makes these evidentiary images so vibrant. Police photographs convey a 'parachuted-into-the-scene kind of view', representing a 'very rare sort of visual capture'. Rarity is what makes evidentiary materials so compelling for law's outsiders, but it is also indicative of their fragility. As Doyle has said, 'Authenticity is just a quagmire, isn't it?' (Biber, Doyle and Rossmanith 2013, 807).

There is jurisprudential uncertainty about whether media access of this kind is required by the principles of open justice. Whereas Lord Halsbury LC said in 1889 that 'such publication is merely enlarging the area of the court' (*McDougall v Knight*, at 200), more recently Mahoney JA stated that

> the principle that the courts are to be open and that the media may publish what is done in them is not an end in itself. The principle is adopted because it is judged to be the means by which other and more fundamental goods will be achieved.
>
> (*Fairfax v Local Court of NSW*, at 164)

While the release of the photographs from Adrian Bayley's committal proceedings probably did not promote the objectives of open justice, it is also not clear where a line might be drawn. The judge was certain that 'sensitive' and 'distressing' images should not be released. As insensitive as it seems to ask the question: *Why* can't we see photographs of Jill Meagher's dead, naked body in a shallow grave?

In November 2013, media reports revealed that a Victoria Police detective *had* shown one such photograph to a civilian audience during a fundraising presentation, and there was a brief performance of public outrage about this – 'shock', 'sadness', 'sickening', 'error of judgment' (see e.g. Bucci 2013). The detective said he had shown the image with the support of Meagher's parents, and that it was 'never, even intended to demean the victim', and that the image was visible to the audience for 'one second' (Silva 2013). Given the prurient nature of so many of these evidentiary disclosures and the courts' willingness to surrender such intimate secrets in the purported pursuit of open justice, is it even feasible to reclaim sensitivity or dignity or restraint?

We can watch video footage taken from a traffic camera showing a man being killed by a drunk driver (Roberts 2013). We can watch images captured by a Taser camera which shows a man being Tasered to death by police (Davies 2012). We can watch a video of a police officer executing a handcuffed man (Lennard 2014). Two young men, affected by drugs and driving dangerously, filmed themselves on a mobile phone camera, with the footage capturing their deaths when the car hit a wall; following the inquest, the footage was released on a police YouTube channel (BBC News 2015). Police released audio recordings of two 911 calls made before and during a deadly gun rampage in Colorado (Vicens 2015). Almost six years after Michael Jackson's death, Los Angeles police released photographs of the scene, all of which had been part of the police investigation, but not all of which were tendered into evidence at the manslaughter trial of his doctor, Conrad Murray (Nelson 2013). To mark the twentieth anniversary of Kurt Cobain's suicide, Seattle police released two previously unseen photographs from the scene (Associated Press 2015). Following 'intense public interest' in these photographs, they released an additional 35 photos that, in an evidentiary sense, were described as 'underwhelming' (Fisher 2014).

From these examples, and thousands like them, arise new questions, many of which challenge shifting boundaries and the new expectations they produce. Much of this evidentiary material is released by police, and while some of it is defended on the grounds that it draws public attention to policing, public safety and the administration of justice, much of it appears to do nothing more than feed voyeuristic media consumers. Whether evidentiary material can be consumed without due justification is difficult to answer, and raises the question: why not? The release of Kurt Cobain's suicide note, over the objections of his family, fuelled an entire industry of conspiracy theorists, some of whom also litigated to demand access to still more unreleased evidentiary materials (Edge 2015). While this was probably inevitable, there is no expectation that, in its afterlife, evidence be consumed responsibly.

With bountiful displays of evidence now available to us, questions about responsibility or reasonableness seem outdated and dilatory. In the contemporary mediascape, the afterlife of evidence might be imagined as a grand bazaar. In 2012, George Zimmerman shot and killed an unarmed black teenager named Trayvon Martin in Florida. Following a public outcry, he was charged with murder. He was acquitted despite considerable evidence that he was motivated by racial hatred, and was later banned from Twitter for racist and violent posts. In 2016, after the weapon he used to kill Martin was returned to Zimmerman by the Department of Justice, he listed it for sale on the online marketplace GunBroker.com, describing it as a 'collectible firearm' and 'your opportunity to own a piece of American history' with a starting price of US$5,000 (Hunt, Safi and Luscombe 2016). Public reaction to the auction generated multiple hoax bids, including a bid for $65 million from a buyer identified as 'Racist McShootface'; as a result, GunBroker.com cancelled the auction and the gun was instead listed at United Gun Group where it ultimately sold for $US250,000, a price said to 'far exceed market value' for the weapon (ABC News 2016).

Around the same time, media reports announced that items seized by police from notorious Boston crime figure James 'Whitey' Bulger would be sold at auction. Bulger, aged 81 at the time of his arrest, was implicated in 19 murders, racketeering, money laundering, extortion and firearms offences; he was convicted of 31 offences in 2013 and sentenced to two consecutive life sentences. His personal items were to be sold by the U.S. Marshals Service asset forfeiture division, with the proceeds 'to benefit Bulger's victims' (Smith 2016). To maximise sale prices, the Marshals were selling these items along with other 'murderabilia', but reports stated that federal laws prevented the government from selling any of Bulger's 30 guns, and officials were undecided about whether to sell his partly written memoir. According to U.S. Attorney Carmen Ortiz, 'We certainly don't want to glamorize or minimize the severity and the brutality of his crimes. On the other hand, we'd like to generate a certain amount of interest . . . and have a successful auction'. Steve Davis, the brother of a woman murdered by Bulger, explained his reaction to the auction: 'It sickens me to think, you know, the people and the hype on this . . . They should have just destroyed everything'. On the other hand, Patricia Donahue, whose husband was killed by Bulger, was disappointed that the most valuable items – the guns and the memoir – were not for sale, diminishing the proceeds that would be available to victims' families (Smith 2016; see also Jarvis 2007).

The family of Roberto Laudisio Curti, who died as a result of being Tasered by police, was involved in the coroner's decision to release the footage to mainstream news agencies (Davies 2012). Online viewers could watch him die in real time, in gritty greyscale vision, with flashes of bright light each time the Taser discharged. A haunting and unforgettable viewing experience, it raised the question of whether his family's demand for public witnesses to his death made watching this footage an ethical act. In the work of Mieke Bal, a 'true ethics of vision' is responsive to context, so that politically repressive visual representations – such as Taser footage of a man being killed by police – can be, in Bal's terms, 'redirected'

or 'overthrown' (Bal 2005, 156). Whether this desire of the Curti family – to redirect the gaze of the police Taser onto civil society – is achieved by the broadcast of the footage, remains difficult to determine; it is complicated by issues of commodification, voyeurism and spectacle that are entangled in media broadcasts of criminal evidence. For Bal, the 'commitment to look', the act of bearing witness, turns on the term 'commitment'. Commitment, Bal wrote, demands that we engage in 'the act of seeing-through', of sticking with something until it is concluded. It requires us to consider how visibility commits us *not to overlook* things that demand our attention (Bal 2005, 159–60; emphasis added).

This issue also arose during a coronial inquest in Western Australia following the death in police custody of an Aboriginal woman known, after her death, as Ms Dhu (see Klippmark and Crawley 2017). Ms Dhu had suffered an infection after her boyfriend threw her to the ground, breaking her ribs. The injuries did not heal properly, and the infection entered her bloodstream following her repeated drug injections. She was later taken into police custody for unpaid fines and, despite her complaints of pain, received inadequate medical care and died of staphylococcal septicaemia and pneumonia. Following the coronial inquest, Ms Dhu's family sought the public release of the CCTV footage of her final days and hours of life, but the coroner reserved her decision to release the footage. Ms Dhu's uncle, Shaun Harris, was reported to have said, 'It [the footage] needs to be seen to show the world what really happens and the institutional and systemic racism that still thrives Australia-wide' (Day 2016). A media account reported that the footage 'shows Ms Dhu being dragged from her cell unconscious by police on the morning of her death and carried into the back of a police vehicle, as well as crying and telling police she was in pain' (Perpitch 2016).

The coroner's findings were that Ms Dhu received 'unprofessional and inhumane' treatment by police and that her medical care 'fell below the standards that should ordinarily be expected of a public hospital' (State Coroner of Western Australia 2016). However, while four police officers had been sanctioned for their conduct at the time of her death, the coroner ultimately held no one accountable for Ms Dhu's death. In finalising the inquest, the coroner heard evidence from members of Ms Dhu's family about their desire for the CCTV footage to be publicly screened. She also heard evidence from counsel for multiple media organisations who also sought access to the footage. Counsel for Ms Dhu's father, Robert Dhu, who supported the release of the footage, said it was 'the most powerful and effective way to honour Ms Dhu's memory' and that there was 'no disrespect to Ms Dhu in releasing the CCTV footage in the public domain' (State Coroner of Western Australia 2016, 869–89). However, Mr Dhu sought the redaction of Ms Dhu's final day on the grounds that 'releasing this portion of the CCTV footage is a step across the line between the importance of Ms Dhu's legacy and disrespect' (State Coroner of Western Australia 2016, 871), and the coroner accepted this, ordering the release of the remainder of the footage.

These ethical entanglements were examined by the journalist Philip Gourevitch following the media release of a video in which a civilian, Walter L. Scott, was

murdered by a South Carolina policeman named Michael T. Slager. In an article titled 'Should you watch the video?', Gourevitch tested the range of justifications advanced for the release of the footage, and the individual decisions made about whether or not to watch it (Gourevitch 2015). On one hand, the video – which had been filmed by a civilian bystander on a mobile phone – made it undeniable that Scott's death was an act of homicide; the video resulted in Slager being charged, and ultimately pleading guilty (Blinder 2017). Gourevitch described the video as having done 'a great public service', and noted that Scott's family had 'expressed gratitude that the video exists'. He drew a contrast with the video made of the death of Eric Garner, killed the previous summer by New York City police officers, which was widely broadcast after a grand jury decided not to bring charges against the police. For Gourevitch, the footage of Garner's death was an 'illustration' of 'an incomprehensible failure to hold the police account-able for the utterly needless taking of a citizen's life'. By contrast, the decision to charge Slager for Scott's murder transformed that video into 'the official story' (Gourevitch 2015).

Recognising the speed with which the digital age has driven evidentiary mate-rials into the public sphere, Gourevitch wrote that posting videos is 'fairly new territory' for the American press, and has caused considerable journalistic and edi-torial self-reflection and self-justification about releasing or not-releasing footage of people being killed by police (see e.g. Gladstone and Garfield 2012).

Although these videos are 'new territory' for the mainstream media, Gourevitch anticipated 'uncharted territory', and asked whether – if such foot-age existed – these media agencies would so readily post videos of police being killed, or children, or of judicial executions. He also asked whether it would make a difference if, for example, the condemned prisoner supported the release of such footage as their 'dying wish'. In the absence of clear moral standards, Gourevitch reasoned that in the digital age we are 'our own editors' and that, while he would never call for censorship, he would support 'consistent, respectful restraint' (Gourevitch 2015).

Historian Jill Lepore took a longer view of the democratisation of photogra-phy. Reflecting on the nineteenth century's legacy to race and photography in America, Lepore was reminded of the influence of Frederick Douglass, a liber-ated slave who used the camera as one tool in his quest to humanise black people through photography (see Apel and Smith 2007; Stauffer, Trodd and Bernier 2015; Wallace and Smith 2012). Douglass's vision of technology, and the global exchange of images, would 'dissolve the granite barriers of arbitrary power, bring the world into peace and unity, and at last crown the world with justice, liberty, and brotherly kindness' (Lepore 2016). Lepore was prompted to recall Douglass's utopianism when presented with yet another opportunity to watch citizen footage capturing police violence against a black man. She had decided not to watch any more videos in this genre because, in her words, 'watching had, oh, three or four murders ago, begun to feel like a kind of complicity'. It was while reading reports about a sniper in Dallas who in 2016 had shot twelve police officers, killing five of them, that Lepore – 'sitting at the breakfast table, crying,

like so many people' – came to a different position: 'I thought: maybe watching people shoot one another has become an obligation of American citizenship. So I forced myself to watch' (Lepore 2016). In an important slip, Lepore had written 'people shoot one another', but what she really meant was police shooting citizens, and citizens shooting police, and while these were all, of course, 'people', the status of some of these people as police was an important component of this violence. Further, the role of race in these encounters was also involved in her decision to watch mobile phone footage captured by Diamond Reynolds, documenting the aftermath of the police shooting of her boyfriend Philando Castile. Lepore reflected that Reynolds's decision to record this police violence marked her 'faith in technology' in the face of 'the overwhelming evidence of history'. Making these documents, and posting them on the internet, could be a 'call to action', or it might expose 'the truth', but Lepore reminded us that in the history of images of atrocities, including lynchings of black men, such images have been 'sold as postcards' (Lepore 2016). Lepore didn't elaborate on this point – does their status as postcards makes these images nothing more than cheaply transacted spectacles? Is this the danger, that in an effort to democratise evidence-gathering practices, we run the risk of trivialising the truth?

Citizen-made videos capturing police misconduct and criminality are more easily accommodated by the liberal ideologies of civil society, amenable to justifications aligned with public accountability and transparency. For historian Allyson Hobbs, it was the footage of Castile's killing that changed her mind about showing her students images in this genre: black victims of white violence (Hobbs 2016). Hobbs found Diamond's decision to film the incident 'courageous' and 'heroic', and while looking at such images 'comes with responsibilities and risks', it also provides opportunities for empathy, a crucial response at this historical juncture. Gourevitch distinguished videos documenting police violence from those made by jihadi propagandists, and supported decisions by mainstream media agencies not to publish the latter. He cited Dean Baquet from *The New York Times* who said 'There is no journalistic value to my mind of showing what a beheading looks like'. For Gourevitch – who wrote: 'I didn't look' – the decision not to broadcast beheading videos tells us that 'a sense of decency is also at play . . . a whole complex of ideas about good taste and sensationalism, and the impulse neither to overstimulate nor inure viewers with the horror of graphic violence' (Gourevitch 2015). On some level he worried, as Lepore did, that watching these videos comes too close to 'participating in, and thereby compounding, the original acts of victimization and violation' (Gourevitch 2015). Gourevitch does not, however, address the issue of social media platforms providing unlimited access to these materials without censorship. It means that new media consumers, particularly children and young people, can watch beheadings and other horrors while clustered around their devices in schoolyards, in the streets and on public transport.

These technological affordances have predictably given rise to a struggle over control of the image. Whereas the power to make evidentiary images has probably never entirely vested in the state, the rapid advance of affordable image-making

devices has empowered those who seek to do violence, and indeed those whose violence is perpetrated by image-making machines. For example, shortly before Christmas 2014 a violent criminal who had pledged loyalty to Islamic State ideology, Man Haron Monis, took 18 hostages in a café in Sydney's Martin Place. The siege lasted 16 hours and ended in the deaths of Monis and two hostages. During the siege, Monis forced hostages to contact mainstream media outlets and also to use their own social media accounts to transmit his demands (State Coroner of New South Wales 2017, 173–74). At times, Monis offered to release several hostages in exchange for the wider broadcast of his messages. Hostages were required to record videos which they then uploaded onto YouTube, or post status updates on their own Facebook accounts, and these were then re-broadcast by traditional media outlets while the siege was still in progress. Police agencies, scrambling to manage a complex and unpredictable negotiation process, asked media outlets to desist from these broadcasts while the siege remained in progress, although not all of them complied (Duffy 2014).

After the siege, there was a considerable backlash against the conduct of media agencies (see e.g. Posetti 2014; Muller 2014; Vanstone 2014). On the one hand, the media had been given access to irresistible material in which participants in a violent criminal event were capturing primary evidence of their ordeal in real time. On the other hand, the broadcast of this material potentially interfered with the police management of the siege. Certainly, it was through the live broadcast of siege footage that Monis was identified by police officers (State Coroner of New South Wales 2017, 166). But from within the café, Monis had access to live media reports of surreptitious hostage escapes, and this news enraged him (State Coroner of New South Wales 2016, 207).

The voyeuristic feeding frenzy that occurred through the night was deplored when it became clear two hostages had been killed. Suddenly, the dignity of the deceased, the injured, and those who had survived the siege, became more important commodities, and mainstream news outlets vied to appear more self-reflective about their own conduct. For example, *The Sydney Morning Herald* reported the conclusion of the siege and, several hours later, amended their online article:

> Editor's Note: Fairfax Media has decided to cease showing YouTube videos that hostages were forced at gunpoint to appear in during the Martin Place siege.
>
> (Begley 2014)

At the end of the article appeared the reasoning behind this decision.

Editor's note

Fairfax Media has decided to cease showing YouTube videos that hostages were forced at gunpoint to appear in during the Martin Place siege. We have done this for a number of reasons.

We respect those who lost their lives overnight and do not wish to detract from the focus on them.

We also respect the surviving hostages and their families, who have faced severe trauma and who must be allowed to heal and to recover from the ordeal they have been through.

And finally we do not wish to give a platform, even posthumously, to the messages of hate that Man Haron Monis wished to spread.

The decision to publish these videos was made in the immediate aftermath of the siege ending, as a way of providing our readers an insight into the ordeal suffered by those inside.

We note that these videos were widely circulating on social media on Monday, when Fairfax agreed with requests from police not to broadcast the gunman's demands while the siege was underway.

There are also parallels with numerous videos of Islamic State hostages in the Middle East, some of which this website has published.

Fairfax believes covering the demands made by the gunman – now the tragic incident is being investigated and analysed – continues to be in the public interest.

However we are sensitive to the concerns that have been raised that the screening of the videos can only further distress those recovering from the hostage ordeal.

On balance, we believe these outweigh the news value of this material. We have also amended the text story to remove the hostages' names.

(Begley 2014)

This is just one example in which mainstream news agencies have begun to resile from, or at least hesitate over, the commodification of evidentiary material. This is prompted, in large part, by widespread disapproval of the media's role, with accusations of commercial values dominating journalistic ethics. In particular, the attitude of Rupert Murdoch, conveyed in a tweet following the conclusion of the siege, generated significant public reaction against the role of the media; Murdoch had tweeted:

AUST gets wake-call with Sydney terror. Only Daily Telegraph caught the bloody outcome at 2.00 am. Congrats.

(Rupert Murdoch (@rupertmurdoch), 15 December 2014)

Murdoch was criticising those commercial media agencies that, with the exception of his local tabloid, had agreed to a police demand to desist from transmitting audio and video material of the siege in progress. His position was widely and negatively reported (see e.g. Muller 2014; Alexander 2014).

For Jessica Silbey, the demand that through photographic images we 'bear witness' to an event requires more scrutiny. Having already challenged the assumption that *evidence verité* represents the 'real', she asks what, exactly, we are bearing witness to when we look at a documentary image. For Silbey, all we can

really bear witness to is the passage of time: 'there was a then, which the photograph records, and we are now'. But for Silbey, time doesn't simply pass; time has content: 'time becomes history' (Silbey 2010, 1264). What we have borne witness to is history, our shared understanding of what has happened and what it means. Where families of deceased people desire an audience for footage of their loved ones' deaths, they are not only asking that we watch them die, and see the manner and cause – and sometimes also the perpetrator – of their death; what they are really demanding from us is our solidarity and our vigilance. For these families, the image is proof of the traumatic moment: *this is who we loved; this is how we lost them.*

Disclosure is both a thing and a practice; the secret and its revelation. Sensitivity applies to both – the disclosures we make and the way we disclose them – because disclosures, once made, cannot be taken back, and the effects of disclosure operate upon a cohort who had taken refuge in a secret. Disclosure can be mitigated by concealment or withholding. The withholding might be to protect something vulnerable, or something powerful, or the withholding might itself be a source of pleasure.

With the plethora of affordable technologies enabling the production of secret, sometimes intimate, media, there also arises a confusing entanglement of voyeurism and pleasure, and consequences that are unpredictable and unexpected (see Berlant and Warner 1998). The counterpoint to open justice is not closed justice. A sensitive jurisprudence could respond by working slowly, asking questions, consulting widely, deliberating, acting and then reflecting, and maybe then re-thinking, articulating concerns, regrets and proposing new ways forward.

Outside the criminal trial, although sometimes during its course, criminal evidence continues to proliferate, unprotected by the rules of evidence. An urgent challenge arises for us to be attentive to the consequences of this *other* life of evidence – evidence not examined for its probative value but for other qualities it might possess: violence, pleasure, surprise, shock, intrigue or banality. Gleaning enjoyment from evidence is something hitherto reserved for law's insiders. Contemporary practices of open justice, however, generate new audiences for evidence, and new risks and opportunities.

Notes

1 See also *John Fairfax Publications Pty Ltd v District Court of NSW* (2004) 61 NSWLR 344 per Spigelman CJ at [17]–[21]; *John Fairfax Publications Pty Ltd v Ryde Local Court* (2005) 62 NSWLR 513 at [60]–[63].

2 *Privacy Act 1988* (Cth) Schedule 1. The Australian Privacy Principles commenced on 12 March 2014.

3 Other examples of legal scholarship about secrecy (excluding scholarship on national secrecy) include Grant (2012) and Siegel (2011).

4 See also the special issue on 'Secrecy and transparency' in *Theory, Culture and Society* (2011), 28(7–8), and particularly Claire Birchall, 'Introduction to "Secrecy and Transparency"': The politics of opacity and openness', 7–25. See also the special issue, 'The secret issue', in *Cultural Studies* (2007), 21(1).

5 During Gerard Baden-Clay's trial, the Queensland Supreme Court ruled on the admissibility of evidence from their relationship counsellor (*R v Baden-Clay* [2013] QSC 351) and from a forensic pathologist (*R v Baden-Clay* [2014] QSC 156]. At the conclusion of his trial he was convicted: *R v Baden-Clay* [2014] QSC, Unreported, 15 July 2014. His appeal to the Supreme Court of Appeal was initially allowed, quashing his conviction for murder and replacing it with a verdict of manslaughter: *R v Baden-Clay* [2015] SCA 256. However, this decision was swiftly vacated pending an appeal to the High Court: *The Queen v Baden-Clay* [2016] QCA 1. The High Court of Australia reinstated his murder conviction: *The Queen v Baden-Clay* [2016] HCA 35.

6 See *Police v Gerard Robert Baden-Clay*, Magistrates Courts of Queensland, Magistrates Court at Brisbane, Hearing date 19 March 2013; judgment delivered 20 March 2013, by Judge Butler SC, Chief Magistrate

7 Butler SC cited McHugh JA in *John Fairfax & Sons Ltd v Police Tribunal of New South Wales* (1986) 5 NSWLR 465.

8 All references herein to this matter are taken from the audio recording of proceedings obtained from the court, with permission.

References

ABC News (2016), 'Gun George Zimmerman used to kill Trayvon Martin sells for $346,000 in online auction', *ABC News*, 22 May, accessible at www.abc.net.au/news/2016-05-22/gun-used-by-george-zimmerman-to-kill-trayvon-martin-sold/7435710

Alexander, Ella (2014), 'Sydney siege: Rupert Murdoch criticised over "heartless" congratulations tweet', *Independent*, 16 December, accessible at www.independent.co.uk/news/people/sydney-siege-rupert-murdoch-criticised-over-heartless-congratulations-tweet-9927863.html

Apel, Dora and Shawn Michelle Smith (2007), *Lynching Photographs*, Berkeley CA: University of California Press.

Associated Press (2015), 'Courtney Love and Frances Bean fight release of Kurt Cobain's death photos', 31 July, accessible at www.theguardian.com/music/2015/jul/31/kurt-cobains-widow-and-daughter-fight-release-of-his-death-scene-photos

The Australian (2012), 'Missing ABC worker Jill Meagher's handbag may have been planted: police', *The Australian* (online), 25 September, accessible at www.theaustralian.com.au/news/nation/police-examine-brunswick-threat-links-to-jill-meagher/story-e6frg6nf-1226480916769

Australian Government (2011), *Information Security Management Guidelines: Australian Government Security Classification System* (18 July), accessible at www.protectivesecurity.gov.au/informationsecurity/Documents/Australian%20Government%20classification%20system.pdf.

Australian Law Reform Commission (2015), *Traditional Rights and Freedoms – Encroachments by Commonwealth Laws* (ALRC Interim Report 127), Chapter 10, subsection on Open Justice, accessible at www.alrc.gov.au/publications/open-justice

Bal, Mieke (2005), 'The commitment to look', *Journal of Visual Culture* 4(2), 145–62.

Barthes, Roland (1981), *Camera Lucida: Reflections on Photography*, New York NY: Hill and Wang.

Baskin, Brooke (2012), 'Lawyers for Gerard Baden-Clay fail in bail application before Supreme Court in Brisbane', *The Courier Mail*, 14 December, accessible at www.couriermail.com.au/news/queensland/lawyers-for-gerard-baden-clay-seeking-bail-before-supreme-court/news-story/08c9dc16fd3d64c0ef4c3bfead0a5c3b#

Baskin, Brooke (2013), 'Images released of home in which starved twins died in Brisbane's Sunnybank Hills', *The Courier Mail*, 7 August, accessible at www.couriermail.com.au/news/queensland/images-released-of-home-in-which-starved-twins-died-in-brisbane8217s-sunnybank-hills/news-story/5d546972001e96052eb af64f29a3d3d0

BBC News (2015), 'Sussex Police release drug driving death crash video', *BBC News*, England, 12 October, accessible at www.bbc.com/news/uk-england-34510180

Begley, Patrick (2014), 'Sydney siege over', *The Sydney Morning Herald*, 16 December, accessible at www.smh.com.au/nsw/sydney-siege-over-lindt-cafe-gunman-forces-hostages-to-appear-in-videos-20141215-127wgy.html

Berger, John (1980), 'Understanding a photograph', in Alan Trachtenberg, ed., *Classic Essays on Photography*, New Haven CT: Leete's Island Books.

Berlant, Lauren and Michael Warner (1998), 'Sex in public', *Critical Inquiry* 24(2), 547–66.

Biber, Katherine (2007), *Captive Images: Race, Crime, Photography*, Abingdon UK: Routledge.

Biber, Katherine (2014), 'Inside Jill Meagher's handbag: Looking at open justice', *Alternative Law Journal* 39(2), 73–77.

Biber, Katherine, Peter Doyle and Kate Rossmanith (2013), 'Perving at crime scenes: Authenticity, ethics, aesthetics: A conversation', *Griffith Law Review* 22(3) 804–24.

Blinder, Alan (2017), 'Ex-officer who shot Walter Scott pleads guilty in Charleston', *The New York Times*, 2 May, accessible at www.nytimes.com/2017/05/02/us/michael-slager-walter-scott-north-charleston-shooting.html?_r=0

Bucci, Nino (2013), 'Senior detective shows graphic Meagher photos at fundraiser', *The Age*, 27 November, accessible at www.theage.com.au/victoria/senior-detective-shows-graphic-meagher-photos-at-fundraiser-20131127-2yanc.html

Calligeros, Marissa (2014a), 'The trial of Gerard Baden-Clay', *Brisbane Times*, 30 May, accessible at www.brisbanetimes.com.au/national/queensland/the-trial-of-gerard-badenclay-20140530-zrtgh.html

Calligeros, Marissa (2014b), 'Gerard Baden-Clay trial: Diary reveals Allison's pain', *Brisbane Times*, 9 July, accessible at www.brisbanetimes.com.au/national/queensland/gerard-badenclay-trial-diary-reveals-allisons-pain-20140709-zt0sc.html

Cunliffe, Emma (2011), *Murder, Medicine and Motherhood*, Oxford UK: Hart Publishing.

Cunliffe, Emma (2012) 'Open justice: Concepts and judicial approaches', *Federal Law Review* 40(385), 405.

Davies, Lisa (2012), 'Distressing video of Tasered student released', *The Sydney Morning Herald*, 9 October, accessible at www.smh.com.au/nsw/distressing-video-of-tasered-student-released-20121009-27afq.html

Day, Lauren (2016), 'Ms Dhu death in custody: Family criticises coroner for reserving decision over CCTV footage release', *ABC News*, 29 September, accessible at www.abc.net.au/news/2016-09-28/family-of-ms-dhu-criticise-coroners-decision-footage/7885962

Derrida, Jacques (1987/1996), 'How to avoid speaking: Denials', in Sanford Budick and Wolfgang Iser, eds, *Languages of the Unsayable: The Play of Negativity in Literature and Literary Theory*, Stanford CA: Stanford University Press.

Derrida, Jacques (2001), *A Taste for the Secret*, Cambridge UK: Polity.

Dowsley, Anthony and Wayne Flower (2012), 'CCTV shows man in a blue hoodie spoke to missing ABC worker Jill Meagher moments before she disappeared', *news.com.au* (online), 23 September, accessible at www.news.com.au/national-news/missing-

woman-jill-meagher-seen-on-cctv-speaking-to-man-in-blue-hoodie-before-vanishing/
story-fndo4eg9-1226479708333

Duffy, Conor (2014), 'Sydney siege: Social media could hamper police operations, being exploited by modern terrorists,' expert says', *ABC News*, 16 December, accessible at www.abc.net.au/news/2014-12-16/sydney-siegesocial-media-a-liability-says-expert/5971622

Edge, Sami (2015), 'Judge dismisses lawsuit seeking release of Kurt Cobain death-scene photos', *Seattle Times*, 31 July, accessible at www.seattletimes.com/seattle-news/judge-dismisses-lawsuit-seeking-release-of-kurt-cobain-death-scene-photos/

Fenster, Mark (2014), 'The implausibility of secrecy', *Hastings Law Journal* 65, 309–63.

Fisher, Greg (2014), 'Dozens of new photos released from Kurt Cobain death probe', *CBS News*, 27 March, accessible at www.cbsnews.com/news/dozens-of-new-photos-released-from-kurt-cobain-death-probe

Garner, Helen (2004), *Joe Cinque's Consolation: A True Story of Death, Grief and the Law*, Sydney NSW: Picador.

Gilbert, Jeremy (2007), 'Public secrets: "Being-with" in an era of perpetual disclosure', *Cultural Studies* 21(1), 22–41.

Gladstone, Brooke and Bob Garfield (2012), 'The ethics of photographing tragedy', *WNYC Studios*, 7 December, transcript accessible at www.wnyc.org/story/255875-photographing-tragedy?tab=transcript

Gourevitch, Philip (2015), 'Should you watch the video?' *The New Yorker*, 8 April, accessible at www.newyorker.com/news/news-desk/should-you-watch-walter-scott-video

Grant, Claire (2012), 'Secret laws', *Ratio Juris* 25(3), 301–17.

Hagerty, Barbara (2002), *Handbags: A Peek Inside Woman's Most Trusted Accessory*, Philadelphia PA: Running Press.

Hobbs, Allyson (2016), 'The power of looking, from Emmett Till to Philando Castile', *The New Yorker*, 5 August, accessible at www.newyorker.com/news/news-desk/the-power-of-looking-from-emmett-till-to-philando-castile

Hunt, Elle, Michael Safi and Richard Luscombe (2016), 'George Zimmerman to auction gun he used to kill Trayvon Martin', *The Guardian*, 12 May, accessible at www.theguardian.com/us-news/2016/may/12/george-zimmerman-trayvon-martin-gun-auction

Jarvis, Brian (2007), 'Monsters Inc.: Serial killers and consumer culture', *Crime Media Culture* 3(3), 326–44.

Judicial Commission of New South Wales (2017), 'Closed court, suppression and non-publication orders', *Criminal Trial Courts Bench Book*, accessible at www.judcom.nsw.gov.au/publications/benchbks/criminal/closed_court_and_non-publication_orders.html#p1-350

Klippmark, Pauline and Karen Crawley (2017), 'Justice for Ms Dhu: Accounting for Indigenous deaths in custody in Australia', *Social & Legal Studies* 10(1), 80–94.

Kosofsky Sedgwick, Eve (1993), 'Epistemology of the closet', in H. Abelove, M.A. Barale and D.M. Halpern, eds, *The Lesbian and Gay Studies Reader*, London: Routledge.

Kyriacou, Kate (2012), 'Court releases journal entries by Allison Baden-Clay, one written days before she disappeared', *The Courier Mail*, 15 December, accessible at www.couriermail.com.au/news/queensland/brisbane-supreme-court-releases-journal-entries-by-allison-baden-clay-one-written-just-days-before-she-disappeared/news-story/70a1ba4fabeef040ed984f96b2611ad8

Kyriacou, Kate (2014), 'Allison Baden Clay's personal diaries read to husband Gerard's murder trial', *The Courier Mail*, 25 June, accessible at www.couriermail.com.au/news/queensland/allison-badenclays-personal-diaries-read-to-husband-gerards-murder-trial/news-story/bce8711ad054f8af721fdc19d09af949

Lee, Murray and Alyce McGovern (2013), *Policing and the Media: Public Relations, Simulations and Communications*, London: Routledge.

Lennard, Natasha (2014), 'El Paso releases video of cop executing handcuffed man – where's the anger?', *Vice*, 20 June, accessible at https://news.vice.com/article/el-paso-releases-video-of-cop-executing-handcuffed-man-wheres-the-anger

Lepore, Jill (2016), 'American exposure', *The New Yorker* [online], 12 July, accessible at www.newyorker.com/news/daily-comment/american-exposure

Masco, Joseph (2010), '"Sensitive but unclassified": Secrecy and the counterterrorist state', *Public Culture* 22(3), 433–63.

Muller, Denis (2014), 'News Corp's siege coverage built on a "take-no-prisoners" culture', *The Conversation* (Australia), 19 December, accessible at https://theconversation.com/news-corps-siege-coverage-built-on-a-take-no-prisoners-culture-35656

Nelson, Sara C. (2013), 'Michael Jackson: LAPD release images of singer's bedroom at the time of his death', *Huffington Post*, 12 June, accessible at www.huffingtonpost.co.uk/2013/06/12/michael-jackson-lapd-singers-bedroom-death-pictures_n_3426835.html

NSW Police Force (2016), *Media Policy*, March, accessible at www.police.nsw.gov.au/__data/assets/pdf_file/0003/175269/media-policy-internet.pdf

Perpitch, Nicolas (2016), 'Ms Dhu inquest: Coroner criticises "inhumane" WA police treatment before death in custody', *ABC News*, 16 December, accessible at www.abc.net.au/news/2016-12-16/ms-dhu-inquest-coroner-slams-police-over-death-in-custody/8122898

Posetti, Julie (2014), 'Q&A: how the Sydney siege was reported by the public and news professionals', *The Conversation* (Australia), 16 December, accessible at https://theconversation.com/qanda-how-the-sydney-siege-was-reported-by-the-public-and-news-professionals-35518

Roberts, Brendan (2013), 'CCTV captures drunk driver's deadly crash', *7News*, 12 November, accessible at https://au.news.yahoo.com/vic/a/19795075/cctv-captures-moment-killer-drunk-driver-hits-victorian-father/

SBS News (2014), 'Graphic pictures shown to Baden-Clay jury', *SBS News* [online] 10 June, accessible at www.sbs.com.au/news/article/2014/06/10/graphic-pictures-shown-baden-clay-jury

Siegel, Dina (2011), 'Secrecy, betrayal and crime', *Utrecht Law Review* 7(3), 107–19.

Silbey, Jessica (2010), 'Evidence verité and the law of film', *Cardozo Law Review* 31(4), 1257–99.

Silva, Kristian (2013), 'Detective Senior Sergeant Ron Iddles sorry for showing Jill Meagher photos', *The Sydney Morning Herald*, 28 November, accessible at www.smh.com.au/national/detective-senior-sergeant-ron-iddles-sorry-for-showing-jill-meagher-photos-20131128-2yblz.html

Smith, Tovia (2016), 'Murderabilia: "Whitey" Bulger items go up for auction', *NPR News*, 25 June, accessible at www.npr.org/2016/06/25/483221458/murderabilia-whitey-bulger-items-go-up-for-auction?ft=nprml

Sontag, Susan (1971), *On Photography*, London: Penguin.

Spigelman, James (2006), 'The principle of open justice: A comparative perspective', *UNSW Law Journal* 29(2), 147–66.

Stauffer, John, Zoe Trodd and Celeste-Marie Bernier (2015), *Picturing Frederick Douglass: An Illustrated Biography of the Nineteenth Century's Most Photographed American*, New York NY: W.W. Norton & Company.

The Sydney Morning Herald (2003), 'Diary of mum accused of killing her four babies', *The Sydney Morning Herald*, 6 April, accessible at www.smh.com.au/articles/2003/04/05/1049459859119.html

Tagg, John (1988), *The Burden of Representation: Essays on Photographies and Histories*, London: Macmillan.

Taussig, Michael (1999), *Defacement: Public Secrecy and the Labor of the Negative*, Stanford CA: Stanford University Press.

Vanstone, Amanda (2014), 'Treating the Sydney siege horror as real-time entertainment eroded our humanity', *The Sydney Morning Herald*, 22 December, accessible at www. smh.com.au/comment/treating-the-sydney-siege-horror-as-realtime-entertainment-eroded-our-humanity-20141219-12aq9o

Vicens, A.J. (2015), 'Here is the audio of the 911 call just minutes before the Colorado gun rampage', *Mother Jones*, 5 November, accessible at www.motherjones.com/politics/2015/11/colorado-springs-shooting-911-calls-audio/

Wallace, Maurice O. and Shawn Michelle Smith (2012), *Pictures and Progress: Early Photography and the Making of African American Identity*, Durham NC: Duke University Press.

Cases

Australian Securities and Investments Commission v Rich (2001) 51 NSWLR 643 ('ASIC v Rich').

John Fairfax Group Pty Ltd v The Local Court of New South Wales (1991) 26 NSWLR 131 ('Fairfax v Local Court of NSW').

McDougall v Knight (1889) 14 App. Cas. 194.

Police v Gerard Robert Baden-Clay, Magistrates Courts of Queensland, Magistrates Court at Brisbane, Hearing date 19 March 2013; judgment delivered 20 March 2013, by Judge Butler SC, Chief Magistrate.

The Queen v Baden-Clay [2016] QCA 1.

The Queen v Baden-Clay [2016] HCA 35.

R v Tait (1979) 24 ALR 473, 487.

R v Baden-Clay [2013] QSC 351.

R v Baden-Clay [2014] QSC 156.

R v Baden-Clay [2014] QSC, Unreported, 15 July 2014.

R v Baden-Clay [2015] QCA 265.

Raybos Australia Pty Ltd v Jones (1985) 2 NSWLR 47 ('Raybos v Jones').

Rinehart v Welker [2011] NSWCA 403.

Scott v Scott [1913] AC 417.

State Coroner of New South Wales (2017), *Inquest into the Deaths Arising from the Lindt Café Siege, Findings and Recommendations*, accessible at www.lindtinquest.justice.nsw. gov.au/Documents/findings-and-recommendations.pdf

State Coroner of Western Australia (2016), *Record of Investigation into Death: Inquest into the Death of Julieka Ivanna DHU (11020-14)*, Ref no 47/15, accessible at www. coronerscourt.wa.gov.au/_files/dhu%20finding.pdf

Victoria Police v Adrian Bayley, Melbourne Magistrates' Court (Criminal), Court 13, 12 March 2013 (C12725657), Broughton DCM presiding.

4 The Oscar Pistorius trial

An afterlife in real time

In the small hours of 14 February 2013, Oscar Pistorius fired four hollow-tipped 'black talon' bullets from a high-calibre weapon through a bathroom door in his Pretoria house, killing his girlfriend Reeva Steenkamp. He would later claim he feared an intruder was inside the house and did not intend to kill Reeva. He was charged with murder and several unrelated firearms offences. Pistorius, a South African of Afrikaner ancestry, was an athlete, a gold-medal winning Paralympian and double leg amputee. Steenkamp was a white law graduate with an emerging career as a model and television identity. Not well known prior to her death, the identity of her killer and the tawdry aftermath of her death brought her posthumous celebrity. The facts of the case motivated an appellate judge to open his judgment with the statement: 'This case involves a human tragedy of Shakespearean proportions' (*DPP v Pistorius* at [1], per Leach JA).

The Pistorius trial was broadcast live across various media, following a careful and deliberative court ruling. Media-driven portrayals of criminal cases are not new, nor are they uncontroversial, but this chapter examines the distinctive context of South Africa.[1] The post-apartheid Constitution provides a framework for achieving social transformation, with open justice playing an important role. While transparency and accountability – vital principles for open justice – are important attributes of post-apartheid governance, so too are human dignity, equality and freedom. All these values have constitutional force, and the decision to broadcast the Pistorius trial demanded that they somehow survive concurrently. Dignity, in particular, was invoked during the trial as a potential casualty of open justice. Despite concerns about sensationalism and voyeurism, the broadcast of the Pistorius trial functioned as a constitutional experiment, testing the role of open justice in national transformation. The Supreme Court of Appeal of South Africa stated recently: 'Thus with *Pistorius*, the Rubicon had been crossed. The *Pistorius* trial . . . changed irreversibly the manner in which the media and the justice system of our country converge' (*The NDPP v Media 24 Ltd*, at [47]).

Oscar Pistorius was found not guilty of murder, but guilty of the lesser offence of culpable homicide. The trial judge's verdict was overturned on appeal and replaced with a conviction for murder. He was sentenced to a maximum of five years imprisonment, increased on appeal to six years and again, in November

2017, to 15 years. One year after commencing his term of imprisonment, but before the appeal had been heard, Pistorius was released from prison and placed under house arrest in his uncle's mansion in Pretoria.

The focus of this chapter is the effect of the 'instantaneous afterlife'. This arises where the afterlife of evidence occurs concurrently with its legal life. In the digital age, and compounded in cases where trials are broadcast live, evidentiary materials appear outside the law in the same instant that they are tendered before the law. In this way, the life and afterlife of evidence occur simultaneously and in parallel. One of these is bound by the laws, rules, conventions and procedures of evidence; the other is cut loose from these bonds and instead responds to the demands of populism, voyeurism and the marketplace.

The Pistorius murder case continues to lead a busy afterlife, with multiple documentaries and books on the case, as well as innumerable journalistic offerings.[2] According to South African columnist Danielle Bowler,

> Reeva Steenkamp's death has been turned into something that has market value. The proliferation of books on the trial, from journalists to ex-girlfriends' mothers and now Steenkamp's own mother, raises a question about the limits of journalistic ethics, the influence of capitalism, our supposed right to see it all, and concern for how to give Steenkamp a voice and maintain her dignity.
>
> (Bowler 2014)

The afterlife of evidence, in the Pistorius case, is entangled with South African transitional jurisprudence, and the aspiration to achieve dignity, equality and freedom. Whether these goals proved compatible with open justice, or whether the Pistorius trial represented a lost or failed opportunity, is examined in this chapter. Before the trial began, the High Court of South Africa in Pretoria was asked to rule on whether media agencies were to be granted access to all the evidence as it was presented in the courtroom, in order to broadcast the trial live. While not the first time that South African courts had been asked to broadcast proceedings,[3] this application resulted in a dedicated 24-hour television channel, a radio channel, and multiple online sites, all providing round-the-clock coverage and commentary on the trial as it unfolded.

In a lecture shortly before he became Chief Justice of South Africa, Arthur Chaskalson argued that the post-apartheid constitution demands that '[South African] society be transformed from the closed, repressive, racial oligarchy of the past, to an open and democratic society based on human dignity, equality and freedom' (Chaskalson 2000, 199). Dignity, in South Africa, is not only a value but a 'justiciable and enforceable *right* that must be respected and protected' (*Dawood, Shalabi & Thomas v Minister of Home Affairs*, per O'Regan J at para 35; emphasis in original), and the topic of dignity was raised at several important moments in the trial of Oscar Pistorius as a principle that could be undermined by open justice practices. Dignity was examined in the context of the decision

to broadcast the trial, but was also invoked in the decision to not permit certain evidence to be broadcast live or shown on courtroom monitors.

Yvonne Mokgoro, a law reformer and judge on the first Constitutional Court, identified a distinctive South African jurisprudence of dignity connected to indigenous law. She explained how *ubuntu*, a humanistic philosophy of southern Africa, embraced the values at the heart of the constitution, including 'human dignity itself, respect, inclusivity, compassion, concern for others, honesty and conformity' (Mokgoro 1997, 7). As described by anti-apartheid activist and judge Albie Sachs, *ubuntu* means 'I am a person because you are a person' (Sachs 2007, 705). In the context of legal proceedings, *ubuntu* aims to achieve the restoration of harmony and dignity, and to sensitise a wrongdoer to the hurtful impact of their actions (*Dikoko v Mokhatla* at [68]). *Ubuntu* requires case-by-case analysis, and attention to social relationships and practices examined in context (Mokgoro 1997, 4). The South African jurisprudence of dignity repeatedly demands that dignity be deployed to 'contradict our past', 'to inform the future', and to demand 'respect for the intrinsic worth of all human beings' (*Dawood v Minister for Home Affairs*, at para 35); wherever dignity is undermined, the result is that life 'all too quickly and insidiously degenerates into a denial of humanity and leads to inhuman treatment by the rest of society in many other ways' (*National Coalition for Gay and Lesbian Equality v Minister of Justice*, per Ackermann J at 42). The challenge, according to former Constitutional Court judge Laurie Ackermann, was to find ways to give meaningful expression to the constitutional principles: 'A transforming Constitution such as ours will only succeed if everyone, in government as well as in civil society at all levels, embraces and lives out its values and its demands' (Ackermann 2004, 678–79).

During the Pistorius trial, it was Reeva Steenkamp's dignity that was most invoked, and that gave rise to questions about whether her dignity – constitutionally speaking – survived her death, and whether her surviving family and friends might continue to guard her dignity in the afterlife. Of course, Pistorius himself, as a criminal defendant, had constitutional rights and protections that also operated to preserve his dignity and human rights. Significantly, his dignity – constitutionally speaking – was also maintained following his criminal conviction and his imprisonment (*S v Walters*, at [142]), although the broadcasting of the trial gave rise to questions about whether he was able to remain dignified. But another important consideration, in the South African context, was the dignity of all South Africans, potential trial observers, all of whom would live with the legacy of the trial and its reflection of criminal justice in the postapartheid state. How could the trial be conducted so as to dignify the nation?

The constitutional framework was invoked by the presiding judge in the media application, President Mlambo, when deciding whether and how to permit media agencies to broadcast the trial. In the opening paragraph of his judgment, making it clear that these foundational concepts would guide his decision, he articulated the various rights of the accused person, the obligations of the prosecution, the rights of the media, and the principles of open justice, describing these as 'critical constitutional rights that are seemingly on a collision course with one another' (*Multichoice v NPA*, per Mlambo JP at [1]).

The media application was adjudicated in *Multichoice (Proprietary) Ltd v National Prosecuting Authority, In Re: S v Pistorius,* with other applicants including Combined Artistic Productions CC, Primedia Broadcasting (a division of Primedia (Pty) Ltd), Media 24 Limited, Times Media Group Limited, and Independent News and Media Limited. President Mlambo's judgment contained important remarks about the role of the media in open justice, particularly in a society with stark inequalities. He took judicial notice of how most South Africans felt about the criminal justice system: that it was 'still perceived as treating the rich and famous with kid gloves while being harsh on the poor and vulnerable'. President Mlambo found merit in the arguments made by the applicants that live broadcasting had the effect of democratising the proceedings. Whereas the extant media access rules permitted journalists to use Twitter from within the courtroom, President Mlambo described this as a tool with 'minority access', serving only a 'small segment' of the community. Since the Pistorius trial would involve 'a local and international icon' and 'celebrity', a live broadcast of the trial would counteract 'negative and unfounded perceptions about the judicial system' (*Multichoice v NPA*).[4]

Allowing the evidence to lead an instantaneous afterlife in the mediascape as it was presented in the courtroom served the objectives of open justice by making the proceedings accessible live and *un*-mediated. At the same time, President Mlambo was not oblivious to the risks of such access. He wrote:

> it has come to my attention that there are media houses that intend to establish 24 hour channels dedicated to the trial only and that panels of legal experts and retired judges may be assembled to discuss and analyse proceedings as they unfold. Because of these intentions, it behoves me to reiterate that there is only *one court* that will have the duty to analyse and pass judgment in this matter. The so-called trial by media inclinations cannot be in the interest of justice as required in this matter and have the potential to seriously undermine the court proceedings that will soon start as well as the administration of justice in general.
>
> (*Multichoice v NPA*, per Mlambo JP at [28];
> emphasis in original)

He recognised that, in defending the constitutional principle of open justice, he was also complicit in setting the scene for a televisual tragedy to unfold. He knew that he was delivering to media agencies a captive audience, eager to witness the spectacle of the wheels of justice turning in real time. He recalled that, during Pistorius's bail application, the Magistrates Court experienced a 'near chaotic situation' when members of the press and the public could not be accommodated within the courtroom, and foresaw that 'scores of journalists' from around the world would be covering the trial (*Multichoice v NPA*, per Mlambo JP at [5]).

Mlambo JP, citing the Constitutional Court, noted that the publicity and openness of the courts provided not only knowledge and information about proceedings, but ensured that 'the people can discuss, endorse, criticize, applaud or

castigate the conduct of their courts' (*S v Mamabolo*, per Mlambo JP at [23]). While no doubt he had in mind sober civic discourse, he was also describing practices that could give rise to an atmosphere of sensationalism and voyeurism. Acknowledging that Oscar Pistorius, and his witnesses, would be affected by giving evidence in the knowledge that they were being recorded or photographed, Mlambo JP ordered that their testimony not be recorded or broadcast in any visual medium, but that their testimony be audio recorded and broadcast on radio.

Following his plea of not guilty to murder, and not guilty to the firearms offences, the trial of Oscar Pistorius commenced on 3 March 2014. As juries have been abolished in South Africa, the presiding judge was Justice Thokozile Masipa, who was assisted by two lay assessors.

A considerable amount of time during the trial was taken up with the management of media matters. This was done with considerable care, patience and sensitivity, and there were a number of instances where Justice Masipa was required to clarify or modify her orders. For example, one day she opened proceedings by modifying an order she had made earlier. She had banned the publication of reports from a psychologist and a psychiatrist that had been tendered as exhibits. However, she later heard that the media attorney had come to an agreement with the defence team about the contents of that evidence and, since they had agreed that it could be published, she reversed the ban and permitted publication of that evidence (YouTube 2014). This is just one instance in which the realisation of open justice was delegated to – or assumed by – the parties, with the court seemingly out of step and racing to catch up. While the intention was for the court to maintain control and oversight, there were occasions on which criminal evidence achieved an instantaneous afterlife because of negotiation between the parties.

The court heard 49 days of evidence in the trial. Multiple witnesses – Pistorius's neighbours – testified that they had heard screams or an argument during the night of the shooting, albeit with some disagreement about whether it was a woman or a man screaming. Under cross-examination, they held fast to their evidence that the screaming occurred before the shooting. There was also evidence from the security guard and estate manager who responded to the shooting. Expert evidence was called by both prosecution and defence from fields including ballistics, pathology, anaesthesiology, police forensics, acoustic engineering, forensic psychiatry, social work and sports medicine. The court even heard from the surgeon who had amputated Pistorius's legs when he was 11 months old. Pistorius himself gave evidence and was subjected to cross-examination for five days. Testimony was heard from one of Pistorius's ex-girlfriends, and from his agent. The bathroom door through which Steenkamp had been shot, and which Pistorius broke down with a cricket bat, was brought into the courtroom, as was the cricket bat; a forensics expert conducted an in-court demonstration with the bat. In an anecdote typical of the cultural afterlife of the Pistorius evidence, South African Test cricketer Herschelle Gibbs, viewing the trial on television, tweeted:

'Just saw my signature on the bat used by the accused in oscar trial . . . lol #neveradullmoment' (Rice 2014).

An important feature of the trial and its media portrayal was evidence that came directly from Reeva Steenkamp – her own words, albeit not delivered in her voice. She and Pistorius had communicated during their four-month long court-ship using the messaging system WhatsApp. Fragments of their correspondence were tendered into evidence and displayed on the courtroom monitors during the testimony of the police captain, Francois Moller, who had examined over 2,000 messages between the couple, exchanged over at least eight devices. In his testi-mony, Moller read aloud from several of the messages. Later in the trial, during his examination-in-chief, some of the messages were read aloud by Pistorius. A journalist close to the Pistorius family reported that the family felt that the loving nature of most of the messages – they calculated that over 99 per cent of the mes-sages were affectionate – cast the relationship in a positive light (Marszal 2014). However, despite the absence of her voice throughout the trial, the messages clearly provided Steenkamp's perspective on their relationship – and provided an insight into Pistorius's sulky, childish and bullying behaviour, and her fear of his outbursts.

When these messages were reproduced outside the courtroom, on media web-sites, they were often framed in sensational terms. One site, which was typical, referred to the 'highlights' of the messages, and drew attention to 'strife' in the relationship and Steenkamp's fear of Pistorius (E. Smith 2014). A great deal was made of the fact that Steenkamp, who was killed on Valentine's Day, had written Pistorius a loving Valentine's Day card which he didn't open until many months later, and which he read aloud during his evidence-in-chief (see e.g. Laing 2014). On the evidentiary value of their courtship correspondence, Masipa J was clear: 'Neither the evidence of a loving relationship, nor of a relationship turned sour can assist this court to determine whether the accused had the requisite intention to kill the deceased' (cited in Rose 2015).

Unsurprisingly, some of the most compelling and memorable evidence pre-sented at the trial – and in its mediated afterlife – was visual evidence, including photographs and video footage. Both the prosecution and defence tendered evidence of this kind, and it was displayed on monitors in the courtroom. The monitors were visible to the witness box, prosecution and defence, the judge and assessors, and to the gallery. The televised broadcast of the trial displayed these monitors, except when the judge prohibited such broadcasting. In addition to videos and images, the monitors were used to display the SMS (text) messages and WhatsApp messaging tendered into evidence.

There were three primary groups of images used in the trial, giving rise to separate considerations. These were architectural images of Pistorius's home; post-mortem images of Reeva Steenkamp; and the Sky News shooting video, which is described below. According to David Smith, a journalist at *The Guardian*, June Steenkamp's lawyer, Dup de Bruyn, had an agreement with lead prosecutor Gerrie Nel that Nel would notify the Steenkamp family in advance of displaying any graphic images; Reeva's mother, June, used this notification in order to avoid viewing those images during the trial (D. Smith 2014b; BBC3 2014).

To understand the circumstances of Steenkamp's shooting and weigh Pistorius's defence that he believed there was a possible intruder in the house, it was important for the court to understand the architectural layout of his home. Both interior and exterior images of Pistorius's home were frequently displayed on the courtroom monitors, including aerial photographs and photographs taken from the homes of neighbours. There were also many photographs of the interior of the Pistorius home, including crime-scene photographs depicting blood, the weapon and other graphic images of the shooting's aftermath.

For example, during Days 4 and 5 of the trial, during the testimony of Pistorius's neighbour Dr Johan Stipp, images of Pistorius's home were shown to demonstrate the veracity of Dr Stipp's testimony as to what he saw and heard on the night of Steenkamp's death. In another example, on Day 8 of the trial, images of the bathroom door were displayed as a forensic expert testified as to whether or not it was likely that Pistorius was wearing his prosthetic legs while breaking down the door with a cricket bat. This questioning continued the following day, and further photographs were displayed of the bloodied interior of the room. Throughout the trial, several photographs were shown of various bloodstained scenes around the home demonstrating Pistorius's movements during and after the shooting.

When police investigators first arrived at the Pistorius home after the shooting, photographs were taken of both Steenkamp's body and Pistorius himself. Steenkamp had been shot in the right thigh, the shoulder and the head. A fourth shot missed her. Those photographs were graphic and had very high impact, and Masipa J and both parties were sensitive to, and vigilant about, the impact of the images. Early on Day 6, Masipa J clarified her earlier order prohibiting the print media from broadcasting images and publishing photographs of some witnesses for the duration of the trial, noting that the court had 'the duty to respect the dignity and privacy of witnesses who have taken the trouble to come and give their evidence' (WildAboutTrial.com 2014; see also Hess 2014 at 9:39). The print media complained that they were normally permitted to publish images of any witness after they had been excused; however, Masipa J explained that this was not a 'normal' situation, and that a 'cautious' approach was demanded. She said all witnesses were vulnerable to having public perceptions of them altered by their having given evidence, and this was compounded for witnesses who were otherwise private people. She had been informed that two witnesses had been humiliated and attacked on social media after testifying, and she was motivated to protect their 'private family life' as well as their dignity and privacy. Masipa J also said that the state had a duty to protect state witnesses, and that duty continued until the conclusion of the trial.

Her ruling was that witnesses who were public figures could have their images published after they finished providing evidence at the trial, but images of witnesses who were not public figures, and who objected to their image being broadcast or published, could not be published for the duration of the trial. This ruling did not apply to audio broadcasting of their testimony, and there were no constraints upon journalists live-tweeting their testimony. It also did not apply to broadcasting images of the public gallery. This decision was

intended to conform with constitutional jurisprudence in which privacy and dignity are bound together, and according to which only famous people, in limited contexts, might have fewer privacy protections (*NM & Others v Smith*, per Sachs J at 88). It had the effect of conflating privacy with dignity, as if it were somehow more dignified to hear – but not to see – a witness testifying, or as if privacy were vested in one's image but not one's voice or speech. It also had the effect of placing into stark contrast the live broadcast of images and audio of Pistorius himself, and his visceral reactions to some of the evidence; whether his dignity could have survived these events is discussed below.

The state prosecutor then made a special application to the court to further restrict the broadcast of the testimony of state pathologist Professor Gert Saayman (Smith and Hosken 2014; see also Harding 2014 at 14:20). This application sought to prevent entirely his testimony being broadcast, banning both audio and video, and preventing any publication of the exhibits – photographs – he would show during his testimony. The application was framed in terms of 'the respect and dignity of . . . the deceased' and the 'rights' of Steenkamp's family and friends, and described as an instance where press freedom, or freedom of communication, should be restricted. While the court was not required to rule on the issue, there is no extant South African jurisprudence that recognises a right to dignity after death. There is recognition that the right to life incorporates the right to dignity, and consideration given to the quality of one's life (*S v Makwanyane*; also cited in *Ex parte Minister of Safety and Security: In re S v Walters*). There is further recognition that 'people who lack the capacity to cultivate the subjective aspects of dignity can nevertheless be said to have a type of dignity which demands respect' (Feldman 2002, 127; see also Feldman 1999 and Feldman 2000). German law, which has close ties with post-apartheid South African jurisprudence, clearly proscribes disseminating depictions of violence and violating intimate privacy by taking photographs.[5] German law also recognises personality rights, which survive after death (Rösler 2008, 175). However there has been no South African adoption of these laws, and it is unlikely Reeva Steenkamp's dignity entitled her to claim protection after death from the broadcast of explicit evidence of her wounded corpse.

Despite this, Professor Saayman, early in his testimony, asked that his evidence not be broadcast because 'the very graphic details pertaining to some of the injuries and wounds which may be described have the potential to compromise the dignity of the deceased'; he further invoked 'the good morals of society' (Smith and Hosken 2014; see also Harding 2014). The defence agreed with the state about the dignity of the deceased and the rights of her family and friends, and defence counsel reminded the court that it had discretion to restrict the live feed cameras (YouTube 2014, at 15:228 to 18:00). The trial was then briefly adjourned while the court waited for the media's advocate, Nick Ferreira, to make his way through traffic to attend court.

When he arrived, Ferreira made submissions about the 'groundbreaking case' before the court, and the 'highly unusual trial' that was unfolding. Ferreira agreed that the dignity of the deceased and her family were a priority and suggested that

the live broadcast be stopped for the duration of the pathologist's evidence. He proposed a compromise position, which was that the media provide a summarised version, or package, of Saayman's evidence to the parties and the court for approval and subsequent broadcast. Ferreira argued that his approach addressed 'the issues of sensitivity that the witness has raised' and 'accommodates all of the concerns which have been raised by the witness, it accommodates any possibility of infringement of dignity of the deceased or of any kind of trial-related prejudice that may occur as a result of the broadcast'. He continued:

> And moreover [the media's proposed approach] has the advantage of being the far less restrictive approach insofar as the media's right to freedom of expression is concerned and insofar as the principle of open justice is concerned because it's an approach which says 'we do not ban in advance everything that this witness might say because we don't know what he might say'. It might be that some of his evidence is perfectly benign, doesn't raise any concern at all. If so, there's no good reason to limit the rights of freedom of expression or the principle of open justice insofar as that evidence is concerned. But it appropriately strikes the balance between the sensitivities which have been raised by the witness, and those important principles of freedom of expression and the principle of open justice.
>
> (YouTube 2014, at 26:21 to 27:32)

Ferreira requested that the media retain access to the testimony, that live tweeting be permitted and that the media broadcast an approved summary following the testimony. Defence counsel Kenny Oldwage was concerned about these delays and interruptions to his client's trial, and also made the point that the media's proposal that the parties collaborate on preparing a media package went far beyond their roles in the administration of justice. Prosecutor Gerry Nel, in an effort to expedite the proceedings and, in his words, 'just to get the show on the road, m'lady', proposed a mutually agreed live broadcast blackout. In the end, Masipa J banned all live broadcasting and live tweeting during the testimony of Professor Saayman (YouTube 2014; the video ends with Masipa J's order banning live broadcast of video or audio, ending at 50:47). The trial continued with journalists and the public remaining in the galleries. During Saayman's testimony, some images were blocked from being displayed to the courtroom gallery or on certain monitors within the courtroom (Associated Press 2014); instead, images of the deceased were circulated around the courtroom. Steenkamp's parents were forewarned about the 'gruesome' images that would be shown (BBC3 2014). During the lunch recess, Lulama Luti, a spokesperson for the Ministry of Justice, clarified the judge's order: summaries and paraphrasing were allowed after the testimony, but direct quotations and live reporting (including tweeting and blogging) were not permitted (Hess 2014).

The constraints placed on reporting led to the outcome that a proportion of the reporting related to the constraints themselves. That is, open justice and its limitations became a substantial topic in the reportage of the trial. For example,

during Saayman's testimony, when journalists were prevented from reporting live about his evidence, the News24 channel devoted to trial coverage, included the following reports in its live news feed:

9:33 – Pieter Baba is already in the witness box.

9:36 – And we've started. Judge Masipa is granting an order . . .

9:37 – Order regards witness images being used by media.

9:39 – Court has duty to respect witnesses' dignity and privacy, says judge Masipa.

9:40 – Judge says character of two witnesses attacked in social media after taking stand.

9:41 – Duty to protect witnesses until end of trial, says judge.

9:41 – Print media prohibited from publishing photos of witnesses irrespective of source.

9:43 – Judge Masipa grants court order allowing print media to publish photos of witnesses who are public figures once they have finished evidence.

9:44 – Judge also orders that no picture of objecting witnesses (who are not public figures) can be published for duration of trial.

9:44 – Roux (BR) starts cross-examining Pieter Baba (PB).

. . .

12:04 – No live broadcast of evidence. Applies to Twitter too, says judge.

12:13 – The UK Telegraph's Aislinn Laing has tweeted: 'In the absence of clarity from the judge, we'll try to update you on the Telegraph live blog but will be summarised'. Personally, I think this might not be best. Agree?

12:14 – Saayman has started giving his evidence but we can't tell you what it is because of the order.

12:32 – David Smith has quoted Judge Masipa as saying: When I referred to Twitter, I failed to refer to blogging as well. Twitter is not allowed, blogging is not allowed.

12:34 – To clarify: We can tell you, for instance, what OP's doing in court right now. We can't tell you what Saayman is saying while testifying though. Not now (Hess 2014).

13:28 – Ministry of Justice says Saayman's testimony can be summarised but no direct quotes, tweets Debora Patta.

Following Saayman's testimony, journalists in the courtroom reported that Oscar Pistorius had vomited, gagged and retched repeatedly while hearing the

evidence. While the gallery could not see the images shown by Saayman as he testified, these would have been visible to Pistorius. The testimony and images detailed the bullet wounds to Steenkamp's body, including the exit wounds and other marks and discolouration of her skin, which he testified were consistent with the impact of a bullet fired through a door. It included testimony that said the expanding bullets used by Pistorius had caused maximum tissue damage to Steenkamp's head, leaving fragments in her skull (D. Smith 2014a).

Pistorius was described as 'hunched over' and with 'hands on his ears as if trying to block out the words', 'weeping and clasping his hands behind his neck' as he heard the testimony, and Masipa J briefly adjourned proceedings twice to ask defence counsel Barry Roux to attend to his client (Associated Press 2014). She also asked whether Pistorius was able to hear and understand the proceedings. Pistorius's sister, Aimee, went to sit with him in the dock and embraced him, but he was described as 'inconsolable' and 'curling into a ball'. When Professor Saayman described a photo that showed the 'smearing and scattering of tissue including bony elements', Pistorius rocked back and forth and retched. Masipa J asked Roux if he could assist his client, to which Roux replied, 'My lady, he's not fine but he's not going to be fine. He's having some difficulty. He's very emotional but it's not going to change' (D. Smith 2014a). The dock microphone was moved away from him and a metal bin was placed at his feet. He vomited into it several times (Associated Press 2014).

One journalist reported that, while Pistorius had 'mostly retained his self-possession' during the testimony of neighbours and his ex-girlfriend, it was the 'cold, clinical, scientific' language used by Professor Saayman that 'finally robbed [him] of his composure' (D. Smith 2014a). In one respect, Pistorius's emotional performance represents what Mokgoro J, above, had identified as a component of *ubuntu*: the 'sensitising' of the wrongdoer to the harmful effects of their wrongdoing. Meanwhile, Steenkamp's family and friends were described as weeping during the testimony. Carl Pistorius, the defendant's brother, left the courtroom. The judge's registrar was described as having her hand over her mouth as she heard the testimony; other court personnel were described as looking nauseated (Hess 2014). In witnessing the evidence, these people were demonstrating the *ubuntu* qualities of '[g]roup solidarity, conformity, compassion, respect, human dignity, humanistic orientation and collective unity' (Mokgoro 1997, 4).

The issue of Steenkamp's dignity was briefly raised by reporters and commentators; some criticised the ruling on the grounds that the dignity of other deceased crime victims had not been so carefully guarded (Hlongwane 2014). In particular, a contrast was drawn between the dignity of Steenkamp and that of 34 miners shot by police in Marikana in 2012, whose injuries and deaths had been graphically broadcast and reported upon following extensive media access to the court. Another contrast was drawn between the dignity of Steenkamp and that of Anene Booysen, a young black woman who was gang-raped until she died of her injuries; again, extensive and high-impact reporting of the trial evidence of her injuries was permitted, as her death had triggered widespread public protest and condemnation. South African journalist Debora Patta, comparing the cases, wrote of

Booysen: 'Her injuries were horrific – but no detail was spared, including the very graphic testimony from a paramedic who found her with her intestines hanging out. The dignity of Booysen and her family was not ever raised in court' (Patta 2014). Jacqueline Rose noted that, following Booysen's death, Reeva Steenkamp had retweeted a report of her funeral and, on Instagram, had posted an image of a man's hand silencing a woman's scream with the text: 'I woke up in a happy safe home this morning. Not everyone did. Speak out against the rape of individuals' (Rose 2015). At the time of her death, Steenkamp was preparing to give a speech in a Johannesburg school in honour of Booysen and to draw attention to rape and sexual violence. For Rose, this was evidence of a cross-racial affinity that Steenkamp felt with Booysen, given their shared experience as women living in a society that was dangerous for women. For Patta, it warranted no distinction in the manner in which the evidence of their injuries was reported. She argued that open justice demanded that the public have access to the evidence, and that while a temporary ban on live broadcasting might be justified in the Pistorius case, there was no rationale for banning reporting of the verbatim testimony of Professor Saayman. She wrote, 'But the public has a right to hear these details – undiluted and as harsh as they are. South Africa's justice system cannot be seen to serve rich and poor, black and white, in different ways' (Patta 2014).

Steenkamp's parents gradually came to a different view of the photographs that had been tendered during Saayman's evidence. More than two years later, when Pistorius was being re-sentenced following the upgrading of his conviction, Barry Steenkamp addressed the court and insisted – 'I want the world to see' – that the images be released as evidence of what had been done to his daughter. Their decision echoed that made 60 years earlier by the mother of Emmett Till, a 14-year-old African-American boy murdered in Mississippi, in an event that triggered the civil-rights movement. Mamie Till Bradley decided to have an open-casket funeral for her son, saying 'Let the people see what I've seen' (Hobbs 2016). The historian Allyson Hobbs wrote that 'the black press disseminated the image of Till's mutilated corpse', bringing national attention to his killing and, at the same time, shifting the ethical position of those who publish, and those who look at, these images. Barry Steenkamp, meanwhile, broke down in tears and admitted that he had only been able to look at one of the images of Reeva. His request was reaffirmed by the prosecutor, Gerrie Nel, as evidence of the aggravating factors in the crime. Defence counsel, Barry Roux, opposed the request – 'Must children look at it? What is going to be achieved?' – but Masipa J agreed to release the images (Sims 2016). The international media gladly published them, together with warnings about their graphic content, and also published opinion pieces in which journalists wrangled with the media's responsibilities to Reeva, her privacy and dignity, in the afterlife (Thamm 2016).

It was during the testimony of the forensic analyst Gerhard Vermeulen on Day 10, when further interior home images were to be shown, that graphic images were accidentally displayed in the courtroom. First, an image of Steenkamp's body lying on the floor momentarily flickered across gallery monitors. An image

of Pistorius's bloodstained prosthetic leg and blood-soaked sock was then shown. Thereafter, while scrolling through a series of thumbnails, an image of Steenkamp's bloodied face was inadvertently shown. Pistorius looked sickened and his monitor was eventually turned off. At least one of Steenkamp's supporters openly wept and left the courtroom. Footage of the courtroom and gallery shows most people turning away, and Reeva Steenkamp's mother looking down (BBC3 2014).

Later, the prosecutor, Gerrie Nel, during his cross-examination of Pistorius, confronted him with footage that had been screened on the Sky News network showing him shooting a watermelon at a firing range. After the shooting, a voice said to be that of Pistorius was heard to say, 'It's a lot softer than brains, but f*** it is a zombie stopper' (Gifford 2014). The footage also recorded loud laughter. Nel argued that the bullets Pistorius used to shoot Steenkamp had the same effect, 'exploding' her skull. The admissibility of the video had been disputed, as it did not form part of the state's case. The defence had not seen the video, and was apparently unaware of it until Nel asked Pistorius about it during his cross-examination. Pistorius replied that he was unaware of any such video but, if it existed, he would wish to view it. The defence team objected to its screening, on the grounds that it was impermissible for the state to introduce fresh evidence without prior warning to the defence. The prosecutor argued that the video went to Pistorius's character; he had put his good character into issue and, having done so, exposed himself to cross-examination on his character. Nel further explained that the video itself was not in evidence, but rather that Pistorius's answers and explanations about it were the evidence. The court adjourned so that the defence could view the video; after doing so, the defence withdrew their objection in order to expedite proceedings (Tran 2014; see also Grant 2014).

Following the screening of the video, Nel demanded that Pistorius look at a photograph of Steenkamp's smashed and bloodied skull and matted hair. He said to Pistorius, 'Look at it. Take responsibility for what you did. I know you don't want to see this, but look at it'. Pistorius looked away and shortly afterwards Masipa J adjourned proceedings to enable Pistorius to regain his composure (Gifford 2014). At least one media outlet remarked upon the mutual reliance of mass media outlets and the state, given that this item of evidence used by prosecutors had been obtained from a commercial media agency (Findlay 2014).

For trial observer and law professor James Grant, Pistorius and his defence had fallen into a 'cleverly constructed trap' set when prosecutors bundled his murder charge together with firearms offences (Grant 2014). Pistorius had pleaded not guilty to all of them, and so the Sky News footage, which was probably only relevant to the firearms charges, was presented alongside material relevant to the homicide charge, and was woven into a broader narrative about his reckless or dangerous use of firearms. When Pistorius offered, as a late explanation for his conduct, that the firearms discharged involuntarily in both an earlier restaurant incident and in Steenkamp's death, the bundling of charges compounded

the unlikelihood of this explanation. It didn't help Pistorius that among the WhatsApp messages between him and Steenkamp was one in which he asked her not to mention the firearm incident in the restaurant. He had apparently asked one of his friends to take responsibility for discharging the weapon, and was asking Steenkamp to keep quiet about it (News24, 2014). Again, while the evidence related to the firearms charge, it also disclosed information about their relationship, and his efforts to influence her to conceal his violence.

During the final days of the trial an Australian television station, Channel 7, broadcast a video showing Pistorius and his sister Aimee re-enacting the night of the shooting. Filmed in his uncle's house, it showed Pistorius moving around the house without his prosthetics, holding an imaginary gun, performing the events of that night. He was then shown carrying his sister, playing the role of Steenkamp, down the stairs and laying her on the floor. The re-enactment video had been commissioned by the defence team from the American forensic animation firm Evidence Room, and was said to be a 'visual mapping' of the events that led to Steenkamp's death (eNCA 2014). Evidence Room markets itself as 'demonstrative evidence specialists' undertaking 'forensic legal art' and states that its services are 'Court tested, Jury approved' (Evidence Room n.d.). Part of a growing field of commercial providers of 'visual persuasion' for legal uses, Evidence Room promises to review all the evidence, storyboard a narrative and create three-dimensional computerised models that are then coloured, lit and animated. They also offer to provide expert interpretations of the events, either in written reports or by testifying in court, and their rates are advertised on their website.

Although the video was made in preparation for the trial, it was never used in evidence. Through a media release the defence claimed the footage had been illegally obtained in breach of a non-disclosure agreement, and that it also breached privilege and privacy (Feeney 2014; see also eNCA 2014). In the video, the executive head of the Evidence Room, Scott Roder, explained,

> When he's on his prosthetics, you know he's a very tall broad-shouldered athletic guy, he looks like he can really handle himself. But when he takes his prosthetics off and he's on his stumps, he's short, the confidence washes away from his face.
>
> (Findlay 2014)

Nevertheless, some media outlets interpreted the footage as undermining defence claims about Pistorius's limited mobility when not wearing his prosthetics. The high profile South African journalist Mandy Wiener tweeted: 'Difficult ethical dilemma for local journalists covering #OscarPistorius story—many exclusives appear to have gone to the highest bidder' (Findlay 2014).

There was media speculation about the legal consequences of the leaking of the re-enactment video. One legal commentator believed the screening of the video might give Pistorius grounds for appeal on the basis that his right to a fair trial had been violated. Another, however, disagreed, saying 'The evidence

is not before the court, it's in the media' (Roane 2014). Given the reciprocal relationship the trial established between the court and the media, it was difficult for many observers to discern the difference. In pursuing the objectives of open justice, the court had achieved the commodification of the trial and of all the evidence it generated. At the same time, both parties relied upon media outlets and commercial producers to generate evidence for them, as the Sky News footage and the Evidence Room re-creation proved.

There were two other, less ambiguous, media events that likely overstepped the boundary, and where criminal evidence became a pure media spectacle. Two journalists, Andrew Harding from the BBC and Jeff Rossen from the NBC network, were separately granted access to the crime scene. It was well known that Pistorius had sold his house in order to fund his defence. Both journalists suggested that the new owners had given them access to the bedroom and bathroom, where each staged his own walk-through. These two reports were televised to global audiences on 10 and 11 September 2014; the verdict was delivered on 11–12 September 2014.[6]

In Harding's re-enactment, he walked through the bedroom and bathroom, shaping his hands to form a gun as he advanced the various theories presented about Reeva's killing. He pointed to bloodstains on the carpet, and to bathroom tiles cracked by the impact of the bullets. In Rossen's re-enactment – which was longer, more detailed and more melodramatic – viewers saw him remove an imaginary gun from under an imaginary bed, form his fingers into the shape of a gun, count his paces and imagine Reeva's fear in her last moments ('nowhere to run, nowhere to hide'). Rossen had brought along a South African legal commentator to explain the defence case and form his own conclusion ('being in this bathroom, I think his version is improbable'). The segment also included a montage of crime scene photographs and audio recordings of Pistorius's trial testimony. Rossen then carried an imaginary Reeva down the staircase and laid her down on the floor, acknowledging that she was about to take her final breath before dying. He described the experience of visiting the crime scene as 'absolutely chilling' before throwing back to the NBC Today studio, where anchor Matt Lauer announced that the verdict was expected the following day.

Eight months after the delivery of the trial verdict, the National Press Club of South Africa announced that its 2014 Newsmaker of the Year Award was to be given to the Oscar Pistorius trial. (The previous year's winner had been Nelson Mandela, awarded posthumously.) The 2014 award reflected the 'news value' and 'media attention' garnered by the trial and the fact that it 'dominated the news in 2014'. A media release explained that the award for the trial included the 'roles played' by Oscar Pistorius himself, Judge Thokozile Masipa, prosecutor Gerrie Nel and defence counsel Barry Roux. Acknowledging the tragedy and loss at the heart of the trial, the chairperson of the National Press Club, Jos Charle, expressed the National Press Club's 'heart-felt sympathy to all the role-players

that suffered from the actions that gave rise to this trial – especially the Steenkamp family' (National Press Club 2014).

In describing the features of the trial that made it worthy of the award, Charle said:

> Media-wise the trial was bigger than the FIFA 2014 World Cup. Judge Thokozile Masipa's banning of blogging and tweeting of graphic evidence by pathologist Gert Saayman prompted 2500 articles. In 24 hours news and social media hit over 106,000 unique inserts. Pistorius having retched in court was carried in 2300 news articles. In nine days the press hit the 750,000 article mark.
>
> (National Press Club 2014)

In support of the award, Johannes Froneman, a professor of journalism, stated, 'the shroud of secrecy has been ripped off court proceedings'. He continued, 'this trial has finally drawn the line on the old mass media dispensation', and the announcement detailed the new formats and opportunities presented by the digital age and media convergence (cited in National Press Club 2014).

The then-Deputy Chief Justice of South Africa, Dikgang Moseneke, delivered the address at the award ceremony. Moseneke was a lifelong friend of Mandela, whom he met as a fellow prisoner on Robben Island; he was executor of Mandela's estate, and he is a scholarly judicial thinker and an outspoken proponent of the proper administration of justice. In the audience at the award ceremony was Justice Thokozile Masipa. In his speech, Moseneke acknowledged that the Pistorius trial 'changed irreversibly' the nature of the interaction between the justice system and the media, and 'ushered in a new era' in that relationship. He conceded that with 'the rapid advancement in technology', the expectation that citizens 'must, or should have to, wander into courtrooms to find out what is happening' was no longer valid. The sources of open justice in South Africa are both constitutional and traditional, he explained; the preamble of the Constitution describes a democracy founded upon accountability, responsiveness and openness. However, traditional African culture saw disputes resolved under the shade of a tree, witnessed by all, and enabling everyone to participate, in a process known as *lekgotla*; Moseneke pointed out that the architectural symbolism of the Constitutional Court building is justice under a tree. He said that open justice is vital in post-apartheid South Africa, because 'trust in government institutions in this country is hard-earned', demanding that 'we [. . .] subject ourselves to the greatest of scrutiny'. Moseneke also stated that, in the absence of a jury system, and without the 'threadbare fiction' of implied undertakings (which in some jurisdictions, including Australia, prevent parties from sharing documents with any non-party, for any reason), and with the *sub judice* rule 'on the verge of extinction', South Africa was well positioned to commit itself fully to the principles and practices of open justice (Moseneke 2015).

Reviewing the *Multichoice* ruling, Moseneke said: 'before the [Pistorius] trial even began, Judge Mlambo did what no South African court had before dared

to do: media organisations were given permission to broadcast, live and in full Technicolour, a criminal trial'. Aside from his quaint reference to an outmoded film process, Moseneke reflected on the distinctions Mlambo had drawn between audio, video and still photography and the different risks and opportunities presented by each. He then asked whether the time had come to push further the technological opportunities:

> should we begin to address intentionally the question of whether those in the gallery, including the media, should also be allowed to use their smartphones and laptops? And if so, to what extent? Should live-streaming be permitted, straight from the courtroom?

He raised the issue of Twitter and similar live text-based platforms, even tweeting performatively during his own speech, and stated: 'delayed information is as good as denied information'. He adopted Justice Mlambo's view that journalists and reporters offered 'second-hand' accounts of court proceedings, and that interpretation, context and sometimes mischief created the risk of undermining accuracy (Moseneke 2015, 33).

He closed his speech by urging media agencies and professionals to 'worship at the altar of accuracy', to avoid mistakes and misleading reporting, but also to avoid sensationalism. He was clear that he was not supporting 'media circuses' nor 'a witchhunt traipsing around in the guise of open justice', and that the courts and the media shared these responsibilities.

It is important to attend to another feature – specifically another character – that haunted the Pistorius trial in its instantaneous afterlife. While he was never named or described during the trial itself, media commentators began to write about the 'intruder' at whom Pistorius claimed he had been shooting. Early in the trial, South African journalist and crime writer Margie Orford named the spectre of 'the third body' in the trial, that of the purported 'intruder' from whom Pistorius claimed he was protecting himself, and Reeva (Orford 2014). The defence relied upon the court's acceptance that Pistorius was in fear of a dangerous stranger, and that this fear was reasonable. Orford challenged the position that intimate-partner homicide, domestic violence, and male sexual violence against women, could be obliterated by the 'chimera' of a violent black man who, on the facts, was not there and was not shot. Pistorius inhabited a world of fortress-like housing estates, armed security guards, surveillance cameras and panic buttons. He carried a gun with him, and slept with one under his bed. Orford argued that his defence relied upon an apartheid-era notion, *swart gevaar* (black peril), used to justify white violence against black South Africans. She reasoned that Steenkamp either died because of sexual violence or racial violence and that both continue to beset the psychology of modern South Africa. Likewise, for Jacqueline Rose, reviewing the case in the *London Review of Books*, whichever way you examined

the evidence, Steenkamp's death was either a sex crime or a race crime. In his book *Chase Your Shadow: The Trials of Oscar Pistorius*, the journalist John Carlin had written, 'the faceless intruder of [Pistorius's] imagination had to have a black face' (Rose 2015).

South African journalist Sisonke Msimang pointed to other racially skewed facets of the Pistorius trial (Msimang 2014). She noted that, in the courtroom next door, another case was unfolding, in which a black man, Thato Kutumela, was on trial for the rape and murder of his 18-year-old girlfriend, Zanele Khumalo – like Reeva Steenkamp, a model. However, whereas police acted upon Steenkamp's murder immediately and laid charges swiftly, Kutumela was not charged for nine months and Khumalo's family waited two years for the trial to commence. Msimang noted that, regardless of race, South African women experience the world's highest danger of intimate-partner homicide. However, she argued that race continues to matter to the way this violence is experienced, perpetrated and addressed. Importantly, she stated that the rate of violence perpetrated by strangers, or intruders, is dramatically eclipsed by that perpetrated by intimate partners.

While the objectives of the constitution were ever foremost in the mind of those who made careful and considered decisions to open the courtroom to the media, the spectacle of open justice often made it difficult to determine whether human dignity had survived in the voyeuristic and exploitative mediascape. Oscar Pistorius was paraded before the cameras at the beginning and end of each day of the hearing, often appearing frightened and exhausted. Images of him crying, rocking, crumpled in his seat, holding his head, retching and with strings of mucous coming out of his nose cannot be reconciled with his constitutional rights to dignity, equality and freedom. While it is true that the criminal courts generate intense emotions, and while open justice ought to provide an accurate account of the administration of justice, the global media celebration of these scenes was not consistent with the transformational aspirations of the constitution.

Technologies of media production remain mostly at odds with the techniques of the criminal trial, which is characterised by lengthy oral submissions, motionless personnel, disjointed narratives, delays and arcane, awkward legal terminology.[7] Traditionally, open justice has relied upon the expectation that the citizen will make the effort to attend court, observe its rituals and follow its processes. For those who make that effort, the brief moments of visceral, traumatic or true emotion are all the more poignant for the extended formality and prolixity that surrounds them. In traditional open justice regimes, dignity is maintained by only sharing intimate, humiliating or personal facts with those citizens who did make the effort to attend. By live broadcasting the trial, and offering these sensitive details to an infinite global community of strangers, there is no expectation of sustained attention, no demand that the viewer sees a courtroom incident in the time-consuming context of all the evidence. Viewers can switch the trial on and off, tune in for highlights, avoid complexity and rely upon sensational commentary. The decision to live broadcast the trial did nothing to address the court's

concerns about poor media practices, and it remains difficult to see why improving sloppy journalism should be a responsibility of the criminal justice system.

For many observers, broadcasting the trial had the effect of putting South Africa itself on trial. It enabled the international media to see peripheral but significant facets of the courts: the 'dusty, shabby, rundown' courthouse, 'not many windows', 'unclean, bare brick corridors', 'no seats on the toilets and the cubicles do not lock' (Peck 2014). However, others worried that the trial had exactly the opposite effect, by failing to provide any account of what really happens in South Africa's criminal justice system, which has the world's highest rate of spousal homicide, and epidemics of violence against women and among black people. Pippa Green observed that the 'metanarratives' that emerged from the trial coverage were the larger themes of gender violence, disability, crime and guns (Green 2014). Meanwhile, Wallace Chuma worried that the disproportionate media focus on the Pistorius trial had the effect of distorting any sense of context, with the real crises preventing South Africa's transition to democracy entirely effaced. He wrote of the unacknowledged 'backdrop of increasing social inequalities, poverty and crime, all of which raise fundamental questions about the material content of democracy two decades after the formal end of legislated racial segregation' (Chuma 2016, 330). Broadcasting the Pistorius trial did nothing to address public perceptions about injustice in South Africa, and in some quarters only served to consolidate them. Transparency and openness have the important effect of revealing uncomfortable truths about inequality and indignity, and it is these facts that continue to beset South Africa under transition.

Notes

1 For a detailed examination of open justice in South Africa and internationally, see *The NDPP v Media 24 Limited & others and HC van Breda v Media 24 Limited & others* [2017] ZASCA 97.

2 Books include Steenkamp (2014); Carlin (2014); Ferguson and Taylor (2014); Fitzpatrick (2014); Salzwedel (2014); Weiner and Bateman (2014). BBC 3 produced an hour-long documentary titled *Oscar Pistorius: The Truth*, first aired on 15 September 2014. NBC's Dateline produced a documentary, *Oscar Pistorius: The Verdict*, a digital-only release which went live on 12 September 2014.

3 Previous cases included *Dotcom Trading 121 PTY Limited v King NO and others* 2000(4) SA 973 (C); *SA Broadcasting Corporation Ltd v Thatcher and Others* [2005] 4 ALL SA 353 (C); *Midi Television (Pty) LTD t/a E-TV v Downer and Others* (D+CLD15927/04) and (D+CLD 17272/04).

4 All quotations in this paragraph are from *Multichoice (Proprietary) Ltd v National Prosecuting Authority, In Re: S v Pistorius* [2014] ZAGPPHC 37, per Mlambo JP.

5 German Criminal Code, 13 Nov 1998, Federal Law Gazette I (Bundesgesetzblatt) p. 3322, last amended by Article 3 of the Law of 2 October 2009, Federal Law Gazette I p. 3214, www.gesetze-im-internet.de/englisch_stgb/index.html. Sections 131 (Dissemination of depictions of violence) and 201a (Violation of intimate privacy by taking photographs).

6 Andrew Harding's footage can be seen at: www.bbc.com/news/av/world-africa-29152077/oscar-pistorius-a-close-look-at-scene-of-shooting. Jeff Rossen's footage can be seen at: www.today.com/video/today/56021691

7 Pistorius's defence counsel, Barry Roux, caused a viral internet sensation when he repeatedly used the phrase 'I put it to you' in his cross-examination of witnesses. It was ridiculed in a rap song on YouTube at www.youtube.com/watch?v=IlWOjuOx0sQ ['I put it to you, that it's true / everything you say, I will misconstrue / I'm Barry Roux and I put it to you / ten times in a row just to confuse you'], on Twitter (https://twitter.com/wsj/status/446246258152595456) and in multiple online memes.

References

Ackermann, Laurie (2004), 'The legal nature of the South African constitutional revolution', *New Zealand Law Review* 4, 633–79.

Associated Press (2014), 'Oscar Pistorius vomits in court as girlfriend's injuries are described', *The Guardian*, 11 March, accessible at www.theguardian.com/sport/2014/mar/10/oscar-pistorius-vomits-court-reeva-steenkamp-injuries

BBC3 (2014), *Oscar Pistorius: The Truth*, originally aired 15 September, viewed on BBC iPlayer (UK) on 1 October 2014.

Bowler, Danielle (2014), 'The commodification of Reeva Steenkamp's life', *Eyewitness News*, 28 October, accessible at http://ewn.co.za/2014/10/28/OPINION-Danielle-Bowler-The-commodification-of-Reeva-Steenkamps-life

Carlin, John (2014), *Chase your Shadow: The Trials of Oscar Pistorius*, London: Atlantic Books.

Chaskalson, A. (2000), 'Third Bran Fischer lecture: Human dignity as a foundational value of our constitutional order', *South African Journal of Human Rights* 16, 193–205.

Chuma, Wallace (2016), 'Reporting the Oscar Pistorius trial: A critical political economy reading of the mediation of the "trial of the century"', *Journal of African Media Studies* 8(3), 323–38.

eNCA (2014), 'WATCH: Pistorius's lawyers issue statement on airing of leaked footage', eNCA, 7 July, accessible at www.enca.com/pistoriuss-lawyers-issue-statement-airing-leaked-footage

Evidence Room (n.d.), 'The demonstrative evidence specialists', accessible at http://evidence-room.net/

Feeney, Nolan (2014), 'Leaked video shows Pistorius re-enact events of girlfriend's killing', *Time*, 6 July, accessible at http://time.com/2960297/oscar-pistorius-shooting-reenactment-video/

Feldman, David (1999), 'Human dignity as a legal value – Part 1', *Public Law*, Winter, 682–702.

Feldman, David (2000), 'Human dignity as a legal value – Part 2', *Public Law*, Spring, 61–71.

Feldman, David (2002), *Civil Liberties and Human Rights in England and Wales*, Oxford UK: Oxford University Press.

Ferguson, Melinda and Patricia Taylor, *Oscar: An Accident Waiting to Happen*, Johannesburg: MFBooks.

Findlay, Stephanie (2014), 'Oscar Pistorius re-enacts Steenkamp shooting in leaked video', *The Hamilton Spectator*, 6 July, accessible at www.thespec.com/news-story/4617703-oscar-pistorius-re-enacts-steenkamp-shooting-in-leaked-video/

Fitzpatrick, Marida (2014), *Die Staat vs Oscar* (The State vs Oscar), Johannesburg: Jonathan Ball Publishers.

Gifford, Gill (2014), 'Zombie stopper video breaks Oscar', eNCA, 9 April, accessible at www.enca.com/south-africa/zombie-stopper-video-breaks-oscar

Grant, James (2014), 'Legal view: Oscar Pistorius "in grave jeopardy" of being convicted of Reeva Steenkamp's murder', *The Telegraph*, 7 August, accessible at www.telegraph.co.uk/news/worldnews/oscar-pistorius/11018205/Legal-View-Oscar-Pistorius-in-grave-jeopardy-of-being-convicted-of-Reeva-Steenkamps-murder.html

Green, Pippa (2014) 'Watching the Oscar Trial channel', *The New Yorker*, 4 April, 14, accessible at www.newyorker.com/news/news-desk/watching-the-oscar-trial-channel (accessed 29 August 2017).

Harding, Andrew (2014), 'Pistorius trial: The pathologist's report', BBC, 10 March, accessible at www.bbc.co.uk/news/world-africa-26517305

Hess, Lauren (2014), 'As it happened, Pistorius trial, Day 6 Part 1', *News24*, 10 March, accessible at www.news24.com/SouthAfrica/Oscar_Pistorius/Live/LIVE-UPDATES-Pistorius-trial-day-6-part-1-20140310

Hlongwane, Sipho (2014), 'Protecting Reeva's dignity', *News24*, 10 March, accessible at www.news24.com/SouthAfrica/Oscar_Pistorius/Protecting-Reevas-dignity-20140310

Hobbs, Allyson (2016), 'The power of looking, from Emmett Till to Philando Castile', *The New Yorker*, 5 August, accessible at www.newyorker.com/news/news-desk/the-power-of-looking-from-emmett-till-to-philando-castile

Laing, Aislinn (2014), 'Reeva Steenkamp to Oscar Pistorius: "I think today is a good day to tell you that I love you"', *The Telegraph*, 15 April, accessible at www.telegraph.co.uk/news/worldnews/oscar-pistorius/10767277/Reeva-Steenkamp-to-Oscar-Pistorius-I-think-today-is-a-good-day-to-tell-you-that-I-love-you.html

Marszal, Andrew (2014), 'Oscar Pistorius murder trial: April 8 as it happened', *The Telegraph*, 8 April, accessible at www.telegraph.co.uk/news/worldnews/oscar-pistorius/10754021/Oscar-Pistorius-murder-trial-April-8-as-it-happened.html

Mokgoro, Yvonne (1997), 'Ubuntu and the law of South Africa', paper delivered at the first Colloquium Constitution and Law held at Potchefstroom on 31 October; first published by the Konrad-Adenauer-Stiftung in their Seminar Report of the Colloquium (Johannesburg 1998).

Moseneke, Dikgang (2015), 'Media coverage of the Oscar Pistorius trial and open justice', edited text of a speech, published in *Advocate (Journal of the General Council of the Bar of South Africa)* 28(2), 29–36.

Msimang, Sisonke (2014), 'How race factors into the Pistorius and Kutumela murder trials in South Africa', *Huffington Post*, 14 July, accessible at www.huffingtonpost.com/sisonke-msimang/how-race-factors-into-the_b_5325446.html

National Press Club, 'Media release: Oscar Pistorius trial commemorated as Newsmaker of the Year for 2014', 15 May, accessible at www.nationalpressclub.co.za/releases/20150515.php

News24, 'Oscar's WhatsApp message to Reeva: "Angel, please don't say anything"', *News24*, 24 March, accessible at www.news24.com/Archives/City-Press/Oscars-WhatsApp-message-to-Reeva-Angel-please-dont-say-anything-20150430

Orford, Margie (2014), 'Oscar Pistorius trial: the imaginary black stranger at heart of the defence', *The Guardian*, 4 March, accessible at www.theguardian.com/world/2014/mar/04/oscar-pistorius-trial-black-stranger-defence

Patta, Debora (2014), 'Why special treatment for Pistorius harms media freedom', *Channel 4 News* (UK), 10 March, accessible at www.channel4.com/news/oscar-pistorius-south-africa-debora-patta-press-freedom

Peck, Tom (2014), 'The trial next door: Oscar Pistorius gets the headlines, but what about Thato Kutumela?' *The Independent*, 16 March, accessible at www.independent.co.uk/

news/world/africa/the-trial-next-door-oscar-pistorius-gets-the-headlines-but-what-about-thato-kutumela-9194821.html

Rice, Simon (2014), 'Oscar Pistorius trial: Cricketer Herschelle Gibbs tweets "lol #neveradullmoment" after autographed bat is used as evidence', *The Independent*, 12 March, accessible at www.independent.co.uk/sport/cricket/oscar-pistorius-trial-cricketer-herschelle-gibbs-tweets-lol-neveradullmoment-after-autographed-bat-9186413.html

Roane, Brendan (2014), 'Leaked video throws Oscar a lifeline', *IOL*, 7 July, accessible at www.iol.co.za/news/crime-courts/leaked-video-throws-oscar-a-lifeline-1715620#. VGCi2b6M9SV

Rose, Jacqueline (2015), 'Bantu in the bathroom', *London Review of Books* 37(22), 3–10.

Rösler, Hannes (2008) 'Dignitarian posthumous personality rights – an analysis of U.S. and German constitutional and tort law', *Berkeley Journal of International Law* 26, 153–205.

Sachs, Albie (2007), 'Enforcement of social and economic rights', *American University International Law Review* 22(673), 745–99.

Salzwedel, Ilse (2014), *Van Sprokie tot Tragedie in die Kolleg* (From Fairytale to Tragedy in the Spotlight), Penguin (Kindle edition).

Sims, Alexandra (2016), 'Reeva Steenkamp: Photos of Oscar Pistorius' girlfriend's dead body released to the public', *The Independent*, 15 June, accessible at www.independent. co.uk/news/world/africa/reeva-steenkamp-pictures-of-oscar-pistorius-girlfriend-s-dead-body-made-public-after-judge-approves-a7084386.html;

Smith, David (2014a), 'Oscar Pistorius vomits as Reeva Steenkamp wounds described in court', *The Guardian*, 11 March, accessible at www.theguardian.com/world/2014/ mar/10/oscar-pistorius-vomits-reeva-steenkamp-shooting

Smith David (2014b), 'Oscar Pistorius recoils in court at grisly photograph of dead girlfriend', *The Guardian*, 8 April, accessible at www.theguardian.com/world/2014/ apr/09/oscar-pistorius-trial-forced-photograph-reeva-steenkamp-head

Smith, Emily (2014), 'Messages between Oscar Pistorius and girlfriend read in court', *CNN*, International edition, 24 March, accessible at http://edition.cnn.com/2014/03/24/ world/oscar-pistorius-trial-whatsapp-messages/index.html

Smith, Tymon and Graeme Hosken (2014), 'The Oscar Pistorius murder trial Day 6', *TIMES Live*, 10 March.

Steenkamp, June (2014), *Reeva: A Mother's Story*, London: Sphere.

Thamm, Marianne (2016), 'The images of Reeva Steenkamp's corpse invade her privacy, even in death', *The Guardian*, 17 June, accessible at www.theguardian.com/ world/2016/jun/17/the-images-of-reeva-steenkamps-corpse-invade-her-privacy-even-in-death

Tran, Mark (2014), 'Oscar Pistorius trial – live 9 April', *The Guardian*, 9 April, accessible at www.theguardian.com/world/2014/apr/09/oscar-pistorius-trial-live-9-april

Weiner, Mandy and Barry Bateman (2014), *Behind the Door: The Oscar Pistorius and Reeva Steenkamp Story*, London: Macmillan.

WildAboutTrial.com (2014), 'Oscar Pistorius Trial Day 6 Part 1', accessed 7 October 2014, accessible at http://new.livestream.com/wildabouttrial/events/2811169/videos/ 47393958

YouTube (2014), 'Oscar Pistorius Murder Trial Day 6 Part 2', You Tube, 10 March, accessible at www.youtube.com/watch?v=G8xlFVC6WjQ

Cases

Dawood & Another v Minister of Home Affairs & Others, Shalabi & Another v Minister of Home Affairs & Others, Thomas & Another v Minister of Home Affairs & Others [2000] ZACC 8; 2000 (3) SA 936 (CC); 2000 (8) BCLR 837 (CC) (*'Dawood, Shalabi & Thomas v Minister of Home Affairs'*).

Dikoko v Mokhatla (CCT62/05) [2006] ZACC 10; 2006 (6) SA 235 (CC); 2007 (1) BCLR 1 (CC) (3 August 2006).

Director of Public Prosecutions, Gauteng v Pistorius (96/2015) [2015] ZASCA 204 (3 December 2015) (*'DPP v Pistorius'*).

Director of Public Prosecutions, Gauteng v Pistorius (950/2016) [2017] ZASCA 158 (24 November 2017).

Ex parte Minister of Safety and Security: In re S v Walters [2002] (2) SACR 105 (CC).

Multichoice (Proprietary) Ltd v National Prosecuting Authority, In Re: S v Pistorius [2014] ZAGPPHC 37 (*'Multichoice v NPA'*).

National Coalition for Gay and Lesbian Equality & Another v Minister of Justice & Others [1999] (1) SA 6 (CC), 1998 (1) BCLR 1517 (CC) (*'National Coalition for Gay and Lesbian Equality v Minister of Justice'*).

NDPP v Media 24 Limited & others and HC van Breda v Media 24 Limited & others [2017] ZASCA 97 (*'NDPP v Media 24 Ltd'*)

NM & Others v Smith & Others (CCT69/05) [2007] ZACC 6; 2007 (5) SA 250 (CC); 2007 (7) BCLR 751 (CC) (4 April 2007).

S v Makwanyane [1995] (CCT 3/94) 1995 (3) SA 391.

S v Mamabolo [2001] (3) SA 409 (CC).

S v Walters [2002] (CCT 28/01) 2002 (4) SA 613 (CC)

5 The museum
Curating evidence

In 2015, the Wellcome Collection in London staged an exhibition called *Forensics*. Subtitled 'The anatomy of crime', the exhibition explored the history of forensic science techniques as tools of criminal investigation, and included many objects, images and ephemera from that history, as well as cultural and creative works made from and about forensic criminal materials. The exhibition was always crowded, and the associated events were booked out quickly. The museum bookshop offered a large selection of books and gifts with a forensics theme, including scholarly work, lavishly illustrated books of photographs and a trove of crime fiction.

Forensics drew attention to the tendency of both science and art to visualise their responses to crime. Whether visually capturing crime scenes, portraying the results of scientific analysis, rendering visible the invisible traces of crime or materially presenting the artefacts or remnants of a crime, police and forensic investigation rely upon the visual register to make sense of evidence. Described by one reviewer as 'something of a black museum of evidence', *Forensics* was explicit in its exhibition of death and violence, human remains and traces.

The exhibition was arranged according to five themes, which more or less followed the criminal process chronologically: the crime scene, the morgue, the laboratory, the search and the courtroom. Typical of the Wellcome Collection's approach to science curation, *Forensics* contained a large body of artwork that paralleled its theme.

In one of the museum's cabinets, visitors could see a little jar of maggots floating in formaldehyde, retrieved from the mutilated bodies of Dr Buck Ruxton's homicide victims in 1935. These maggots had formed part of the vanguard of forensic entomology, having been used – apparently for the first time – to determine a time of death. Eighty years later, in their afterlife, they are held in the collection of the Natural History Museum. In another room sat a large postmortem table, or slab, made in 1925 by Royal Doulton and last used in 1944 at the Rotherhithe Mortuary. There were human remains, including a human kidney with stab wounds displayed alongside the knife used in the attack. Other human body parts showed bullet wounds – in the scalp, the skull, the brain. On display was one of the DNA swab kits distributed to Glasgow bus drivers in 2006, enabling them to gather evidence when they were spat on by passengers.

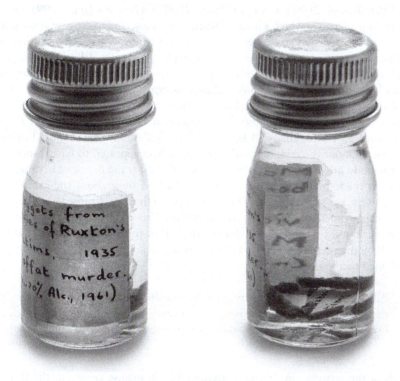

Figure 5.1 Maggots from bodies of Ruxton's victims. NHM Images. © The Trustees of the Natural History Museum, London.

There was an exhibition case dedicated to the 'Dr' Hawley Crippen case, in which Crippen and his lover were on trial: he, for the murder of his wife, Cora; she, for complicity in the crime. The display included histology slides of abdominal scar tissue from his victim, whose identity was disputed, as well as documents and photographs from the police file. That case relied upon evidence presented by the celebrated pathologist Sir Bernard Spilsbury, using techniques of forensic pathology and toxicology to secure Crippen's conviction, exhibits of which survive in the museum today. In another area, visitors could listen to an episode of the radio show 'The Black Museum' narrated in 1951 by Orson Welles, a dramatisation of the notorious 1915 'Brides in the Bath' murders case in which George Smith was convicted of drowning three of his wives for financial benefit. Dogged forensic experimentation by Spilsbury, who used female divers to test various methods of drowning, enabled him to determine Smith's technique. *Forensics* also included a selection of Spilsbury's index cards, recording almost 7,000 pathological investigations, which the Wellcome purchased in 2008 at a Sotheby's auction (BBC News 2008). The exhibition included a continuous screening of clips from popular films – *Madeleine* (1950), *Anatomy of a Murder* (1959), *Trial*

and Retribution (2007), *Criminal Justice* (2008), *Garrow's Law* (2009) – each portraying a scene in which a medical witness was subjected to cross-examination. Many of these evidentiary objects were on loan from permanent collections at public institutions including the National Archives, the Royal London Hospital Archives and Museum, the National History Museum, the Science Museum and Barts Pathology Museum at Queen Mary University London.

One weekday lunchtime, I took a colleague along for a public tour of the exhibition, led by one of the curators, Lucy Shanahan.[1] A surprisingly eclectic group of around 25 people followed her around the galleries; some disclosed tightly held views about the criminal justice system, others appeared to have joined the tour with no prior knowledge. Shanahan had chosen as the theme of her tour the artworks made by female artists, richly represented throughout the exhibition. Collectively, she said, this body of work reflected a 'human impulse to make sense of shocking violence'. She observed that all the artists had had a close relationship with crime and forensics. They did not undertake this work lightly or casually; each brought a sense of urgency or intensity to her art practice. As Shanahan had explained to a journalist:

> All of [the artists] have a very close relationship with the subject matter. It's not a voyeuristic interpretation, and for me it was about getting to the real lives and real human stories, and making sure we didn't lose sight of that.
>
> (Saner 2015)

Each of the artworks in *Forensics* attempted to humanise crime. In the face of voluminous evidence, most of these works sought to shift crime into an individual register. Some focused on the body upon which crime is committed, others on spaces within which crime occurs. Some attended to scale so that crime, otherwise overwhelming, might be brought down to size so it could be encountered and apprehended.

Of the impact of curating the exhibition, which Shanahan spent several years researching, she said:

> There are a few books – some included in the exhibition – which I first opened and then closed again very quickly. I think over the years I did probably become slightly desensitised, but there were always things I saw and knew that was where the line had to be drawn. We did not need to see that in the exhibition.
>
> (Kennedy 2015a)

For Shanahan, it was important to focus upon the victims of crime and their loved ones, and sometimes also the accused, particularly those wrongfully convicted. The role of the artworks was to find a channel to express the complexity and the emotion involved in the story of forensic evidence.

Our tour began with one of Frances Glessner Lee's Nutshell Studies of Unexplained Death; these, the focus of Chapter 2, are doll's house-sized crime

scenes made for the purpose of instructing police detectives in the techniques of criminal investigation. Commending it for its 'rigour and thoroughness', Shanahan also spoke of Corinne May Botz's photographs of the nutshells – some of which were also included in *Forensics* – which, by magnifying details within the doll's houses, achieved a focus on the home lives of women, and particularly domestic violence. According to art journalist Laura Cumming, 'three-dimensional staging' of the crime scene enables the viewer to 'see everything at once' in a way photographs, diagrams and scientific analyses cannot (Cumming 2015). The inclusion of a nutshell in the Wellcome exhibition was a rare coup, as before their 2017 showing at the Smithsonian they had never been exhibited outside the Medical Examiner's Office in Baltimore. The nutshell at the Wellcome was unfinished, and thought to portray a murder staged to look like a fatal alcohol binge. Lee was said to have been working on it at the time of her death (Cain 2015; see also Jensen 2015).

Also represented in the exhibition were images by Angela Strassheim from her *Evidence* series (2008–09). Strassheim had trained as a forensic and biomedical photographer, taking photographs at crime scenes and autopsies and during police investigations. In the photographs from *Evidence*, Strassheim had visited homes that had been the scenes of homicides and, using a chemical reagent called

Figure 5.2 Evidence #11, 2009, 48" × 60", archival pigment print. Courtesy of Angela Strassheim.

Figure 5.3 Evidence #8, 2009, 48" × 60", archival pigment print. Courtesy of Angela
 Strassheim.

BlueStar, which is similar to luminol, was able to illuminate the presence of blood
that was no longer visible to the naked eye. BlueStar produces a temporary blue
glow wherever latent blood proteins are present, even after cleaning and repaint-
ing. Strassheim reduced natural light at these crime scenes, closing doors and
curtains, and shot long exposures using colour film, because of the short-lived
illumination of blood BlueStar achieves. These were converted to black-and-white
images during digital post-production (Brook 2010). By bringing back into the
visible register the traces of real crimes, Strassheim was reviving what the curator
described as the 'memory of past acts of violence', but doing so in a manner that
conveyed the 'strange, ethereal beauty' of crime scenes.

Critics have described Strassheim's *Evidence* photographs as 'beautiful, eerie'
and 'uncanny' (Saner 2015; Best 2013). While Strassheim had the support of
crime scene specialists, including the CEO of BlueStar, during her project, some
forensic scientists challenged her claims that what she had illuminated in her pho-
tographs was, in fact, blood. BlueStar also achieves luminance through contact
with other substances, and so her title – *Evidence* – points to the entanglement of
interpretation and imagination in fact-finding processes. Strassheim visited 140

homes and negotiated access to 18 of them, with many of the current occupants unaware that these were the sites of earlier homicides. One home was the site of a homicide only two months earlier. Others had occurred as much as 54 years prior to the photographs; describing the effect of the BlueGlow reaction, she wrote: 'All around me I observe a glowing trail of bloodshed as swaths and constellations of light, helping me put together the pieces of a violent puzzle' (Brook 2010). Of course, Strassheim's work is not 'evidentiary' in the forensic sense of that term, and she is not seeking to solve a crime or bring wrongdoers to justice. To a large extent, her project is to situate crime within benign domestic interiors, homes that no longer bear the visible signs of criminal violence, but are nevertheless now crime scenes in perpetuity. Her use of BlueGlow draws attention to the fragility of efforts to clean the scene. Some of her photographs refer in their titles to the weapon used, which also achieves the effect of making homicide banal and domestic: *Evidence (small rod, kitchen knife)*, (2009); *Evidence (gun, type unknown 1)*, (2009); *Evidence (scissors, clock radio cord, large fan)*, (2009); *Evidence (shotgun, hands)*, (2009), and so on.

While it was not examined in the tour, the labour of cleaning crime scenes is hidden, difficult, visceral work, frequently done by women, and deliberately effaced from the narrative of crime investigation or aftermath (see e.g. Krasnostein 2014). Cleaning up after crime is regarded as occurring outside, or after, the evidentiary process, although an essential stage in crime's afterlife. Of police officers I have spoken to, only women mentioned the work, including cleaning, they had done to make violent crime scenes more presentable, but most of this labour of erasure was, itself, invisible. One female former detective reminded me of the 2013 Australian television series *Mr and Mrs Murder*, about a couple who clean crime scenes and, in doing so, solve murders (Ten.com.au 2013). The same former detective reminded me that Bruce Morcombe, whose son Daniel was abducted and murdered by a paedophile in 2003, took great exception to the premise of the program; he criticised it for trivialising murder and fuelling voyeurism, saying, 'You don't have TV shows called Mr and Mrs Rape or Mr and Mrs Child Molester, so why do we put up with this?' (Williams 2013). Mexican artist Teresa Margolles, who was represented in *Forensics*, also made 'What Else Could We Talk About? *Cleaning*' for the 53rd Venice Biennial in 2009, in which the Mexican Pavilion was mopped, daily, with a mixture of water and blood from people murdered in Mexico (Scott Bray 2011, 945).[2] This work was intended to draw attention to the demanding, continuous and sad work of crime scene rehabilitation.

Next, our tour group gathered around Margolles's work, *32 años (Suelo donde cayó el cuerpo asesinado del artista Luis Miguel Suro)* [32 Years (Floor where the murdered body of the artist Luis Miguel Suro fell)], 2006. The work is a section of a tiled studio floor on which Margolles's friend, 32-year-old artist Luis Miguel Suro, was murdered in 2004 in Guadalajara. While it had been perfunctorily wiped, the blood smears and paint stains remain apparent. This piece of the floor was extracted from Suro's art studio, and the hole it left behind

serves as an indelible excavation and a reminder that the perpetrators of his murder have not yet been brought to justice. Margolles was trained as a forensic pathologist, working in morgues in Northern Mexico. She was co-founder of the SEMEFO artists' collective, taking its name from the Mexican coroner's office, Servicio Médico Forense. Their work critiqued criminal and state violence in Mexico and was marked by the use of materials, including human remains, associated with death, autopsy and criminal investigation. Margolles was represented in the *Forensics* exhibition by two other works. One of these was *PM 2010* (2012), made from 313 front pages collected from a tabloid newspaper in Ciudad Juárez during 2010, all graphic images of people bludgeoned, shot and decapitated in Mexico's drug wars. Many of these front pages included, alongside the dominant image of the murder victim, a smaller colour photograph of a topless female model, presumably promoting the inclusion of a larger and more revealing photograph within the newspaper. Whether Margolles is drawing our attention to the celebration of violent death, or the conflation of pornography and murder, or the complicity of us all in the drug trade, the inclusion of her work in the *Forensics* exhibition, and our lunchtime tour, had precisely the desired effect of making us uncomfortable with these juxtapositions.

Figure 5.4 Teresa Margolles, *32 años (Suelo donde cayó el cuerpo asesinado del artista Luis Miguel Suro)* [32 Years (Floor where the murdered body of the artist Luis Miguel Suro fell)], 2006. 105 ceramic tiles, metal frame. 200 × 200 × 1 cm (78 ¾" × 78 ¾" × 3/8"). Courtesy the artist and Galerie Peter Kilchmann, Zurich. Exhibition view: 'Artes Mundi – Wales International Visual Art Exhibition and Prize', National Museum Cardiff, Cardiff, UK, cur. Ben Borthwick, 2012. Photo: Amgueddfa Cymru.

Our guide then indicated several headphones hanging from hooks on a wall, Margolles's third work in Forensics. Titled *Sonido de la primora incision toracica durante la autopsia, a una victim de asesinato (sonidos de la morgue)* [Sound of the first thoracic incision during the autopsy of a murder victim (sounds of the morgue)] (2006), it is a 66-minute audio recording of an autopsy. Warning us that this work was 'not for the faint hearted', Shanahan reflected on the 'intimate' experience of listening, and the tendency we have, given no visual references, to fill these gaps with imagination. This work offers up the gurgling, bubbling and splashing sounds of the autopsy, distant sirens and traffic a backdrop for more immediate sounds of cutting, slicing and hacking.

Margolles is well known for making artworks that generate a lingering afterlife for the evidence of crimes. Working with blood, body parts, broken glass, clothing, mortuary products, earth collected from crime scenes and myriad other traces of criminal violence, her work draws attention to the overwhelming abundance of evidence generated by crimes that are never investigated, solved or punished. Her work points to the complicity of all of us in these crimes, in a geopolitical complex in which the global drug trade flourishes, leaving countless corpses in its deadly wake (Scott Bray 2007; Scott Bray 2011). These works preserve and activate the evidence of crimes that the law has failed to adjudicate. Many of the corpses in Margolles's work are anonymous and unidentified; many of the materials from which her work is made had been discarded before she retrieved them for her art practice (Scott Bray 2007). This draws attention to the socio-political discourses of 'disappearance' that are commonly invoked in Mexico but are, in fact, acknowledged to be widespread practices of state criminality around the world, and which are crimes against humanity. Margolles not only materialises the disappeared through the presentation of objects and artefacts, she also materialises them sensorily. As described in the work of Rebecca Scott Bray, some of Margolles's artworks smell, sometimes putridly; some work releases vaporised water that lingers in the air and which can be aspirated or even ingested by museum visitors, or is released as bubbles floating in the gallery and popping on visitors' skin (Scott Bray 2007). For Scott Bray, Margolles's work is evidence of 'juridical failure', cases 'unresolved by law', but which are, nevertheless, probative of 'forensic compassion' (Scott Bray 2007, 27, 34). This seems the crux of Margolles's inclusion in *Forensics*, and also in the work of all the women artists represented in the exhibition.

Our tour group moved towards Sally Mann's photographs from her series *What Remains* (2000–04). These document Mann's unfettered access to the Forensic Anthropology Center at the University of Tennessee Knoxville, known as 'The Body Farm'. A scientific facility devoted to the study of human decomposition, Mann's images portray dead bodies cast into the woods, some clothed but mostly naked, in various stages of decay: some clearly freshly deceased, some little but skeletal remains. In the *Forensics* exhibition, Mann's photographs appeared in the context of forensic entomology, the study of insect activity upon human remains. For one critic, *What Remains* 'explores the nuanced and uncertain boundaries between landscape and memory, life and death' (Shinkle 2010, 52);

for another it confirmed Mann's 'unsqueamish' view of the world (Morrison 2010); and yet another called the body farm images the 'most disgusting' of Mann's oeuvre (Boxer 2004). Mann's photographs of corpses might be seen as portrayals of the end-stage of life, following on from her most famous and controversial work (the *Immediate Family* series) documenting childhood. One reviewer wrote, 'remarkable was the fact that no one questioned her right to publish the photos' (Morrison 2010), although another described her as a 'grave robber' guilty of 'violation of the privacy and decency of the dead' (Boxer 2004).

Reflecting on the vulnerability of the dead, and their inability to consent to photography, Mann said,

> In life, those people had pride and privacy. I felt sorry for them. I thought if they knew I was taking photos, without them having a chance to comb their hair or put their teeth in, they'd die of shame. So I expected critics to ask: is this right?
>
> (Morrison 2010)

Her concerns were compounded by her discovery that, while most of those whose corpses ended up at the body farm had formally donated their bodies for scientific research, some had not. Some of these bodies were those of deceased homeless people, and this gave Mann pause. While even those who had given consent would, in her view, have expected their bodies to be photographed in a manner that was 'scientific, not artsy-fartsy', her realisation that some of the bodies came from involuntary subjects made her reluctant to make them identifiable or undignified after their death. She said, 'I decided to keep the subjects anonymous. I didn't want to aestheticise them, either. It was important to treat them with respect' (Morrison 2010).

An important section of *Forensics* examined the role of forensic science in examining mass graves for evidence of war crimes. Our group watched a video interview with Professor Sue Black, a forensic anthropologist who led a team of investigators in Kosovo, working on behalf of the United Nations to identify civilian victims of the Kosovo War in the 1990s. Black spoke of the importance of helping the living by identifying the dead, and of the immense compassion that she said might explain why women, in particular, are drawn to forensic professions.

Included in this section of the exhibition is a major work by Šejla Kamerić, titled *Ab uno disce omnes* ('From one, learn all'), which was commissioned by the Wellcome Collection specifically for the *Forensics* exhibition. The work is contained within a large mortuary fridge which visitors must enter, and which emits the thrumming sound of a motor. Once inside they are presented with randomly generated files, documents, images and footage from Kamerić's research in the Bosnian war of 1992–95 and its aftermath. The work, and Kamerić's engagement with her evidentiary sources, is described in detail in Chapter 7.

Our tour group moved to another part of this room, towards a work by Jenny Holzer titled *Lustmord* (1993–94). Also responding to the Bosnian war,

Holzer sought to address rape, which was first established as a war crime by the International Criminal Tribunal for former Yugoslavia (ICTY). The ICTY, in the trial of Duško Tadić, convened the first international war crimes trial involving accusations of sexual violence, which arose from allegations of systematic sexual violence against men.[3] The ICTY then repeatedly heard cases alleging sexual violence against women, and achieved the first international convictions for rape as a form of torture, recognising sexual enslavement as a tool of war and linking rape with ethnic cleansing and genocide. It also convicted offenders for rape as a crime against humanity. Of the 161 accused tried by the Tribunal, 78 (48 per cent) involved charges of sexual violence (United Nations International Criminal Tribunal for the former Yugoslavia 2016).

Lustmord ('sexual murder') presents three perspectives of the crime: the perpetrator, the victim and the witness. The work itself comprises three poems, a table of human bones, and photographs. Lines of Holzer's poetry are engraved on silver rings which are wrapped around fragments of human bones. These bones are displayed in long, neat rows across a large table, organised taxonomically, by size. The largest bones – presumably human femurs – are arranged furthest from where the viewer stands, at the far end of the table. At the closest edge of the table is a long line of human teeth, molars. Holzer was said to have purchased the bones from a dealer in New York, and they were not associated with the victims of the Bosnian war. Not all the bones have a silver ring, but viewers cannot look too closely at them because a barrier prevents the viewer getting too close to the table. Viewers who wish to read the text on the silver bands are directed to the museum's website, which includes the following text: 'Trigger warning: this post contains mentions of sexual violence' (Wellcome Collection 2015).[4] Holzer's poetry shares some attributes with her earlier work, in which she displayed large illuminated texts in public sites, usually articulating political and feminist sentiments. The *Lustmord* poems, however, are tiny and difficult to read and, regardless of the perspective they take, their content – which the Wellcome website describes as 'ambiguous and subtle' – is actually violent and dreadful.

Our tour concluded in a final room devoted entirely to three large photographs by Taryn Simon, from her series *The Innocents* (2000–03). Curator Lucy Shanahan included these to raise questions about the fallibility of evidence. Most of the people portrayed in *The Innocents* were convicted on the basis of eyewitness testimony and later acquitted when DNA analysis proved they could not have been the perpetrator. For Shanahan, this work pointed to the importance of forensic science in achieving acquittals; however, it also leaves the visitor with a lingering anxiety about miscarriages of justice.

Simon commenced *The Innocents* in 2000 in collaboration with the Innocence Project, which was founded at Cardozo Law School. The Innocence Project uses evidence that was unavailable or not admitted at trial – primarily derived from DNA – to exonerate people wrongly convicted. Simon photographed and interviewed people who had been acquitted through this process. She photographed them in a setting that had acquired significance during the criminal process: the crime scene, the scene of their arrest, their alibi location or the courtroom. Her

entire project – the photographs and accompanying text – was first exhibited in 2003 at P.S.1 in New York, and was published as a book (Simon 2003). For Simon, the project was largely intended to show the dangers of photography in achieving just outcomes. Photographs, particularly mug shots, were misused in many of the cases to obtain erroneous identifications from victims and eyewitnesses. By photographing her subjects in crime scenes, sometimes in transgressive poses, knowing that they were not *there* at the time of the crime, she was pointing out the manipulability of the visual register and the complexities of evidence and proof. She wrote, 'Photographing the wrongfully convicted in these environments brings to the surface the attenuated relationship between truth and fiction, and efficiency and injustice' (Simon 2003, 7; see Biber 2006).

Her photographs are formally composed, carefully constructed and saturated with colour. They look nothing like evidentiary photographs. Rejecting the form, technique and equipment of crime scene photography, they are probably evidence's counterpoint; they are the opposite of evidence. Evidentiary photographs are intended to capture proof of guilt; Simon's photographs show us what innocence looks like. On the cover of her accompanying publication, Simon arranged into a grid 45 thumbnail photographs of innocent people taken to look like mugshots. Inexpressively staring at the camera, these people – 44 men and one woman – were posed to look like criminals. But inside the book, each posed in their own wrongful crime scene, their heterogeneity is striking. Innocence doesn't look like anything in particular; it can occur in any landscape, any type of room, wearing any kind of clothing. Innocence appears at any time of day or night. All that guilt and innocence have in common is evidence. Simon's project teaches us that evidence makes mistakes, and evidence sometimes corrects them.

This work represents a larger move – within the visual arts but also, more broadly, within museum culture and cultural criminology – to scrutinise the relationship between crime and photography. From its inception, photography has had evidentiary uses. Since at least the middle of the nineteenth century, photographs have been given evidentiary uses in policing and prosecution; these are described further in Chapter 1. Prompted by a re-examination of Susan Sontag, this work challenges her claim that it is the 'muteness' of photographs that makes them so desirable (Sontag 1977, 24). While Sontag sought to expose the role of images in the aestheticisation of lived experience, Simon's images prove that photographs are not mute: they testify, they corroborate, they contradict. The problem with photographs – the *forensic* problem with photographs – is that, despite popular belief that they are self-evident, evidentiary photographs do not speak for themselves. For John Tagg, a historian of photography, '[t]o serve as evidence and record, the image had to be said to speak for itself, though only qualified experts could read its lips' (Tagg 1992, 129). Criminologist Alison Young said that 'crime's images should be imagined as a response; that is, part of a dialogue that is always already taking place' (Young 1996, 16). For Roland Barthes, the photograph's role was to ratify what existed in our consciousness; for Pierre Bourdieu, the photograph was an accompaniment to memory and recollection (Barthes 1981, 85; Bourdieu 1990, 22).

And so, despite contemporary social and juridical assumptions to the contrary, forensic photographs demand either captions or champions.

For legal scholar Richard Sherwin, the 'aesthetic gratification' we experience when we encounter evidentiary images pushes us swiftly – *too* swiftly – towards 'the natural human craving for certainty' (Sherwin 2011, 112), with the result that, in the words of Michael Pardo, 'the visual persuasiveness of the evidence may not track its epistemological warrant' (Pardo 2011, 135). The danger, in Sherwin's analysis, is the probative value of images being over-estimated by jurors, legal counsel, judicial officers or the public, all acculturated to conflate seeing with believing.

Pardo reminded us that trial narratives, including those illustrated with visually persuasive material, remain constrained by the evidence, and the rules of evidence. Legal participants know – or are required to believe – that 'events in the real world' do not unfold with cinematic coherence; evidence 'resists the sheer coherence of art' (Pardo 2011, 143). Law generates legal fictions that hold its doctrines together. As Pottage and Mundy wrote, all of law's participants suspend disbelief and proceed on the assumption that these fictions fill the gaps 'between legal propositions and the "things" to which they refer' (Pottage 2004, 13). Viewing evidentiary photographs demands a similar response, an urge to form narratives from jumbled clues and fragments.

In Taryn Simon's photographs, her inclusions are not bound by the laws of evidence, but they are nevertheless probative. A large part of the reason her photographs are so persuasive is their striking beauty. In this respect they differ from literal evidentiary photographs, which, in the words of Luc Sante, are sometimes marked by 'certain off-register kinds of beauty' (Sante 2013, 72), although Sante and others have cautioned strongly against appreciating evidentiary photographs aesthetically. Cultural criminologists have, however, considered the importance of aesthetics in criminal practice and discourse. For Jack Katz, cultural criminology itself can be seen as a study of the aesthetic and emotional attractions of the criminal experience (cited in Lyng 2004, at 361), and Jeff Ferrell observed that '[t]he esthetic of criminal events interlocks with the political economy of criminality' (cited in Hayward and Young 2004, at 267). *The Innocents* cautions us about the two sides, the power and the danger, of aesthetic judgment. Simon wrote of her project, 'As I got to know the men and women in this book, I saw that photography's ambiguity, beautiful in one context, can be devastating in another' (Simon 2003, 7).

The Innocents also functions as a rebuke to post-structural theories of crime and deviancy. Each of the subjects in *The Innocents*, posing in a site of criminal significance, looks as if he or she *belongs* there. The fact that he or she *was not* there remains important to assert. The criminal justice system relies upon the articulation of key binaries: innocent/guilty, normal/deviant, true/false, probative/irrelevant. While some cultural criminologists have expressed fatigue or scepticism about the value of these binaries (see e.g. Morrison 1995, 309), or pointed to their social constructed-ness, *The Innocents* warns us against accepting the view that there is no difference between an innocent person and a criminal deviant. For each of the subjects portrayed in this project, the difference was crucial.

Simon's photographs, encountered in the final room of *Forensics*, leave us with the lingering and dreadful sensation of evidentiary innocence. It is important that her photographs are accompanied by captions, and by the testimony of each of her subjects (also reproduced in her book). These people are crime's victims. The perpetrators who victimised them are not portrayed, nor (with one exception) can we see the victims of the crimes they were wrongfully accused of committing.[5] For the most part, the perpetrators of these crimes are overworked, incompetent, under-funded or corrupt agents of the criminal justice system, and the inanity of their crimes is impossible to visualise. In the absence of clear evidence of these crimes, Simon's work is an important contribution to the afterlife of evidence. It reminds us of the trauma caused by the misuse and misinterpretation of evidence.

Several months after the *Forensics* exhibition closed, the Museum of London opened its own exhibition titled *The Crime Museum Uncovered*. The Crime Museum is the name given to the collection held by London's Metropolitan Police at New Scotland Yard. Colloquially known as the 'Black Museum' – a name the curators today explicitly disavow – and described as 'the world's most famous and least visited' museum (Kennedy 2015b), the Crime Museum is closed to the public. Founded in the 1870s, it contains the accumulated objects collected by the Metropolitan Police primarily for the purpose of being viewed by other police personnel. In the Met's own narrative, the origins of this accumulation of objects were legislative:

> The Prisoners Property Act of 1869 gave authority for police to retain certain items of prisoners' property for instructional purposes, but it was the opening of the Central Prisoners Property Store on 25th April 1874 that provided the opportunity to start a collection.
>
> (Metropolitan Police 2015)

It was not until later, in 1874, that this collection was conceived as a museum, and the first record of any visitors was not until 1877, when the Commissioner, Sir Edmund Henderson, KCB, visited with other senior police and dignitaries and the first visitors' book was inaugurated. Since 1981, the collection has been crammed into two rooms, and since 2003 it has played a role in the Met's Crime Academy as a formal site of police instruction.

The Museum of London was charged with curating an exhibition *about* the Crime Museum, drawing on objects held in that collection, but also educating visitors about the institution from which they are drawn. While the Crime Museum has gained notoriety for its inaccessibility, a surprisingly large number of civilians have gained access to it, including a fair representation of legal professionals and criminologists. Prior to the opening of the exhibition at the Museum of London, the journalist Peter Watts, from *Time Out London*, was given a private tour of the Crime Museum at New Scotland Yard, and his report of it

conveyed both the sobering reality of the collection and its self-perpetuating mystique (Watts 2009). He described the curator, who 'doesn't want to be named, photographed or quoted', but who conducted what was plainly a well-rehearsed dramatic tour of the collection, combining ghoulish, voyeuristic, pragmatic and pedagogical effects. The museum contains evidentiary materials from criminal cases, as well as disguised weapons and items used to attack police. For Watts, the museum 'works on two levels': one allows police 'to see and handle actual evidence and learn how it was used to solve cases'; the other is psychological, 'showing the police what the people out there will do to them'. He wrote that it is 'clearly a museum by the police, for the police', and it does not attempt to cushion the blow of its impact for visitors. Watts described his visit as a 'chilling, unsettling experience', observing that the museum sat somewhere in the middle of the spectrum of 'self-chosen prurience' and 'necessary horror' (Watts 2009). As a public and mainstream museum, the Museum of London unapologetically targets the middle of the spectrum. As this chapter demonstrates, finding the appropriate middle ground can be difficult. One museum journalist noted that 'there is a clear market for exhibits of this nature' – citing crime, policing or penal museums across the United Kingdom – but he cautioned that 'if handled without full preparation for their reception, they can backfire' (Sharp 2016, 22). By this he meant the danger that such displays could be insensitive to victims of crime, could sensationalise crime and violence, or could overlook the complexities and histories of justice and transgression.

I spoke to two Museum of London staff while they were still preparing the exhibition – Annette Day, head of programmes, and Finbarr Whooley, director of content – and was struck by the degree to which they considered questions of ethics, voyeurism, legality and affect. They thought deeply about what they might show, and how they might show it. There were things they told me they could or would not show, but felt they needed to explain to visitors why some items were not on display. For these curators, the exhibition was not only to show evidentiary items held by the Crime Museum; it was about the Crime Museum *itself*, as an institution, and the ongoing challenges and debates about preserving crime's afterlife. The exhibition told the story of crime and police investigation, but also of a museum that cannot be visited by most people; the curators included the visitors' book from the Crime Museum, identifying past visitors including Sir Arthur Conan Doyle, Harry Houdini, Gilbert and Sullivan, Laurel and Hardy, King George V and other royalty (Kennedy 2015b).

The Greater London Authority, which is led by the Mayor of London, governs policing in the Greater London area, and is responsible for the Crime Museum as well as other policing collections, which include a vehicles collection, a river police collection, a mounted police collection, a general collection of historical, uniforms and weapons, records and photographs, and separate counter-terrorism and forensics collections. The exhibition was initially proposed by the Museum of London, which then began a complex collaboration with the Metropolitan Police Service and the Mayor's Office for Policing and Crime. Throughout this process, they drew upon the expertise and involvement of the London Policing

Ethics Committee, in a process chaired by a professor of law and ethics, Leif Wenar. There was ongoing consultation with the Victims' Commissioner, a series of committees oversaw the process and a range of focus groups were convened to capture civilian responses, resulting in the selection of objects for the Museum of London to curate.

The culmination of this process was an exhibition of around 600 objects and artefacts from the 2,000 held at the Crime Museum. It included weapons, nooses, drugs and poisons, ingenious devices, bombs, disguises, documents, counterfeit currency, photographs, police investigation equipment, death masks. One report describes the 'gruesomely banal objects' within the exhibition, which included everyday objects and artefacts used or found in the context of crime (Kennedy 2015b).

The exhibition told its story through 24 cases, including famous and infamous cases as well as lesser-known crimes. Curators were interested in portraying cases that marked a change in the law or in detection methods, with a particular focus on forensic techniques of criminal investigation. They represented crimes ranging from terrorism to abortion, and included notorious homicides: Dr Crippen's murder of his wife, Cora, in 1910, represented by the spade used to bury her; the crimes of the Kray twins, and Jack the Ripper; and the case of John George Haigh, the Acid Bath Murderer, whose gas mask and thick gloves were included in the exhibition along with plaster casts made of three gallstones from one of his victims; the gallstones had failed to dissolve in the acid bath and were recovered during the police investigation, becoming crucial evidence in securing his conviction.

Conscious that the Museum of London would be leading the curation of the exhibition, and would do so with independence, Day and Whooley explained the careful and consultative process they designed, a 'bespoke process' (Day n.d.) that enabled them to form consensus about the content of their exhibition. Whooley conceded that it was 'the most complex exhibition we have ever done'. Central to the process was the involvement of the London Policing Ethics Panel, an independent body tasked with focusing on 'ethical dilemmas' (Mayor's Office for Policing and Crime 2017) in order to ensure public confidence in policing issues. As Whooley explained, selecting objects for an exhibition 'isn't their core business' and the Panel was 'slightly amused' at the Museum's request but, once presented to them, found it 'intriguing' and offered ethicist Professor Leif Wenar to chair the process of selecting objects.

Day first made a list of objects based upon the narrative of the proposed exhibition. That list was then put through what she called several 'filters', ethical, legal and practical. For instance, some objects were connected with legal cases that, at least in a technical sense, were still open; some objects contained asbestos. As this process unfolded, certain objects were 'flagged' as requiring detailed consideration.

Next, they created a template with several columns. This included the object, the arguments for and against inclusion, and any possible mitigation of the arguments against certain objects. In what she described as 'quite a long meeting', the

Figure 5.5 Photograph of plaster casts of Olive Durand-Deacon's gallstones. © Mayor's Office for Policing and Crime. Reproduced with permission.

multi-disciplinary committee worked through the template step by step, inching towards consensus on the final list of objects. The purpose of the template, she explained, was to make the process 'dispassionate', because 'it was very easy to become quite passionate about some of these questions'.

They also identified at least four 'particularly challenging' cases; so challenging that they held focus groups to seek public responses to them, which they described as 'a little bit of formative evaluation'. One of these was the case of Dennis Nilsen, a serial killer in the late 1970s and early 1980s in north London. Nilsen and his crimes remain very well known in London, and it is thought that not all of his victims have been identified. He is currently serving a life sentence for six counts of murder and two of attempted murder, but is suspected of having killed at least 12 young men.

It is widely known that the Crime Museum holds the cooker and cooking pots associated with Nilsen's post-mortem treatment of his victim's bodies, and the curators described 'quite an involved discussion' about exhibiting these. For

journalist Peter Watts, who had earlier visited the Crime Museum, these objects gave rise to the most visceral response: 'I look at the Nilsen display. It's an old white cooker topped by a battered aluminium cooking pot. I feel sick' (Watts 2009). While the collection as a whole, for Watts, acquired its impact from 'the accumulated weight of otherwise anodyne objects that collectively represent the many horrible things people have done to each other', he singled out the Nilsen objects – 'Nilsen's cooking pot excepted' – for their individual weight.

The Museum of London curators were conscious of distinguishing between public knowledge, public interest and public demand. But they were concerned that *not* including well-known objects might undermine the whole exhibition, one aim of which was to provide public access to an otherwise-closed collection. The curators heard strong legal arguments against including these materials because they were connected to still unsolved murders, although the likelihood of further prosecutions was extremely small. Stronger still were the arguments that the families of these unidentified victims, some of whom were still liaising with police, might be distressed by the inclusion of these objects.

They spoke about the issues that arose from living memory, noting that with the passage of time, some of the arguments against inclusion would dissipate. Whooley reasoned, 'Nilsen's pot in 30 years' time may be quite acceptable to put on display'. This temporality has transformed Nilsen's crime scenes, two modest north London flats in which he lived and murdered his victims, later renovated into desirable real estate. In 2013, his flat in Willesden Green, in which he murdered up to 12 victims between 1978 and 1981, was sold for £425,000; it was described by real estate agents as, 'An excellent two bedroom ground floor flat . . . benefitting from a bright and airy interior throughout, lovely private garden with conservatory and a location ideal for local amenities' (prospective buyers were not alerted to the property's history and were reportedly surprised the price was 'not massively reduced'; see Charlton 2013). Around the same time, his home in Muswell Hill, where three further victims were found, was sold for a reduced price of £250,000, and swiftly renovated and re-sold for £370,000; the estate agents advised, 'Buyers are kindly asked to research the history of this property or enquire with the marketing agent prior to viewings' (Brinded 2015).

Curator Annette Day explained that in the case of John Haigh, a serial killer from the 1940s known as the Acid Bath Murderer, 'the passage of time . . . made that feel different to some of the more recent cases'; materials from his case, including plaster casts of the gallstones from of one of his victims, were included in the exhibition. The curators were emphatic that what changed with the passage of time was emotional attachment, and familial and other important relationships. They were not moved by the aesthetic attributes that an object accrued as time passed. For example, Nilsen's cooking pots conveyed a time, place and class, but these attributes were not an element of the curatorial decision-making process. However, as Day acknowledged, the passage of time was an important narrative in the story of crime and detection that the exhibition wanted to narrate. For instance, older objects conveyed the sense of the development of techniques – whether of perpetrating crimes, or investigating them. Their decision to include

The curators also realised that some objects, while associated with gruesome crimes, were themselves not used in the investigation or prosecution of Nilsen. That is, their *evidentiary* value was not established. The curators ultimately decided not to include the cooking equipment, but to explicitly acknowledge its absence by including in the exhibition some interpretive materials that explained the process and the decision. One reviewer later wrote that the 'ethical conundrums' of curating this exhibition were 'subtly intercut' throughout the exhibition (Teskey 2015). Interestingly, they decided that while they were not comfortable about showing the real objects, they could show photographs of them (in part because there were already photographs of them available on the internet). They reflected on what they called 'the power of the object', particularly in the digital age where images of these objects have become commonplace, so that the material thing itself becomes more charged and vibrant. Displaying it creates an impact that is more forceful than a photographic representation; withholding it creates another kind of impact, and requires the delicate management of expectations.

In managing expectations, the curators found that they were also required to insert themselves into relationships, including existing relationships between victims of crime, or their families, and the Metropolitan Police. The curators recognised the ethical force that came from a victim or family member saying 'no', opposing the display of certain objects or narratives. They were clear that they would not exhibit an object over the objections of relatives. However, they also identified the 'ethical weight' that attached to the approval of a family member – 'this is shown with the permission of the family' – and that this created an additional layer of significance in the context of display. What was important throughout was that, while the curators' list was necessarily focused on objects for inclusion in an exhibition, they were not motivated to curate a collection of objects; instead, they wanted to tell stories about people. To focus on the objects, they felt, was to focus on criminal acts, whereas they wanted to focus upon the people – police, perpetrators, victims – in order to humanise crime.

The curators were mindful of how to interpret 'success', with all the pitfalls of sensationalism and voyeurism that could accompany such an exhibition. As Whooley worried, 'this is potentially a blockbuster exhibition', and with that success came opportunities and responsibilities. On the one hand, he noted, 'we're very confident that the material is very sobering' but, on the other hand, 'you get drawn in and you also feel a little bit . . . a bit dirty at the end of the whole thing'. For the curators, it was important that visitors maintained a self-reflective dialogue; it was crucial to prime visitors at the beginning with critical questions, so that when they entered the exhibition space 'they're going around like critics, because most people aren't like critics when they go to exhibitions'. Their intention was to use narratives to remind visitors that these were real cases, involving real people, humanising crime and its aftermath. They wanted the exhibition to remind audiences that even the most famous criminal cases, such as Jack the Ripper, were not fictional, despite their widespread cultural dissemination.

Their aim was that visitors, at the end of the exhibition, would be encouraged to undergo some kind of 'decompression, reflection' that would impress

upon them the realities of these criminal events. Through a video presentation at the end of the exhibition, and 'digital feedback stations' at which visitors could leave their comments, the curators were able to both guide and glean the public reaction to the show. This feedback included responses of people who were 'horrified and chastened', some who were disappointed – in particularly about the omissions – and some who were left with ongoing questions about the 'complexities and ambiguities' of viewing criminal evidence in the museum (Day n.d.).

Several clear parameters were established for the exhibition: it would contain no victims' stories from later than 1975; it would contain no human remains; there would be a recommendation against children younger than 16 attending unaccompanied; and warning signs would be used to prepare visitors for potentially 'distressing content' (Sharp 2016, 22). The co-curator, Jackie Keily, explained that the inclusion of human remains 'didn't feel appropriate'; in any case, displaying such material less than 100 years old would require a licence under the *Human Tissue Act 2004* (UK).[6] For Keily, the exhibition was 'testing the water' but also 'opens up a debate about displaying such material', and so the self-consciousness of the curatorial choices within the exhibition was purposeful (Sharp 2016, 22).

In providing criminal evidence with an afterlife, these curators knew that, for all their careful processes and stated intentions, these exhibitions might lead to unforeseeable harms. They talked about the emotional effects of the exhibition upon museum staff, including themselves. They were conscious of their own fascination, self-conscious about voyeurism, and aware that, with the passage of time, they themselves became desensitised to some of the trauma associated with crime. They endeavoured to remember that most museum visitors, and many museum staff, would be seeing these materials for the first time. They wanted the exhibition to try to hold onto the experience of seeing the objects afresh, and as one of law's outsiders: the impact, the surprise and some sense of empathy with criminal justice professionals for whom these objects and images are part of their everyday working lives. Day, recalling her first visit to the Crime Museum, spoke of how she took 'an extraordinary number of photographs', and explained this as an effort to 'put something [her camera] between myself and it', *it* being the forceful impact of her first visit. Recognising the importance of that first experience, Day began to attend to the reactions of others with whom she visited the Crime Museum, those who were themselves seeing it for the first time: 'because you start to see how someone reacts for the first time. That's actually quite useful to hold onto that, because you do become familiar with the material'.

In talking to me about 'staff wellbeing', and the need to promote this 'conscientiously', they also acknowledged the professional lives of police officers, for whom these materials had lost some of their charge. Whooley observed, 'It gives you a glimpse into how the police need to put a distance between themselves and this stuff', 'how police must separate themselves from the rest of society'. Evidence demands labour, even in its afterlife, and the ongoing work involved in gathering, preserving and making sense of evidence is important to acknowledge.

By all measures, *The Crime Museum Uncovered* was a success. It received 130,000 visitors, was widely reviewed and discussed, and generated precisely the kind of complex dialogue and response the curators intended. One review described it as 'grisly' (Glanfield 2015), another as 'confrontational but not gratuitous', 'emotive but never mawkish'; it 'thoughtfully probes our ideas about crime and punishment' (Teskey 2015). Another recognised that 'Reading about execution is one thing, seeing objects associated with it is another' (Sharp 2016, 22). In part because of the success and popularity of the exhibition, London's then-mayor Boris Johnson announced plans for a permanent Policing and Crime Museum to unite the distributed collections held by the Metropolitan Police (see Mayor of London 2015; Mayor's Office for Policing and Crime 2015).

This future museum, providing a unified afterlife for these criminal archives, will likely present further challenges for its custodians. Some of these collected objects will remain evidentiary, 'alive' in the legal sense, relevant to active, ongoing or open investigations, and will remain activated by sensitivities arising from the Met's relationships with victims or families. For materials that are no longer alive in this way, curators will need to attend to the multiple qualities that survive in their afterlife. Some will have pedagogical value, to new police recruits and others, and may be instructive in procedural methods, or engage them in policing history and culture. Others are undeniably 'trophies', in the sense that they convey some sort of symbolic message – whether to crime's perpetrators, victims, police or the public – and this vibrancy gives rise to significant risks. These conflate voyeurism, notoriety and crime, and, for all the dangers these pose, these are facets of the afterlife of evidence that cannot be shaken off.

Notes

1 This took place on 21 May 2015.
2 Footage of the work can be viewed at https://vimeo.com/69195492
3 This was in the case in Tadić (IT-94-1). Later cases involving allegations of sexual violence against men included Češić (IT-95-10/1), Todorović (IT-95-9/1) and Simić et al. (IT-95-9). Other relevant cases include Mucić et al. (IT-96-21) (convictions for rape as a form of torture); Kunarac et al. (IT-96-23 & 23/1) and Furundžija (IT-95-17/1) (sexual enslavement as a tool of war); and Krstić (IT-98-33) (linking rape with ethnic cleansing and genocide). In Kunarac et al. the accused were also convicted for rape as a crime against humanity, following the first international convictions of this kind under the International Criminal Tribunal for Rwanda (ICTR).
4 The text on the rings can be accessed from the Wellcome website at https://wellcome collection.files.wordpress.com/2015/06/holzer_lustmord-2.pdf; there is a trigger warning about the sexual violence it contains.
5 Jennifer Thompson and Ronald Cotton are portrayed in one of Simon's photographs, at the scene of her rape. Thompson mis-identified Cotton as her attacker, and he served ten-and-a-half years of a life sentence before his conviction was quashed. She subsequently became a vocal spokesperson in public debates about the dangers of eyewitness identification (Simon 2003, 42).
6 Display in these contexts is governed by the *Human Tissue Act* (UK) 2004, sections 16(2)(f) and 16(4). See Rob Sharp (2016), at 22.

References

Barthes, Roland (1981), *Camera Lucida: Reflections on Photography*, New York NY: Hill and Wang.

BBC News (2008), 'Forensic expert's notes on sale', *BBC News*, 2 July, accessible at http://news.bbc.co.uk/2/hi/uk_news/england/london/7485733.stm

Best, Kenneth (2013), 'Uncanny: Exhibit result of unusual collaboration', *UConn Today*, 27 September, accessible at https://today.uconn.edu/2013/09/uncanny-exhibit-result-of-unusual-collaboration/

Biber, Katherine (2006), 'Photographs and labels: Against a criminology of innocence', *Law Text Culture* 10, 18–40.

Bourdieu, Pierre (1990), *Photography: A Middle-Brow Art*, Cambridge UK: Polity Press.

Boxer, Sarah (2004), 'Photography review: Slogging through the valley of the shutter of death', *The New York Times*, 23 July, accessible at www.nytimes.com/2004/07/23/arts/photography-review-slogging-through-the-valley-of-the-shutter-of-death.html

Brinded, Lianna (2015), 'What's it like to sell the flat that belonged to Britain's most famous serial killer', *Business Insider*, 4 June, accessible at www.businessinsider.com.au/denis-nilsen-cranley-gardens-muswell-hill-flat-on-sale-for-300000-2015-6

Brook, Pete (2010), 'Photographer exposes crime scenes, with a dash of chemistry', *Wired*, 15 December, accessible at www.wired.com/2010/12/strassheim-crime-scenes/

Cain, Taryn (2015), 'Death in a Nutshell', *Wellcome Collection*, 11 March, accessible at https://wellcomecollection.org/articles/death-in-a-nutshell

Charlton, Joseph (2013), 'I don't think we'll be going for a viewing: Flat where "Muswell Hill Murderer" and necrophile Dennis Nilsen killed and disposed of 12 victims goes up for sale for £425,000', *The Independent*, 7 September, accessible at www.independent.co.uk/news/uk/crime/i-don-t-think-we-ll-be-going-for-a-viewing-flat-where-muswell-hill-murderer-and-necrophile-dennis-8803303.html

Cole, Simon A. (2001), *Suspect Identities: A History of Fingerprinting and Criminal Identification*, Cambridge MA: Harvard University Press.

Cumming, Laura (2015), 'Forensics: The anatomy of crime; Cornelia Parker; Cai Gui-Qiang – review', *The Guardian*, 22 February, accessible at www.theguardian.com/artanddesign/2015/feb/22/forensics-the-anatomy-of-a-crime-cornelia-parker-review-wellcome-collection-whitworth-manchester

Day, Annette (n.d.), 'The Crime Museum uncovered: The complex ethics and expectations', *Museum iD*, accessible at www.museum-id.com/idea-detail.asp?id=1566

Glanfield, Emma (2015), 'Doors open to a very grisly exhibition', *Daily Mail* (Australia), 9 October, accessible at www.dailymail.co.uk/news/article-3265971/Doors-open-grisly-exhibition-Scotland-Yard-s-Black-Museum-notorious-crimes-opens-today-revealing-weapons-fascinating-police-documents-remained-hidden-public-decades.html

Hayward Keith J. and Jock Young (2004), 'Cultural criminology: Some notes on the script', *Theoretical Criminology* 18(3), 259–73.

Jensen, Chris (2015), 'Tiny murder scenes are the legacy of N.H. woman known as "The Mother of CSI"', *NHPR.org*, 11 July, accessible at http://nhpr.org/post/tiny-murder-scenes-are-legacy-nh-woman-known-mother-csi#stream/0

Keily, Jackie and Julia Hoffbrand (2015), *The Crime Museum Uncovered: Inside Scotland Yard's Special Collection*, London: I.B. Tauris/Museum of London.

Kennedy, Maev (2015a), 'Wellcome Collection exhibition tracks murder from crime scene to courtroom', *The Guardian*, 25 February, accessible at www.theguardian.com/artanddesign/2015/feb/24/wellcome-collection-forensics-exhibition-crime-scene

Kennedy, Maev (2015b) 'Scotland Yard's Black Museum of reveal its dark secrets', *The Guardian*, 19 March, accessible at www.theguardian.com/culture/2015/mar/19/scotland-yards-black-museum-reveal-dark-secrets

Krasnostein, Sarah (2014), 'Secret life of a crime scene cleaner', *Narratively*, 24 November, accessible at http://narrative.ly/the-secret-life-of-a-crime-scene-cleaner/

Lyng, S. (2004), 'Crime, edgework and corporeal transaction', *Theoretical Criminology* 18(3), 359–75.

Mayor of London (2015), 'Mayor announces plans for permanent Policing Museum in London', press release, 9 October, accessible at www.london.gov.uk/press-releases/mayoral/crime-museum-uncovered

Mayor's Office for Policing and Crime (2015), 'Metropolitan Police Museum: DMPCD 2015 120', 7 October, Mayor of London, accessible at www.london.gov.uk/what-we-do/mayors-office-policing-and-crime-mopac/governance-and-decision-making/mopac-decisions--71

Mayor's Office for Policing and Crime (2017), *London Policing Ethics Panel: Terms of Reference*, accessible at www.policingethicspanel.london/uploads/4/4/0/7/440 76193/london_policing_ethics_panel_terms_of_reference_2017.pdf

Metropolitan Police (2015), 'The Crime Museum', Metropolitan Police website, accessed 26 November 2015; link no longer exists.

Morrison, Blake (2010), 'Sally Mann: The naked and the dead', *The Guardian*, 29 May, accessible at www.theguardian.com/artanddesign/2010/may/29/sally-mann-naked-dead

Morrison, Wayne (1995), *Theoretical Criminology: From Modernity to Post-Modernism*, London: Cavendish Publishing.

Pardo, Michael S. (2011), 'Upsides of the American trial's "Anticonfluential" nature: Notes on Richard K. Sherwin, David Foster Wallace, and James O. Incandenza', in Austin Sarat, ed., *Imagining Legality: Where Law Meets Popular Culture*, Tuscaloosa AL: The University of Alabama Press.

Pottage, Alain (2004), 'Introduction: The fabrication of persons and things', in Alain Pottage and Martha Mundy, eds, *Law, Anthropology and the Constitution of the Social*, Cambridge UK: Cambridge University Press.

Saner, Emine (2015), 'True crime: The women making art out of murder', *The Guardian*, 25 February, accessible at www.theguardian.com/artanddesign/2015/feb/24/forensics-the-anatomy-of-crime-wellcome-collection-female-artists

Sante, Luc (2013), 'Further evidence', *Contrapasso* (Noir issue, December), 71–77.

Scott Bray, Rebecca (2007), 'En Piel Agena: The work of Teresa Margolles', *Law Text Culture* 11, 13–50.

Scott Bray, Rebecca (2011), 'Teresa Margolles' crime scene aesthetics', *The South Atlantic Quarterly* 110(4), 933–48.

Sharp, Rob (2016), 'Courting controversy', *Museums Journal*, January, 20–25.

Sherwin, Richard K. (2011), *Visualising Law in the Age of the Visual Baroque: Arabesques and Entanglements*, Abingdon UK: Routledge.

Shinkle, Eugene (2010), 'Affirmations of Life: Sally Mann, Photographers' Gallery' [review], *Source* 64, 52.

Simon, Taryn (2003), *The Innocents*, New York NY: Umbrage Editions.

Sontag, Susan (1977), *On Photography*, London: Penguin.

Tagg, John (1992), *Grounds of Dispute: Art History, Cultural Politics and the Discursive Field*, London: Macmillan.

Ten.com.au (2013), 'Mr and Mrs Murder: Take murder to the cleaners', accessible at https://web.archive.org/web/20130424124649/http://ten.com.au/tvshows/mr andmrsmurder-about.htm

Teskey, Rachel (2015), 'The Crime Museum uncovered', *Culture* 24, 12 October, accessible at www.culture24.org.uk/history-and-heritage/art539136-crime-museum-uncovered-museum-of-london-review

United Nations International Criminal Tribunal for the former Yugoslavia (2016), 'Sexual violence – in numbers', September, accessible at www.icty.org/en/in-focus/crimes-sexual-violence/in-numbers

Watts, Peter (2009), 'The Black Museum', *Time Out London*, 11 May, accessible at www.timeout.com/london/attractions/the-black-museum

Wellcome Collection (2015), 'Lustmord', Wellcome Collection, 16 June, accessible at https://wellcomecollection.org/articles/lustmord/

Williams, Patrick (2013), 'Bruce Morcombe lashes out at "funny" new TV murder show', *Sunshine Coast Daily*, 22 February, accessible at www.sunshinecoastdaily.com.au/news/bruce-slams-tv-show-mr-mrs-murder-morcombe/1765883/

Young, Alison (1996), *Imagining Crime: Textual Outlaws and Criminal Conversations*, London: Sage.

6 The Lindy Chamberlain case

The afterlife of a miscarriage of justice

This is all we have that remains of Azaria.

(*Lindy Chamberlain-Creighton*)

Lindy Chamberlain is the victim of Australia's most notorious miscarriage of justice. In 1980, her nine-and-a-half-week-old baby Azaria disappeared from the family's tent during a camping trip at Uluru; Lindy was tried and wrongfully convicted for murder; her husband, Michael Chamberlain, was convicted of being an accessory after the fact. After Lindy had served almost three years in prison, the chance discovery of an important piece of evidence prompted a Royal Commission into the convictions. The Chamberlains were later pardoned, exonerated and compensated. Two more coronial inquests followed, the last of which concluded in 2012 – on the day after what would have been Azaria's 32nd birthday – that Azaria had been killed by a dingo. Although the story is complex, the Chamberlains' wrongful conviction was largely due to bad forensic science (Bryson 1985; Chamberlain 1990; Staines et al. 2009). However, an important context for this saga is the unique character of Australia's Northern Territory, a vast, sparsely populated jurisdiction that is both the nation's spiritual heart and its lawless frontier (Reynolds 1989; see also Gans 2007).

The wrongful conviction of Lindy and Michael Chamberlain precipitated an era of unresolved anxiety in Australian cultural and legal history. It has been trivialised in mass culture, as a gag or punchline in programs including *The Simpsons, Seinfeld* and *Buffy the Vampire Slayer*. While the profile of Michael Chamberlain, who died in 2017, waxed and waned, Lindy has held the unwavering attention of the nation. In addition to the tenacious coverage of her life in women's magazines – some of which championed her innocence – Lindy's story has been told in feature film, television mini-series, opera, poetry, art and theatre, as well as in her own best-selling memoir.[1] Her experiences have also been the subject of considerable multi-disciplinary scholarly attention, studied for their importance to understandings of law, forensic science, religion, media, landscape and, particularly, the treatment of women in each of these spheres (see e.g. Staines et al. 2009; Howe 1996 and 2005; Sawyer 1996; Edmond 1998; Anderson 2016; Middleweek 2016).

In the decades following her exoneration, Lindy Chamberlain-Creighton, as she is now, came to an arrangement with the National Museum of Australia and the National Library of Australia to care for the objects and papers, including evidentiary materials, accumulated during the coronial and criminal processes and the Royal Commission (National Museum of Australia n.d.). This chapter explores the afterlife of this evidence, the archived remainder of Azaria's life and death, and of her parents' dreadful misadventures in the law. It studies the two sites – the museum and the library – as providing two distinct qualities of evidentiary afterlife, one curatorial, the other archival. In researching this chapter, I spoke to Lindy Chamberlain-Creighton about the afterlife of materials from her case. She described a kind of restless atmosphere in the afterlife of her evidence. As she put it, 'it came and went, and came and went, and then some went permanently'.

In his book *Curationism*, art critic David Balzer asserts that ours is a 'curationist moment', in which everyday lives and experiences can be 'curated' (2014, 2–3). He recounts the emergence of the curator from obscurity into the limelight, as the 'star' around whom the gathered objects orbit. More broadly, he describes the 'curationism' of ordinary experiences outside the museum, in our daily life and on social media, and the self-consciousness of gathering and re-presenting one's things in a curatorial manner. While curating criminal evidence always involves dangers and sensitivities (Biber 2013), curating the Chamberlain case is complicated by its dispersal, in a phenomenon described by archaeologist Laura McAtackney as 'the distributed self' (2014, 244–45): some of the evidence no longer exists; some is not publicly accessible; much is the personal property of the Chamberlain family.

The curation of the case is also overshadowed by the fact that, despite being criminal evidence, there was *no crime*. In his book *The Judge and the Historian*, about a miscarriage of justice against his friend, the historian Carlo Ginzburg described his 'sense of disorientation' when presented with legal materials that did not support what he knew to be the truth (1999, 7). In dealing with events that didn't occur, Ginzburg, a historian of medieval witchcraft, sorcery and folk belief, wrote, 'What made these phantasmagorical events historically significant was their symbolic efficacy' (1999, 15). Deeply conscious of how strongly people can be made to adhere to beliefs that have no evidentiary basis, Ginzburg insisted that while contemporary historians might play with concepts like 'truth' or 'proof', the law must hold close to 'the principle of reality', and that we must develop techniques for dealing with 'errors' (1999, 17, 98). Curating the Chamberlain evidence presents exactly these contradictions: the case has enormous symbolic weight, its artefacts are loaded with accrued meanings, and a wide range of beliefs continues to circulate. Curators are interested in responding to ideas that circulate in a culture. However, there is also the important reality that Azaria was *not* the victim of a crime, that the Chamberlains were wrongly convicted, and curators must find ways of asserting these facts.

When the High Court of Australia dismissed their appeal against their convictions in 1984 (*Chamberlain v R (No 2)* (1984) 153 CLR 521), the Chamberlains had exhausted all avenues of appeal. Despite this, according to Lindy, the Chamberlains' possessions were still not returned. She explained, 'even though you're supposed to get things back to keep, we were allowed access, but not to keep'.

It was after their failed appeal to the High Court that the Chamberlains, supported by a growing group of independent scientists, were able to arrange further scientific testing, related to dingos, to the forensic materials applied to their car and to Azaria's clothing. This testing considerably undermined the conclusions drawn by the Crown's scientific experts at their trial, and the Chamberlains' supporters, led by the Chamberlain Innocence Committee, lobbied for a review of the case. A petition calling for a judicial inquiry was signed by 150,000 people, and a number of eminent lawyers joined the call, demanding Lindy's release on licence, all to no avail.

But in early 1986, in an event that would transform Australians' confidence in their legal institutions, Azaria's matinee jacket was discovered. At her trial in 1982, explaining the absence of dingo saliva on Azaria's jumpsuit, Lindy testified that Azaria had been wearing a knitted matinee jacket (*R v Alice Lynne Chamberlain and Michael Leigh Chamberlain* (1982) NTSC, unreported). Almost four years later, an English tourist named David Brett died while attempting to climb Uluru; his body was not recovered until eight days later, badly mutilated by dingoes. In the search for his missing bones, the missing matinee jacket was discovered. There is conjecture that Territory officials intended to conceal its discovery, but, on 3 February 1986, Lindy's lawyer received a tip-off; three days later, Lindy identified it as the one Azaria had been wearing. The following day, the Attorney-General of the Northern Territory announced Lindy's release from prison and his decision to open an inquiry into the case (Staines et al. 2009, 142). On Friday 7 February 1986, the day of her release from prison, the *Northern Territory News* carried a front-page headline that read simply 'LINDY OUT'.

By April 1986, Justice Trevor Morling had been appointed to lead a Royal Commission with wide-ranging powers to review the Chamberlain case, particularly doubts or questions about the safety of their convictions, and to locate and hear evidence and conduct further research, and to make findings and recommendations. Speaking to me about the custody of her possessions, those with evidentiary weight, Lindy explained, 'everything was bound over for the Royal Commission'.

The Commissioner concluded that 'in the light of all the evidence, there are doubts as to the Chamberlains' guilt . . . I do not think any jury could properly convict them on the evidence as it now appears' (Morling 1987, 330). The report of the Royal Commission was tabled in the Northern Territory House of Assembly on 2 June 1987. On that day, the Northern Territory government granted a formal pardon to the Chamberlains.

In closing the Commission, Justice Morling made orders that conclusively distributed the evidentiary materials, finally returning the Chamberlains' possessions back to them. At that time, the Chamberlains believed some of the evidentiary

material might be relevant in future cases – for example, if there was a need for aged blood samples, or if there were allegations relating to the behaviour of dingos. For this reason, they wanted evidentiary material of this nature kept in conditions that facilitated its preservation or survival. Lindy explained,

> So we approached the Victorian Institute [of Forensic Medicine] and asked them if they had proper facilities, as it was supposed to be kept in temperature-controlled blah, blah, blah. They said 'yes'; they did, they'd be happy to have it there, and it was allowed to be accessed by anyone that had a genuine interest or need in research, but it was not to be just out on display in their museum, 'look what we've got', sort of thing. So that's what happened'.

In 1988 the Northern Territory Court of Criminal Appeal adopted the Royal Commission's findings; Nader J ruled: 'The convictions having been wiped away, the law of the land holds the Chamberlains to be innocent' (*Re Conviction of Chamberlains* (1988) 93 FLR 238, 254). A third coronial inquest opened on 29 November 1995. The Chamberlains urged the Coroner not to return an open finding, but the Coroner closed the inquest by recording 'the cause and manner of death as unknown' (in Staines et al. 2009, 149–51).

When the third inquest concluded in that manner, Lindy told me,

> Michael and I felt that Azaria's clothes should not be in the hands of the Crown any longer. But they should be around for the sake of history, [and any further] testing that's necessary, because it was still an open verdict.

It was around this time that the Chamberlains began to think about the papers and materials they had accumulated during these extraordinary legal episodes. What to keep, where to keep it and why they were keeping it: the survival of evidence, the quality of its afterlife, gave rise to questions that were only gradually rising to the surface as the urgency of their legal battles started to wane.

The National Museum of Australia (NMA) now holds many of the material artefacts associated with the Chamberlain case; the collection is 'one of the most significant collections to have been entrusted to the museum's care' (Jensen 2009, 253–54). I spoke to the curator of the Chamberlain collections, Sophie Jensen, who explained that the primary rationale for the Museum's National Historical Collections is 'significance'. When Lindy herself first gave thought to the significance of the materials she had accumulated, she told me, 'Well, initially I didn't think there was any significance at all. I was thinking, well . . . this is all we have that remains of Azaria. Nine-and-a-half weeks is not a lot of life history'.

The Chamberlain collection comprises six smaller collections. The first five collections, deposited by Lindy, had come together in a manner that was, in Jensen's words, 'serendipitous', being drawn from items either discovered by,

or returned to, Lindy concurrently, but not necessarily items that were thematically related to each other. As Jensen explained, 'you might get a dress and then six months later she finds the shoes'. The sixth collection came from Michael Chamberlain; it includes the yellow Holden Torana the Chamberlains drove from Mount Isa to Uluru on their holiday, which was taken for forensic examination and returned to them in pieces after the conclusion of the Royal Commission.

Some objects in the first part of the collection were exhibited by the Museum in 1994, soon after they were acquired, in a temporary display named *Lindy's Story* at the Yarramundi Visitors' Centre. Immediately, media agencies criticised the Chamberlains for profiting from their case and exploiting Azaria's memory, and the Museum received letters from the public complaining about the acquisitions; one writer argued, 'the nick-nacks [sic] associated with such a sordid event should have no place in a public exhibition' (Jensen 2009, 255). However, as Paul Williams wrote in his work on memorial museums, 'controversy' over the manner of memorialising traumatic histories is 'a near-default expectation' (2007, 1). While much that was said about the Chamberlain collection in the media reports and correspondence was incorrect, the collection's metamorphosis from private to public touched a nerve.

With important exceptions, most of the Chamberlain collection is *not* on display. The NMA's *Eternity* exhibition is part of the Museum's permanent exhibition, telling 'a story from the emotional heart of Australia', using different themes to

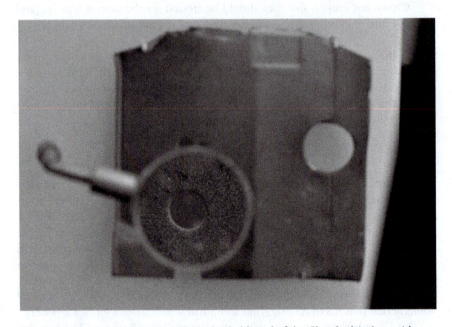

Figure 6.1 Metal panel from area under the dashboard of the Chamberlains' car with a spray of sound deadener that was incorrectly identified as blood. Photo: Dragi Markovic, National Museum of Australia. Reproduced with permission

narrate the nation. Within this exhibition, the Chamberlain case is curated under the theme of 'Mystery'.[2] Of course, from a legal perspective, the case is not a mystery: Azaria was taken by a wild dingo. Exhibited in *Eternity* is a very small piece of the interior of the Chamberlain's car, which was subjected to forensic examination. The forensic pathologist who examined it testified that she had found blood spatter consistent with Azaria's throat having been cut; this was the notorious 'arterial spray' that was later discredited as one of many evidentiary errors made in that case. Forensic scientists working for the subsequent Royal Commission found that this spray was a form of sound insulation applied at the time the car was manufactured. In this museum cabinet, visitors can see this crucial item of evidence that was used both to convict and later acquit Lindy Chamberlain. For curator Sophie Jensen, the decision to curate the case as a 'Mystery' was 'to examine the fascinating hold' of the Chamberlain case on the nation (Jensen 2009, 253).

Lindy Chamberlain-Creighton Collection No. 5 contains much of the surviving evidentiary material. Alongside forensically examined fabrics, fibres and plant materials (with the surprising inclusion of Lindy's wedding dresses), this part of the collection includes all the clothing in which Azaria died. As required under the arrangement between the NMA and Lindy Chamberlain-Creighton, Lindy provided her formal agreement that I should have access to it. At present, the NMA has agreed with the Chamberlain family not to exhibit the garments in which Azaria was taken.

The Chamberlain collections are not kept in the National Museum itself, but in its repository on the industrial outskirts of Canberra. On a hot, dry day I drove there and met the curator, Sophie Jensen, and Sarah Streatfeild from the accessions team. We entered a large, bright room dominated by a huge white table, on which Streatfeild had arranged soft, white satiny pads in preparation for displaying the objects. Jensen and Streatfeild wore blue latex gloves. The items are stored individually in lidded plastic tubs, which Streatfeild had stacked in a pile.

We started with the microscope slides, still housed in evidence bags with security seals from the Victorian Institute of Forensic Medicine (VIFM). Streatfeild laid out two tiny pieces of purple blanket, a small orange square of fabric from a mattress, another tiny piece of a yellow towel. Labels and tags identify exhibit numbers, indicating that these items played an evidentiary role in the Supreme Court of the Northern Territory, and the Royal Commission, before being sent to the VIFM. These scientific slides proved first that the Chamberlains were guilty, and then that they were not. At the Royal Commission, these became evidence of sloppy science. Now, in the museum repository, they are evidence of something else; the afterlife of the Chamberlain case, a miscarriage of justice that rested on these tiny, contested fragments.

Streatfeild began laying out fluffy bunches of white fibre; 'They're bits of nappy', she explained. Streatfeild and Jensen started talking about the need to rehouse some of these items; the way they are currently stored involves more

Figure 6.2 Royal Commission and Northern Territory Supreme Court tags from
purple woollen blanket that was in Azaria Chamberlain's carry cot the night
she disappeared, 17 August 1980. Photo: National Museum of Australia.
Reproduced with permission.

handling than they can withstand. Their age and fragility places them under pres-
sure. Streatfeild, who has expertise in managing the Museum's collections of
garments, explained that fabrics degrade over time; baby clothing, in particular,
is not designed to endure beyond the short stage of infancy and yet here, 36 years
after her birth and death, was Azaria's shredded nappy.

On a clean white pad, Streatfeild arranged another object, her hands mov-
ing quickly as she folded, unfolded and revealed its original form. 'This is the
jumpsuit', she explained. 'It is quite stained, so I'll just warn you'.

It is so small. Dirty, bedraggled, heartbreakingly lacerated around the neck, it
also has ruled lines drawn on it, sharp scissor cuts and markings left from forensic
examination. This tiny, filthy scrap bears the imprint of violent death, accusation,
investigation and proof. It also shows the aftermath of a fatal attack by a wild
desert animal. Now, in its sterile plastic box and touched only with latex gloves, it
survives in the museum as evidence of the Chamberlains' grief and loss, and their
cruelly long journey to justice.

For the curator, the history or biography of an object is constrained by how
the object appears *now*. Like contemporary archaeologists, curators are attentive
to what might be termed 'absent presences' and 'present absences', sparked by
objects or spaces in which something is evidently missing (McAtackney 2014,
50, 98; see also Hauser 2004, 299). The challenge, for curators, is to find ways

of 'repopulating' or somehow reviving the life no longer inherent in the object (McAtackney 2014, 98). What is missing from the jumpsuit now, of course, is Azaria. Jensen spoke of her concern, and Lindy's, that people might think Lindy had dressed her baby in dirty clothing, 'as though she hadn't loved her baby because it's dirty . . . To see *this*, people could imagine her baby in this alive. The point is, of course, that [Azaria] wasn't ever like *this*'.

When Azaria's clothing was first recovered near a dingo lair, a police constable physically examined it before returning it to the ground, clumsily attempting to re-create its condition and arrangement, after which it was then officially photographed by police (see Edmond 1998, 406). A police sergeant gave evidence at the first and second inquests, and again at the trial, that Azaria's clothing had been cut with an instrument. Despite having no scientific training or experience, he swore that, after considerable experimentation upon it, he had concluded that the damage was caused by curved scissors because these were the 'only way' he could reproduce that kind of damage (Edmond 1998, 409, 415). Later, in the Federal Court judgment of Bowen CJ and Forster J, they admitted: 'We have examined the jumpsuit ourselves and the damage certainly appears to us to resemble scissor cuts. The jury were entitled to, and no doubt did, make a similar examination' (*Chamberlain v The Queen* (1983) 46 ALR 493). Jensen's point – that *it wasn't ever like this* – is well made. How Azaria's jumpsuit appears *now* testifies to the considerable handling of it, most of which was pseudo-scientific or amateur fumbling, and which affirms the need for curators to preserve this garment as evidence of dangerous criminal justice practices.

Jensen indicated the lines and incisions on the jumpsuit made by forensic examiners. For her, '*these* are as distressing as the dirt . . . knowing the distress that this process caused'. Not only was Azaria wearing these garments when she was mauled to death by a wild animal, but the irrational doubt of investigators caused those garments to be subjected to further violation. These are the 'depredations of scientists' referred to at the Chamberlains' trial (Edmond 1998, 406). Nevertheless, it is these forensic markings that remind us of the role of the Chamberlain case in transforming Australian forensic science practices and standards. At their trial, crown prosecutor Ian Barker QC summarised the textile evidence for the jury: '[T]he evidence, unassailable and unassailed, is that the garment was cut by scissors' (Edmond 1998, 429). He was wrong. The objects I viewed in the museum repository were all subjected to forensic analysis, processes which when scrutinised by the Royal Commission were found to fall far short of proof. The wrongful conviction of Lindy and Michael Chamberlain represented a turning point in the funding, administration and professionalisation of forensic science. Jensen explained that

> for both Lindy and Michael [forensics] is something that they would be really happy to have explored more [through exhibiting the Chamberlain collection] because I think that they both feel very passionately about the role that forensics played in their own experience.

This forensic consciousness is evident in the account Jensen and Streatfeild gave of the day the Chamberlains handed this part of the collection to the Museum. Following the Royal Commission, these evidentiary objects were kept at VIFM, which (under its earlier title, the Victorian Forensic Science Laboratory) had assisted the Commission in its inquiry. Lindy received the objects back from the VIFM in 2010 and, a very short time later, handed them on to the Museum. On the day of the handover, surrounded by her surviving children, Lindy was adamant that the evidence seals be broken by professional museum staff, and not herself. Streatfeild remembered, '[Lindy] had concerns about them being evidence', and that formal evidentiary protocols were, still, to be observed.

At the Chamberlains' trial, Azaria's jumpsuit had been at the centre of testimony from Professor James Cameron, who claimed to detect upon it the bloody imprint of a small adult hand. The Royal Commissioner later reserved his most scathing assessment for that evidence, saying Cameron's testimony was 'weakened, if not totally destroyed, by new evidence that a great deal of what he thought was blood on the back of the jumpsuit was, in fact, red sand' (Morling 1987, 326; see also Evans 2003, 5–17). As Williams has written, in the context of museum curatorship, '[a]cts of physical violence are ephemeral' (2007, 33), and so curated objects are required to narrate a story that they cannot otherwise materialise. One rhetorical strategy deployed by curators is to conceive of these items as 'witnessing objects', having 'witnessed' and survived a traumatic event (Williams 2007, 31). Through this technique, the object gains a 'life', anthropomorphised in its darkest moment. The surviving object testifies to the absence of its owner, and to the significant event that the museum seeks to memorialise. But while the object becomes a synecdoche for an entire historical context, it also remains itself, a unique artefact whose survival is the final chapter in its history. How did this thing survive? As Aby Warburg observed, in the cultural world survival is *not* the triumph of the fittest, nor is it evidence of adaptation or selection. For Warburg, cultural survival made historical time more complex, challenging the very nature of historicity. In its afterlife, Azaria's jumpsuit does not 'triumphantly outlive' so much as 'survive its own death'; having 'disappeared from a point in history', it now reappears in the museum repository, 'when it is perhaps no longer expected' (Didi-Huberman 2002, 68). Its survival is confounding and, for its entanglement of law, forensic science, family memory, human remains and myriad other qualities, it poses ongoing practical and ethical challenges for those charged with its preservation.

Streatfeild moved the jumpsuit aside and brought out a tiny singlet. Ribbed cotton with fine scalloped edges around the neck and arms, it was indistinguishable from the singlets worn by millions of newborn babies – except that, like the jumpsuit, it was badly stained around the neck, torn, and bore the indelible markings of forensic examination. The transformation of an ordinary thing into a curated artefact has been called 'musealisation', a term coined by the philosopher Hermann Lübbe 'to describe the aura that any object gains once it has been turned into something worthy of consideration as a singular, aesthetic, historically loaded artefact' (in Williams 2007, 169). That Azaria Chamberlain wore the

same singlets as every other Australian baby of her generation is important; also important is that Azaria's singlet, unlike all others, shows the violent manner of her death and the forensic processes that followed.

With extraordinary understatement, Streatfeild announced the next garment: 'The matinee jacket'. Since August 1980, the phrase 'the matinee jacket' has, in Australia, invoked only one person: Azaria. The matinee jacket is an example of Williams's 'hot' objects, those that 'can be made to speak emotionally' given their 'high capacity for personification' (2007, 34). Whereas 'cool' objects can more calmly narrate an event, 'hot' objects spark an affective response. In the museum repository, it lay on the white table, filthy, gnawed, but undeniably itself. It has tiny, delicate patterned stitching, scalloping around the edges, lacing and buttons. Its survival for almost six years in sand at Uluru was astonishing; it was also extraordinary to see it in the museum repository, 36 years after it was worn for the last time, arranged on a shiny white pillow as the three of us stood tearfully beside it. Our response was an example of what McAtackney termed 'the affective experience of visiting' an emotionally loaded site of significance, and the importance of 'co-presence' with those who share the visit with the researcher (2014, 270). As Sophie Jensen noted, the matinee jacket is now, conceptually and literally, 'public property', and the museum is responsible for curating it in a manner that reflects this status. In curating the wrongful conviction of the Chamberlains, the NMA is committed to remembering what happened *after*. This is what Williams called the 'generational framing of memory (2007, 8), and it demands that the Chamberlains' subsequent pardon, exoneration and compensation survive in the public memory of the case.

The Chamberlain collections at the NMA have acquired their form largely through the palpable curatorial presence of Lindy Chamberlain-Creighton herself. The bulk of the collections have been acquired directly from Lindy's personal archive, and so they intermix evidentiary and non-evidentiary objects. Having been acquired directly from Lindy, this intermixing is relevant: the criminal proceedings are inseparable from the loss of the baby she loved. Many items are literally evidentiary, and the Museum has retained the documentation, markings and appendages that denote this evidentiary status. Some items were initially thought to have evidentiary status and were later discredited – a Chamberlain family bible mistakenly believed to contain underlined passages relating to a murder with a tent peg; a miniature coffin used by Michael Chamberlain during his anti-smoking talks. Other items relate to Azaria herself – her clothing and the hospital wristband she wore after her birth. The NMA also holds the souvenirs manufactured and sold during the Chamberlains' trial, including commemorative tea towels and joke-bearing t-shirts. More broadly, the collection also includes contextual material from Lindy's life: the dresses she wore for court appearances, her cell door number from Berrimah prison, a lock of hair sent to her in prison from her daughter Kahlia following her first haircut; Kahlia was

born during Lindy's imprisonment and removed from her care until her release (Jensen 2009, 258).[3]

Lindy's curatorial role is important to understand, and involves a careful balancing of her roles as donor, as curator and as the public figure whose life and experience give significance to each of these objects. In this respect, her status is different from the 'star' curators described by Balzer, who lack professional curatorial skills but whose celebrity orients the objects they have gathered (2014). In another respect, contemporary practices of 'curationism' see the curator's identity and status as the source of the collection's value, and this does reflect Lindy's role in relation to the NMA. According to Sophie Jensen, Lindy 'does play quite a significant curatorial role'. The Museum's primary acquisition principle is 'significance', and Jensen explained that for some items 'their significance is affected by the significance that they have for Lindy herself'. She reasoned, 'At the end of the day it is about her experience; this collection is a big part of representing her thoughts, her actions, her emotions through these objects'.

––––––––––

Why should the nation collect these objects? In their afterlife, long after consensus on the Chamberlains' innocence has been reached, what role does this evidence play? National collections always anticipate some kind of *use*. Materials that can never be used will not be acquired, and are typically destroyed. What use is the criminal evidence that wrongfully convicted Lindy Chamberlain?

One use, of course, is display. At the centre of curatorial practice, as distinct from archival practice, is the idea of exhibition, a transparent act of showing: this is what we have. Can the clothes in which Azaria was taken be shown? Jensen explained:

> I do think theoretically [everything in this collection] is showable and I think that with the museum we create a context . . . [so] that you can warn people about what they're going to see, you can display things in areas in which people can make choices about what they're going to view and whether they want to view it.

Notwithstanding that it *could* be shown, Jensen told me, 'We have made an undertaking to Lindy at this stage . . . that we don't show the matinee jacket and Azaria's clothing that she was wearing on the night she was taken'. Jensen explained that Lindy's wishes are a core component of the ethical management of the collection, and that causing distress to Lindy, or contradicting her clear wishes, is not something the Museum would do. For Jensen, 'exhibiting isn't the only reason that we would collect these items'. Items that cannot be exhibited might still be important, since these particular evidentiary artefacts anchor the substantial remainder of the collection. The last garments worn by Azaria provide material evidence of her death, the event that gives significance to every other

object in the collection. As Jensen explained, despite being out of public view, the Museum's possession of Azaria's final outfit is still significant.

For Lindy, there are various factors underlying her wish not to display Azaria's clothing; these are primarily united by a temporal limitation: not yet. For Lindy, it is the closeness in time and the associated ghoulishness that might motivate public interest. In her words, 'I don't believe that you should have something there just for ooh-ahh reasons'. As Williams observed, in memorial museums voyeurism is a perpetual curatorial risk (2007, 37; see also Biber 2016). Lindy explained that, while some items were suitable for contemporary display – she identified the under-dash of the car as an example – this was because they do not evoke the 'emotive response' Azaria's clothing still does. For Lindy, the primary motivation for entrusting these items to the NMA was that they would be pre-served if needed 'for forensic purposes or for genuine study'. As Lindy told me, 'If there's another dingo attack and there are accusations like in my case of what a dingo can and can't do, there is actually a reference that they can go to. In that way, it is extremely significant'.

When I spoke to Jane Taupin, who worked as a forensic biologist at the then-Victorian Forensic Science Laboratory during the Royal Commission into the Chamberlain convictions, she too spoke of the scientific need to preserve exhibits beyond the conclusion of proceedings. In Taupin's view, it was only the sur-vival of these items that provided the Chamberlains a pathway to justice. Taupin asked rhetorically: 'If there was no car and there was no jumpsuit, what would the Chamberlain Royal Commission have done?' But reflecting on the legacy of the Chamberlain case and the preservation of many of the exhibits, she noted, 'Having that jumpsuit preserved in a museum hasn't impacted one iota the prac-tices of forensic science'. In her contemporary work, Taupin has seen frustrating instances of scientists ignoring, or simply being ignorant of, the recommenda-tions of the Chamberlain Royal Commission to improve their practices.

In the contemporary museum, emerging ethical challenges are posed by the digital and online environment, where non-physical access might be provided to the Museum's collections. Jensen acknowledged that much of the intellectual and curatorial focus of these questions had, until recently, been applied to the Museum's Indigenous collections, which include secret and sacred items. The sensitivities, ethics and processes associated with the description and dissemina-tion of Indigenous materials has been extensively examined. However, 'very little thought' has been given to sensitive objects of a non-Indigenous nature, and the Chamberlain collection gives rise to 'questions we haven't had to deal with before'. Jensen noted that, in the museum world, attitudes to the display of sensi-tive objects had shifted, due at least in part to the museological response to the terrorist attacks of 9/11. For her, questions of trauma and dignity, entangled in issues arising from materials containing human remains, give rise to new thinking about what is viewed and viewable, accessible and open, and much of that new thought arises from changes in public perceptions about the role of museums.

The museum has emerged as an increasingly popular site for the display of crime, broadly conceived, and criminologists have begun to examine the techniques and

effects of crime curation. In its afterlife, the death of Azaria Chamberlain has challenged the museum, as an institution, to function as a crucial repository for preserving knowledge about a notorious criminal case in which there was, as was ultimately proven, no crime. Curating this case poses challenges different from those arising from true crimes. The significance of the collection, the maintenance of ethical relationships with its donors, responsiveness to the public interest in the case, the preservation of fragile and sensitive objects – all demand careful curatorial thought. In this case, curators are committed to ensuring that the ethical, practical, affective and aesthetic responses to the collection are always grounded in the foundational historical and legal facts of the Chamberlains' innocence.

———————

The 'archival turn' in the humanities and social sciences has brought to the surface questions about the materiality of documents, understanding them as objects, artefacts and technologies. Understanding documents as forms of material culture brings scholarly attention to the 'vibrancy' attributed to things, the force or power of their materiality distinct from their informational value (Bennett, 2010; see also Cramerotti 2009; Connarty and Lanyon 2006; Millar, 2010). The Chamberlain Papers in the National Library of Australia are vibrant in precisely this way. As data, they are invaluable for scholars and creative practitioners; but working with them materially provides new opportunities for legal scholars to understand documents, papers, record-keeping and bureaucracy.

Following her release from prison, Lindy Chamberlain made an arrangement with the National Library of Australia (NLA), which sought to acquire her papers. Subject to ongoing continued donations, the 'Papers of Lindy Chamberlain, 1944–2010' is a manuscript collection comprising correspondence, poetry, photographs, telegrams, newsletters, books and drawings.[4] At the time of writing it filled 213 archive boxes, one carton and six folio boxes, but is subject to ongoing donations from Lindy. It includes her personal copies of the legal transcripts of her proceedings, many of which contain annotations and marginalia. There is also a large body of material (12 boxes) relating to Lindy's autobiography, *Through My Eyes*. There are associated collections, including materials of the Chamberlain Information Service (27 boxes, one folio box), and collections from the many other groups and individuals who offered support to the Chamberlains and championed their innocence.[5] The NLA also holds Azaria Chamberlain's birth details and her hospital identity bracelet;[6] it has Lindy's strike statement of 1986, reflecting her plan to go on strike from prison labour following the Northern Territory government's refusal to hold a judicial inquiry into her conviction.[7]

The Chamberlain Papers are not, strictly speaking, evidentiary; most of them were produced outside and after the legal process. However, legal scholars have begun to demand a broadening of the concept of 'legal records', an alignment with the legal scholarship of Cornelia Vismann, Bruno Latour and others who argue that documentation produces law; paper might be implicitly lexogenic (see Vismann 2008; Latour 2010). The distinction between the 'life' and the

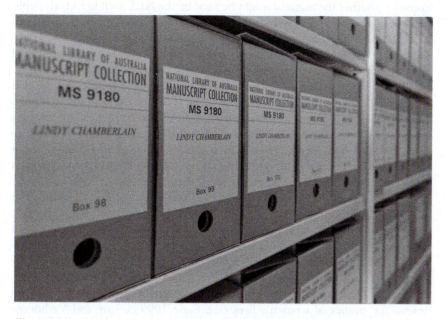

Figure 6.3 Archive boxes containing papers of Lindy Chamberlain-Creighton in the
National Library of Australia, Papers of Lindy Chamberlain, 1944-2010,
MS 9180. National Library of Australia, reproduced with permission.

'afterlife' of the case might give rise to a separation of 'legal' and 'extra-legal'
papers. However, the afterlife of the Chamberlain case – in which a convic-
tion became wrongful, and in which legal institutions lost credibility – has the
capacity to bring the extra-legal within law's domain, reminding us that at the
centre of this archive is one of law's victims. As the legal subject at the heart of a
scandalous conviction, inquiry and exoneration, Lindy's collection and arrange-
ment of the papers becomes a significant feature in itself. These personal papers,
correspondence and ephemera acquire further significance for legal scholarship
because of the criminal processes that provoked their making, their retention,
their arrangement and their current access arrangements.

The NLA negotiates a 'rights agreement' with all donors.[8] This document
governs the way a particular collection is to be accessed and used. In this context,
'access' permits viewing and note-taking, while 'use' means copying, publishing
or otherwise publicly exposing the material. The rights agreement enables the
donor to place limitations upon access to or use of all or part of their collection,
for 'a reasonable period of time'; these limitations might require the specific
permission of the donor for access to identified materials, or might keep spe-
cific materials closed until certain dates or events have passed, the death of the
donor being the most common condition. The agreement also invites donors
to contemplate the digitisation of the materials, and the NLA's commitment
to providing digital access to manuscripts through its website. It asks donors to

consider whether the material might be used by the NLA itself in its own publications, or made available to outsiders who might wish to use it in publications, films, performances, transmissions, broadcasts, in online media or in other public ways. Once the rights agreement is finalised, the Library claims ownership of the papers and undertakes to manage them in accordance with the agreement.

The current Curator of Manuscripts, Kylie Scroope, explained to me that in most cases where a donor's permission to access or use papers is required, permission is granted; the access control is simply a mechanism that enables the donor to know what is being done with their papers, rather than an attempt to limit their use. In Scroope's view, there is 'nothing particularly different' about the process by which the Library acquired the Chamberlain Papers. Like most traditional collections of correspondence, it records 'one side' of the conversation; these are letters received by Lindy. For Scroope, additional sensitivities arise from correspondence where 'an exchange between two people' is made at a time when there is no expectation that third parties will be reading their letters in the National Library in the future. The NLA is cautious about personal epistolary collections, where letters might be written in an atmosphere of privacy, intimacy and limited disclosure. This poses both ethical and methodological challenges for scholars, as personal letters are often an important source for studies of women's lives (see Earle 1999; Gilroy and Verhoeven 2000; Jolly and Stanley 2005). What is different about the Chamberlain Papers, compared to other collections in the NLA, is that whereas most personal papers are obtained from people who achieved national significance through a long career in a particular field, Lindy Chamberlain acquired national significance for reasons entirely outside of her own control. Whether this gives rise to additional sensitivities, or demands empathy, is something that the Library has kept in mind.

When Lindy Chamberlain was in Darwin Prison following her conviction, thousands of people sent her letters and cards. After her release from prison, thousands more wrote to her. At that time, Lindy had received more than 20,000 letters from strangers, some of them addressed to her at 'Lindy at Ayers Rock', 'the Darwin courthouse' or simply 'Darwin' (Howe 2009, 223). Since then, and following the advent of electronic mail, Lindy Chamberlain-Creighton now estimates she has received over 40,000 letters and emails in total. She told me that initially the Chamberlains had no clear plan for retaining the letters: 'We kept them, and then it became more and more, and some of them had extremely interesting material.' Through the letters, for instance, the Chamberlains discovered a large body of evidence about dingo attacks that had not been presented at their trial; they also discovered the names of people who had been camping near them when Azaria was taken, and who had never been called as eyewitnesses. She continued,

> They all just went into a box: too busy; deal with it later . . . They just went . . . into a box, then got bigger and went into a tea chest and two boxes. That was after we filled the filing cabinet up.

Lindy told me, 'I came out of prison thinking we'll just keep a few significant ones and I'd burn the rest'. She recounted the day in 1986 that two archivists from the National Library visited her home: 'They had knocked on the front door, got no reply, thought they'd try the back door and walked round to see me with the letters. I was burning them in a big bin'. She estimated having burnt around 50 letters and, following that visit, immediately desisted from any further destruction.

A few years later, another manuscript librarian, Graeme Powell, visited her home in Cooranbong to commence the appraisal process. He recalls:

> [W]e could see immediately that the papers were extensive. They were mostly on the floor, some in boxes, others just heaps of loose papers, with letters mixed up with cuttings, leaflets, and an array of objects . . . In a short visit it was hard to assess the value of such a disorganised archive, but it did seem to us that it documented in detail a family tragedy and, in addition, public attitudes towards the Chamberlains, and the public campaigns to secure Lindy's release and exoneration.
>
> (Powell 2005)

Following that encounter, the Chamberlain Papers were rapidly examined and an arrangement made between the Chamberlains and the NLA to acquire the papers, but Lindy wanted the opportunity to review the papers, to ensure that any personal disclosures were protected. Then, on further thought, she wanted to organise them. 'So I said "yes" and then I thought "well, they can't go in like that; they should be filed". So I started filing, picking out things that I thought should be particularly mentioned'. The playwright Alana Valentine, whose 2016 play *Letters to Lindy* is drawn from the letters held in the NLA, spoke to me about researching the letters. She told me:

> [Graeme Powell] described to me a marvellous event where he went to Lindy's house and the letters were all in this chaotic form. Then when he came back a month later, it was all beautifully archived and he said he had a sobering moment where [Lindy] was telling the children what to do and he realised that his job was so sophisticated that a seven-year-old could do it.

Prior to acquisition, the collection was appraised. One of the collection's independent valuers wrote,

> The style and spirit of its ordering is such that it offers an unusual degree of completeness. It has been assembled in a fashion so rigorous that it is almost impossible to imagine an instance of conscious or willing exclusion.
>
> (cited in Cunningham 2009, 264)

What Lindy Chamberlain achieved was transformative, and is a feature of the Chamberlain Papers much mentioned by archivists, scholars and others who use the collection. As Powell described it:

A large quantity of the papers had been filed, each file had a sticker with a summary of the contents, and they had been put in alphabetical order in boxes. The files were colourful, as Lindy had colour-coded her correspondence. Letters addressed to her were in blue folders, letters addressed jointly to Lindy and Michael were in red folders, letters to her parents were in green folders and so on. In addition, the files were divided into 'specials' and 'ordinaries'. The filing, annotating and classifying by Lindy Chamberlain and her parents involved a huge amount of work and greatly enhanced the usability and the research value of the archives. It meant that we now had a good idea of the range and content of the material that we were acquiring.

(Powell 2005).

Valentine, a verbatim playwright who makes theatre from archival sources, described being attracted to the Chamberlain Papers in part because of their organisation. Other peoples' papers, Valentine told me, are 'just chaos. There's electricity bills and dead mice'. By contrast, when Valentine commenced her Harold White Fellowship at the National Library of Australia, awarded in 2013 for her to undertake the research that formed the basis for *Letters to Lindy*:

Well, the first day, the librarian took me up to the stack and showed me the 199 boxes and I pulled out one of the first boxes and there was this row of blue manila folders. They were beautifully filed. Each letter writer had their own manila folder. When you pulled the file up, on the top of the blue folder, there was a little yellow Post-It note in which Lindy, I found out, had précis-ed everything that was in the letter. So if I was interested in dingo stories, I need just go through. So it was just magnificent. Your heart sang, it was so beautifully organised.

The papers' current curator, Kylie Scroope, agrees, recalling instances when the NLA has gone to collect materials and 'there's just piles and piles of boxes'. Scroope, who spoke to me about the management of the Chamberlain Papers, observed tactfully, 'I guess what I would say is there are some people who are natural record-keepers and there are some people who aren't'. Scroope described Lindy's approach to arranging her papers: 'I think it's unusual in the sense that her particular approach is – "idiosyncratic" is maybe the wrong word, but it is relatively unique'.

Lindy Chamberlain-Creighton was mindful that, while liberating herself of the burden of having to store this enormous trove of paper, she wanted to maintain her right to access these materials, and this arrangement was agreed. In handing all the papers to the NLA, she also handed to them the responsibility of ensuring that letters written by an author who had sought privacy, or who had asked Lindy not to reveal a personal disclosure, would have this promise observed. She also ensured that access was limited for personal papers associated with her surviving children; some materials are not accessible during her lifetime, or Michael's, or someone else's. She alluded to the sensitivities or risks associated with providing

access to some documents when she told me, 'I've written notes on some of them of what I thought of them at the time'.

The NLA identifies itself as the 'keeping place' for records which define Australian 'collective identity' and which 'record the range and diversity of the national story' (Thompson 1995, 21). The Chamberlain Papers' previous archivist at the NLA, Adrian Cunningham, asserted that they 'reveal the depth of emotional involvement in the Chamberlain case experienced by countless thousands of ordinary Australians' (Cunningham 2009, 253). Most of the letters came from supporters of Lindy, 90 per cent were sent by women, and many described themselves in their letters as 'ordinary Australians'. The criminologist Adrian Howe, who has conducted research on the letters, examined the self-professed ordinariness of the writers, for instance, 'Who am I? . . . just another mother, a fellow Australian, a Christian . . . I drive a white HQ Holden with scratches on the paintwork': 'You don't know me. I'm just another Christian mother'; 'just a face in the crowd'. She also draws attention to the self-conscious attempts of their authors to convey their feelings: 'Dear Lindy, may I call you Lindy? I feel that I know you'; 'I feel so helpless'; 'I feel so upset at the injustice that has been done'; 'if I meet you I will feel as though I am meeting an old friend'(Howe 2009, 224–25). For all their emotional and affective impact, as a collection the letters become records of and for the law; they directly address the law, and they demand that a legal error be corrected.

The intimate and personal nature of some of the letters, as explained by scholarship into the epistolary form, gives rise to questions about privacy, confidence and disclosure. As some scholars have observed, 'In the normal course of events, we do not regard kindly those who read other people's mail and poke around in the private papers. Yet, scholars confronting intimate archives appear licensed to do just that' (Dever et al. 2009, 24). Scholars of the epistolary genre, as Rosanne Kennedy wrote, have observed 'a strong association between femininity, epistolarity, and privacy' in personal letters (2014, 22). Since 90 per cent of the letters in the Chamberlain Papers were written by women, scholars attentive to the archival turn have had to think carefully about what it means to be granted access to papers that were never intended to be read by strangers in a National Library Reading Room. Recent scholarship in this field has been examined by Kennedy, in her work on the use of intimate letters as criminal evidence. She shows how newer, particularly feminist critiques have begun to challenge the tendency to conflate the female with the private (Kennedy 2014, 22–24). In the context of letter-writing and letter-reading, this work situates letters in the context of collaboration and circulation, suggesting that assumptions about privacy, secrecy and discretion are anachronistic or false. As Alana Valentine told me, while there were a few letters in the Chamberlain Papers that say words to the effect of 'this is between you and me and it's completely private', most of them do not.

The Chamberlain Papers are a literal archive of feelings (Biber and Luker 2017, 4; see also Cvetkovich 2003). Specifically, they prove the strength of their authors' feelings about the law. For Howe, the letters to Lindy are:

testimony to an extraordinary expression of emotion, ranging from rage against a palpable injustice, grief at her terrible loss and subsequent persecution, remorse at early misgivings . . . admiration and love and above all, shock, horror and incredulity that this could happen in Australia.

(Howe 2009, 222)

That the law arouses intense feelings is vaguely assumed but rarely documented; the letters sent to Lindy Chamberlain are proof of law's emotional force. For Howe they are evidence of 'a nation in shock'; indeed, Howe describes the 'shock' of finding one of her own letters in the archive, in which she had, decades earlier, invited Lindy to a performance of the play she had written about the case (Howe 2009, 229).

Another user of the letters to Lindy Chamberlain is cultural scholar and poet Deborah Staines. Staines's project was to investigate the Chamberlain case as an instance of 'cultural trauma', drawing upon the letters written to Lindy as evidence of the existence and nature of that trauma. For Staines, cultural trauma occurs when an event is collectively adopted by a society and understood as somehow catastrophic; her project situates the Chamberlains' convictions as a catastrophe or disaster, a legal event that generated a cultural trauma of which the letters are proof (Staines 2008). In Staines's research, some of the letters reveal their author's 'contrition' at having once thought Lindy guilty, and they write to her seeking 'forgiveness'. Some contain 'crackpot theories', or are 'sick and obsessive'; many provide insights into the nature and depth of religious belief or intolerance, responding to Lindy's adherence to the Seventh Day Adventist Church (Cunningham 2009, 263). For Staines, the archive represents a 'community of dissent' (Staines 2008, 105), voices that, for the most part, rejected the narrative of Lindy's guilt and instead testified to her – and their own – grief, apology and regret. The archive, in Staines's work, is 'an evidence trail, a discourse stream, and reading across its strata enables traumatic incoherence to divulge a telling narrative' (Staines 2008, 101). That narrative is a legal one; it achieves its legal status through materiality and archival thinking. As Latour showed, the production and accumulation of paper invokes the law, and in the profusion of paper and with the benefit of hindsight, we see the importance of paper in forcing us to remember the Chamberlains' slow journey from wrongful conviction to exoneration.

I spoke to Staines about her experiences and memories of working with the Chamberlain Papers, which she had done around 15 years prior to our conversation. Within her cultural trauma study, Staines recalled her project investigating two key sites: objects and stories. In the former, the materiality of the letters was central. That the archive contained thousands of letters, cards and notes was, in itself, important. In the latter, she was looking for the stories that could be told from the letters collectively: Did these letters narrate a different or distinctive account of public sentiment about Lindy?

Part of the materiality of the Chamberlain archive was, for Staines, found in the symbolism of the National Library – its rules and protocols, even its

architecture, signalling the significance and preciousness of the material. Inside the Library building, the researcher was inaugurated into a relationship with the nation. She told me, 'After reading the letters, I understood I'd walked into the public sphere . . . what I call the counter-public'. She was clear that she was not meeting these letter-writers as individuals but as a collective; they represented the public.

Another layer of materiality was evident in the volume of letters and, particularly, cards. Staines recalls that there were many small gift cards with Christian psalms and short messages in the vein of 'Dear Lindy, Thinking of you'. The sheer number of such cards rendered them 'innocuous' and 'repetitive'; Staines tried to attend to details including legibility, spelling, the type of writing implement used by their author. These generated evidence of materiality, of physicality, and moved the researcher to reflect upon the effort, time and thought invested by the writer who had acted upon a decision to communicate with Lindy. Staines told me, 'I can recall sitting in that room having to pause to process what that person feels for Lindy'. The letters, in her memory, contained a lot of emotion. They were a direct personal address; many contained confessional details. They were located within a particular time and place in Australia, making them transparently historical but nevertheless full of the emotions of life.

It was overwhelming at times, Staines told me, and she remembers constantly battling a sense of not being able to do justice to the archive. She reminded herself that she was not there for pleasure; this was a responsibility of scholarly work, the difficulty of which was an intrinsic part of her project. Her focus was on trauma, and so she was especially drawn to letters written by people who'd experienced the loss of a child, imprisonment, persecution and pain. Many of these writers articulated that their connection to Lindy was through their shared experience of pain; for the researcher, this immersion into intense pain was difficult to endure.

A further layer of materiality evident to Staines through the letters was 'the imprint of Lindy Chamberlain-Creighton herself'. Lindy's presence asserted itself in various ways: 'through the marginalia, her distinctive cataloguing, her occasional responses, and the closed files' (Staines 2008, 101). It was an important reminder of the reality that the miscarriage of justice at the centre of this archive was experienced, accumulated and documented by its victim. Grounding Staines's research was the absolute certainty that Chamberlain was innocent. Explaining that her project was founded upon 'basic ethical courtesies', Staines told me that 'the most basic courtesy is that you are upfront about her innocence and don't play around with that'.

As well as being an academic scholar, Staines is a poet, and so she also talked to me about her 'self-imposed standard' as a creative writer. She revealed that she had written a poem based on one of the letters, 'an amazing letter that had a big effect on me'. Through her poetry, she 'edited' the letter, 'rewrote it', in order to 'abstract from it what I thought was the poetic essence of the letter'. While the effort of making the poem conveyed considerable thought and judgment, Staines was clear: 'I would not publish the poem'.

The acquisition of the Chamberlain Papers coincided with concurrent shifts in archival appraisal theory, wherein an archivist assigns evidentiary, historical and/or cultural value to records. Archival theory has, as the Chamberlain Papers illuminate, moved away from a power-based structure of records to a memory-based structure, from the state to the individual (Ridener 2009, 112; see also Biber 2011). There is a state-controlled archive relating to the Chamberlain case, in a closed collection in the Northern Territory, and Lindy spoke to me about her inability to access information about its whereabouts or contents. This nineteenth-century notion of the archive, inaccessible and secretive, has been eclipsed by contemporary moves – the 'archival turn' – in which documentation *itself* motivates archival inquiry. Documents have become implicated in memory, poetics, affect and transgression, and these practices now dominate archival appraisal and acquisition. Archival practices once rooted in traditional understandings of history and historiography have since embraced poststructuralist challenges to historicity itself.[9] The power to designate social facts or epistemic truths no longer vests exclusively in the state; the 'archival turn' has seen the official Chamberlain case archive, hidden somewhere in Darwin, eclipsed in significance by Lindy's own papers, which testify to the primary social fact evidenced by her experience: justice gone awry.

Lindy's ongoing accumulation of papers relating to Azaria, a discipline she continues today, is motivated by her desire to remember and honour her daughter. However, Cunningham writes that her persistent collecting, and her decision to deposit her papers with public institutions, responds to her knowledge of the 'symbolic significance' of her case in the Australian collective memory (Cunningham 2009, 265). The letters received by Lindy Chamberlain acquire their significance from the fact that more than 40,000 Australians were sufficiently moved by the events surrounding Azaria's death to write to Lindy. These authors are likely to be otherwise missing from the national archive; individually their letters do not meet the criteria of significance for acquisition and retention. However, in their commonality of purpose they constitute an archive, and they provide evidence that despite her short life, Azaria Chamberlain triggered one of the nation's largest and most significant archives of paper, data and objects.

Scroope has noticed that Lindy manages her personal papers in a distinctive way. For most people, Scroope observes, personal papers are subject to 'natural accumulation'; a person's lifetime archive might be found in 'a shoe box or something under the bed'. Scroope invokes archival theory when explaining that 'original order is a core principle of any archive management'. The rationale for this, she explains, is that researchers 'can glean as much information from the way things are arranged and how they link together, as from what the actual content of a single item is'. And so when a collection of personal papers is donated, 'we would attempt to maintain it in the order that it's in when it comes to us'. Anticipating a handover of personal papers to a national collecting institution, 'We encourage people not to reorganise too much if there is a natural order or arrangement that's been established during accumulation'.

In Scroope's experience, however, Lindy is:

> more attentive to keeping things, and not just keeping them, but also to
> putting that sort of marker on them that almost gives them extra evidentiary
> value. Not evidentiary in a legal sense, but it does clearly establish when and
> where they came from, in a way that not many other people would con-
> sciously do.

I have personally observed Lindy doing this. At a symposium commemorating
the twenty-fifth anniversary of Azaria's death, Lindy approached each of the
presenters after they had spoken and asked them to give her the notes from
which they'd read. She asked them to sign and date the first page before keep-
ing the papers for her collection. The chair on which she sat had a 'Reserved'
sign, and she collected that also. She also told me that, during the making of the
film *Evil Angels*, she asked the actors, including Sam Neill and Meryl Streep, to
sign the first hardback copy of her memoir, *Through My Eyes*. When that book
was stolen, she had them sign another copy, which is now in the NLA. The
making of the mini-series *Through My Eyes*, coincided with the release of a new
edition of her memoir, and she told me:

> I've got [signatures of] all the actors and journos and all sorts of people like
> that in that one. I initially thought I'd keep it and then I thought, well, it's
> sitting there, if anything happens to it it's going to get ruined, I'm the only
> one that will treasure it. The kids have got their own copies and [so] that
> should go in [the National Library]. So that's yet to come.

In this manner, we see layers of materiality rise to the surface. Lindy's memoirs
are published in a volume; her personal copy of that book is then handed around
a film set, touched, marked, signed and inscribed by the personnel of significance.
For her, this adds new value to the object – she now regards it as a 'treasure'.
These material markers represent the fact that each of these people touched this
object, giving it new vitality and significance.

Aside from the letters written to Lindy Chamberlain, the Chamberlain Papers also
include legal documents, which occupy four large archive boxes.[10] Primarily, the
legal papers in this collection are not original documents; they are Lindy's per-
sonal copies of indexes and transcripts of legal proceedings, and also include some
transcripts given to her by Ken Crispin QC, who represented the Chamberlains
before the Royal Commission, and other members of her legal team. They do not
represent the most complete collection of transcripts – the NLA has better and
more comprehensive copies of these in its other collections.[11] But because they
are Lindy's, and because they contain material traces of her possession of them,
they fulfil the requirements of 'significance' for inclusion in a national collection.

As Scroope explains, personal collections of legal transcripts are not unique. The significance of Lindy's own copies of these is a matter for judgment. According to Scroope, 'What tends to sway the decision one way or the other is if something's been annotated, so it has extra information added; that would make us more likely to keep it'. This conforms with Heather Jackson's work on marginalia, in which archival documents are enriched by these markings. A literary scholar, Jackson concedes that we don't know who is being addressed by these textual marginalia, nor what motivated their makers; in her analysis, 'marginalia are written for the good of the work itself' (Jackson 2001, 86). Aside from these marks, Scroope explains that the legal proceedings in which Lindy Chamberlain was entangled:

> are so much at the heart of what made her a public figure to start with, which is the reason why we then go and collect her papers. Then it makes sense to keep them. They're a really intrinsic part of her story, and therefore it would be silly to collect her papers and not keep [the transcripts].

Notwithstanding that these are *Lindy's copies* of legal transcripts, transcripts themselves give rise to unresolved challenges about ownership, particularly in the face of commercialisation and corporatisation (Biber 2014b). Many Australian jurisdictions now outsource transcription services to commercial agencies, and these agencies claim copyright in the transcripts they produce. For Scroope, collections of papers originating from lawyers often include transcripts as well as other case materials, and this gives rise to 'fairly broad ethical questions about whether they're really the owners of that material'. The transcription might become a 'work', but so too might be the intervention of the annotator, the highlighter, the copier and the marginal note-maker. As Scroope explains, the National Library's decision-making here relates to the research value of the material, rather than proprietorial decision-making, but the rights agreements for such collections can be convoluted and demand that the donor 'give a lot of thought to the interests of other people who are represented in the material'. In Lindy Chamberlain's legal transcripts, we cannot know the names or number of those people represented in this material, but we sense their presence in the material traces they have left upon these pages.

Materiality becomes a vital concept in encountering the legal materials within the Chamberlain Papers. Mostly these are spiral-bound volumes from coronial, criminal and appellate hearings. Some of these seem fragile; some have been treated (not very successfully) for water damage. Some pages have turned brown, some are spotted with mould, some are torn. There are redactions and hand-written notations in more than one hand. Some volumes are photocopied onto pink paper. There are parts that are highlighted and some sticky notes stuck in places where their significance is not apparent. Some pages have been copied askew and sit at an oblique angle from the others. Also spiral-bound, on the spine of one of them is what appears to be written in a children's silver marker reading 'AZARIA TRIAL VOL 1'.[12] The materiality of these documents suggests that many different hands have touched, used, notated, marked, organised and labelled these pages, as well as those that have bound and boxed them.

The physicality of the page is important for scholars attentive to the material-ity of archival papers. In the work of Bonnie Mak, the page is a crucial site for analysis, linking materiality with meaning. For Mak, the page is 'a technological device', a 'communicative space'; it discloses 'strategies' and embodies the ideas it transmits (Mak 2011; see also Biber 2014a). One box contains very large bound volumes transcribing the testimony of forensic experts, which was highly signifi-cant in obtaining the wrongful conviction.[13] There is a lot of highlighting and underlining in these areas – for example, where testimony is taken relating to the damage to Azaria's jumpsuit, or purporting to support the finding of foetal blood in the car, all of which was ultimately discredited by the Royal Commission. Here, the transcript appears to have been heavily highlighted and underlined before being photocopied and bound. Then, it has been annotated in pencil. Again there is notation, underlining, highlighting and circling. Some of the pages have been inadvertently folded; somebody has corrected the transcription, for example 'cored blood' is corrected to read 'cord blood'. Here we come to under-stand Mak's argument about the inseparability of meaning and materiality. These papers record ideas about ideas. Some of these ideas are evident just by looking at the page; for instance, somebody with scientific knowledge has made various annotations throughout, such as an exclamatory marginal note that reads '$Na+$ Cl !' Other ideas are more opaque, such as question-marks drawn in uneven patterns in the margins, or a sticky note requesting multiple copies – '10 copies'; '5 copies' – with no clue as to what was to be copied, or to whom it ought to be distributed. Lindy explained to me that most of the notes and copies were associ-ated with the examination and cross-examination of witnesses. On one volume, the spiral binding has come apart and a complex arrangement of bulldog clips attempts to hold it together.[14] One idea is captured in this arrangement; another in its preservation. Collectively, these archived papers bring together one unifying idea: here is a miscarriage of justice. This is the idea that has brought these pages together, and caused them to be preserved, managed and periodically visited by researchers. For legal scholars and practitioners, these papers send a powerful cautionary message: this happened; don't forget.

As mentioned earlier, Alana Valentine is a verbatim playwright; her theatrical work is made from existing transcripts or the testimony of her informants. Awarded a Harold White Fellowship by the NLA in 2013, she was granted access by Lindy Chamberlain-Creighton to the letters in order to develop a work of theatre; this resulted in the stage play *Letters to Lindy*, which premiered in Wollongong in July 2016 and has since toured several Australian cities. The play is moving, at times emotionally wrenching, and often very funny. It puts the voices of many letter writers into a kind of dialogue with each other and with Lindy, and also draws on the voices of lawyers, judicial officers and scientists. We also see Lindy mourning Azaria by caressing and folding replicas of the tiny blood-stained and torn garments which were found after Azaria was taken – the jumpsuit, singlet,

nappy and booties, and years later the matinee jacket – all now held in the collections of the National Museum of Australia. Through Lindy's voice, we appreciate the absurdity of the proposition that she murdered her baby without motive and with nail scissors in the family car during a short absence from a barbecue. When the Lindy character re-tells dingo jokes that circulated in popular culture during her legal ordeals, we hear with a new intensity their cruelty. The play presents us with the voices of the vitriolic and awful letter writers but also the spectrum of sweet, charming, kind, absurd, apologetic and well-meaning letters; letters from supporters, friends, strangers, children.

Valentine spoke to me at a time when she was still researching and writing the play, at which time she said, 'My role is not to proselytise for Lindy, or protect Lindy'. She explained that verbatim theatre, at least in her own writing practice, is 'part of the swing of more authentically-based art in the twenty-first century; I think it's part of a bigger philosophical debate about why we're so attracted to the documentary style and authentic stuff'. While a large part of what Valentine described about her work related to her commitment to giving voice to individuals and communities who might otherwise not appear on the stage, she was attentive to the materiality of researching in the Chamberlain Papers.

Initially, it was the architecture of the Library, and the scale and scope of its collections, that framed her project. In her words, 'The National Library is itself overwhelming as a place. It's kind of like walking into infinity'. In our discussion about the challenges of working with national collecting agencies, and economic and political drivers of digitisation initiatives, she reflected, 'Sometimes people feel like you put something in a cultural institution and that's a way to make it disappear'. This accords with more traditional views of the archive, where bureaucracy, inaccessibility and overabundance create the belief that everything is there, but nothing can be found. For Valentine, the material encounter with a physical thing is important to her creative practice. In her words, 'I really love to get my hands on the actual thing . . . I like to put my hands on these actual letters from the public with stains and all sorts of things that are on them'. These are, for Valentine, the 'primary source', and they need to be experienced tangibly. The letters written to Lindy Chamberlain are, for Valentine, a 'time capsule of Australia in the 1980s' (Valentine 2013).

For Valentine, one way of coping with the volume of the letters was to create categories, of which she identified 20. Amongst the largest were what she termed 'Apologisers' and 'Fellow persons of faith'. Also significant were the numbers of letters from 'Prisoners and ex-prisoners' and letters relating to the internal machinations of the occasionally rivalrous support groups.[15] Interestingly, one of the smallest categories, which Valentine estimates at less than 5 per cent of the total, is 'nasty, poisonous, anonymous' letters. Some of these are pornographic, and all are vitriolic in some way; the play *Letters to Lindy* provides a dramatic representation of part of that material. As Valentine reasoned, 'They're the most evil bastards in the world. So when they're bad, they're very, very bad'. She also notes that many of these are long, handwritten letters, representing a genre of communication largely lost in modern correspondence.

Valentine also explained the painstaking process of seeking to locate the copyright holders of the letters. After first clearing her selection of letters with Lindy Chamberlain-Creighton, Valentine then attempted to contact the letter writers, many of whom had signed and addressed their letters. Unpublished works remain the copyright of their authors in perpetuity, and Valentine went to considerable lengths to demonstrate that she had made every effort to contact them to obtain their approval for her use of their words in her play. Seeking legal advice, she kept 'return to sender' envelopes, and used the electoral rolls – also held in the NLA – to find current addresses for letter writers who had moved. The need for the user – in this case, the playwright – to take responsibility for the intellectual property issues arising from their research is a part of the NLA's negotiated agreement with the donor. For Kylie Scroope, this issue poses 'one of the biggest complexities in managing collections of manuscript material or unpublished material'. The Chamberlain Papers comprise thousands of copyright owners, representing just one of many sensitivities arising from the nature of this collection. As a collection unified by the theme of law's mistakes, it is striking that it is now managed with very careful attention to how the law might be engaged by its survival.

In the afterlife of the law, evidence might be created outside legal institutions, but nevertheless be probative of law's work. At the centre of the Chamberlain Papers is their central subject, Lindy Chamberlain-Creighton, whose experiences of law prompted the accumulation of papers that would later become one of the National Library of Australia's most celebrated acquisitions. That the overwhelming majority of this collection was *not* made by legal officers is a crucial feature of this archive, and demands new ways of examining this collection and its significance. In many respects, the collection was given legal significance by Lindy herself, who transformed a disordered hoard of paper into an archive. Through its ordering, filing and annotation, and perhaps also in donating it to a national collecting agency, Chamberlain-Creighton produced a record of law's work and law's failures that had hitherto not existed. She made her personal experiences of trauma, loss and miscarriage of justice materially examinable for scholars and creative practitioners. By attending to the moves advanced by the archival turn, Stoler noticed that 'we are no longer studying things, but the making of them' (Stoler 2002, 89–90). That the Chamberlain Papers were *made* by thousands of ordinary people and then *re-made* by Lindy Chamberlain-Creighton tells us something important. In their abundance and in their distinctive arrangement, and through the thoughtful manner in which they were acquired for the nation, we learn about the value of tenacity in the face of injustice, and the deeply felt compassion for one of law's victims.

Notes

1 These include *Evil Angels* (1988) [film]; *Through My Eyes* (2004) [TV]; Henderson (1997) [opera]; Murray (1999) [poetry]; Croggon (1995) [poetry]; Dawson (2002) [paintings]; Valentine (2016) [theatre]; Chamberlain (1990) [memoir]. See also Lindy Chamberlain-Creighton's website (http://lindychamberlain.com) for a large volume of material, including a timeline.

 2 NMA, *Eternity*, accessible at www.nma.gov.au/exhibitions/eternity/mystery
 3 See also NMA, Chamberlain collection images, accessible at www.nma.gov.au/collections/highlights/azaria-chamberlains-dress/chamberlain_images
 4 National Library of Australia, Papers of Lindy Chamberlain, 1944–2010 [manuscript] MS 9180, MS Acc09.079, MS Acc10.091.
 5 National Library of Australia, Papers of Lindy Chamberlain, 1944–2010 [manuscript] MS 9180, Series 13: Chamberlain Information Service, 1982–90; National Library of Australia, Papers of Chamberlain support groups, 1982–86 [manuscript] MS 7400; Papers of Guy and Phyllis Boyd, 1890–2001 MS 7551; Records of the National Freedom Council, 1980–2000 MS 7845; Papers relating to the Chamberlain case, 1980–90 [manuscript] [papers of Norman H. Young] MS 8292; Papers of Betty Hocking, 1982–86 [manuscript] MS Acc10.210.
 6 National Library of Australia, manuscript reference no.: MS 9180, Series 1, Box 62, Azaria birth memorabilia folder.
 7 National Library of Australia, Lindy Chamberlain strike statement from Darwin Prison, 1986 [manuscript] MS 9180, Series 1, Box 66, Darwin Prison folder. The statement had been smuggled out of prison for a planned media release by Senator Bob Collins, however the strike plan was abandoned when Azaria's matinee jacket was found.
 8 National Library of Australia, Manuscript Collection Rights Agreement. Document provided by Kylie Scroope.
 9 Ridener's study identifies Fredric Jameson, Jean-Francois Lyotard and Hayden White as the scholars who were instrumental in this move. Biber and Luker (2017, 11–14) identify some of the key feminist, postcolonial, queer and critical race theorists who also challenged historical traditions.
10 National Library of Australia, Papers of Lindy Chamberlain, 1944–2010 [manuscript] MS 9180, Series 12: Trial transcripts and related material, 1981–84.
11 For example, National Library of Australia, Papers relating to the Chamberlain case, 1980–90 [manuscript] [papers of Norman H. Young] MS 8292.
12 National Library of Australia, Papers of Lindy Chamberlain, 1944–2010 [manuscript] MS 9180, Series 12: Trial transcripts and related material, 1981–84, Box 144 Transcripts of the Trial in the Supreme Court of the Northern Territory (1982) volumes 1 & 3.
13 National Library of Australia, Papers of Lindy Chamberlain, 1944–2010 [manuscript] MS 9180, Series 12: Trial transcripts and related material, 1981–84. Box 145 Transcripts of the Trial, volumes 4 & 5.
14 National Library of Australia, Papers of Lindy Chamberlain, 1944–2010 [manuscript] MS 9180, Series 12: Trial transcripts and related material, 1981–84. Box 145, volumes 6 & 7.
15 Other categories identified by Valentine in her lecture include: Poets; Funny letters; Nuts; Close and casual friends of Lindy's; Immediate family; Journalists; Aboriginal people; Octogenarians; Children; Givers (of money, gifts, craft); New Zealanders; International writers; Visual artists; Dingo story tellers.

References

Anderson, F. (2016), '"Photographing Lindy": Australian press photography and the Chamberlain case, 1980–2012', *Media International Australia* 162(1), 7–18.

Balzer, D. (2014), *Curationism: How Curating Took Over the Art World and Everything Else*, Toronto: Coach House Books.

Bennett, Jane (2010), *Vibrant Matter: A Political Ecology of Things*, New Brunswick: Duke University Press.

Biber, K. (2011), 'Evidence from the archive: Implementing the *Court Information Act* in NSW', *Sydney Law Review* 33(3), 575–98.

Biber, K. (2013), 'In Crime's Archive: The cultural afterlife of criminal evidence', *British Journal of Criminology* 53(6), 1033–49.

Biber, K. (2014a), 'In Jimmy Governor's archive', *Archives & Manuscripts* 42(3), 270–81.

Biber, K. (2014b) 'Inside Jill Meagher's handbag: Looking at open justice', *Alternative Law Journal* 39(2): 73–77.

Biber, K. (2016), 'Peeping: Open justice and law's voyeurs', in C. Sharp and M. Leiboff, eds, *Cultural Legal Studies: Law's Popular Cultures and the Metamorphosis of Law*, Abingdon UK: Routledge.

Biber, Katherine and Trish Luker, eds (2017), *Evidence and the Archive: Ethics, Aesthetics and Emotion*, Abingdon UK: Routledge.

Bryson, J. (1985), *Evil Angels*, Ringwood, Vic: Penguin.

Chamberlain, L. (1990), *Through My Eyes: An Autobiography*, Port Melbourne, Vic: William Heinemann Australia (since reprinted under the new title *The Dingo's Got My Baby*).

Connarty, Jane and Josephine Lanyon, eds (2006), *Ghosting: The Role of the Archive within Contemporary Artists' Film and Video*, Bristol UK: Picture This Moving Image.

Cramerotti, Alfredo (2009), *Aesthetic Journalism: How to Inform Without Informing*, Chicago IL: University of Chicago Press.

Croggon, A. (1995), 'Lindy' [poem], in S. Lever, ed., *The Oxford Book of Australian Women's Verse*, South Melbourne, Vic: Oxford University Press.

Cunningham, Adrian (2009), 'Icons, symbolism and recordkeeping: The Lindy Chamberlain and Eddie Mabo papers in the National Library of Australia', in Deborah Staines, Michelle Arrow and Katherine Biber, eds., *The Chamberlain Case: Nation, Law, Memory*, Melbourne, Vic: Australian Scholarly Publishing.

Cvetkovich, Ann (2003), *An Archive of Feelings: Trauma, Sexuality and Lesbian Public Cultures*, New Brunswick: Duke University Press.

Dawson, N. (2002), *Lindy Chamberlain: A Personal Visual Response*, DCA thesis, University of Wollongong; 36 artworks, acrylic on board or canvas.

Dever, Maryanne, Sally Newman and Ann Vickery (2009), 'Introduction', in Maryanne Dever, Sally Newman and Ann Vickery, *The Intimate Archive: Journeys Through Private Papers*, National Library of Australia.

Didi-Huberman, G. (2002), 'The surviving image: Aby Warburg and Tylorian Anthropology', *Oxford Art Journal* 25(1), 59–70.

Earle, Rebecca, ed. (1999), *Epistolary Selves: Letters and Letter-Writers, 1600–1945*, Aldershot UK: Ashgate.

Edmond, G. (1998), 'Azaria's accessories: The social (legal-scientific) construction of the Chamberlains' guilt and innocence', *Melbourne University Law Review* 22, 396–441.

Evans, C. (2003), *A Question of Evidence*, Hoboken NJ: John Wiley and Sons.

Evil Angels (1988), *motion picture, F. Schepisi director: Warner Bros.*

Gans, J. (2007), 'The Peter Falconio investigation: Needles, hay and DNA', *Current Issues in Criminal Justice* 18(3), 415–30.

Gilroy, Amanda and W.M. Verhoeven, eds (2000), *Epistolary Histories: Letters, Fiction, Culture*, Charlottesville VA: University Press of Virginia.

Ginzburg, C. (1999), *The Judge and the Historian*, trans. A. Shugaar, London: Verso.

Hauser, K. (2004), 'A garment in the dock', *Journal of Material Culture* 9(3), 293–313.

Henderson, M. (1997), *Lindy* [opera], libretto by J. Rodriguez and M. Henderson, Opera Australia.

Howe, A. (1996), 'Imagining evidence, fictioning truth: Revising (courtesy of OJ Simpson) expert evidence in the Chamberlain case', *Law Text Culture* 3, 82–106.

Howe, A. (2005), *Lindy Chamberlain Revisited: A 25th Anniversary Retrospective*, Canada Bay NSW: LHR Press.

Howe, Adrian (2009), 'Writing to Lindy – "May I call you Lindy?"', in Deborah Staines, Michelle Arrow and Katherine Biber, eds, *The Chamberlain Case: Nation, Law, Memory*, Melbourne, Vic: Australian Scholarly Publishing.

Jackson, H.J. (2001), *Marginalia: Readers Writing in Books*, New Haven CT: Yale University Press.

Jensen, S. (2009), 'The Chamberlain Collection at the National Museum of Australia', in Deborah Staines, Michelle Arrow and Katherine Biber, eds., *The Chamberlain Case: Nation, Law, Memory*, Melbourne, Vic: Australian Scholarly Publishing.

Jolly, Margaretta and Liz Stanley (2005), 'Letters as/not a genre', *Life Writing* 2(2), 91–118.

Kennedy, Rosanne (2014), 'Affecting evidence: Edith Thompson's epistolary archive', *Australian Feminist Law Journal* 40, 15–34.

Latour, Bruno (2010), *The Making of Law: An Ethnography of the Conseil d'Etat*, trans. Marina Brilman and Alain Pottage, Cambridge UK: Polity Press.

Mak, Bonnie (2011) *How the Page Matters*, Toronto: University of Toronto Press.

McAtackney, L. (2014), *An Archaeology of the Troubles: The Dark Heritage of Long Kesh/ Maze Prison*, Oxford UK: Oxford University Press.

Middleweek, B. (2016), 'Deviant divas: Lindy Chamberlain and Schapelle Corby and the case for a new category of celebrity for criminally implicated women', *Crime Media Culture: An International Journal* 13(1), 85–105.

Millar, John Douglas (2010), 'Watching v looking', *Art Monthly*, October, 7–10.

Morling, T. (1987), *Report of the Commissioner, Royal Commission of Inquiry into the Chamberlain Convictions*, Darwin, NT: Government Printer of the Northern Territory.

Murray, L. (1999), 'A deployment of fashion' [poem], in L. Murray, ed., *Conscious and Verbal*, Sydney NSW: Duffy and Snellgrove.

National Museum of Australia (n.d.), Collection Explorer – 'Chamberlain', accessible at http://collectionsearch.nma.gov.au/ce/chamberlain (accessed 2 September 2016).

Northern Territory News (1986), 'Lindy out', 7 February.

Powell, Graeme (2005), 'The Chamberlain Papers', paper presented at *Nation, Law, Memory: A Chamberlain Case Symposium*, Macquarie University; reproduced at: http:// littledarwin.blogspot.com.au/2012/06/lindy-chamberlain-linked-to-prominent.html

Reynolds, P. (1989), *The Azaria Chamberlain Case: Reflections on National Identity*, Brisbane QLD: University of Queensland.

Ridener, John (2009), *From Polders to Postmodernism: A Concise History of Archival Theory*, Duluth MN: Litwin Books.

Sawyer, P. (1996), '"Naming Whiteness": An inquiry into Lindy Chamberlain's *Through My Eyes* and Australian nationalist discourses', *Law Text Culture* 3, 107–23.

Staines, Deborah (2008), 'Textual traumata: Letters to Lindy Chamberlain', *Life Writing* 5(1), 97–114.

Staines, Deborah, Michelle Arrow and Katherine Biber, eds (2009), *The Chamberlain Case: Nation, Law, Memory*, Melbourne Vic: Australian Scholarly Publishing.

Stoler, Ann Laura (2002), 'Colonial archives and the arts of governance', *Archival Science* 2(1) 87–109.

Thompson, John (1995), 'Making history: Acquiring the Mabo papers', *National Library of Australia News*, October.

Through My Eyes: The Lindy Chamberlain Story (2004), television series, D. Drew, director; Liberty and Beyond.

Valentine A. (2013), Harold White Fellowship Lecture, 18 October, National Library of Australia, accessible at www.nla.gov.au/events/harold-white-fellowships

Valentine, A. (2016), *Letters to Lindy* [stage play], Merrigong Theatre Company.

Vismann, Cornelia (2008), *Files: Law and Media Technology*, trans. G. Winthrop-Young, Stanford CA: Stanford University Press.

Williams, P. (2007), *Memorial Museums: The Global Rush to Commemorate Atrocities*, Oxford UK: Berg.

Cases

R v Alice Lynne Chamberlain and Michael Leigh Chamberlain (1982) NTSC, unreported.

Chamberlain v The Queen (1983) 46 ALR 493.

Chamberlain v R (No 2) (1984) 153 CLR 521.

Re Conviction of Chamberlains (1988) 93 FLR 238: 254.

7 International crimes

The afterlife of evidence of genocide, war crimes and crimes against humanity

We do not wish to dwell on this pathological phase of the Nazi culture; but we do feel compelled to offer one additional exhibit, which we offer as Exhibit Number USA-254. This exhibit, which is on the table, is a human head with the skull bone removed, shrunken, stuffed, and preserved. The Nazis had one of their many victims decapitated, after having had him hanged, apparently for fraternizing with a German woman, and fashioned this terrible ornament from his head.

—*Thomas J. Dodd, United States prosecutor, International Military Tribunal, Nuremberg, Thursday 13 December 1945. (International Military Tribunal 1947, vol. 3, 516)*

The shrunken head of an unnamed Buchenwald prisoner was tendered into evidence on the nineteenth day of the first Nuremberg trial, alongside flayed human skin marked with tattoos and a preserved human skull and human organs.[1] Later, these exhibits were said to have tested the limits of law. These items were evidence not of any direct legal culpability of the defendants but, instead, proved the barbarity and depravity of the Nazi regime. As the legal scholar Lawrence Douglas argued, they were evidence of '*crimes against atavism*: horrific deeds committed in an orgy of mass savagery and lawlessness' (Douglas 1998, 42). The challenge for the Tribunal was the reassertion of civilisation, order and control but, as these exhibits demonstrated, the Tribunal asserted its civility with occasional evidence of abject horror.

While observers of the trial recoiled at the wrongness of this object, including its wrongness as an evidentiary exhibit, it was not as if head-shrinking was unknown to civil society, or even to the personnel of the court. Douglas tells us that its English Chief Justice, Geoffrey Lawrence, was elevated to England's High Court in 1932, the same year Oxford University, his alma mater, acquired two shrunken heads from the Shuar and Achuar (formerly Jivaro) people in Ecuador for its Pitt Rivers Museum. They remain on display today and postcards and other souvenirs are still available today from the gift shop (Douglas 1998, 43–44).

The shrunken head of Buchenwald has suffered an awkward fate, unsuitable for elevation to the position of what Douglas has called the 'quintessential

icons of the Holocaust' – the Zyklon B canisters, mountains of eyeglasses, shoes, human hair and suitcases, and perhaps the *Arbeit macht frei* signs at the entrances of some concentration camps. The head 'enjoyed a brief career' at other war crimes trials, appeared before a U.S. Senate subcommittee and was identified in the U.S. Army's shipping records as 'Little Willie' (Douglas 1998, 56). Both the Smithsonian and the Army's Museum of Military Medicine declined to exhibit the head and, when Douglas tried to discover its contemporary whereabouts, he was led to believe that it was now in the hands of a private collector. The Nazi Holocaust is the most notorious crime of the twentieth century, its crime scenes spanning Europe and its evidence dispersed amongst institutions and collections from the highest to the lowest ends of the cultural spectrum. Memorabilia is traded by reputable dealers and by black market operators. Reports of souvenirs being stolen by visitors at Auschwitz, including Swedish neo-Nazis, English schoolboys and an Israeli student, while dreadful, seem unsurprising (see Der Spiegel 2010; Halliday and Grierson 2015; Davies 2017). The afterlife of the Holocaust seems no longer bounded by any sense of deference to its victims or survivors. The Holocaust has generated an evidentiary afterlife like any other.

Conventionally, the laws of evidence rely on a conceptual alignment between the crime in issue and the evidence tendered to prove it. The Nuremberg Tribunal, which established *sui generis* rules of evidence for itself, disturbed these conventions, seeking instead to prove *more* than the crimes of the defendants; the shrunken head was one of a cohort of exhibits that enabled this evidentiary surplus to be generated. Even as they appeared before the court, these evidentiary artefacts were building up a cultural charge that would sustain them in their afterlife: these are the things that proved atrocities. Acknowledgement of their potential afterlife began in the courtroom, where their impact was demonstrated by the defendants themselves. Of Field Marshal Keitel, the third-highest ranking Nazi tried at Nuremberg, Douglas wrote that, upon seeing the shrunken head in court, 'Keitel, himself no stranger to brutal behavior, whispered *"Furchtbar! Furchtbar!"* – Horrible! Horrible!' (Douglas 1998, 44).

The Holocaust presented a representational crisis for lawyers from the earliest moments. Framing judicial proof of these crimes demanded the creation of new jurisdictions, new evidentiary rules and a new imaginative register. Prosecutors at the International Military Tribunal at Nuremberg were attentive to the need for simultaneously probative and shocking testimony, images and objects. As Douglas wrote, 'the law had to locate an adequate idiom of both representation *and* judgment' (Douglas 1995, 453). Because the crimes being prosecuted were unprecedented, the Tribunal admitted new types of evidence – visual evidence – invoking the necessity 'to translate images of atrocity into a discourse of illegality' (Douglas 1995, 457). For example, on 29 November 1945, prosecutor Thomas J. Dodd introduced into evidence an hour-long compilation of film footage made as Allied troops liberated concentration camps. He referred to it as a 'documentary film' and it was later known by the title *Nazi Concentration Camps*. Dodd told the court:

> Prosecution for the United States will at this time present to the tribunal, with its permission, a documentary film on concentration camps. This is by no means the entire proof which the prosecution will offer with respect to the subject of concentration camps. But this film, we offer, represents in a brief and unforgettable form an explanation of what the words 'concentration camp' imply.
>
> (International Military Tribunal 1947, vol. 2, 431)

In presenting the evidence, Dodd told the court defence counsel had been given the opportunity to view the film beforehand, but only eight had attended. He identified affidavits made by the film's producers, including its director Lieutenant Colonel George C. Stevens, a future Academy Award nominee and winner.[2]

The prosecution counsel, Commander James Donovan, told the court that 'these motion pictures speak for themselves in evidencing life and death in Nazi concentration camps' (International Military Tribunal 1947, vol. 2, 433). Trial footage of the reaction of the defendants to the screening of the film can be viewed online at the United States Holocaust Memorial Museum website. It shows some defendants with hands over their eyes; one is seen to be drying his eyes; and some are chatting animatedly amongst themselves (Holocaust Museum (b) n.d.; see also Douglas 1995 at 455–56 for four different accounts of the defendants' reactions to the film). The second-highest ranking Nazi tried at Nuremberg, Herman Göring, later said 'And then they showed that awful film, and it just spoiled everything' (Douglas 1995, 449). Göring's remark suggests that he recognised the impact of this evidentiary exhibit; its wrongness consolidated its lingering effect and guaranteed it an afterlife. It is now available for streaming on Netflix, catalogued as a Classic Movie (*Nazi Concentration Camps* 1945).

The documentary film and the shrunken head highlight the distinction between evidence of legal guilt and evidence that evokes visceral responses. The distinction teaches us that evidence is always *more than* proof. It is this excess that survives, once the processes of proof have expired. The artefacts tendered at Nuremberg inaugurated a new evidentiary category of horror; as the United States Chief Prosecutor Robert H. Jackson stated at the Tribunal, 'These are things which have turned the stomach of the world' (Douglas 1998, 45). This affective impact enabled materials that were not relevant to proving the facts in issue to nevertheless acquire their status as legal 'evidence'. It also ensured that, once their evidentiary life had concluded, they would survive in the cultural sphere as evidence of atrocity.

———

In investigating the afterlife of crimes against humanity, it is impossible to avoid the endless wrangling over how the Nazi Holocaust should be remembered. Generating the most emotionally laden criminal evidence of the twentieth century, the Holocaust continues to be policed to preserve its status as history's most traumatic crime scene. In 2002, the Jewish Museum in New York exhibited *Mirroring*

Evil, in which contemporary artists represented the Holocaust. Holocaust survivors demonstrated against the exhibition, holding placards in the street outside. One, 81-year-old Buchenwald survivor Isaac Leo Kram, carried a sign that read: 'I was there. I testify: Genocide is not art!' (Kershaw 2002).

A sign at the entrance of the museum warned visitors that some might be upset by the exhibition. The New York press, typically supportive of the city's art institutions, repeatedly questioned the Museum's judgment in holding the exhibition. At the heart of the controversy was grave concern that some of the artworks were testing the limits of how the Holocaust could be represented and remembered. Some of the artists were challenging long-standing conventions about Holocaust memory, which demanded that all representations respect the evidence. Instead, they were testing whether it was possible to employ irony, satire and pastiche, or to *depart from the evidence* and be speculative or imaginative.

Exhibited in *Mirroring Evil*, Alan Schechner's work 'It's the Real Thing – Self-Portrait at Buchenwald' (1993) appropriated a famous photograph taken by Margaret Bourke-White in April 1945. The image was taken in the aftermath of the Allied liberation of the camp, and shows starving male inmates crowded into their bunks, staring imploringly at the camera. Schechner superimposed a photograph of himself in the foreground, wearing a striped prison shirt and holding a can of Diet Coke. In this black-and white image, only the Coke can is in colour, illuminated in a shining flare of light. Bourke-White's photographs of the camps, first published in *Life* magazine in May 1945, were some of the first evidence presented to the wider world of Nazi atrocities.[3] Schechner's work aims to critique the manipulation of Holocaust-related imagery in contemporary contexts, particularly the Israel/Palestine conflict.

Philosophers and other scholars have remained resolute that, when it comes to the Holocaust, the evidence imposes strict limitations upon its own use. Ernst van Alphen wrote that 'Holocaust survivors and new generations after the Holocaust have a special responsibility towards its historical events' (Van Alphen 2001, 45). Theodor Adorno warned that 'wringing pleasure' from the Holocaust would be 'barbarism' (cited in Geuens 1995, 114). Hayden White asked rhetorically, 'Are there limits on the kind of story that can responsibly be told about these phenomena?' (White 1992, 37). James R. Watson warned of the perils of failing to impose limits. Concurring with Jürgen Habermas, he wrote of the necessity for 'critical intellectual activity' to identify and police the limitations of the human condition. Failure to do so would allow the unimpeded perpetuation of the 'almost autonomous economic system' whose 'rampant reduction of everything and everyone to a resource in the self-destructive frenzy of consumption' enabled 'State organized mass murder'. The development of institutions to set limits upon this murderous autonomy needs to be supported, he argued, and the failure of art and philosophy to defend those limits is a 'delusional intellectual pretension' (Watson 1992, 171–72). Without limiting how the evidence can be used and redeployed, this argument claims, the Holocaust is always imaginable, possible and repeatable.

The artwork of Tom Sachs seems deliberately made to test every moral boundary, simply to demonstrate that it can be done. His work 'Giftgas, Giftset' (1998) contains three dented cylinders labelled as containing Zyklon B. The deadly poison exterminated over one million people in gas chambers at Auschwitz-Birkenau and other camps, and after the war its inventors were tried and executed by a British military tribunal. In Sachs's work, each cylinder is wrapped to look like a gift using the colours and typeface from the Chanel, Hermes and Tiffany & Co. fashion labels. In another work, 'Prada Deathcamp' (1998), Sachs has made a 27-inch scale model of a concentration camp from a deconstructed Prada hat box, ink and wire. Sachs was interviewed in *The New York Times* about these works:

Sachs: I'm using the iconography of the Holocaust to bring attention to fashion. Fashion, like fascism, is about loss of identity, Fashion is good when it helps you to look sexy, but it's bad when it makes you feel stupid or fat because you don't have a Gucci dog bowl and your best friend has one.

Q: How can you, as a presumably sane person, use the Nazi death camps as a metaphor for the more coercive aspects of the fashion industry? It makes me think you have failed to grasp the gravity of the Holocaust.

Sachs: My agenda isn't about making a point about the Holocaust. I don't think any of the artists in the show are trying to make a point about the Holocaust. We're mostly in our 30s and 40s, and we have a certain distance from those events . . .

Q: So what are your aims as an artist?

Sachs: My main interest is bricolage . . .

(Solomon 2002)

On one level of interpretation, Sachs's work seems to comment on precisely the 'frenzy of consumption' that Watson identified as analogous with genocide. Yet the main critical and public response to Sachs's work was that it suffered from 'delusional intellectual pretensions' that Watson characterised as the worst in Holocaust art; Sachs was in large part responsible for reviews dismissing the entire show as 'an emergency ward for toxic narcissism' (Schjeldahl 2002), 'sheer stupidity' and 'not to be forgiven' (Kramer 2002). The show's curator, Norman L. Kleeblatt, admitted the capacity for 'Nazi-era images to probe issues at the center of *prevailing* cultural and discourses, among them desire, commodification, and spectatorship' (Kleeblatt 2002, 15; emphasis added). Jean-Pierre Geuens rejected imposing limitations upon the re-use of Holocaust imagery and evidence, writing 'the wounds should be repeatedly and mercilessly stabbed open with a knife for the Holocaust to remain the mirror that truly defines our limits' (Geuens 1995, 127). It isn't certain that Sachs's work met Geuens's challenge; dismantling a Prada hatbox to explore one's interest in fashion, commodity fetishism and bricolage seems a considerably lower aim than the merciless self-examination Geuens demanded. Much more needed to be said about precisely what could be learned about desire or commodification from the Holocaust before Sachs was

acquitted of accusations of being 'facile' (Saltzman 2002, 94). It is not that these conversations cannot take place, nor that evidence of the Holocaust cannot lead an afterlife. But more is required than the assertion that it can be done. If the Holocaust's crimes teach us nothing else, it is the gravity of pursuing the possible simply to explore its possibility.

Whether engaged in cultural provocation or deeper meditation about genocide and its memory, *Mirroring Evil* offered a forum for contemporary artists and their curators to confront the limits imposed upon Holocaust representation by an earlier generation of survivors and scholars, all of whom felt bound by the evidence. While not all the artists drew on legal evidentiary materials in their artwork, some did, and most of those drew upon the evidentiary vibrancy of materials that proved Holocaust crimes. These evidentiary transitions – where the non-probative becomes evidentiary, where what is nauseating proves facts – represented an open invitation to contemporary artists, for whom 'transgression' is an expectation. For Susan Sontag, it was the 'chronic habit' of contemporary art to displease, provoke or frustrate, but as an actual practice, the regularity of these violations was anticipated. She wrote, 'the artist's transgression becomes ingratiating, eventually legitimate' (Sontag 1976, 7). Thus, in the Director's Preface to the *Mirroring Evil* exhibition catalogue, Joan Rosenbaum referred to the artworks as 'transgressive', 'difficult, challenging', 'provocative and troubling', as if in its afterlife the Holocaust had become a site of everyday creative practice.

Viewing the *Mirroring Evil* exhibition, Holocaust scholar James E. Young asked, 'Just what are the limits of taste and irony here?' (Young 2002, xvi). Michael André Bernstein argued that there are artistic or literary representations of the Shoah that are 'deeply offensive' because they are characterised by 'tastelessness', 'vulgarity' and 'exploitation' (Bernstein 1994, 52). For *taste* to become a term of judgment in response to the afterlife of evidence entangles aesthetic, moral and evidentiary standards. Moreover, as Omer Bartov warned, even tasteful representation carried with it the mendacious potential for voyeurism, the dangerous pleasure that describes our fascination with crimes, including mass crimes (Bartov 1996).

Susan Sontag also cautioned against giving in to the enduring fascination with fascism. When artist Robert Morris posed in Nazi gear for an exhibition poster in 1974, he is said to have done so on the grounds that it was 'the only image that still has any power to shock', relegating Nazism to some back-catalogue of all-purpose icons. As a view of art, Sontag suggested, it conformed to the quest for 'ever-fresh gestures of provocation'. As a view of society, it failed to address the mendacious allure of fascism, both aesthetically and politically (Sontag 1980, 101). When Nazi imagery becomes art, it says something troubling about a socio-cultural milieu in which repression, cruelty and mass murder are evidence of nothing more than contemporary aesthetic iconographies.

The curator of *Mirroring Evil*, Norman L. Kleeblatt, admitted 'most ideological boundaries – especially those regarding representation – have a way of dissolving with time. What has seemed shocking, transgressive, or inappropriate in one decade becomes normalized by repeating exposure and by distance'

(Kleeblatt 2002, 11). In the case of the Holocaust's afterlife, there are those who take an orthodox position (which promotes respect for victims and survivors as the primary consideration) but who accept that the current 'cycle' of Holocaust representation will roll forward when the last of the survivors is dead. With the passing of this generation, Peter Schjeldahl lamented that 'both direct responsibility and proprietary grievance regarding the Holocaust are expiring like patents, and the business of reflecting on it has become a free-for-all' (Schjeldahl 2002).

Introducing the documentary film into evidence at Nuremberg, Chief Prosecutor Robert H. Jackson said, 'Our proof will be disgusting and you will say I have robbed you of your sleep' (Douglas 1995, 450). It seems necessary to locate Holocaust representation within a discourse of disgust, because it may be the only way out of the sense of profound pointlessness that comes from strolling through a gallery and thinking about the Holocaust. Disgust becomes an affect in crime's afterlife, representing the embodied difference between neutral curiosity and something more. For Ian William Miller, disgust described 'our responses to the ordinary vices of hypocrisy, betrayal, cruelty, and stupidity' (Miller 1997, 194). But we must take care not to impart a kind of equivalence to these vices. Cruelty disgusts us; we condemn it. Stupidity disgusts us, but it is not as bad. When we have visceral reactions to cultural artefacts, we must ensure that our affective response does not prevent us from differentiating. To think about the shrunken head of Buchenwald invites overwhelming despair; we might also despair after reading an interview with Tom Sachs about fashion's manipulative potential. One of these represents atrocities of dehumanisation, the other is a conceptual artist's failure to think things through.

————————

Susan Schuppli is a London-based artist and researcher interested in the materiality of war, conflict and disaster. She examines the methods by which images of violence are captured, archived and used, and the transformations wrought by transitions between different media, including digitisation. One of her major projects, *Evidence on Trial*, is drawn from the archives of the International Criminal Tribunal for the former Yugoslavia (ICTY), which, at the time of her project, comprised 9.3 million documents and objects. These form an archive of videos, photographs, aerial footage, x-rays, diagrams, diaries, exhumation records, radio intercepts, audio recordings, scale models, maps, computer hard drives and other remnants, including blood-stained clothing and charred timber. They record not only the accumulated evidence of war crimes, but the creation and operation of the jurisdiction itself – 'the complex inner workings of an international court' – a court founded to preside over prosecutions but also to archive in perpetuity the evidence that they generate (Schuppli 2014a, 280). This, too, represents a transformation: of things into evidence; and of evidence into archives.

Schuppli is mindful of the stakes involved in working in this field as an artist, noting that 'The work that we do [as artists] has to be rigorous so it can actually withstand cross-examination and be tested in the domains in which it attempts

to make a difference' (Schuppli 2014b). Schuppli works across multiple media, attentive to the techniques by which procedures and processes 'convert testimony and material artifacts into matters of legal evidence' (Schuppli 2014a). Of course, this is the substance of every undergraduate 'law of evidence' course: the legal rules governing the taking of people, documents and things from the world and deploying them to resolve disputed facts. That rules, standards, limits and principles are engaged in the production of 'evidence' is a legal commonplace. Viewing these techniques from the perspective of an artist generates new attention to the materialisation of law: how it is actually made from worldly things.

The ICTY was established in 1993 by Resolution 827 (1993) of the United Nations Security Council, in which 'grave alarm' was expressed over 'widespread and flagrant violations of international humanitarian law' in the former Yugoslavia, and especially in the Republic of Bosnia and Herzegovina. These included 'reports of mass killings, massive, organised and systematic detention and rape of women, and the continuance of the practice of "ethnic cleansing", including for the acquisition and the holding of territory'. The Resolution called for the establishment of an *ad hoc* tribunal to prosecute 'serious violations of international humanitarian law'. It also called for the continued collection of evidence 'on an urgent basis' to support the prosecutions (UNSC 1993). When its final prosecution concluded in 2017, the ICTY had prosecuted 161 people, of whom 90 were convicted. In its final days, the courtroom itself became a crime scene when the defendant, Slobodan Praljak, a former general in the Croatian Army, drank poison and died, moments after the Appeals Chamber confirmed his conviction and sentence for war crimes, crimes against humanity and grave breaches of the Geneva Conventions. His death (which imitated the suicide by cyanide poisoning of Herman Göring on the eve of his judicial execution at Nuremberg) is under investigation by both UN and Dutch authorities.[4]

By 2009, the ICTY records occupied 3704 metres of storage shelving and 8000 terabytes of electronic records; they included 45,000 videotapes of proceedings and 5500 video tapes of evidence, 6 million articles and still photographs, and 13,000 artefacts (Campbell 2012, 250). *This* was the evidence used to prove crimes against humanity, genocide, war crimes and other grave allegations. In scrutinising the transformation of these objects into proof, Schuppli was attending to the afterlife of *things* – as evidence. In all litigation, most evidentiary material existed before it was tendered into evidence. The transformation of that thing into evidence is governed by the rules of evidence and procedure. Schuppli casts a critical eye over this process of transition, drawing our attention to the fact that the evidentiary life, itself, can be scrutinised for its qualities of afterlife, aftermath and residue. Her work reminds us that, before it became evidence of mass crimes, this material lived its own life.

In particular, Schuppli was interested in media and non-textual evidence, by which she meant audio and audiovisual broadcasts taken from radio and television, as well as citizen audio and video recordings. In many instances, these were later used as evidence before the ICTY, and Schuppli used the term 'material witness' to describe these materials. They were, she recognised, 'entrusted with

the task of testifying to history', albeit after first testifying to the charges on the indictment (Schuppli 2014a, 281). Schuppli aimed to interrogate the 'postproduction treatment of media materials – their copying, editing, digitizing, and chain-of-custody handling' and how these transformations either produced or undermined the truth claims they were tendered to support. She was interested in the transformations that continued to occur once the material entered the domain of the criminal court; as she wrote, 'the Tribunal itself becomes a processing machine' (Schuppli 2014a, 282).

Some of these materials, before becoming exhibits, led lives as family photo albums, home movies, private papers and other personal mementos. Many were sent unsolicited to the Tribunal and, while 'dutifully logged', were unlikely to be tendered into evidence. Nevertheless, they now form part of the permanent archive of the Office of the Prosecutor (Schuppli 2014a, 282). While records relating to court proceedings are available online, and a major digitisation and access program is being undertaken by the ICTY, the archives of the Office of the Prosecutor are not publicly accessible. They include sensitive and rare materials, exhumation records and x-rays. They also include 22 notebooks written by General Ratko Mladić between 1991 and 1995 and discovered by Serbian police behind a false wall in his home in Belgrade (Simons 2010).[5] The notebooks were significant evidence in at least six prosecutions, and were admitted in their entirety in the prosecutions of Radovan Karadžić and Zdravko Tolimir, as well as the prosecution of Mladić himself.[6]

Schuppli was granted access to all these materials and described the 'Row upon row of brown archival storage boxes and grey files' that captured this voluminous trove of evidence (Schuppli 2014a, 283). Once the Tribunal concludes, these records will move to a purpose-built archive in The Hague, where they will remain in perpetuity. There, they will become what Kirsten Campbell refers to as 'permanent traces of legal memory' (Campbell 2012, 254). This, too, gives rise to an 'afterlife' consideration. Known as the 'Legacy Debates', the afterlife of the Tribunal's archive has been deeply considered, both at ICTY-sponsored conferences in 2010, 2011 and 2017, and within the former Yugoslavia. Who should be its custodians, whether it should be repatriated and whether it remains intact or dispersed; these questions become more urgent as the Tribunal's prosecutorial role draws to a close. That this archive, when its legal life has concluded, will enter its afterlife in The Hague is controversial; most United Nations business records are held in the UN Archives in New York.[7] Some, including Schuppli, have argued that these records ought to be repatriated, in order to regenerate local knowledge and heritage (Schuppli 2014a, 285). For Schuppli, preserving the legacy of these atrocities – and the response to them by international justice mechanisms – demands that their afterlife be emplaced, located in sites geographically bound to the events to which they testify. For other scholars, conceiving of the archive as a 'legal memorial' implies that the law has somehow concluded, or died, and plays no role in rebuilding or reconciliation or the survival of 'living memory' (Campbell 2012, 249). Campbell identified two dominant discourses in the Legacy Debates: those framing the legal archive as a site of remembrance

and those framing it as an agent of forgetting. She proposed an alternate way of imagining the archive, inaugurating the concept of *memorial law*, in which transition and commemoration become practices of law, inverting the usual structure (Campbell 2012, 256 and 261–63).

Throughout her work, Schuppli was cognisant of the 'magnitude of information, voluminous and overwhelming material' (Schuppli 2014a, 289). She reproduced transcripts of proceedings at the ICTY where counsel and judges engaged in painstakingly tedious discussions about pages, binders, CDs, multiple versions of what might be ostensibly the same document, or suggestions that these were *not* the same document, and the various technologies and tools needed for witnesses, parties and the public to apprehend these materials during proceedings. Bureaucratic and spirit-crushing, these transcripts reveal a Tribunal a world away from the conflicts to which it seeks to bring justice. These observations can be made of any courtroom, and about any legal dispute, but the distinction between evidence and the *process* of evidence is magnified in the context of genocide and crimes against humanity.

Schuppli was also attentive to the fact that this evidence of atrocity, gathered in conditions of risk and trauma, arising from pernicious conflict, is now stored with 'mundane regularity [in] humble cardboard boxes' with only alphanumerical codes and sometimes sticky notes to distinguish them (2014a, 284). The codes themselves benignly conceal their contents: Schuppli explained that K is for Kosovo, O for Omarska, S for Srebrenica, X for exhumation, and so on (2014a, 284). Some of the archive boxes are marked with neon-yellow triangles. In the event of a natural disaster or other catastrophe requiring a salvage operation, *these* are the boxes to save first.

For Schuppli, the concept of the 'material witness' captured two properties. First, these items have themselves somehow borne witness to crimes, or arisen from crime scenes. Second, they have also come to embody their own transformation into evidence. They bear the markings or otherwise convey the fact of having become evidence. An object becomes a material witness when 'the complex histories entangled within [it] are unfolded, translated, and transformed into legible formats' (Schuppli 2014a, 292). Schuppli was at pains not to smooth over the fact that intangible objects, including information-capturing machines, do not *really* testify to the events they record. Testimony comes from someone who has borne witness; as Jacques Derrida wrote, 'It is not possible to bear witness without a discourse' (cited in Schuppli 2014a, 309). Witnessing is a human act, reliant upon attention, memory, conscience and speech. Technology does not displace this requirement, either at law or out in the world. Nevertheless, as every legal professional can affirm, the role of the witness has been dramatically eclipsed by the affordances of documentation, and in the digital age this tilting of the balance becomes even more pronounced.

With this in mind, Schuppli explained that the broadcast materials and other media gathered by the Tribunal 'testify' to the 'specific historical conditions out of which they emerged', but also to their current life, in which they inhabit the archive of the Office of the Prosecutor (Schuppli 2014a, 292). This became

even more apparent when she learned that, although every document in the archive likely has a notional 'original' – whether in the archive itself, or somewhere 'out there' in the world – the Tribunal relies upon digitised versions of these documents. Materials might be reproduced by any means – photocopy, scanner, screen capture – but what is presented in the courtroom appears on a monitor. That image might contain clues about the document from which it was sourced, whether these are hole punches, binding, diminished visual qualities, and so forth. Schuppli drew upon the work of Isabelle Stengers to describe these transformations as having generated 'informed material', material 'enriched by information' (Schuppli 2014a, 299). Here, the material is enriched by the traces it bears of its own passage from, say, a crime scene investigation, through a court registry, digital processing and uploading, into the brief of evidence, various pre-trial processes and, ultimately, the trial itself.

Schuppli describes the gradual awakening of her realisation that law's processes *do* constitute an enrichment of evidentiary material. To acquaint herself with sites of evidentiary significance, Schuppli travelled to the sites of the Izbica and Padalishte massacres, where more than 120 Kosovar Albanians were murdered in 1999. Criminologists describe this kind of journey as 'dark tourism', a term that now captures the wide spectrum from commercialised voyeurism to scholarly fieldwork (Lennon & Foley 2000; Strange and Kempa 2003; Dalton 2014). The trip was motivated by her desire to 'supplement' what she had learned through the legal processes, which she felt had 'systematically disarticulated' the events, and any feelings associated with them. The sites themselves no longer bore any visible signs of violence; instead, Schuppli was confronted with the 'latency expressed by ordinary things'. She reflected on her deep immersion in the evidentiary materials – video footage, documentation, pages of court transcripts – and found that they had not, after all, 'flattened' the horror of these massacres. While it did not reproduce the emotional or visceral impact of the violence, the material evidence *did* 'move and speak' (Schuppli 2014a, 306–07). Law's processes for the production of evidence included repeatedly playing the video, authenticating it, editing it into sequential clips, translating it into multiple languages, rewinding, fast-forwarding, pausing, cross-examining, corroborating and then playing it again, and as these processes accrued, the material became 'more saturated and impregnated with information'. For Schuppli, the legal processes of the Tribunal gave the video a 'machinic afterlife' (Schuppli 2014a, 307–08). Here, its 'afterlife' was both its life *as evidence*, but also its life *after death.*

For their *Forensics* exhibition (see Chapter 5), the Wellcome Collection commissioned a work by the Bosnian artist Šejla Kamerić. Kamerić works in multiple media, and most of her practice examines the role of memory in shaping the present. Her commission resulted in the multimedia installation *Ab uno disce omnes* ('From one, learn all') (2015), which is also an ongoing web project (Kamerić 2015a). The work is contained within a mortuary fridge, which visitors must

Figure 7.1 Šejla Kamerić, *Ab uno disce omnes*. Multimedia installation and ongoing web
project. Installation view at Wellcome Collection, 2015. Courtesy Galerie
Tanja Wagner, Berlin.

enter; once inside, they are presented with randomly generated files, documents,
images and footage from Kamerić's research on the 1992–95 Bosnian war and
its aftermath. The work is Kamerić's attempt to create a vast repository of data
relating to the war, including murder, torture, rape and disappearance on a mass
scale. Wellcome curator Lucy Shanahan described the work as a 'monument' and
an 'archive of everything related to the massacres'.[8] Kamerić, whose father and

two uncles were killed in the conflict, has accumulated photographs, film footage, documents, forensic reports and transcripts of testimony, as well as making her own videos during her fieldwork. At the time of the exhibition, these included over 50,000 files and over 85 hours of viewing material. The work interweaves memory, data, statistics and documentation, and at times enables the reconstruction of cases, some of which were investigated by the ICTY examination teams.

In a separate event, Kamerić appeared on stage in conversation with the writer and curator Gareth Evans (Kamerić 2015b). Kamerić began by discussing the rationale for exhibiting the work in a fridge, noting that her objective was not to shock the audience, nor to generate the claustrophobia many visitors experienced when the fridge door was closed. For her, the fridge was a place where precious things are kept and preserved. The mortuary fridge was intended to preserve human remains, but in her work she used it to preserve information.

Kamerić explained that, in Bosnia, control over information was a political technique; when she commenced her project she was shocked at the absence – and, perhaps, the withholding – of information about, for example, the lists of victims and the locations of mass graves. She realised she would need to create this archive for herself, and so her work needed to engage with the concept of 'archive' at its foundations. With an estimated 100,000 people killed in the conflict, and over 30,000 missing (ICMP n.d.), Kamerić experienced the sensation that the data was simultaneously 'too much' and 'not enough' (Kohn 2015). As she explained to a journalist,

> When you think about 34,000 missing, it's just a number, but if you start counting it you understand – each single person had their own lives, families. One big wish for me is to show through this work how we are all connected, how each of us is just one knot in a huge web.
>
> (Saner 2015)

As her project advanced, she gathered support that forced political authorities to release some data, including lists of names and maps of mass grave sites and concentration camps. She also continued to generate her own data and documentation. Kamerić wanted to preserve and to learn from the past, but also to maintain some sense of objectivity. She felt that there would be no need for balance, nor for justification, if her work was based on science and data. Her view was that data, once accumulated, would eliminate the need for a personal point-of-view; it would speak for itself.

Kamerić recalled the moment during the war when victims stopped being named and were instead counted. She insisted on naming the dead, and gathered as much qualitative and personal information as she could. Her archive included dates of birth, dates of disappearance and, sometimes, dates of exhumation. She also added the names of the sites of war crimes – Prijedor, Višegrad, Foča – to the list of more notorious places, such as Sarajevo and Srebrenica. There were images of skeletal remains, clothing, personal items. She gathered satellite footage and footage from war crimes trials. She came to appreciate the emotional significance

of weather reports. She made videos of roads that had once transported prisoners to camps, or bodies to graves, or refugees, or perpetrators, remembering that these roads remain as thoroughfares and transport routes. She articulated the emotional weight of her work to a journalist:

> There were so many situations where I felt I was breaking. Going through the evidence of atrocities and seeing so much pain is very difficult, but somehow you find a way to accept it. What is difficult to accept is the present in which the truth is constantly hidden, and in which the survivors don't have the space to share their stories.

> (Saner 2015)

Kamerić formed links with the Missing Persons Institute of Bosnia & Herzegovina, the International Commission on Missing Persons and the International Court of Justice. In undertaking her research, she came to appreciate the part the Bosnian war played in advancing forensic science. The identification of human remains, some of which had been deliberately dispersed and intermixed to hamper identification, demanded improvements in DNA analysis techniques. At the Wellcome event, she ruminated on the possibilities offered by combining archives and DNA, and the potential for DNA synthesis innovations to allow us to gather and carry historical and evidentiary data within our bodies, in a fantastical somatic afterlife. She said, 'It would be a nice metaphor, that one day all this archive could be stored in DNA'.

———————

In 2015, while visiting the Zabludowicz Collection, a large private art gallery in London, I came across a work that drew me to it – six small, rectangular canvases arranged on a wall, two by three, in bold patterns. Reading the label, I saw that the work had won the Future Map Prize in 2013, a prestigious award given to a graduating arts student. His name was Jason File and the work was titled 'The Hole Truth, 2015'. A label described the materials from which it was made:

> Hole-punch waste from evidence binder at the International Criminal Tribunal for the former Yugoslavia, canvas, plywood, brass eyelets, masonry nails, additional mixed media.

Each canvas was stretched over concealed materials beneath it, representing hidden bumpy terrain. In the centre of each work was a single upholstered indentation, and a tiny circle of hole-punch waste covered the indent. The circle of hole-punch waste had some fragments of visible text: 'the end', 'stop', 'next time'.

The work, and particularly its link to an evidence binder, stayed with me. This was a work made from familiar office garbage. However, this was garbage from an office that was both significant and mysterious, garbage made from criminal

evidence, and I was curious as to how the artist had acquired this particular garbage. By chance, I met Jason File soon after at another London gallery, where he was participating in a group exhibition, *Et Mon Droit*, exploring the relations between law and contemporary art (Copperfield Gallery 2015). It was then I learned that File had another job: he was a prosecutor at The Hague, in the ICTY, and he agreed to speak to me about his entwined legal and creative practices.

Figure 7.2 Jason File, The End (2015), from The Hole Truth series. © Jason File; courtesy Jason File and Zabludowicz Collection, London.

'The Hole Truth' (2015) is a series of 12 works, each titled after the text – or absence of text – on the hole-punch in its centre: The End, Next Time, Wild Metal, Code Map, Fix Facts, Stop, Vague Day, Empty Mark, The Void, Uncharted Territory, White Noise, Dead Radio. The canvases are A4-sized, reflecting the standard paper format used in the ICTY. The coloured canvases represent the circus tents used to protect forensic investigators from bad weather during excavations at mass grave sites in Bosnia and Herzegovina. The uneven surfaces beneath the canvases corresponded to features on maps identifying the locations of mass graves or criminal incidents during the war. Each hole-punch corresponds to a piece of paper included in ICTY evidence binders. The words preserved by the hole-punch generate meanings that are random, but they are nevertheless evidentiary, probative of a process of documenting and preparing for an international war crimes prosecution.

File, who studied law at Yale Law School, and humanities and social sciences at Oxford and Yale, told me 'I started off as someone who thought that he would just be a lawyer and was quite interested in criminal prosecution work'. Pursuing this aspiration, he said 'my first job out of law school was working as a law clerk to a Federal judge in New York. I chose to work for her in particular because of her background as a criminal prosecutor'. Later, he became a prosecutor at the International Criminal Tribunal for the former Yugoslavia, prosecuting former president of Serbia Radovan Karadžić and former Bosnian Serb general Ratko Mladić, amongst others.

His interests in visual arts, at that time, was satisfied through visiting galleries and museums – 'I was just kind of a consumer of the arts' – and gradually he found himself curious about how contemporary artists were working with institutional materials. He found himself thinking that the work he was seeing lacked the kind of engagement with 'authentic material' he was interested in, and eventually decided he 'could actually just make the sorts of things that I'm interested in seeing myself'. As he explained in another context, the two disciplines of art and law 'cohabit in my brain quite nicely'. Practiced cooperatively, they have the potential for 'revealing hidden aspects of our relationships with institutions and each other' (Lewis 2016, 159). He was accepted into fine arts programs at both Chelsea College of Arts, London, and the Royal Academy of Art, Netherlands, and now combines his legal practice with his role as a fine arts lecturer at the Royal Academy.

During a normal day, File 'would be in the office at the International Criminal Tribunal for the former Yugoslavia . . . going to court and cross-examining witnesses and writing motions and responses to motions and things like that'. Artistic activities, he said, often occur at the same time, and sometimes in his office. On Tuesday nights, he teaches art students at the Royal Academy of Art.

Describing his art practice as an 'opportunistic' response to his legal work, File said, 'I'll use what's around me and what I see . . . if I was working in some other institution, the work I would be making would probably be quite different'. He explained that 'The Hole Truth' 'really started with the very first hole punch that I found'. He explained that he was working late at night, preparing

for court, when he realised that the basket in the printer that collects the hole punches needed to be emptied. As he emptied it, the holes fell on the floor and, picking them up, 'I saw that one of the little hole punches had actually isolated this phrase, "the end"'.

> When I saw that it was just – it was just a wonderful and bizarre coincidence that I thought I've got to do something with this. I didn't know what exactly but I just saved it. From that point on, I made sure that I would always empty out the little basket of hole punches and look for these things in the future.

The work draws attention to the materiality of legal practice. It deals with the literal materials – paperwork and documentation – of litigation, and the evidentiary process. In one respect, File's work relies upon the banality and ubiquity of paper, and printing, and hole punches. But it offers a material encounter with a piece of paper that has played a role in a landmark international criminal prosecution, that was prepared by, touched by, these legal professionals. File is self-consciously attentive to the role of paper in legal practice. Legal process, File explained, is a kind of 'processing machine' that transforms the complexity of the world into 'a stack of very uniform A4 or letter size white sheets of paper with information contained on it'. In the contemporary office, records that were once 'physical pieces of paper' are now digitised, and many practitioners might never see, touch or need an 'original'. File referred to 'transition points', the moments physical artefacts, human memories and experiences are transferred onto paper, and paper in turn into digital information. He is interested in these moments of transition, and the ambiguities they leave behind. The hole punches have a 'one-to-one correspondence' with an actual piece of paper in the Tribunal, but they also operate as metaphors for an enormous system. The ontological status of holes has puzzled philosophers: whether they exist, or whether they are material, whether they have parasitic reliance upon the 'host' which surrounds them, whether they represent something's making or its removal; the writer Kurt Tucholsky wrote, 'There is no such thing as a hole by itself' (1930). Just 12 tiny fragments are presented in File's work, but they are a synecdoche for a massive, overwhelming quantity of paper, and for an epic series of prosecutions.

Reflecting on the material and digital practices of law, File wrote, in a catalogue essay for his show at Stroom Den Haag, that a trial at the ICTY 'resembles the process of digital image compression called 'lossy' compression' (File 2015, 16). This refers to the process by which the digital image 'compresses' information, thereby losing a great deal of data. When magnified again, 'you will see the compressed image break down into blocky pixels earlier than the uncompressed image'. Drawing his analogy to legal practice, File wrote, 'In its laws, rules, procedures, technology and practical resource constraints, an international criminal tribunal has its own compression algorithm'. By this, File was referring to law's need to distil 'raw information and experience' into

'facts that are *relevant* for the purpose of the investigation' (File 2015, 16–21; emphasis in original). He wrote,

> Under a tent, the physical remains of a victim excavated from a mass grave are converted into words and images on paper through the mediating influence of an investigator drafting a report. The report becomes a proxy for the real thing, the smell of the location, the dirt, the feel of a bone which itself stands in for the personal experience of the victim himself, now irretrievably lost.
>
> (File 2015, 17)

File was not intending to be critical of the ICTY; his essay describes the reality of all adversarial litigation. Rather, he was drawing attention to the information discarded by the legal process. He explained that his work is an attempt to bring a fresh perspective to this process of selection and elimination, asking 'what happens when we take the materials, procedures and context of an international criminal tribunal from the inside, and we consciously choose to look at them with the selection criteria of an artist instead of a lawyer?' (File 2015, 19).

In another of his evidentiary works, titled 'The Earth and the Stars' (2015), File drew attention to the artistry of evidence. He explained that, when investigators first uncovered mass grave sites, the photographs they took were often unintelligible because of the entanglement of bodies within the graves, and the natural material that obstructed visibility. In response, investigators made drawings to record each individual body, in addition to their written reports. Each drawing described the position of one body in the place in which it was discovered, as well as indicating whether it was blindfolded, bound at the wrists, and so on (File 2015, 19).

File has used thousands of these drawing-documents in his prosecutorial practice, describing each as 'a small brick in the massive foundation of proof of atrocities' (File 2015, 20). As examples of legal documentation, they are unexpected. This makes them strange and powerful, a genre unto themselves. File spoke of the power of these simple drawings, in the context of the larger visual archive of the Tribunal. He explained, 'Our archives are full of all kinds of difficult-to-look-at images that relate to crime scenes, locations of massacres. They have an extremely macabre aspect to them which is almost overwhelming'. In contrast, 'when you see something as simple as a drawing, that raises in the viewer's imagination this idea of the one-on-one meeting between the investigator and this person in front of him or her'. His observation is a reminder that criminal evidence is made by people: crime's victims and crime's investigators inadvertently collaborate in the production of evidence. People, objects and papers in the world don't acquire their evidentiary status unless and until they encounter an investigator who leads them into law's fact-finding, dispute-resolving processes. These drawings show us that these investigators are constantly adapting to the challenges presented by crime.

File, in both his legal and artistic practice, is interested in the 'rare, testimonial properties' of these simple drawings. In an age of high technology, the resort to

Figure 7.3 Jason File, The Earth and the Stars (II) (2015). Installation view, Stroom, The Hague, Netherlands. © and courtesy Jason File.

the simple perceptive and descriptive properties of the human eye and hand has a powerful effect. This technique restores humanity to the evidentiary processes, individualises the victims and conveys a kind of humility. In a discipline saturated with text, the presence of these images is striking. The experience of discovering and excavating a mass grave demands an evidentiary response appropriate to these

Figure 7.4 Jason File, The Earth and the Stars (III) (2015). Installation view, Stroom, The Hague, Netherlands. © and courtesy Jason File.

atrocities. It must, of course, be probative, but it also needs to engage sensory, emotional and ethical responses. In File's words,

> I think that there's a human intimacy that is contained in that process of drawing that is much more poignant than clicking the shutter on a camera. There's something about those images that is not just about what it shows, but about what you can imagine about the process of making it as well.

He is reminding us of the human act of making evidence, which also encompasses the human need to seek justice for wrongdoing, and the innumerable steps along that path that must be taken by a justice-seeker.

Importantly, for File, even this hand-made evidence is susceptible to the 'compression' he has noticed in legal evidentiary practices. A forensic investigator must 'transcribe' what they have seen in a mass grave into a drawing. With the accumulation of these drawings, a brief of evidence is produced; they are probative in their volume as well as in their individual content. Hundreds of little drawings, together, represent a *mass* grave, and a mass grave is evidence of an atrocity, whether genocide, war crimes or crimes against humanity. Despite their individual evidentiary properties, as File acknowledged, all these drawings might be reduced to 'a single footnote in a judgment' (File 2015, 20).

Writing about File's work, art scholar Jo Melvin situated him within the field of artists whose work reflects 'transparency [about] what it is to have made an artwork' (Melvin 2015, 3); that is, the artwork bears traces of its own making. Melvin's analysis points to the significance of time, and the passage of time, for File's work – both his legal and his art practice. With time, value changes. It might depreciate or accumulate; with age, things become more valuable or they become worthless. File, in much of his law-themed work, is attempting to squeeze value from law's detritus, from materials that have lost their legal significance and are now garbage. With the passage of time, meaning might soften or intensify. Over time, aesthetic qualities rise to the surface in objects that previously concealed them. Because they eventually look old, objects from the past testify to their own age, and their death, or survival, or revival. Their afterlife offers a vantage point from which to practise hindsight, enabling us to see what was and what ought to have been.

The artwork File has made from this evidence is a series of wall drawings, life-sized reproductions of these forensic sketches. The work does not disclose the origins of these drawings – neither the sites in which they were made nor the prosecutions in which they were tendered. His aim was to enable these drawings to 'speak again in a new way, perhaps to be revived' (File 2015, 20). His allusion to *revival* is significant here; it contains the implicit suggestion that these drawings, this evidence, were otherwise dead, perhaps killed by law. He provides for this evidence a kind of *afterlife*, retrieving these paper corpses from their binders and restoring them to the world. He also makes the significant decision to enlarge them to the full size of the dead bodies they were made to represent; unable to revive these victims, he nevertheless restores them to their proper stature.

Careful to balance the roles and responsibilities of his two distinct disciplines, File has thought closely about how to manage the legal, ethical and other professional responsibilities of his prosecutorial work. Thinking about the limits he places upon whether and how to make art from evidence, File admits that he makes a lot of art that he would not show. Some of that art is, strictly-speaking, unmade – it is 'made in my head only and may get made one day'. There is other work – 'a fair amount of work' – that he has 'made but not shown and probably won't show, maybe never, or not for a long period of time'. He referred to the concept – discussed by other commentators at the nexus of art and law – of the

'artist as legislator',[9] making the point that artists set their own rules, unbound by the strictures that bind lawyers. In the context of his own art practice, he said, 'I have my own document classification policy, like a government would'. This policy operates to 'limit the things that I might think about or make', and whether or when they should be made public. In one respect, he has what he calls 'pragmatic concerns' or his own 'set of guidelines' arising from the fact that he is engaged in live, high-stakes prosecutions and would never want to act in any way that might 'jeopardise' or 'sabotage' a trial or its outcome. In the context of his day job, File necessarily demands of himself a high standard when it comes to his artistic work, much higher than if his day job was not as a war crimes prosecutor. In another respect, File points to the motivation to make art from legal materials in the first place – namely, to use legal materials 'in ways that are sensitive to the traumas that have been suffered by families of victims of mass atrocities', a sensitivity not typically one of law's aspirations, and one the law rarely attains.

In crime's afterlife, it is difficult to imagine a more appropriate perspective on what ought-to-have-been than that of the war crimes prosecutor. Unable to undo atrocity, war crimes prosecutors are devoted to seeking whatever justice remains available, for whoever has survived. These are already remnants of a ruined past, irreparable and vulnerable to the very practices of law conjured to bring them justice. How to serve these objectives without perpetrating further harm is something File keeps in mind. Ambivalent about the emotional effects of visually persuasive evidence, File understands that one part of his role is 'to vindicate the memories and interests of victims'. But he is reticent about allowing the evidentiary process to 'become a kind of spectacle'. Reducing this trove of drawings into a footnote in a judgment may be one method whereby this unsavoury spectacle is averted. His aspiration is that his art practice offer 'a sensitive way that we can gain or learn or realise from those materials' in a manner that is not explicitly evidentiary. He has come to see that, separate from law's practices of proof, what he calls 'the framework of the trial' might not be the best method – emotionally and philosophically speaking – of coming to terms with the atrocities perpetrated by people upon other people.

Notes

1 The production of this evidence is captured in footage: see Holocaust Museum (a).
2 George Stevens, John Ford and Samuel Fuller were Hollywood directors who all worked in film units for the U.S. Armed Forces and Secret Services during World War II. This history is told in an exhibition titled *Filming the Camps: John Ford, Samuel Fuller George Stevens, From Hollywood to Nuremberg* at the Los Angeles Museum of the Holocaust, 27 August 2017–30 April 2018.
3 The photograph frame used by Schechner was not published in *Life* in the 7 May 1945 issue, although another image from the same camera roll, showing starving prisoners piled into bunks, was published in that issue.
4 See Prilić et al., Case No. IT-04-74; Praljak was one of the six appellants in this case. His death was noted in a UN press release: 'Statement on the passing of Slobodan Praljak', Press Statement, The Hague, 29 November 2017, accessible at www.icty.org/en/press/statement-on-passing-of-slobodan-praljak See also Corder (2017).

5 Simons (2010) and Schuppli (2014a) refer to 18 notebooks. The ICTY, however, refers to 22 notebooks: see www.icty.org/x/cases/mladic/tdec/en/120925.pdf

6 Prosecutor v. Ratko Mladić, Case No. IT-09-92-T, Decision on Prosecution First Motion to Admit Evidence from the Bar Table: Mladić Notebooks, 25 September 2012 at [8], accessible at www.icty.org/x/cases/mladic/tdec/en/120925.pdf. Ratko Mladić, a Bosnian Serb general, was sentenced in November 2017 to life in prison on counts including war crimes, genocide and crimes against humanity. Radovan Karadžić, the former president of the Serb Republic (Republika Srpska), was sentenced to 40 years in prison in March 2016 on counts including war crimes and crimes against humanity. Both Mladić and Karadžić have enjoyed the sobriquet 'Butcher of Bosnia' in media reports. Zdravko Tolimir, a former Bosnian Serb military commander, was sentenced in 2012 to life in prison on counts including genocide, conspiracy to commit genocide, extermination, murder, persecution on ethnic grounds and forced transfer. He died in Scheveningen prison in February 2016. See Prosecutor v Mladić, Case No. IT-09-92; Prosecutor v. Karadžić, Case No. IT-95-5118-T, T.6104-6105; Prosecutor v. Tolimir, Case No. IT-05-8812-T, T. 8142-8143.

7 The first two 'legacy' conferences and debates around the management of the archive after the conclusion of the Tribunal are set out in Campbell (2012, 250–51 and 254–60). Documents relating to the ICTY 'legacy' conferences are accessible at www.icty.org/sid/10293; www.icty.org/sid/10405 and www.icty.org/en/outreach/legacy-conferences/icty-legacy-dialogues-conference-2017

8 This was during a curator tour of *Forensics: The Anatomy of Crime* at the Wellcome Collection, London, on 21 May 2015.

9 This was one of the themes examined at a panel discussion at London's Copperfield Gallery, coinciding with the exhibition *Et Mon Droit*, on 24 June 2015, at which Jason File spoke alongside Costas Douzinas, Joan Kee, Daniel McClean, Nina Power and Carey Young. See www.copperfieldgallery.com/uploads/2/8/0/5/28058061/et_mon_droit_bios.pdf

References

Bartov, Omer (1996), *Murder in our Midst: The Holocaust, Industrial Killing, and Representation*, New York NY: Oxford University Press.

Bernstein, Michael Andre (1994), *Foregone Conclusions: Against Apocalyptic History*, Berkeley CA: University of California Press.

Campbell, Kirsten (2012), 'The laws of memory: The ICTY, the archive, and transitional justice', *Social & Legal Studies* 22(2), 247–69.

Copperfield Gallery (2015), *Et Mon Droit [exhibition]*, 28 May–11 July; artists included David Birkin, Etienne Chambaud, Jason File, Marco Godoy, Jill Magid, Carey Young. See www.copperfieldgallery.com/et-mon-droit.html

Corder, Mike (2017), 'Slobodan Praljak death: UN orders independent review into "internal operations"', *The Independent*, 1 December, accessible at www.independent.co.uk/news/world/europe/slobodan-praljak-death-poison-drink-the-hague-war-criminal-bosnia-independent-review-un-court-order-a8086651.html

Dalton, Derek (2014), *Dark Tourism and Crime*, Abingdon UK: Routledge.

Davies, Gareth (2017), 'Israeli student steals items from Auschwitz death camp for an art project . . . including a sign telling people not to take anything', *Daily Mail*, 20 July, accessible at www.dailymail.co.uk/news/article-4713586/Israeli-student-steals-items-Auschwitz-death-camp.html

Der Spiegel (2010), 'Former neo Nazi in Sweden "proud" of helping police', *Spiegel Online*, 11 January, accessible at www.spiegel.de/international/world/auschwitz-sign-theft-former-neo-nazi-in-sweden-proud-of-helping-police-a-671211.html

Douglas, Lawrence (1995), 'Film as witness: Screening Nazi concentration camps before the Nuremberg tribunal', *Yale Law Journal* 105(2), 449–81.

Douglas, Lawrence (1998), 'The shrunken head of Buchenwald: Icons of atrocity at Nuremberg', *Representations* 63 (Summer), 39–64.

File, Jason (2015), 'Justice, uncompressed', catalogue essay in *A Crushed Image (20 Years After Srebrenica)*, The Hague: Stroom den Haag, 16–21.

Geuens, Jean-Pierre (1995), 'Pornography and the Holocaust: The last transgression', *Film Criticism* 20(1–2), 114–30.

Halliday, Josh and Jamie Grierson (2015), 'UK school boys fined and released after theft of Auschwitz artefacts', *The Guardian*, 24 June, accessible at www.theguardian.com/world/2015/jun/23/uk-teenagers-held-thefts-artefacts-auschwitz-museum

Holocaust Museum (a) (United States Holocaust Memorial Museum) (n.d.), 'Buchenwald historical film footage – Liberation of Buchenwald; Germany, April 1945', *National Archives, Film, Silent, 0:59*, accessible at www.ushmm.org/wlc/en/media_fi.php?ModuleId=10005198&MediaId=159

Holocaust Museum (b) (United States Holocaust Memorial Museum) (n.d.), 'We will show you their own films' – Historical Film Footage, Screening of Concentration Camp Film Footage, Nuremberg, Germany, November 29, 1945, *National Archives, Film, 1:06*, accessible at www.ushmm.org/wlc/en/media_fi.php?ModuleId=10007163&MediaId=5690

ICMP (International Commission on Missing Persons) (n.d.), *Bosnia and Herzegovina*, accessible at www.icmp.int/where-we-work/europe/western-balkans/bosnia-and-herzegovina/

International Military Tribunal (1947), *Trial of the Major War Criminals Before the International Military Tribunal, Nuremberg, 14 November 1945–1 October 1946*, Nuremberg, Germany: Secretariat of the International Military Tribunal.

Kamerić, Šejla (2015a), 'Ab uno disce omnes', in *Forensics: The Anatomy of Crime [exhibition]*, *Wellcome Collections*, accessible at http://abunodisceomnes.wellcomecollection.org/

Kamerić, Šejla (2015b), 'In conversation with Gareth Evans', 21 May, *Wellcome Collection*, London.

Kershaw, Sarah (2002), 'Exhibition with Nazi imagery begins run at Jewish Museum', *The New York Times*, 18 March, accessible at www.nytimes.com/2002/03/18/nyregion/exhibition-with-nazi-imagery-begins-run-at-jewish-museum.html

Kleeblatt, Norman L. (2002), 'The Nazi occupation of the White Cube: Transgressive images; moral ambiguity/contemporary art', in N. L. Kleeblatt, ed., *Mirroring Evil: Nazi Imagery/Recent Art*, New York NY: The Jewish Museum and Rutgers University Press.

Kohn, Marek (2015), 'Šejla Kamerić: An artist's search for Bosnia's missing', *Financial Times (subscriber service)*, 30 January, accessed online at www.ft.com/content/3c851938-a741-11e4-8a71-00144feab7de

Kramer, H. (2002), 'The Jewish Museum show full of vile crap, not to be forgiven', *New York Observer*, 1 April.

Lennon, John and Malcolm Foley (2000), *Dark Tourism*, London: Thomson.

Lewis, Chris (2016), *Too Fast to Think: How to Reclaim your Creativity in a Hyper-Connected World*, New York NY: Kogan Page.

Melvin, Jo (2015), 'Some opening words', catalogue essay in *Jason File: An Ornament and a Safeguard*, London: The Ryder Projects, 2–10.

Miller, William Ian (1997), *The Anatomy of Disgust*, Cambridge MA: Harvard University Press.

Nazi Concentration Camps (1945), *documentary film, dir. Col. George Stevens*, produced by John Ford; accessible at www.netflix.com/au/title/80119192

Saltzman, L. (2002), 'Readymade redux: Once more the Jewish Museum', *Grey Room* 9, 90–104.

Saner, Emine (2015), 'True crime: The women making art out of murder', *The Guardian*, 25 February, accessible at www.theguardian.com/artanddesign/2015/feb/24/forensics-the-anatomy-of-crime-wellcome-collection-female-artists

Schjeldahl, Peter (2002), 'The Hitler Show: The Jewish Museum revisits the Nazis', *The New Yorker*, 1 April, accessible at www.newyorker.com/magazine/2002/04/01/the-hitler-show

Schuppli, Susan (2014a), 'Entering evidence: Cross examining the court records of the ICTY', in Forensic Architecture, ed., *Forensis: The Architecture of Public Truth*, Berlin: Sternberg Press, 279–316.

Schuppli, Sussan (2014b), closing remarks at 'Evidence on trial' at The Hague Institute for Global Justice, 2 October. Details of the event are at www.thehagueinstitutefor globaljustice.org/events/evidence-on-trial/

Simons, Marlise (2010), 'Data on Balkan Wars found in home of suspect', *The New York Times*, 10 July, accessible at www.nytimes.com/2010/07/11/world/europe/11mladic.html

Solomon, Deborah (2002), 'Designer death camps: Questions for Tom Sachs', *The New York Times*, 10 March, accessible at www.nytimes.com/2002/03/10/magazine/the-way-we-live-now-3-10-02-questions-for-tom-sachs-designer-death-camp.html

Sontag, Susan (1976), *Styles of Radical Will*, New York NY: Farrar Straus and Giroux.

Sontag, Susan (1980), 'Fascinating Fascism', in Susan Sontag, *Under the Sign of Saturn*, New York NY: Farrar Straus and Giroux, 73–108.

Strange, Carolyn and Michael Kempa (2003), 'Shades of dark tourism: Alcatraz and Robben Island', *Annals of Tourism Research* 30(2), 386–405.

Tucholsky, Kurt (1930), 'The social psychology of holes', in *Stanford Encyclopedia of Philosophy [electronic resource]*, Stanford CA, c.1997 [entry titled 'Holes' first published 5 December 1996, substantially revised 18 February 2014; no author attribution].

UNSC (United Nations Security Council) (1993), Resolution 827, adopted by the Security Council at its 3217th meeting, 25 May, accessible at www.icty.org/x/file/Legal%20Library/Statute/statute_827_1993_en.pdf

Van Alphen, Ernst (2001), 'Deadly historians: Boltanski's intervention in Holocaust historiography', in Barbie Zelizer, ed., *Visual Culture and the Holocaust*, New Brunswick: Rutgers University Press, 45–73.

Watson, J.R. (1992), 'Auschwitz and the limits of transcendence', *Philosophy & Social Criticism* 18(2), 163–83.

White, Hayden (1992), 'Historical emplotment and the problem of truth', in Saul Friedlander, ed., *Probing the Limits of Representation: Nazis and the 'Final Solution'*, Cambridge MA: Harvard University Press, 37–53.

Young, James E. (2002), 'Foreword: Looking into the mirrors of evil', in N. L. Kleeblatt, ed., *Mirroring Evil: Nazi Imagery/Recent Art*, New York NY: The Jewish Museum and Rutgers University Press, xv–xviii.

Conclusion
Destroying the evidence

In 2016, the Philadelphia General Assembly passed a law enabling people convicted of crimes to have their criminal records expunged (Crimes Code (18 PA.C.S), 2016). Destroying the evidence of their criminal pasts would enhance their prospects for securing employment and housing and would restore some dignity to their lives. Volunteer attorneys set up expungement clinics at various locations to assist applicants in what is a complex process available only to certain candidates.[1] Community-based activists encouraged applicants to undertake symbolic actions marking the significance of these acts of destruction. One of these groups, the People's Paper Co-Op, led participants in printing, tearing up and then shredding their criminal records in a blender. They then turned this pulp into recycled paper upon which they would write a statement in response

Figures 8.1–8.3 (continued)

(continued)

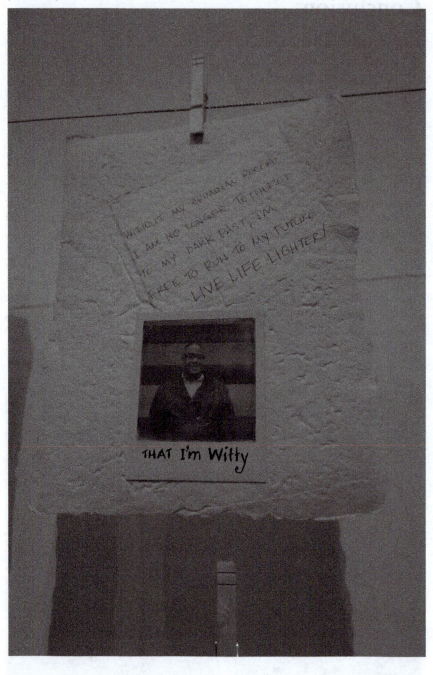

Figures 8.1–8.3 People's Paper Co-op (PPC) *Without My Record I am Free to Be. . .* (2014–16), pulped criminal records, Polaroid photographs, written reflections, repurposed notebook paper, pen, pencil. Photographs by Katherine Biber at the exhibition Philadelphia Assembled, exhibited in the Philadelphia Museum of Art, Perelman Building 2017. Reproduced with permission.

to the prompt *'Without these records I am . . .'* (People's Paper Co-Op n.d.). In 2017, a collection of these handmade papers was displayed in the Philadelphia Museum of Art, showcasing the many positive outcomes associated with destroying evidence of these past crimes.[2]

At around the same time, the United States Court of Appeals, Sixth Circuit, made a landmark ruling which also had the effect of shielding criminal defendants from evidence of their past crimes and criminal allegations. Overturning two decades of jurisprudence, the court ruled that the people captured in police mugshots are entitled to privacy. Media agencies and other commercial interests had, until the decision in *Detroit Free Press Inc. v United States Department of Justice*, treated mugshots as cheap commodities, freely available from state agencies and easily disseminated online. Deriving limitless pleasure and profit from their publication, these enterprises turned mugshots into online click-bait, or exploited them in vigilante operations or public shaming spectacles, or promised to 'erase' them from the online marketplace for a fee. Trafficked easily under the guise of 'freedom of information', the digital age has facilitated a lavish afterlife for the mugshot (Stelloh 2017). The court, however, catalogued the regrettable consequences of the online proliferation of police booking photographs (vulnerability, humiliation, guilt), observing that mugshots 'cast a long, damaging shadow over the depicted individual' and can 'haunt the depicted individual for decades' (*Detroit Free Press Inc.*, per Cook J at 482 and 485). Once seen as benign public records, mugshots, for the majority of the court, were now regarded as 'painful' and 'malevolent', as 'preserv[ing] the indignity of a deprivation of liberty', and as a tool of extortion (*Detroit Free Press Inc.*, per Cole CJ at 485–86). The court held that the privacy interests of people photographed in mugshots are 'non-trivial', and that they are entitled to protection from the embarrassment arising from their release. While there remains a patchwork of provisions in the United States responding to requests for the release of arrest photographs, the court's decision represents what might be a turning point in the afterlife of criminal evidence.

What might be done with criminal evidence separated from its official purposes? Can it live, should it survive, outside the law? And if so, *how* should it live? Does it require special care, tact and sensitivity? Or should it be destroyed, to prevent further harm?

Destroying criminal evidence is a commonly used technique for mitigating the potential dangers of its dissemination. This occurs where evidentiary material contains, for instance, biohazardous substances such as blood, or contaminants such as asbestos, or other dangerous ingredients, such as narcotics. Where wildlife smuggling poses the threat of disease, the creature is euthanised and this final stage of the evidentiary process – the killing of the evidence – is photographically recorded. One legal professional spoke to me about the beauty of photographs documenting the seizure and destruction of illicitly imported fauna, particularly rare birds and reptiles, many of which are trafficked while still in eggs. The final photograph in these evidentiary series is always an archival photograph from a natural history museum, intended to represent how the creature would have looked had it grown to maturity.

Visually capturing the destruction of evidence offers new opportunities for voyeurism and spectacle, such as when police agencies broadcast footage of the destruction of seized weapons or drugs. In the digital age, the genre of the police trophy shot, as the work of criminologist Travis Linnemann demonstrates, achieves both institutional and personal goals. When accompanying a 'major bust', the police trophy shot is a standard element in a police press release. But contemporary social media affordances also enable individual police officers to stage and distribute their own trophies, and these now follow their own digital distribution networks, which Linnemann calls 'visualities of domination', or 'gloating' (Linnemann 2017, 58–60). While not all police trophy shots document the destruction of evidence, the genres of seizure and display are a carefully blended amalgam of pleasure and control.

Another form of cultural gratification arises from a different act of evidentiary destruction: the redaction of public records. To 'redact' is a neologism, now meaning 'to conceal from unauthorised view, 'to censor but not to destroy' or to render 'unreadable' (Safire 2007; Bier et al. 2009, at 46). With its brutal visibility, redaction displays the pleasure taken by the state in its brazen withholding of evidence. 'Redaction' usually refers to the concealment of specific information within state records, prior to their release. It is regarded as a tool of transparency, enabling the concurrent functioning of open government and the maintenance of certain secrets. Redaction is an accepted feature of legal record-keeping and information management, and the considerable jurisprudence relating to freedom-of-information is, in large part, also a jurisprudence of redaction and non-disclosure, where discourses of transparency confront state secrecy (Fenster 2006; see also Fenster 2014).

A growing field of creative practitioners have sought to take advantage of the visual effects of redacted records, resulting in a rich range of artworks made by and about destroyed evidence (Powell 2010). Jason File, the artist and war crimes prosecutor discussed in Chapter 7, made a video artwork documenting the moment he destroyed a classified military document in the course of his legal practice. Titled 'Erasing a Classified Military Document' (2013), the short (1 minute and 39 seconds) video shows him using an industrial shredding machine to destroy the document. File described this work as a 'readymade performance', in which a 'real and consequential event' (the destruction of the document) was 'repurposed' and analysed for its 'aesthetic and critical content' (Koole and File 2015, 25). Although File was deliberately citing earlier artworks that conflated destruction and creation (notably Robert Rauschenberg's *Erased De Kooning Drawing*, 1953), his work took the important further step of destroying a work created for an evidentiary or administrative purpose. By destroying a legal document, File implicitly elevated its evidentiary significance: documents are only destroyed by this method when they are important; trivial documents are simply thrown in the garbage.

An artist whose materials are found in a criminal prosecutor's office, File's work engages with the destructive nature of evidentiary and fact-finding processes. His work 'The Hole Truth' (discussed in Chapter 7) is activated by hole-punch

waste made from evidence binders in an international criminal tribunal; the random words caught by the hole-punch have been removed permanently from the document from which they were taken. In a counterpoint to this work, the artist William E. Jones (discussed in the Introduction) in his video works 'Killed' (2009) and 'Punctured' (2010) made films from archival photographs in which a hole-punch was used to visibly and permanently damage photographic negatives. Jones's videos are montages of photographs taken for the United States Farm Security Administration (FSA) between 1935 and 1943, and now held in the Library of Congress. Taken by photographers including Walker Evans, Dorothea Lange, Ben Shahn and Gordon Parks, the photographs were commissioned by the FSA's head, Roy Stryker, who believed photography would best document and promote the FSA's work to alleviate rural poverty during the Great Depression. When a photograph did not meet with Stryker's approval, he used a hole punch and – in his own words – 'killed' it (Mandelbaum 2009).[3] Jones's work benefits from Stryker's archival sensibility: he killed these documents, and he kept them. Had he thrown unwanted negatives into the garbage, Jones's work could not have been made. While Stryker was emphatically not an artist, Jones's work relies upon Stryker's creative intervention, or signature: the ragged circle left behind by his hole punch.[4] Without the distinctive mark of their destruction, these photographs sink back into a vast archive, from which they would demand time and expertise to analyse them. Instead, they are really only about the punched hole, and serve as a lesson in the creative techniques used for destroying official records.

The artist Daniel Knorr, in his series *The State of Mind* (2007), presents what appear to be grey rocks of variable sizes. These rocks are actually made from documents shredded by agents of the Ministerium für Staatssicherheit, or Stasi, in the final days of the East German regime. Pulverised using a *feuchtschredder*, or wet shredder, or sometimes with agricultural composters retooled to destroy papers, microfilm and audio tapes, these machines transformed official records into enormous lumps. Some were buried; others were flushed down drains. The Leipzig municipal sewer system, after several days, became so clogged that it spewed watery pulp into the streets. This is how the 'file-stones' were produced, and Knorr displays them as evidence of state secrecy, and of the malign artistry of state officials (see also Biber 2018).

In another project, the artist Jenny Holzer draws attention to the creativity evident in the destructive practices of state secrecy. Her 'Redaction Paintings', commenced in 2005, are large works presenting United States government records declassified after 11 September 2001. Holzer's works represent documents requested under freedom of information legislation by the American Civil Liberties Union, which were heavily redacted before being released. The documents provide evidence about the war in Iraq, extraordinary rendition from Afghanistan, torture at Abu Ghraib and interrogation techniques at Camp X-Ray, but in Holzer's work they are primarily evidence of the removal of these facts from the official record. Her canvases represent documents sometimes entirely obscured by blocks of black redaction marks. For the literary scholar Joseph

Slaughter, Holzer's paintings represent the death of narrative (Slaughter 2010). These are dead stories, killed by an unknown bureaucrat, and while they tell us nothing factual about torture and illegality, they tell us everything about the state's will to keep these facts secret (Slaughter 2010; see also Bailey 2012). In their cultural afterlife, they serve as evidence of obfuscation, as well as of the powerful aesthetic effects of well-executed legal administration.

While most of this book explores the creative labour wrought upon evidentiary materials after their legal life has expired, legal scholars including Cornelia Vismann and Annelise Riles have urged us to remember the immense creativity of legality and bureaucracy (Riles 2006; Vismann 2008). Sometimes creativity is demanded by the legal enterprise itself, and sometimes this creativity is what activates legal materials, allowing them to exceed or survive their legal purposes, bringing their materiality into our view. For Bruno Latour, in his ethnography of legal process, this is the 'shimmering' that occurs in the gap between a rule and its application, or between an assertion and its proof (Latour 2010, 159–60 and see also 98). For Riles, not only are there aesthetic qualities implicit in legal materials, but these materials (documents, forms, records) 'anticipate and enable certain actions by others – extensions, amplifications, and modifications' (Riles 2006, 21). These are the actions that facilitate the afterlife of legal materials. Criminal evidence is amplified in its afterlife because its aesthetic and affective qualities mark is as evidentiary; whatever else this material can tell us, it announces itself as evidence. Its evidentiary properties – its authentic status as evidence – are implicitly, transgressively, seductive. Although a considerable body of creative practice draws upon techniques that *resemble* criminal evidence (portraits made to look like mugshots; fashion shoots that look like crime scenes) an additional vibrancy emanates from materials genuinely associated with criminal investigation, and this power has been achieved through the work of law's agents (Biber 2016).

In its afterlife, the materiality of evidence comes into sharp focus. This is the stuff that floats in law's wake, that may be picked up and salvaged, or left to oblivion. Thinking materially about law's processes has been made possible by the work of Cornelia Vismann, who drew attention to so many astonishing facets of documentation, administration and legal process. For Vismann, practices of cancellation or deletion were themselves acts of law, productive of law's authority. Vismann traced the history of the cancellation or effacement of legal information, which was later replaced with files and administration. Whereas destruction is sometimes practised to manage the sensitivities contained within legal materials, in the digital age, sensitive information is *replaced* with a sanitised version, both documents surviving concurrently, albeit with different access afforded to different parties. In the digital age, the afterlife of evidence sees multiples and surrogates eroding the distinction between an original and a copy, and replacement, redaction and sanitisation indelibly and imperceptibly changing the form and content of evidence. As Vismann cautioned, 'In cultural memory . . . these technologies of effacement have themselves been effaced' (Vismann 2008, 27). Paper shredders, hole-punches and industrial composters have been superseded

by software, some of which is designed to leave no trace of its own destructive endeavours (see also Biber 2018).

As this book has revealed, there is no clear boundary between law and its afterlife; these exist on a continuum, with the law gradually surrendering its status at front-and-centre and receding into the distance. Legal processes and cultural production co-exist and are mutually sustaining. The laws of evidence, the techniques and tools of proving truths and resolving disputes, rely on ever-shifting foundations that are culturally produced. Cultural representations and interventions made from criminal evidence – outside and after the law – can help legal scholars and practitioners understand how the laws of evidence collectively represent sites of sensitivity and confidence within legal discourse. From the lawyer's perspective, evidence is that which is admissible under the laws, as determined on an in/out basis. But these standards do not extend to the cultural field, and so cultural work using law's materials illuminates and scrutinises law's boundaries. When the laws of evidence are invalid, ignored or overruled, we can see how troubling and fascinating evidentiary materials are, and how promising the processes for working *with* evidence *after* the law. In its cultural afterlife, we find new ways of seeing what criminal evidence *is* and, even more so, *what it does*, and *what we can do with it.*

Notes

1 Including the Philadelphia Bar Association (www.philadelphiabar.org/page/YLD ExpungementEngReg). See also Philadelphia Lawyers for Social Equality (http://plsephilly.org/get-help/expungement/). Records of prior arrests or prior convictions can only be expunged or sealed in limited circumstances. Broadly, these require the applicant to have been conviction-free for a period of time, and for the underlying charges to be of a summary or less-serious nature. People aged over 70 years who have been conviction-free for at least 10 years may also apply. Where the expungement is contested, a court will make the decision. Where expungement is ordered, the records are returned to the applicant, and the associated criminal justice agencies are required to destroy their own records in compliance with the expungement order. In many counties, applicants pay a fee for the expungement process.
2 The exhibition was titled 'Philadelphia Assembled'; details are accessible at http://phlassembled.net/.
3 Other artists have made work from the 'killed' negatives, including Etienne Chambaud, *Personne* (2008) and Lisa Oppenheim, *Killed Negatives: After Walker Evans* (2007).
4 See www.williamejones.com/. See also Jones (2010); Banks (2010); Early (2013); Moshayedi (2011).

References

Bailey, Robert (2012), 'Unknown knowns: Jenny Holzer's redaction paintings and the history of the war on terror', *October* 142, 144–61.
Banks, Eric (2010), 'William E. Jones: Punctured', *The Paris Review Daily*, 4 October.
Biber, Katherine (2016), 'Peeping: Open justice and law's voyeurs', in Cassandra Sharp and Marett Leiboff, eds, *Cultural Legal Studies: Law's Popular Cultures and the Metamorphosis of Law*, London: Routledge, 160–82.

Biber, Katherine (2018), 'The art of bureaucracy: Redacted ready-mades', in Desmond Manderson, ed., *Law and the Visual*, Toronto: University of Toronto Press.

Bier, Eric, Richard Chow, Philippe Golle, Tracy Holloway King and Jessica Staddon (2009), 'The rules of redaction: Identify, protect, review (and repeat)' *IEEE Security and Privacy Magazine* 11 (November), 46–53.

Crimes Code (18 PA.C.S.) and Judicial Code (42 PA.C.S.) – General Regulations, Order for Limited Access and Petition for Expungement or Order for Limited Access Fee, Act of Feb. 16, 2016, P.L. 10, No. 5. ('Criminal Code (18 PA.C.S, 2016')

Detroit Free Press Inc. v United States Department of Justice, 829 F.3d 478 (2016)

Early, Rosalind (2013), 'Artist William E. Jones on his Saint Louis Art Museum exhibit "Killed"', *St. Louis Magazine*, 17 April. Accessed online.

Fenster, Mark (2006), 'The opacity of transparency', *Iowa Law Review* 91, 885–949.

Fenster, Mark (2014), 'The implausibility of secrecy', *Hastings Law Journal* 65(2), 309–62.

Jones, William E. (2010), 'An artist dialogue – "Killed"', conversation with Andrew Roth, *New York Public Library*, 8 September.

Koole, Peter and Jason File (2015), *A Crushed Image (20 Years After Srebrenica)*, The Hague: Stroom den Haag.

Latour, Bruno (2010), *The Making of Law: An Ethnography of the Conseil d'Etat*, trans. Marina Brilman and Alain Pottage, Cambridge UK: Polity Press.

Linnemann, Travis (2017), 'Proof of death: Police power and the visual economies of seizure, accumulation and trophy', *Theoretical Criminology*, 21(1), 55–77.

Mandelbaum, Audrey (2009), 'An invocation of ghosts: William E. Jones's "Killed"', *X-tra: Contemporary Art Quarterly*, 12(2). Accessed online.

Moshayedi, Aram (2011), '500 Words: William E Jones', *Artforum.com*, 26 January. Accessed online.

People's Paper Co-op, The (n.d.), *Expungement Clinics and Community Projects*, accessible at http://peoplespaperco-op.weebly.com/expungement-clinics-and-public-events.html

Powell, Michael G. (2010), 'Blacked out: Our cultural romance with redacted documents', *The Believer*, June. Accessed online.

Riles, Annelise (2006), 'Introduction: In response', in Annelise Riles, ed., *Documents: Artifacts of Modern Knowledge*, Ann Arbor MI: University of Michigan Press.

Safire, William (2007), 'Redact this', *The New York Times*, 9 September. Accessed online.

Slaughter, Joseph R. (2010), 'Vanishing points: When narrative is not simply there', *Journal of Human Rights* 9, 207–23.

Stelloh, Tim (2017), '"Mugged!"', *The Marshall Project*, in collaboration with *The New York Times Sunday Review*, 3 June, accessible at www.themarshallproject.org/2017/06/03/mugged

Vismann, Cornelia (2008), *Files: Law and Media Technology*, trans. G. Winthrop-Young, Stanford CA: Stanford University Press.

Index

Note: References in *italics* are to figures.